NATURE'S HARMONIC UNITY

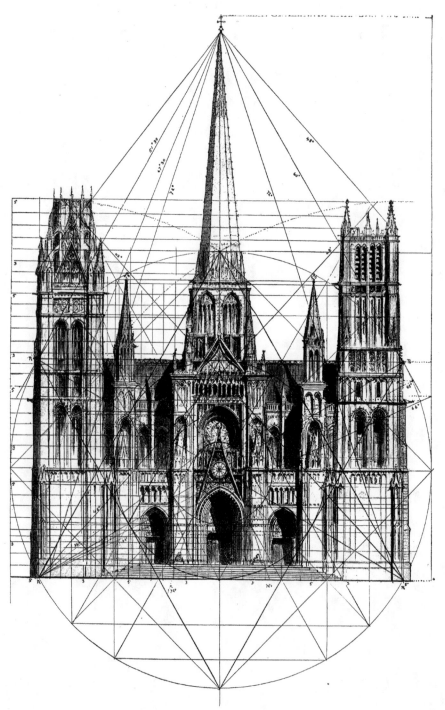

Design for Façade of a Cathedral.—*Frontispiece*

NATURE'S HARMONIC UNITY

A TREATISE ON

ITS RELATION TO PROPORTIONAL FORM

BY

SAMUEL COLMAN, N.A.

EDITED BY

C. ARTHUR COAN, LL.B.

WITH 302 ILLUSTRATIONS BY THE AUTHOR.

THE MATHEMATICAL ANALYSIS BY THE EDITOR

Martino Publishing
Mansfield Centre, CT

2009

Martino Publishing
P.O. Box 373,
Mansfield Centre, CT 06250 USA

web-site: www.martinopublishing.com

ISBN 1-57898-791-1

© *2009 Martino Publishing*

Library of Congress Cataloging-in-Publication Data

Colman, Samuel, 1832-1920.
 Nature's harmonic unity : a treatise on its relation to proportional form / by
Samuel Colman; edited by C. Arthur Coan; with 302 illustrations by the
author.
 p. cm.
"The mathematical analysis by the editor."
Originally published: New York and London, G. P. Putnam's Sons, 1912.
Includes bibliographical references and index.
ISBN 1-57898-791-1
 1. Proportion (Art) 2. Architecture--Composition, proportion, etc. 3.
Mathematics in nature. I. Coan, Clarence Arthur, 1867-1934. II. Title.

Printed in the United States of America On 100% Acid-Free Paper

NATURE'S HARMONIC UNITY

A TREATISE ON
ITS RELATION TO PROPORTIONAL FORM

BY

SAMUEL COLMAN, N.A.

EDITED BY

C. ARTHUR COAN, LL.B.

WITH 302 ILLUSTRATIONS BY THE AUTHOR

THE MATHEMATICAL ANALYSIS BY THE EDITOR

G. P. PUTNAM'S SONS
NEW YORK AND LONDON
The Knickerbocker Press
1912

The Knickerbocker Press, New York

To

MY SON

PREFACE

MANY years ago I became profoundly interested in the study of the laws governing proportional form, both in Nature and in the arts and sciences, and the further these investigations were pursued the firmer became the conviction that the laws of proportion, as exemplified in Nature, were startlingly uniform, whatever might be the complexity of the application. In the course of these investigations covering a vast number of Nature's forms and phenomena, and of the laws governing proportional form, the crystal was found to be their most perfect interpreter, but in the flower, the shell, and many other forms of varying origin or organism, the same constructive principles were recognized, and these it will be my endeavor in this work to explain. As these principles are the fundamental elements by which Nature creates harmony, correlating the parts of her form-compositions into a perfect whole, they must be of interest to the student of beauty and of use to the professional artist. Many of these laws were unquestionably among the valued and guarded secrets of the Masonic Order and of the ancient guilds, and as time went on were, unfortunately, guarded not wisely but so well that for generations they have been lost to the use not only of the world, but to those very architects and masons who most treasured them as well.

It is upon the application of these same ultimate principles of harmonic proportion, governing every natural formation, organic or inorganic, to music, sculpture, painting, and above all to architecture, that consciously or unconsciously man has laid the lasting foundation of all form-beauty in art; and only by the recognition of these principles can we hope to deduce intelligible and universal laws governing the fundamental Harmony of Nature.

In this investigation I have received much help from Mr. Jay Hambidge, the artist, whose work on the proportions of the Parthenon was so warmly recognized by the Hellenic Society of London, and who was among the first students to disclose the true symmetry of shells, and to call attention to the binary principle of Nature.

To Professor Tyndall I owe my knowledge of polar force, which he describes in his lectures on Light, revealing its influence on angular magnitude, lessons of lasting value to the architect as well as to the artist.

I am also much indebted to the writings of D. R. Hay of Edinburgh, who, like Ham-

v

bidge, gives attention to the binary principle, or the law of octaves, declaring it to be as important a factor in form-composition as in the science of music. He also called my attention to the value of mathematical curves in formal art as well as applied to the human figure.

Professor Raymond of Princeton University, in his remarkable book on *Proportion and Harmony of Line and Color*, tells us many truths in his absolutely sound treatise on the theories of this subject, disclosing the influence of the laws of repetition, contrast, variety in unity, etc., on art; and Joseph Gwilt, the English architect, has added greatly to our knowledge of the principles of proportion, which he describes at length in his work *On Architecture*.

The combined works of these writers leaves little to be desired for one seeking information on the subject, and it might almost be felt that there is small need for further words to illumine it. My purpose in adding to these, however, is that I may adduce proofs where heretofore only theories have been advanced, since the above authors say but little of Nature's laws in relation to her forms of growth and production, applying their theories to buildings or other works of art, considered most perfect. Therefore when Gwilt, for example, declares that "the square and the cube have been the fundamental forms in past ages for the just development of proportional spaces in art," the words do not impress the mind as of vital value, since no causes or principles of Nature are forthcoming. But the laws of Nature should be the basic element for all theories, and it is chiefly with these laws that I have to deal.

Of late a new light has arisen on the horizon, for the works of Prof. A. H. Church, of Oxford, the distinguished botanist, have disclosed more truth in the relations of plant-growth to proportion than any other of the numerous writers on botany. The principles governing this growth are clearly described in his work on *Phyllotaxis in Relation to Mechanical Laws*, and it is from this source that much of the material in the chapter on botany is derived.

All of the above men have produced theories which not only stir the imagination but also illuminate the pathway leading to a just understanding of Nature.

New York, December 1st, 1911.

S. C.

CONTENTS

viii Contents

NATURE'S HARMONIC UNITY

INTRODUCTION

PROPORTION is a principle in Nature which is a purely mathematical one and to be rightly interpreted by man through the means of geometry; therefore geometry is not only the gateway to science but it is also a noble portal opening wide into the realms of art. Still to a great majority of artists, and to the world at large, the effort to relate science with art is now looked upon with the greatest disfavor and even repugnance, and this accounts in a measure for the overwhelming percentage of immature work which characterizes all branches of art in our times. The architect, the sculptor, the painter, etc., each places too much confidence in what he is pleased to call his "feeling" or "genius," without considering the fact that this feeling or genius would not only become more profound, but capable of a larger expression, were the mind endowed with fuller knowledge of the laws of beauty. Furthermore the eye becomes better trained under the influences of the exact study of geometry, and thus the student is able more readily to recognize and more justly to appreciate the various charms of Nature.

Analysis discloses the fact that the marvellous symmetry which characterizes the crystal has its exact counterpart in the formation of the flower and the shell; while an examination of the masterpieces of art in the past ages clearly shows that the men who produced them were conversant with those geometric principles which lead to unity of expression; and just in proportion as these artists were masters of this knowledge and imbued with this spirit did their resultant buildings, statues, or pictures become ideal in character and worthy the admiration of all the ages.

But in our day art is taught in studios, academies, and schools in a more or less perfunctory manner, no attempt being made to subject the student to any form of mental or scientific training. The Greek artists as well as those of the Middle Ages were men of learning and many acquirements,—their painters were also accomplished architects, sculptors, and goldsmiths, understanding the principles of chemistry as well, and before

entering the schools of art were required to have an accurate knowledge of geometry. One of the greatest reasons that we should still have hope in the future for a superior form of art in our country comes from the fact that our people are beginning to manifest an eager interest in the suitable decoration of their public buildings, already developing remarkable results by reason of the wisdom shown in selecting the artists for this work from among the men with a comprehensive and rigorous training, qualities rarely to be met with among those who devote themselves to the production of easel pictures only, for this, if continually persisted in, must eventually lead to a debased art.

The time cannot be far distant, however, when it will be universally recognized that the highest possible plane of work for the sculptor, painter, and architect will be that in which each collaborates with the other, all engaged simultaneously upon and engrossed in one great whole, and all alike endowed with a scientific knowledge of the laws of Nature. Then the easel picture, which should be of secondary importance and not the first as we now make it, will take its proper place in our art history.

The study of the various phenomena in the organic and inorganic world leads, at once, to the just consideration of the principles involved in correlated design, which study depends largely upon measurement, and this, it may here be explained, is the only way mathematics can have to do with art. Because of the prejudice arising from a misconception of terms, when mathematics has been mentioned in connection with æsthetics, the study of form-phenomena has been as a closed book to the artist, he considering that an equation must be found for every part of a design-composition: thus confounding "measurement" with "calculation," terms of very different meaning. The justice and accuracy of the rule adopting a measurement or adapting it to a certain purpose may be demonstrated by calculation; but, the reasoning once scientifically laid bare, the artist or designer may have the advantages of the measurement constantly before him, relegating the abstruse calculation from which it arose to the obscure corner from which it emerged to serve its purpose. It is upon his measurement, not upon calculation, that the artist or designer is largely dependent for a just arrangement of details, as well as to a general conception of the mass. The harmonic relations in Nature and Beauty are fixed beyond all change by him. He has but to study them. Thus it is that a geometrical construction in a design will appeal both to the eye and the mind by its reasonableness.

CHAPTER I

ARGUMENT

"Order is Heaven's First Law."

WHAT does the term "Order" imply in this connection? It would seem to imply the just correlation of each of the parts of an object with the whole. This means that all of the details of a form in Nature are accurately united in perfect harmony, but the scheme of this unity can only be determined with precision by the use of mathematical measurements, angles, points, lines, and surfaces, produced by geometric principles. Unity is the highest element of beauty, and there can be no question but that the laws of growth in Nature are the fundamental ones which govern it. If it be one object of man's use of geometry to investigate the stars in space, the same science may be also similarly employed in an analysis of the laws of plant growth, polar force, or of any of the many other evidences of Nature's handiwork, as the underlying principles are the same in each. We must not consider that the circle, the triangle, and the square are simply forms, but elements representing the divine grammar of Nature. These geometric principles continue throughout the universe in orderly and exact methods, not only to secure beauty of proportion but the highest use as well.

> "The heavens themselves, the planets and this centre,
> Observe degree, priority, and place,
> Insisture, course, proportion, form,
> Office, and custom, in all line of order."
>
> TROILUS AND CRESSIDA.

This influence has always been felt, not only by the most civilized races, but by untutored savages as well; man's history has been written in it for thousands of years, from the axehead of the Stone Age up to the mighty Pyramids of Gizeh, which have stood in their geometric form longer than almost any other work of art, dominating by their simple majesty the minds of passing generations.[1]

[1] It was about the time of the building of the Pyramids of Gizeh that the Pentagram of the Magi became the vogue, and not only did architects study it, but it became a mystic emblem among the educated classes which was applied to all manner of subjects.

The people who created them were among the first to consider philosophically the attributes of the circle, the triangle, and the square, recognizing that they contained the elements for the true measurement of proportional spaces. This knowledge, imparted to the Greeks by the great mind of Pythagoras, after his sojourn in Egypt, enabled their artists and architects to create that perfect proportion and ideal refinement of form which were the distinguishing traits of the art of that period and still remain unsurpassed. The Gothic architect and artist re-discovered many of the Greek secrets, causing beauty once more to bloom in statue, picture, and design, while cathedrals, the perfections of which are still the wonder and admiration of all classes of men, arose to glorify the land. Under the influence of this exact knowledge even the simplest village church of that period charms the world to-day by the perfect balance of its parts. Freemasonry was alive and active then, but its mysteries were known only to the brotherhood. So inviolate were its secrets that we can now learn little of the principles of proportion even from dissertations on the subject in Encyclopædias and other writings, beyond a few set phrases. Even in that remarkable controversy between Ruskin and the architects of his day, not one word was given on either side beyond similar trite sayings.

Moreover, the mistake which is made by many people, and it is a vital one, of questioning the value of the geometric theory of proportion, is this: that they consider geometry to be an invention of man involving his formally constructed equations only. I need hardly say, however, that the principles are not man's invention, although the outward form of Algebra, which is one of its visible interpreters, may be. The truth is that the system is simply the logical expression of one of the methods man has borrowed from Nature by means of which he can more easily investigate scientific questions. It is as much a part of her as the very air we breathe. Its use in an analysis of proportion is like the application of a solvent which must be suited to the object to be resolved, otherwise labor is in vain. In order to prove the statement that geometric correlations and the proportions of objects in Nature are one and the same thing, all that one need do, even though examples are innumerable, is to take a drop from a pool of fresh or salt water for examination under the microscope, when various beautiful creations will appear, revealing in their individual forms all five of the regular polyhedra, exactly as though drawn with mathematical instruments.

It is well recognized that light, sound, and heat are geometric in their action and continue on similar lines of "force" to be amenable to accurate calculation by measurement or numbers, the elemental source of all harmony. By what right then have architects or artists in our time considered that they have any peculiar privilege of their own to seek to construct beauty without an accurate understanding of the same system by which the loveliness of all forms of beauty in Nature comes into existence?[1]

[1] Albrecht Dürer (1471–1528) was the first artist of whom we have any record, to write on the theory of proportion, and among other things applying to the subject said: "I have heard how the seven sages of Greece taught

The cant phrase of the day, that "great art can only result from a passionate spontaneity of feeling, and this feeling must be smothered or paralyzed by the employment of scientific methods," comes from a strange misapprehension of the truth. But when to this false statement are added the words, "Hellenic art, in particular, was the outcome of genius under the influence of impulse only," one cannot help thinking that those repeating this idea must be under the influence of blind prejudice, or suffer from a want of knowledge of form-composition or of the facts of history. If Ictinus and Phidias could arise from their graves they would be the first to repudiate and resent such language as applied to their works, for the Parthenon, even with its statues and ornaments in their ruins, is the most perfect form of art that the hand of man has produced, and an analysis of its portico alone will discover the fact that the relation of the details to the mass is one of most perfect unity, owing to the intelligent application of the law contained in the "Progression of the Square," or by the same sure method employed by Nature in her plan of developing the wonderful beauty of the crystal.

Under the influence of exact scientific study the artist will find that his impulses will become more vitally alive, while his imagination as well as intuitive feeling will be greatly strengthened and his achievement become vastly superior and of lasting credit. The sculptor or painter who from want of education or lack of thought condemns mathematics should bear this fact in mind, that the bolder, the swifter, the more impulsive the stroke of the modelling tool or the brush in the hand of a master, the more perfect, the more beautiful, and the more like Nature is the resultant curve, for the arm and hand have become, through training, a sort of mathematical instrument with an exact though complicated radius from which he cannot escape.

From a similar want of thought Beauty is now considered an element impossible to describe in any adequate and conclusive way, while many philosophers and æstheticians agree with Johnson and his intimate friend Reynolds, the artist, who were among the first to declare, "that Beauty exists only in the mind, and just as this mind is prejudiced by its education, will an object be beautiful to one and not so to another. Who shall judge?" A frequently used definition of the word "Beauty" is to the effect "that whatever pleases the eye or the mind is beautiful," but this idea alone is of a kind that might be discussed until doomsday without arriving at any conclusion. The word "Beauty" has come, however, through centuries of use by educated people, to mean something far more than is usually given by lexicographers; very

that *measure* is in all things (physical and moral) the best." "Those arts and methods which most truly approximate to exact measurement are the noblest."

Edgar Allan Poe, a man to whom the term "genius" seems eminently fitted, said, in his work on the *Rationale of Verse*, that "one tenth of the art of poetry is ethical, but nine tenths appertains to mathematics."

This fact should also be remembered, that Music is the most mathematical of all the arts, yet there is no other one of these that leads the mind so persistently to the highest realms of the imagination, and to that ideal land where passionate feeling finds its most perfect life and expression.

many feel that it is the highest manifestation of the Creator, revealed in mountain, cloud, and ocean, with the countless living things that they contain. But it is only through an accurate analysis of these various forms that a clear and distinct idea may be obtained, where no sophistry in argument can change the result. In this analysis we learn conclusively that the essence of "Beauty" is unity and where unity exists it can be clearly proven, remaining no longer a question of what this man thinks, or that, whose prejudices have blinded his faculties of observation.

It is true that one person may prefer the beauty of man, another one that of woman; I look with especial favor on the rose, while my neighbor takes more delight in the lily; both are right, as all are beautiful. That is, they are objects expressing divine unity of construction, or the perfect correlation of parts in form-compositions.[1] This book is not devoted to the philosophy of beauty, these arguments are only advanced to suggest the idea that future investigators may find, through scientific methods applied to Beauty, a clearer means of interpreting the term than now exists, while these methods will ultimately expose the fallacy, now so generally looked upon as truth, that Science and Beauty are antagonistic. The more profoundly the mind considers the question of Science and Beauty the more deeply must man be impressed by Nature's methods, and under the influence of the resulting knowledge will the heart of a passionate artist be more deeply kindled with a fire which must result in work more perfect and more enduring; for the great law of numerical harmonic ratio remains unalterable, and a proper application of it to art will never fail to be productive of good effect, as its operation in Nature is universal, certain, and continuous. She appears never to tire in following out mechanical principles in her works, and her methods should be properly respected by man when he seeks to construct forms of beauty, while his theories of art should be duly founded on her laws, so exact and infallible.

In showing how the rules and principles of harmonic proportions apply to the arts and sciences, we must not look for blind adherence in every instance to the degree, minute, and second of every angle, and no vernier scale nor micrometer is needed to prove or disprove the propositions here set forth. The acid test of mathematical precision and calculation has been applied to all of the fundamental principles which are claimed, and the result proves itself at every step to be well within the limits of Nature's constant variations, as has been indicated from time to time in the Appendix, and if, in the "multiplicity of instances," cases of slight deviation be pointed out, I may venture the statement that the deviation will prove negligible and serve only to sustain the spirit of the rule.

[1] In a remarkable work, *On a Theory of Pure Design*, lately published by Prof. Denman Ross, of Harvard University, the term Beauty is thus described: "We look for it in instances of Order, in instances of Harmony, Balance, and Rhythm. We shall find it in what may be called supreme instances. It is a supreme instance of Order intuitively felt, instinctively appreciated." As Order, including Harmony, Balance, and Rhythm, can be scientifi-

As Nature loves variety, so she produces unexpected results by combining various forces, and while seemingly she deviates continually from the letter of her harmonic laws, she never does from their spirit. We must not look for an uninterrupted identity of mathematically derived rules with natural phenomena. The forces at work are so varied in their application that no one of them is uninfluenced by others. Botanically, torsions will be found occasionally to displace symmetry in a flower, seismic disturbances will interfere with geologic formations, or the solar influence may destroy the ellipse of an approaching comet, but in no case, actual or imaginary, does Nature show any tendency to anarchy. She abides by her rules, though through the veil of composite effects they are sometimes hard to trace.

What Nature permits, man may surely do, and it is doubtful if a clearer example of the necessity of applying to art Nature's compensatory rule of "give and take" could be offered, than the following.

[1] It may safely be said, without fear of contradiction, that of all the Arts, Music is far and away the most mathematically exact, and in this I do not refer to the question of musical "tempo," which is comparatively simple, but to the rules of vibration and tonal production which govern the relationships of the members of the diatonic scale, and the harmony of composition.

Any studious musician will understand that the natural and perfectly constructed scale, true to the ear and to its mathematical proportions of vibration, contains perfect octaves, perfect dominants, mediants, and other intervals, but he will also understand that this natural and perfect scale is *susceptible of no use whatever* in any key except that of the tonic for which it was constructed. Its tone intervals, as established by the ear and by science, are not all equal, nor are its half tones equal. For example, the ratio of vibration between the tonic and its second (a whole tone) is not the same as between this second and the mediant (also called a whole tone), for if the perfect scale for a single key be examined, the interval from the tonic to the second will prove to be in proportion to the interval between the second and the dominant in the ratio of 51:46 or thereabouts, and *not* according to precise equality. Naturally, then, if the perfect scale based, for example, on "C" as a tonic, be used for the rendition of anything written in the key of "D," it will be found that the interval from this new tonic to its second cannot of course be the perfect first step required, since the interval to be utilized has already been restricted to the vibratory difference indicated for the second step in the "C" scale, to wit, we are obliged to use the smaller of the two so-called whole tones, whereas in this new key of "D" we need the larger whole tone for the first interval. The farther the process is carried, the worse will be found the result, except that every octave is a repetition of every other. The ideal and perfect scale for the tonic "C" thus becomes utterly useless for a modulation into any musically remote key.

cally defined, we therefore recognize that the term Beauty is clearly and accurately set forth by this Master of Arts.

[1] The remaining paragraphs are taken from an article by the Editor.

To adapt any keyed instrument to general use, therefore, Nature's principle of compromise has been utilized in setting what is technically called an equalized "temperament," the greater, intervals, representing the greater ratio of difference of vibration, yielding to their lesser neighbors sufficient of their surplus so that all of the so-called whole tones represent equal, or nearly equal ratios of difference, the half tones being treated in the same way, thus leaving no key in its primary perfection at the expense of every other, but permitting all to be alike possible and pleasing. Here, if anywhere, we surely have an example of a universally adopted, measurable variation from mathematical perfection, under a system of compensation which produces a result both artistic and at the same time eminently practical.

From all of these facts it seems clear that, while Beauty is of many kinds and has many exemplars, her form is always controlled by Mother Nature, and if, by studious observation, man can re-learn a few of the principles employed by Nature in the creation of those forms which are universally acknowledged as Beauty, perhaps the determination of what is beautiful in art, music, architecture, and painting may be made simpler, more certain, and less subject to the whim and fancy of temperamental minds and the fluctuating personal equation.

CHAPTER II

CORRELATIONS

Correlations of Numbers[1]

T HE examination of the relations of numbers to each other has been a favorite pursuit of the logicians and mathematical philosophers from time immemorial, and it would seem to be more or less apt that, before endeavoring to analyze the harmonies of substance we should first briefly consider the relations and harmonies of the machinery by which these concrete entities are measured. Let us understand our "yardstick" before we begin to cut our cloth, proceeding in an orderly manner, first to study a few of the fundamentals of numbers in the abstract, then to ponder the conspicuous harmonics of geometrical proportions as adopted by our Mother Nature, turning then from the generic to the specific, to examine her wonders and to see how constantly she applies these proportions; and finally we may learn in what manner these same harmonics of geometry—the veritable "Harmonics of Nature"—have been playing their part in architecture and the arts.

It is not, therefore, the intention, under this head, to treat of concrete numbers as adopted by Nature or man, or as governing factors in any science or art save in the pure science of numbers themselves. Other features will be fully developed in future chapters where the several divisions will be separately taken up, a branch at a time. For the present, let us see what are a few of the harmonic relations of mere quantity to quantity, or of numbers *as such* to each other, rather than to the things numbered.

We shall find, then, that numbers, taken abstractly, bear certain obvious and sometimes harmonic relations to each other regardless of concrete objects. Let us first examine certain individual numbers for their traits and characteristics, for these are as different as the characteristics of our human kind. Since the most ancient times the number representing unity or *one* has stood apart from all others. The ancients, from the time of their first and crudest observations, have set the number *one* in a class by itself for reasons both numerous and conspicuous. Acting upon itself, the number *one* is self-propagative, and in a sense it is its own cause and its own effect, for if it be multiplied by

[1] By the editor.

9

itself, it produces itself ($1 \times 1 = 1$); when divided by itself, again the result is itself ($1 \div 1 = 1$); subjected to the processes of involution, it remains unchanged, since the square, the cube, or the n^{th} power of one is one; and under the influence of evolution it is still unaffected, for the square root, the cube root, or the n^{th} root of one is still *one* perpetually *one*. Its reciprocal is again itself ($\frac{1}{1} = 1$), and while it is an exact divisor of all other integers, so also are all other integers its exact multiple. It is thus invariable in its effect upon itself except through the processes of addition and subtraction, and even under these, its effect is like no other number, for if it be subtracted from itself, it leaves no quantity, but is transformed from a finite term at once to infinity, thus immediately carrying it outside the realms of all measurable calculation, and leaving addition as the only practical process of its self-variation. Hence *one* is unique among all numbers, as indeed the etymology of the very word "unique" proves.

Furthermore, the most ancient observers realized that, as a measure, the number *one* was capable of indicating *position* only, and neither direction, surface, nor content.

The number *two* has individualities less marked, it is true, than the number *one*, but two features alone insure its recognition, and have set it apart from all antiquity. First, then, it is the result of the earliest mathematical process, that of adding one to one (as we have seen, the only manner in which the unit is self-changeable), and secondly, taken as a measure, a term of two members is competent to show not only position, but direction or distance as well, this quantity having both a fixed start and a fixed termination. It is also the means of dividing all quantity into the two great classes of "even" and "odd."

The number *three*, being the lowest number to have a fixed start, a termination, and also a middle point, is vastly important as representing the smallest or lowest number of members capable of enclosing or outlining any portion of a plane surface. It is also the first and lowest number with which we meet having the capacity of a compound, being the result of the double process of adding $1 + 1 + 1$ or $2 + 1$, the latter being already, as we have seen, a combination.

The number *four* is the first and lowest number met with which is the product of any two integers not immediately influenced by the peculiar properties of the number *one* (2×2). *Four* is also the first and lowest number divisible by any other than itself and one; it is, thus, the lowest number not "prime." It is the first and lowest integral result of involution, being the smallest square (excluding the number *one*, which as we have seen is its own square). The number *four* is, as well, the lowest integer susceptible of perfect evolution (the square root of four equals two). The number *four*, moreover, is fundamentally important, inasmuch as it represents the smallest number of members capable of enclosing space, for even the triangular pyramid or regular tetrahedron must have one base and three sides.

These four were the principle elements in the Pythagorean system of fundamentals,

and were designated as the "monad," the "duad," proceeding from the union of monad and monad, the "triad," proceeding from the union of monad and duad, and the "tetrad," proceeding from the union of the duad with the duad. These four are the only terms presenting individual characteristics requiring our examination, and we may therefore proceed to consider numbers in groups or series.

For the purposes of this examination we shall confine ourselves mainly to the various numerical progressions, for it is with these that we have here to do. The simplest of all of these forms is a mere numerical order, 1, 2, 3, 4, 5, 6, 7, 8, 9, etc. This is so axiomatically a progression (by the addition of one each time) that it is usually omitted from classification. It, however, conforms to every requirement of an arithmetical progression and is the most fundamental of all. For the moment, let us pass to the more customary examples of this class such as 2, 5, 8, 11, 14, etc., where the numbers increase by equal intervals or additions (here of 3 each time). It will be observed that, given several factors or members of the series, the mind, in simple cases, supplies the rest intuitively, as would the eye if the series were one of spaces, or the ear, if recurrent sounds were involved. The same would be true were the intervals those of multiplication instead of addition, where the series, for example, would appear as 2, 4, 8, 16, 32, etc., thus coming under the definition of a geometrical progression instead of an arithmetical one. It is perhaps unnecessary to state that if these series were complex instead of the simple examples presented, they would nevertheless be quite as submissive to the rules for their solution, and the value of any unknown term could be immediately predicted, having the rate and other elements given, since these progressions are all of them regular and harmonic.

Besides the two conspicuous forms already referred to, there are many others coming generally under the head of "recurring series." In the ones we have so far examined, every interval is proportional to *every* other, but we find the recurring series presenting certain "free lance" characteristics, since in them *each* interval need not be proportional nor equal to *each* other, provided that after the appearance of one or more intervening members, the same intervals recur in the same order, as for example, 2, 6, 8, 11, 13, 17, 19, 22, etc., in which the respective intervals are seen to be 4, 2, 3, 2, and then repeating, 4, 2, 3, 2, again.

We now arrive at the great point to be attained in thus examining numbers, for of all of the various form of series, the most interesting by far is the one which we shall here take up, and which will well repay study. This series arises out of the natural inclination of the mind to combine any two things under consideration, using the result as a new step or member, to be in turn combined again. This is a well recognized tendency and such a process naturally commences where all numeration begins, with the unit, and grows thus: $1+1=2$; $2+1=3$; $3+2=5$; $5+3=8$; $8+5=13$; $13+8=21$; $21+13=34$, etc., and thus continuing to combine each pair for the production of a new

member. To those versed in such matters I need hardly say that this series has been much treated of and has been utilized under more than one name. It will be recognized by many as the well known "Fibonacci Series" and bears other appellations as well; but named or nameless, either in the form of whole numbers as just explained or in the more perfect ratio of a pure extreme and mean proportion, we shall find it flung broadcast throughout all Nature, as will be clearly shown in the subsequent chapters. [1]

This recognized series will be seen upon examination to present the nearest integral equivalent to what in the exact science of mathematics is known as "Extreme and Mean Proportion," which may be defined as *the division of any quantity into two such parts or portions as that the measure of the lesser part shall bear the same relation to the measure of the greater part as the measure of the greater part bears in turn to the measure of the whole quantity*. In pure mathematics this interesting proportion produces endless decimals, but Nature knows no fractions and is bound by no decimal divisions, for she produces her harmonies with a free hand and with inimitable perfection, being able to measure her distances and proportions with the extremest mathematical nicety yet without being subjected to the need of the cumbersome calculation which man would be obliged to use in her place. Nature's protractor is always right, and in her use of infinite subdivisions the smallest humanly conceivable fraction would seem to her a whole number. For ready service, therefore, this continuing series of 5, 8, 13, 21, 34, 55, etc., will be found to be of immense use where absolute exactness is not requisite, since by the employment of these whole numbers the enormous effort required to handle the large fractions otherwise involved in precise extreme and mean proportion is escaped. If we bear in mind, further, that the ancient systems of mathematical numeration were incapable of handling fractions with our modern facility, we shall understand more clearly why the Egyptians and Greeks did not treat fractions as "numbers" and why they so habitually substituted an integral approximate in place of our decimal precision. [1]

In the subsequent chapters we shall find that Nature uses this as one of her most indispensable measuring rods, absolutely reliable, yet never without variety, producing perfect stability of purpose without the slightest risk of monotony.

Before leaving this abstract subject of Nature's measurements it would be well to bear in mind one other principle invariably employed by her. We should remember that, while Nature selects her harmonies to suit herself, one to govern phyllotaxis, another to control all formations subject to polar force only, and so on throughout the list, yet, *once decided on, she never forgets, never changes her mind*. All changes of natural form or substance are the outgrowth of *combinations* of causes which produce a result different from the uninterrupted effect of either cause working alone, and it is a recognized fact that in whatever proportional group a form or process or chemical reaction belonged at

[1] For those interested in understanding the pure mathematics of extreme and mean proportion, the explanation contained in the Appendix note under that head will not be amiss.

the beginning of time, we may be certain that the identical conditions will invariably produce the identical result till the fulfilment of all things.

Correlations of Form

We have seen that the great or primary cause of harmonic unity is a simple one, consisting in the reduplication of the original unit producing the ratio of 1+1, which is

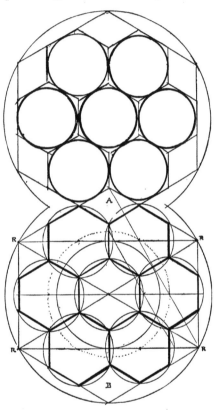

Plate 1—Molecular structure

synonymous with the ever present law of repetition, and at certain stages represents a system of "octaves" closely corresponding to the theory of music. It is the basic element of all growth in Nature, guiding her forms to their ultimate use and beauty. Molecular structure, for example, is made up of repeating particles or octants, which would be round if it were not for atmospheric pressure, but under the influence of this principle molecules are packed in the only possible way without interstices or waste room, as shown for example in Plate No. 1, diagrams A and B. If masses of these circles are drawn on a small scale and regarded with the eye partly closed they will appear to be actual hexagons. Diagram B represents the small circles in A pressed into their ultimate form, and in every seven of these circles seven hexagons result. This primal arrangement is under the inviolable influence of "polar force" causing atom to lay itself to atom in a definite way but liable of course to accident; the law is superior to accident, however, for as we shall see *angular magnitude is a principle ultimately enforced*. Thus Nature from the very beginning reveals herself as an architect, building in accordance with the established law of gravity, and angular magnitude becomes at once the fundamental element of proportional form. On this subject there can be no question of doubt. Whenever we examine any form produced by Nature in which she has employed the agency of polar force, we may count on finding the design to be one in which the conspicuous angles will be those of the most prominent aliquot parts of the circle; that is, the quadrant, of 90°, the eighth, of 45°, the sixth,

of 60°, and its complement, of 30°. These constitute the chief angles in the "geometry of space" and are clearly represented by the cube, the square, and the hexagon with which the pentagon is harmonic and by the regular progressions of these figures. From them the true principles of architectonic design may be deduced, to be followed by perfect results according to the genius of the designer by whom they are employed. The angles of 30°/60° produce all crystals numbered by six, such as snow crystals, while that of 45° decides the proportional spaces of all permanent chemical crystals, rarely failing to do this with an exactitude and perfection of proportional spaces unsurpassed.

The influence of these angles may be distinctly traced not only in the Greek temples, both before and after Ictinus, but also in the Gothic buildings of the Middle Ages; and as competent judges unite in declaring the Parthenon to be the most perfect work by the hand of man, I have employed it as a text or test in many places in these pages, for purposes of comparison with spaces resulting from various geometric correlations applied to works of art. So far as the works of Nature are concerned it would be difficult to say where the angles of polar force cease to exist as the great factors in contributing to the beauty of form, line, and curve, from the waves of the sea to the clouds, the trees, and the flowers. Even the magnificent forms of mountains owe their modelling and line to this law. The catenary curve is the most perfect of all curves and can be traced from the very beginning of things. Its manifestations can be better described mathematically than in any other way and its principle may be equally well applied to other geometric forms, outside of the angles of polar force, for the harmonic relation between them is most perfect.

On the Polyhedra

The Greeks, long before the Christian era, discovered that there could be but five regular solid bodies, or polyhedra, three of these formed by the use of the equilateral triangle, one based upon the square of 90°, and one upon the regular pentagon, which forms we will now analyze as set forth by Euclid.

The simplest regular polygon is the equilateral triangle, and since each apex of an equilateral triangle is an angle of 60°, three such triangles can be combined to form a polyhedral angle. It is seen, then, that a regular polyhedron can be formed, bounded by equilateral triangles and having three at each vertex. This has four faces and is called the tetrahedron. (See fig. A, Plate 2.) Since four angles of 60° are less than four right angles, four equilateral triangles can be combined to form a polyhedral angle and it is seen, then that a regular polyhedron can be formed, bounded by equilateral triangles and having four at each vertex. There is such a regular polyhedron. It has eight faces and is called a regular octahedron. (Plate 2, fig. B.) Since five angles of 60° are less than four right angles, five equilateral triangles can be combined to

form a polyhedral angle, and it is seen then that a regular polyhedron can be formed, bounded by equilateral triangles and having five at each vertex. There is such a regular polyhedron. It has twenty faces and is called the regular icosahedron. (Plate 2, fig. C.) No regular polyhedron bounded by equilateral triangles and having more than five at each vertex is possible, for six or more angles of 60° are equal to or exceed four right angles and cannot form a polyhedral angle.

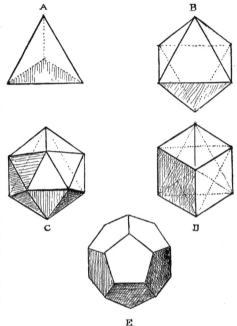

Plate No. 2—The Polyhedra

The regular polyhedron next in order of simplicity to those formed by the equilateral triangle is the polyhedron formed by the square, each of whose angles is a right angle. Three right angles can be combined to form a polyhedral angle. It is seen then that a regular polyhedron can be formed, bounded by squares, three at each vertex. There is such a polyhedron. It has six faces and is called a cube or regular hexahedron. (Plate 2, fig. D.) No regular polyhedron bounded by squares and having more than three at each vertex is possible, for four or more right angles cannot form a polyhedral angle.

The next regular polyhedron is that formed by the use of the pentagon, each of whose angles contains 108°. Three angles of 108° each can be combined to form a polyhedral angle. It is seen then that a regular polyhedron can be formed, bounded by regular pentagons and having three at each vertex. There is such a regular polyhedron. It has twelve faces and is called the dodecahedron. (Plate 2, fig. E.) No regular polyhedron having more than three angles of 108° at each vertex is possible. These five polyhedra, the tetrahedron, the octahedron, the icosahedron, the hexahedron, and the dodecahedron are the only ones possible.

It would be well for the serious student to construct models of these five figures in order fully to comprehend their meaning. This can be done easily and with perfect accuracy by drawing on cardboard the following outlines, cutting them out and gluing the edges. (See Plate 3.) It may easily be seen by examination that the square, the pentagon, and the hexagon by its equilateral triangle are all that appear to the eye in regarding them. This trinity of forms is now disclosed to be harmonic with all five of the polyhedra and they are therefore all that are necessary in an analysis of proportional

spaces, excepting the Egyptian triangle with the angles of 38° 30′ and 51° 30′ and the ideal angles of 42° and 48° which will be considered later.

An examination of the above system of angles, which proved of such value to the Greeks, may prove of equal value to the architects of our day, for by its use they can

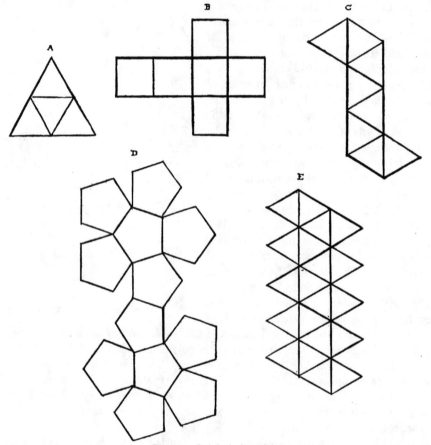

Plate 3. Polyhedral models

create a form-composition not only with greater ease but with a more perfect correlation of parts, which is one of the secrets of success in all forms of art. Moreover, the principle is capable of infinite combinations such as occur in snow crystals, for example, the marvellous forms of which are never repeated, although the angles of 30° and 60° are the basic elements of all their proportions. For the above reasons it is clear that

the student of beauty can hardly waste the time which he expends in a close investigation of geometric relations, however valuable that time be to him, for these relations are the divine parents of proportional form.

Many of these principles of harmonic ratios were undoubtedly understood and made use of by the Free Masons, but have been lost or forgotten for nearly two centuries, as they were never allowed to be reduced to writing, but only handed down from master to apprentice as inviolate secrets. To-day few even of the fraternity know aught of the real significance of the ancient order or of the badges and emblems they wear, such as the seal of Solomon and numerous other designs at one time fraught with so much symbolic meaning. Investigators have been busy of late years in an endeavor to recover these lost secrets and the so-called "Divine Section" of Pythagoras has been set forth by some as the basic element of the principle, and many other theories have been advanced in relation to the subject. Books have been written and papers published in vain as the world still scoffs at what it considers the thoughts of madmen, stigmatizing their ideas as "mere cabala." These ideas contained the elements of truth, however, and if their authors had drawn their facts directly from Nature, giving scientific evidence for their deductions, they would in all probability have been accepted at once, for empirical statements, however plausible, can never be convincing.

In the light cast on the question of proportional growth in plants by the profound investigations of the most advanced modern botanists, we have tangible evidence to guide us and from what is thus revealed it would appear that Nature is forever striving to reach perfection through the use of an ideal angle; while extreme and mean ratio takes an even more important place among her methods. Six centuries ere the dawn of the Christian era Pythagoras promulgated theories in relation to geometry which were much discussed by his disciples; thus principles were formed which laid the foundations of geometric correlations applied by Hermogenes to architecture, and afterward employed by Ictinus in a still more intelligent way in the construction of his divine Parthenon. To-day the knowledge of the laws of growth in Nature is much more thorough among botanists than heretofore, but the result has only served to prove that the geometric principles advanced by Pythagoras have a fundamental influence on plant-growth, not only in relation to the octagon, the pentagon, and the hexagon but in an even more profound way in regard to extreme and mean ratio. Thus the "Divine Section" can now be shown to be one of the greatest factors for the just development of the proportional spaces in all flowers, plants, and shells, and so much is this the case that on the basis of the series of 5:8:13: etc., a theory of proportion may be advanced that will approximately supply the requirements of all students in the art of design.

A large part of the material herein produced is far from new, much of it dating back to the Egyptian priests from whom Pythagoras first learned his laws of geometry, in the proof of which we have the "Egyptian triangle" wherein the first elements of

proportion have their being. It develops at once, by the natural progressions of its complementary angles of 51° 30′ and 38° 30′, the great series of harmonic ratios by the means of which Nature produces the perfect spacing of all parts of her beautiful forms.[1] What I have rendered as more or less new is an analysis of these forms as deduced from geometric principles, advancing no theory without referring at once to some well-known and definite object in Nature as proof.

The simplest and most direct way of producing the harmonic angles with their ratios is by means of the protractor of the quadrant. This remarkable instrument has been in use for the purposes of angular measurement from immemorial time, and although there is no mention of its discovery in history, it was in all probability the invention of the Chaldean Magi. It was certainly employed by the Egyptian priests in their examination of the heavens and in other early research, and it still remains in use for similar purposes, as nothing better can be devised. The circle, as we know, is arbitrarily divided, for purposes of computation, into 360 parts or degrees, as no other figure can be found to combine as a common multiple the lower integers 2, 3, 4, 5, 6, 8, and 9 in so perfect a way, together with many of the higher numbers as 10, 12, 15, 20, 30, and others. Three hundred and sixty is divided by 2 three times, by 3 twice, and by 5 once, as described in the following arrangement:

A.	2)360	3)360	5)360
	2)180	3)120	72
	2) 90	40	
	45		

B.	3) 45	5) 40	2)72
	3) 15	8	2)36
	5		2)18
			9

C.	5) 5	2) 8	3) 9
	1	2) 4	3) 3
		2) 2	1
		1	

The division of the quadrant of 90° by two produces the harmonic angles of 45°;

[1] See explanation of Egyptian triangle, Appendix Note E.—EDITOR.

if divided by four, the resultant angles are 22° 30′, 45°, and 67° 30′; if divided by eight, we have 11° 15′, 22° 30′, 33° 45′, 45°, etc.; and the division by three produces the angles of 30°, and 60°; dividing by six gives us 15°, 30°, 45°, 60°, and 75°; by division by five, we have 18°, 36°, 54°, 72°; division by ten renders the angles of 9°, 18°, 27°, 36°, 45°, 54°, 63°, 72°, 81°, and 90°, together with the supplementary angles of 99° and 108°. These constitute the angles of the octagon, the hexagon, and the pentagon, or all of those necessary in an analysis of proportional form with the exception of 42° and 48° of the ideal angle and the complementary angles of the Egyptian triangle, which will be taken up later on. By the use of these and the trinity of figures we have described, the divisional spaces of Nature's most beautiful works may be justly established.

A method will now be submitted for employing the quadrant by its protractor, which instrument should be constantly in the hand of all students of proportion.

It may first be stated, at the risk of a somewhat pedagogic effect, that the division of the circle by its diameter into two equal parts gives the base or horizontal line from which all angles are calculated by the degrees in the arc of 180° subtended by this diameter, 90° being half; and these degrees being divided into minutes, which in turn are divided into seconds. The vertical line drawn from 90° is a right angle with the base line and therefore the fundamental one for the establishment of all other angles. Plate No. 4 illustrates how the "protractor" of the quadrant "A" may be placed in relation to the circle "B," together rendering the relations of both sides of

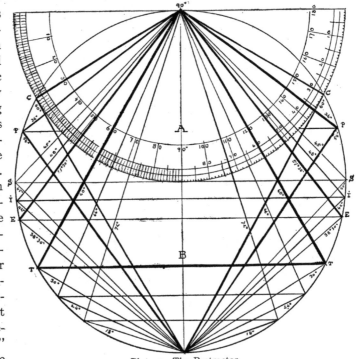

Plate 4—The Protractor

the angles, such as 30° on the one side and its complement of 60° on the other, for the

equilateral triangle; 36° and 54° for the pentagon; 38° 30′ and 51° 30′ for the Egyptian triangle; and 42° and 48° for the ideal angle: the angle of 45° coming on each side of the horizontal line at S. In other words, by ruling 30° from the pole or 90° in A, its complement of 60° will pass to the pole or 90° in the circle B and so on. In this chart only the angles of 30°/60°, 36°/54°, 45°, 42°/48°, 38° 30′/51° 30′, 24°/66° and 18°/72° are drawn as they are the most important ones in any system of proportional form.

In order to understand the unity of result between the workings of the Egyptian triangle, the pentagon, the octagon, and the hexagon and the angles of polar force, it will be necessary to know some at least of the attributes of the forms of which I shall have such frequent occasion to speak, and I regret that the complications of the designs in this system of analysis are at times necessarily so great as to require patient and careful attention from the reader; such patience and attention, indeed, that many of them will protest against this intricate division produced in the necessary diagrams. *But there is no other way to present the facts* if the student wishes to obtain a clear and intelligent understanding of the unity of Nature and to comprehend the exact harmony of parts in her form compositions which establish this unity and which result directly from geometric correlations, revealing truth after truth. By their intersecting lines these harmonic progressions produce points for measurement, often considerably removed and which would never be suspected or recognized by the eye alone however greatly the mind may feel the resultant harmony. It should here be noted that no intersection of less than three lines can be accounted of any value, but the moment a third line crosses a given point, the result is all important; if four or more unite, still further importance attaches. The study of these details is then necessary if the student desires a knowledge of the unity of the pentagon, the hexagon, and the octagon which Nature so continually employs in conjunction. Moreover, they clearly explain why the great architects of antiquity selected these polygons as fundamental elements in the composition of their temples, churches, and other buildings; but more than all else they proclaim that "Order is heaven's first law," revealing in a large measure the hand of Divinity.

After a careful and intelligent study of these principles and their relations to each other, the eye will come to realize that geometric forms are really beautiful in the light cast upon them by the mind, which illuminates them until it throbs with unwonted satisfaction when any one of the polyhedra is regarded. But that mind must be awake; when it does not thus respond, it may be safely counted asleep or dead to the underlying glories of the Creator's constructive laws.

CHAPTER III

Modes of Progression

W E have seen how easily the harmonies of numbers may be established by the use of various arithmetical and geometrical progressions, ratios, proportions, and series, and it must be understood that from time immemorial an analogous method has been sometimes used to compare the proportions or ratios of regular geometric form. For this purpose the inscribed circle is generally used as a unit of measure, for it is plain that if I inscribe a circle in a given square and again inscribe a square within this circle, the second square must bear a fixed and measurable relation in size to the prime or first square, and this proportion will remain unchanged whatever be the size of the prime or original basic square. Many varieties of this method have been followed in the past and it has been given many names, but in this work such a comparison of geometric configurations has been designated as a "form progression" as best fitting the idea to be conveyed, for the word "progression" is defined as being "a regular or proportional advance in increase or decrease,"—and this assuredly is precisely the meaning.[1]

The Pentagon

Those various geometric forms from which all just proportional spaces may be produced in the most perfect manner will now be described, commencing with the pentagon as this figure is the most significant,—a term used advisedly because of the remarkable properties the pentagon has in the production of the extreme and mean ratio, the ideal angle, and the Egyptian triangle, the octagon, the hexagon by its angle of 60°, and all other harmonic elements; for although, as previously stated, the trinity of polyhedra is very closely related, still this figure appears to combine in Nature with the others so frequently and so perfectly, that I have described its properties more at length than those of the others.

[1] Editor.

The method adopted for the production of the progression of the pentagon for the purposes of this work differs somewhat from the mere alternating of inscribed circles and pentagons. That process would disclose many harmonies, but a shorter and equally uniform and harmonic method has been found, which is first to draw that figure inscribed in a Prime circle, as in Plate 5, with its apex at the upper pole in one instance, and again, for convenience, with the apex at the lower pole; the angle of 18° now drawn in either of these figures from P to aP, as in the diagram, will give the point of intersection with the vertical radius at vo, through which the circle of the first progression of the pentagon will be made to pass. In this circle the angle of 18° repeated in like manner will render the position of the circle of the second progression, and so on. Four of these are drawn in the diagram as sufficient to disclose the principle.[1] These circles are now related to each other by an extreme and mean ratio which will be found to exist between their radii, or practically with the ratio of 5 : 8 between each succeeding pair,[2] rendering the "Fibonacci" series of spaces contained in the proportional growth of plants, such as $\frac{2}{3}$, $\frac{3}{5}$, $\frac{5}{8}$, $\frac{8}{13}$, $\frac{13}{21}$, and so on, where it will be noted that any two of the superimposed members, added together, produce the following larger number, as referred to in Chapter II. under Numerical Correlations.

Many other interesting points of coincidence will be noted:

The upper leg of the pentagon in the first progression, starting from the point VO on the line of 18°, if produced, will pass from M to X, cutting the diameter where it is intersected by the inclined sides of the preceding pentagon.[3]

Radii of circles inscribed within each progressing pentagon (see dotted circles) will be octant to the radii of the circumscribing circle of the next larger pentagon, as at IO and so on; that is to say, each pentagon circle will be of a radius twice the length of the radius of the inscribed circle of the progression succeeding.[3]

If with F as a centre, and the distance from F to the upper pole of the circle at IO as a radius, an arc be struck to cut the horizontal diameter at Z, or with H as a centre and VO as a radius, a similar arc be struck to pass through 13, either of the two arcs will

[1] For the mathematical comparison of the various progressions, see Appendix, Note I, under the head of "Progressions." —EDITOR.

[2] The Editor is fully aware that the formula $5 + 8$, or $5 : 8$ does not express a mathematically precise "extreme and mean ratio," or division of the sum of five and eight (13), but the harmonic series occurs so continuously in Nature, and $5 : 8 : 13 : 21 : 34$ etc., varies so slightly from the precision of a true extreme and mean proportion, that for convenience they are frequently treated in the text together—particularly as it will be observed that the variation between contiguous members of the series is seldom cumulative, and also as it is clear that in any event a perfect extreme and mean ratio cannot be expressed in whole numbers unless they be enormously large. (See Chapter II. on "Numerical Correlations" and Appendix, Note A, on "Extreme and Mean Ratio."

Moreover, in the case before us of the progressions of the pentagon, the radii of the circles of the progression are related to each other in an absolutely and mathematically precise extreme and mean proportion. See Appendix, Note D, on the pentagon.

[3] As to the mathematical precision of this statement, see note D, in the Appendix.

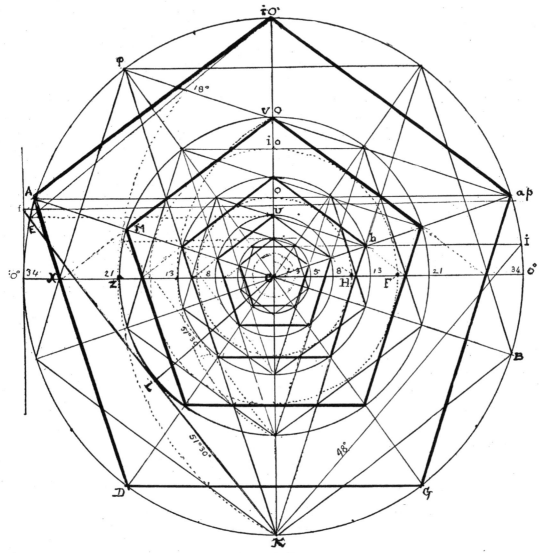

Plate 5.—The Pentagon

23

divide the horizontal radius into the ratio of five to eight, and this principle may be carried throughout.[1]

The Egyptian triangle is intimately connected with the pentagon, the progressions of the two figures, as will hereafter be shown, being in many ways synonymous; and if the side of this triangle of 51° 30′ be ruled from the pole of the circle, the oblique side will pass tangentally to the circle of the first progression of the pentagon, which circles of the pentagonal progressions themselves produce extreme and mean ratio between each succeeding pair[1]; and

The horizontal line on *E*, where the Egyptian triangle cuts the prime circle, will approximately intersect the pole of the pentagon of the third progression at *U*[1]; and, moreover,

If the line of 51° 30′ be produced to the side of the square at *f*, its horizontal line will intersect the vertical radius at a point octant to the radius of the inscribed circle of the first progression of the pentagon,[1] while, as we know, the rectangle of the Egyptian triangle (Plate 8 *EGEG*) will bear the ratio of five in height to eight in base.

Before attempting to explain the relation of the pentagon to the square and the triangle of 60° and the perfect unity of these three geometric figures as described in Plate 6, it will be necessary to say a word as to the harmonic progressions of the square and the equilateral triangle. Natural progressions of both occur in the same way: the square, by inscribing in it a circle, and in the circle a secondary square, again a circle inscribed within this secondary square, and within this a third square, and so to such progression as desired. With the equilateral triangle, a similar natural progression is rendered by inscribing in the triangle a circle, and in the circle a secondary triangle and proceeding as with the square.

Upon examination it will now be disclosed by Plate 6 that two progressions of the square will coincide with one progression of the triangle of 60°. To avoid confusion, the progressions of the square and of the triangle are not here drawn in full, but we will assume a prime square circumscribed about the exterior circle as drawn, and tangent to it at 90° and 0°. This circle then becomes the first inscribed circle referred to above and the side of the square of the first progression will fall upon the chord drawn from the point 90° to 0°. Then will the circle to be inscribed within this secondary square take the position shown by the dotted arc *YSZ*, and the side of the square of the second progression (the third square counting the primary) will be the chord *YZ* or its equivalent *SS*, and the square of the second progression will be that designated as *SSSS*.

In the same manner, relative to the equilateral triangle, we will assume that a prime triangle is circumscribed exterior to the major circle as here drawn, and tangent to it at the upper pole as well as at one point in each lower quadrant. Then will the major circle as drawn be the required inscribed circle as explained above, and the triangle of

[1] As to the mathematical precision of this statement, see Note D, in the Appendix.

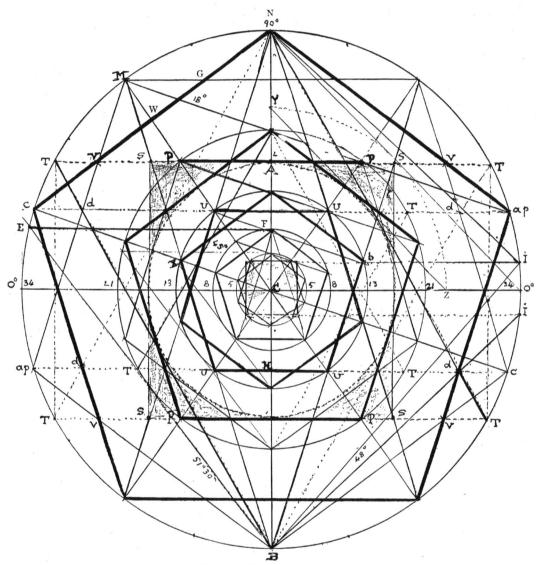

Plate 6.—The Pentagon and Square

25

the first progression will be formed of the chords TT, $T90°$ (upper pole), and $90°T$. It will be seen that the upper leg of this triangle falls upon the same line and coincides in position with the upper side of the square in its second progression.[1] It will be further disclosed also that the upper leg of the pentagon PP in the first progression, as explained, will likewise lie in the same line with the triangle TT and the square SS,[1] or, in other words, the horizontal side of the pentagon in this circle, the side of the square in the circle of its second progression, and that of the triangle of 60° in its first progression, measured from the pole of the primary circle, will all be found to rest on the line $TSVP$.

The sides of the pentagon intersect each other on the same line at V, producing extreme and mean ratio between VG and GN,[2] while

The sides of the pentagram MB will approximately intersect the angles of the square next in order at SS,[2] and this pentagram line will at the same time coincide with the leg of the pentagon in its second progression from X to U.

The "Ideal Angle," that imaginary model of perfection which is so constantly referred to by botanists and which is very real in fact,[3] is most perfectly harmonic with the pentagon, for if the angles of 63° are ruled from the poles 0° of the primary circle, they will virtually pass to the corners of the primary square, intersecting the angles of the primary pentagon at D (as in Plate 7), as well as at the centre points of the sides of the square at X.[4]

And if a circle be now inscribed within the angles of 63°, as by the lines i, i, i, i, it will by its vertical diameter render the great rectangle of 42°, with the diagonals of 66° seated on the points i, i, i, i, on the sides of the primary square.[4] This vital proportional space was employed by Ictinus for the ground plan of the Parthenon as well as for important parts of its portico, and undoubtedly because of its perfect unity with the square and the triangle of 60°, the proportions of whose progressions take such important part in the whole façade. The inclined sides of the primary pentagon, produced from the points G, will also cut the major square at this point i.[4] The remarkable unity in the angles as shown in these diagrams cannot be too carefully examined.

It was probably through his study of the pentagon that Pythagoras learned so much in regard to proportion, after he had studied its principles as revealed to him by the Egyptian priests, in connection with the construction of their great triangle. He then found that the pentagon was not only proportionally divided by its upper angle of 36° and its inclined angle of 54°, but that its five limbs forming its star gave a ratio of approximately 5 : 8 between the sides and the pentagrams.[5] He now invented the great

[1] This is absolutely and mathematically true. See Appendix, Notes B, C, D, and I.—EDITOR.
[2] This is correct. See Note D, Appendix.—EDITOR.
[3] See Appendix, Note G, on the ideal angle.—EDITOR.
[4] As to the mathematical accuracy of this, see Appendix, Note D.—EDITOR.
[5] See Appendix, Note D, on the pentagon, and F on the Pythagorean triangle.—EDITOR.

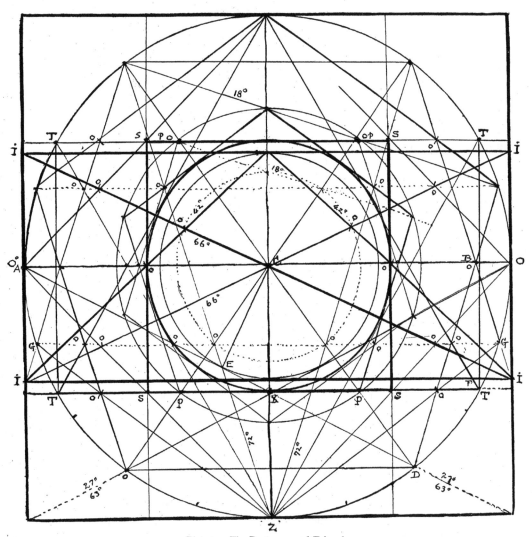

Plate 7. The Pentagon and Triangle

27

triangle principle which is still called after his name, the proportions shown by the simplest application of which are 3, 4, and 5, and these occur again and again throughout the pentagon.[1]

The measurements of the pentagram lines are further given in Plate 8. We have already seen that the circles of the progressions of the pentagon divide the radii into a series of approximately 5 to 8, and it also follows that the limbs of the five-pointed star are to the parts between the limbs in the same extreme and mean ratio.[1] Plate 9 discloses also another attribute of the ideal angle in relation to the pentagon; for its angle of 42°, if ruled from the lower pole of the primary circle, will pass to *i* in the lower quadrant of that circle, the horizontal from this point resting on the side of the pentagon in the fourth progression of 18.[1] This line will divide the five-pointed star at the intersections of the pentagrams on the points *V*,[1] while the lines *io*, *i*, *i*, and *oi*, produced to the square, will create the rectangle of 42° as before described regarding the Egyptian triangle, and the angle of 48° taken from the upper pole of the primary circle will in the same way render the rectangle of 48° by the lines *i*, *ci*, *ci*, and *i*. Thus the square of the pentagon is divided into these two important rectangles. These rectangles may in turn be subdivided by four rectangles in the lower division, each of 42° with diagonals of 61° and four in the upper, each of 48° with diagonals of 66°, which diagonals will intersect the angles of the pentagon in various parts as marked *o*.

Furthermore, the divisional lines of these rectangles on *ii* cut the primary pentagon into the Divine Section, as accurately probably as Pythagoras himself was able to measure it, since from *A* to *ii* measures five parts and from *ii* to *ci* eight parts, or, approximately the ratio of 5 : 8 : 13 etc.[1] All pentamerous forms in Nature are similarly divided in numerous places by this continuous series, thus proving the power of this ratio as a factor in producing true proportional spaces, and justifying its use by the architect or designer.

To bring these statements home to the reader I will submit a drawing at Plate 10 which represents a blossom of the milk-weed family, disclosing how its proportional spaces are placed by the above angles. The rectangle of the Egyptian triangle also measures some of these spaces as on the line *E*, which, as we have seen, harmonically intersects the pole of the third progression of the pentagon, and this circle gives the proportions of the forms around the torus; the points *EE* and *io*, *io*, will now measure a rectangle of approximately extreme and mean ratio. The same rectangle may also be rendered from the poles 0° the angle 51° 30' passing to *V* in the upper quadrant and intersecting the extremities of the corolla at *P*, and passing, as we have already seen, tangent to the circle of the first progression of 18°. If angles of 51° 30' be now ruled from the corners of the square *AA*, they will intersect *P*, disclosing that the rectangle of 5 : 8

[1] As to the mathematical accuracy of these statements, see notes in Appendix. Note D.—EDITOR.

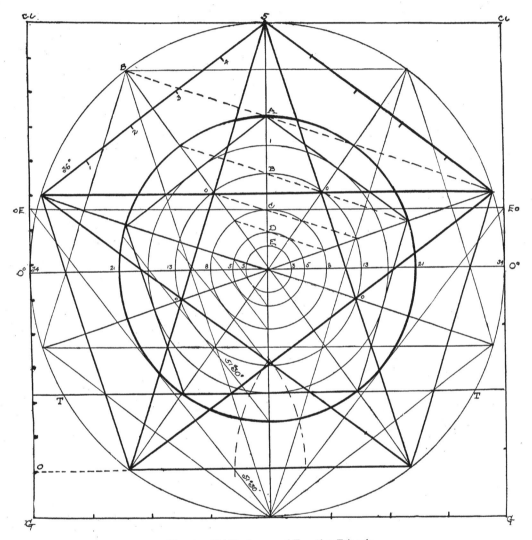

Plate 8. The Pentagon and Egyptian Triangle

29

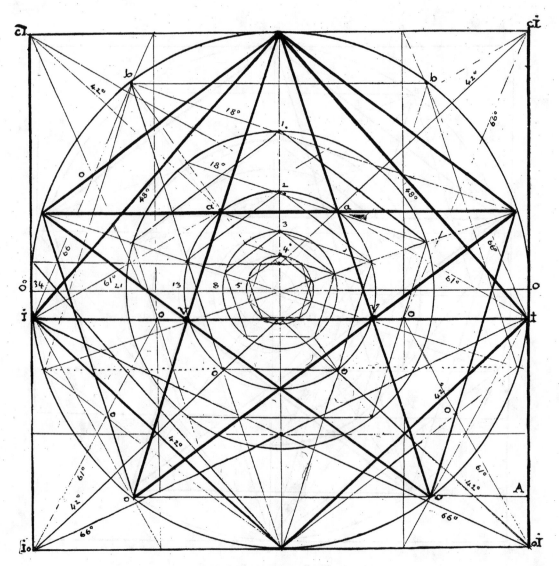

Plate 9. The Pentagram

30

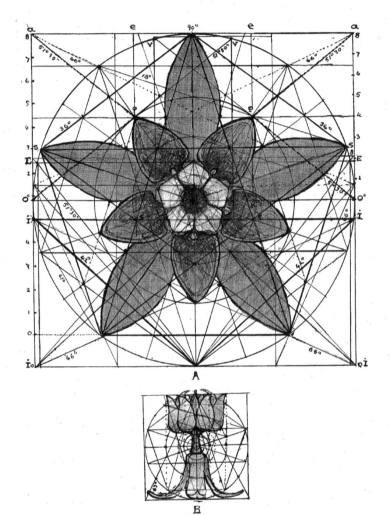

A

B

Plate 10. Milkweed

31

is also seated on the points *a, o°, e, K.* The two rectangles of 42° and 48° of the ideal angle are enclosed in the points *ii, io, oi,* and *aa,* circumscribing the plan of the blossom.[1]

The side view of the same object is drawn in diagram B of the same plate, revealing the influence of the angles of the pentagon with its progressing circles of 18°, and of the square. Other examples of the power of the pentagon in the production of proportional spaces are rendered in the Chapter on Botany.

The Octagon

With the Progressions of the Square

The progressions of the octagon itself are so minute as to be seldom needed for actual demonstration, but those of the square are in constant use. The progression of the square is much the same in its results as that of the equilateral triangle, but their angles produce variations of sufficient value to justify the use of the two, either alone or in conjunction. In order to render the former, the diagonals of 45° are first drawn from the poles of a given circle, then a circle inscribed within them will be that of the first progression; in this circle the diagonals of 45°, again repeated, will result in a square of the second progression, and so on until all desired for the series are rendered as described in Plate 11, where six progressions are drawn as sufficient to disclose the principle.

The diameters of the alternate circles of the progression, produced to the base at *H,* bear a ratio to each other of 3:4, and if the radial difference of two of the larger circles is divided by eight equal parts the like difference of the following three will measure five of these parts. In every five circles in succession many examples of the series 5:8 will readily be found, while every second succeeding pair are octant to each other as at *o,o.* If the semi-diameter of the circle of the second progression is taken upon the compasses, as a radius, then, with the corners of the square circumscribing it used as centres at *S,* four circles may be struck, the arcs of which will pass tangentally to the quadrant vectors and to the sides of the primary square. Where these circles cut the arcs of the primary circle at *Q,* they will divide that circle in the proportions of the pentagon.[2]

If the horizontal sides of the square of the second progression are produced to the points *T* and *R* above and below the horizontal vector, they will render the rectangle of the hexagon with the inclined sides of 60°; thus every second square is equal to one progression of that triangle.[2] This progression is related to the great triangles with their rectangles in a remarkable manner, as described in Plate 12, for if the angle of 51° 30' of

[1] It is clear that if these angles be carried only to the circle, the ends of the rectangle would be infinitesimally within the square, for if the angular lines were extended to the square, necessarily they either would not come to a common focus or else they would not be quite 42° and 48°, since, being without the circumference, their sum must be less than ninety degrees. The difference however is, for the purpose at hand, negligible, and is only mentioned because it is logically obvious.—EDITOR.

[2] As to mathematical accuracy see Notes C and D, Appendix.

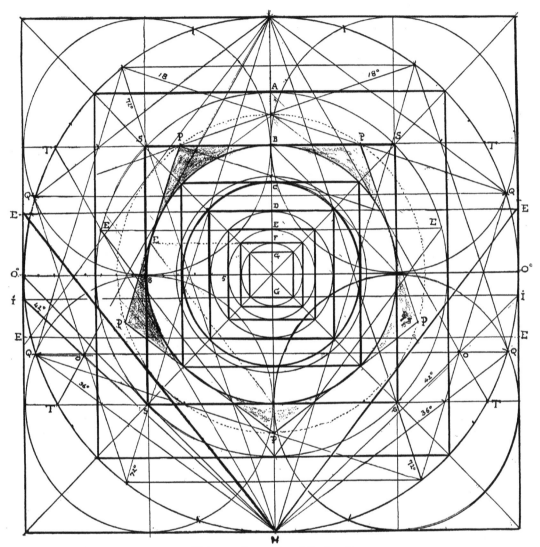

Plate 11. Progression of the Square

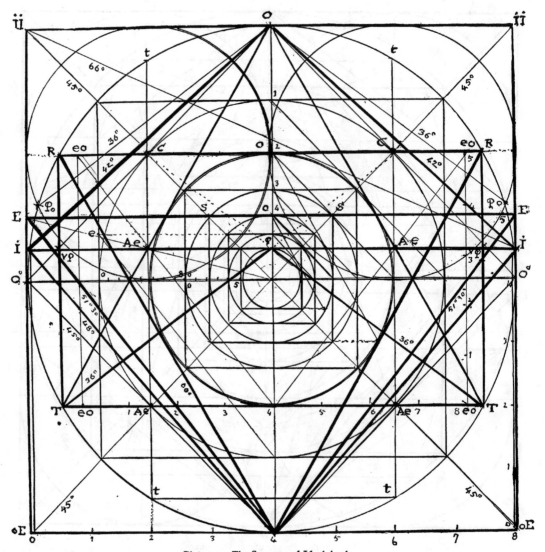

Plate 12. The Square and Ideal Angle

34

the Egyptian triangle is drawn from the lower pole of the primary circle, for example, it will pass out of the primary square in the upper quadrant at *E;* and *EE* if connected by a horizontal line will be one side of the above triangle, while the points *E* and *oE* at base, will render the rectangle of five in height to eight in width, or the integral equivalent of the extreme and mean ratio between length and width, the one so much in use in past ages as an interpreter of proportional spaces in architecture.[1] The line *EE* will now rest on and pass through the upper side of the square in its fourth progression,[1] doing likewise wherever it concurs with this progression; or, if it is drawn from the point *4* to *eo* on the line of the rectangle *RR* and *TT* and the points *eo* joined, it will place the rectangle of the Egyptian triangle there, and so on; thus this ratio, united to others occurring in the various progressions of the square will carry the series of 5 + 8 throughout the plan.[1]

The angle of 48° of the ideal angle, ruled from the upper or lower pole of the outer circle, will pass to the arc of the same circle in the opposite quadrant at *i*, though not to the square, while the angle of 42°, or the complement of 48°, will pass from the opposite pole of the same circle to the same point; thus the points *i* and *oE* in the lower quadrant, joined, will give the rectangle of 48°,[2] while *i* and *ii* united will render the important rectangle of the Parthenon, with its diagonals of 66° in the upper quadrant.[3]

If the angle of 36° of the pentagon be ruled from the points *T*, the two lines will also intersect on *P* the sixth progression of the square, and, produced beyond it, will cut the centres of the two upper circles on *C*.[3] If the upper leg of the square in its sixth progression be then produced, the points *VP* and *TT* joined will render the great rectangle of the Pythagorean triangle. Thus we have the rectangles of 60°, or that of Plato, the rectangle of 42°, of Ictinus, that of the Egyptian triangle, and the right-angled triangle with its rectangle of 90° producing the square, all in harmonious relations to the above progressions.

On the Equilateral Triangle and the Hexagon

This progression is drawn in Plate 13 and for convenience' sake omits any intervening steps, accepting at once the angular measurement of its fundamental part of 60° as a basis for the progression, which is carried out as described in the examination of the pentagon. It thus follows that, upon this basis, one progression of the equilateral triangle coincides with every second progression of the square, and every succeeding

[1] As to the mathematical accuracy of these statements, see Note C of the Appendix.—EDITOR.

[2] The editor is aware that the lines forming the rectangle of the ideal angle do not coincide absolutely with those of the tangent square, since the angles of 42° and 48° cannot pass out of the prescribed circle and still remain angles of 42° and 48°, but the rectangle as depicted is the one in ancient use, as will be seen upon further examination.

[3] As to the mathematical accuracy of these statements, see Note C, Appendix.

circle inscribed in the progression of this triangle is octant to the preceding, with the ratio of one plus one, or one in two.

The progressions of the angle of 60°, however, produce another series of intersecting points of great value to the architect or in an analysis of natural objects such as the snow crystal and other forms numbered by six, which may be called the secant progression,

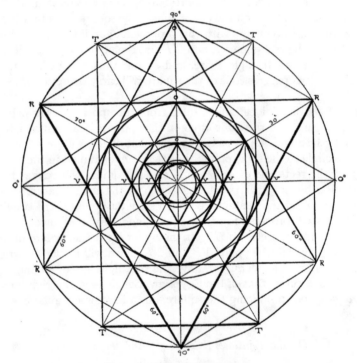

Plate 13. Progression of Triangle

to distinguish it from those as ordinarily described. This is characterized by the direct way in which it produces the seven harmonic circles of the hexagon, the arcs of which pass tangentially to each other as in Plate 14. This progression is carried out as follows: With the distance from the centre to the point where the first equilateral triangle intersects the horizontal vector as a radius and the common centre as a focus, draw the first circle (instead of inscribing the circle in the equilateral triangle as heretofore). Then from one of the poles of this circle, the same angle repeated will intersect oA through which the second circle of the series may be drawn. This circle is the central one of the seven just mentioned, and the other six may be produced on the diagonals of 30°

drawn from the points T and R at the corners of the horizontal and vertical rectangles of 60°, inscribed in the primary circle. The centres for the other six may be correctly placed by drawing a circle tangent to the angle of 48° measured from the upper or lower pole of the outer circle, the arcs of which will cut the above diagonals of 30° and 60° at the points $Co\ oC$.[1] Verticals ruled from these points Co and oC will, with horizontals

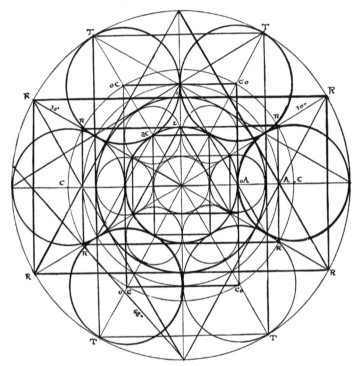

Plate 14. Seven Harmonic Circles

joining them, render the rectangle of 60°, while horizontal lines ruled tangent to Circle *2* (the central one of the seven) will pass to the diagonals of 30°/60° at R, and the points R joined will result in the rectangle of 60° in a horizontal position, in unity with the primary rectangles of the same angular dimensions. Another set of seven circles may now be drawn within the circle of the first regular progression of 60° at *1*, and in order to place these correctly, the angle of 60° must be measured from either pole of Circle *2*, when a circle inscribed within this angle will render the central one of the smaller series, and the centres for the other six come at the points where the arcs of Circle *2*

[1] As to the accuracy of these statements, see Appendix, Note B, where another method is suggested.—EDITOR.

cut the diagonals of 30° / 60° as at *aC*. It may now be noted that the vertical lines *oC* intersect the centres of the two outer circles of the smaller series. This combination of angles and intersections deserves careful attention as from them may be developed proportional spaces not only as found in many objects in Nature, but as similarly employed in the greatest works of architecture produced by the hand of man.

Plate 15 will now be submitted, which discloses the harmonic combination of con-

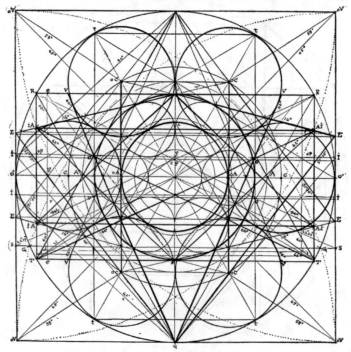

Plate 15. Correlations of the Secant Progression

structive angles easily possible to be developed within the range of the above progressions as shown in the preceding diagram.

All of the great architectonic angles, such as 14°, 22° 30′, 42°, 48°, 36°, 51° 30′, and 66°, intersect each other at conspicuous points and the angles of 45° and 30°–60° divide the primary plan at important proportionals. The angle of 14° drawn from the points *oC* will pass to the points *E*, intersecting in its course the vertical line *RT* at *iA* and the centre of the line *RR*, continuing approximately tangent to the circles with their centres on *C* and to the arcs of the two upper and lower circles of the smaller series of seven[1];

[1] As to the mathematical accuracy of these statements, see Appendix, Note B, on the equilateral triangle and the hexagon.—EDITOR.

while a line drawn from E to the upper and lower poles of the primary circle will be that of 51° 30′ of the Egyptian triangle[1] and a line ruled from the same poles to the points V on the lines R and T will pass tangentially to the arcs of the circles with their centres on oC and will be seen to be the angle of 66° of the Parthenon.[1] The same angles ruled from the points T and T will cut the points Ai and iA, and the lower of the two horizontal lines on ii is one side of the ideal angle of 42° in one quadrant and 48° in the opposite one.

The ideal angle of 42° drawn from the centres of the lines R and T, or at the poles of the first circle of the progression of 60°, will intersect the sides of the rectangle RR and TT where they cut through the angle of 14° at the points iA[1], and if the side of the primary square is taken as a radius at oV and oV as a centre, the vesica picis of the prime square may be struck, the arcs of which will intersect the prime circle at the points G and the great rectangles $RRTT$ at the points iA in their course; the horizontal line on G will pass to the sides of the prime square and a line drawn from s to the centre of the diagram will be that of 22° 30′ of the square. The Egyptian triangle may also be produced from B to e the vertical line e intersecting in its course the point U where the primary triangles of 51° 30′ cut each other. If a line is drawn from the points T and R to P it will be approximately that of 36°,[2] producing the Pythagorean triangle at R and T.[2]

All of the above combinations of angles can now be reproduced in the smaller series of circles, but this has not been done as it greatly complicates the diagram.

The great series of triangles with their rectangles so much employed by the architects of past ages in their works are now in evidence in the harmonic system above described; the primary ones, from which all others are developed, come on the lines R and T with the triangle of Plato as its generator. The rectangle of the Egyptian triangle is seated on the lines EE and EoV joined; the vital rectangle of 42° of the ideal angle with its diagonals of 66°[2] occurs on the lines TT and iA Ai, connected. The Pythagorean triangle and its rectangle developed by the angle of 36°[2] of the pentagon comes on the points oP and T, while the rectangle of 48° of the ideal angle is seated on the points i and oV; and finally the rectangle of the right-angled triangle (the square), as developed by the angle of 45°, occurs at 0° and 0° and on oV as joined together.

In proof that the above proportional spaces, created by the intersecting points of the diagram are most perfect, Plate 16 is submitted, describing the portico of the Parthenon, wherein is disclosed that the rectangle of 42° with its diagonals of 66° which renders the ground plan of this edifice, also produces many of the proportional parts of the portico as well. For example, the points oA, Ao, and T, joined together, will escribe

[1] As to the mathematical accuracy of these statements, see Appendix, Note B, on the equilateral triangle and the hexagon.—EDITOR.

[2] As to the mathematical accuracy of these statements, see Note B, Appendix and Appendix, Note F, on Pythagorean triangle.—EDITOR.

all of that part between the base of the stylobate and the upper line of the main cornice with its angle of 14° resting on the upper corners at *oA* and *Ao;* while the 66° diagonals of this rectangle are correlated with the circles on *oC* since the angle of 66°, passing from the upper and lower poles of the primary circle are tangent to their arcs and also intersect the line *TT* at the points *dA* the vertical lines of which place the centres of

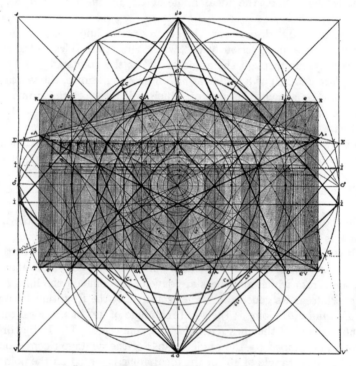

Plate 16. Secant Progression and the Parthenon

the intercolumnia spaces, the third from the outer pair. These diagnoals of 66° in the great rectangle also decide the inner lines of the abacus on the columns next to those at the extremities of the colonnade. The angles of 66° continue from the upper and lower poles of the primary circle, or from *do* to *io*, intersect each other on the centres of the second intercolumnia spaces from the outer ones, while the points *dA* place the centres of the third spaces, and the vertical lines on the points *dA*, with lines joining the points *dA*, produce the proportions of the ground plan again. The angle of 51° 30′ passing from *do* to *E*, intersects the vertical side of the primary square where it is cut by the angle of the raking cornice on 14°; the horizontal line *EE* decides the base line

of the main cornice, or dentils, and where the angle of 14° intersects the vertical sides of the rectangle of 60° *RT* at *oA*, a horizontal line will give the upper line of this cornice or the base of the pediment. The progressing circles of the angle of 45° are here drawn on the numbers *1* to *8*. Circle *2* renders the whole height of the portico; Circle *3* passes through the centres of the second column from the centre where it is cut by the architrave; Circle *4* indicates the line of the dentils above the entablature; Circle *5*, the bottom line of the frieze below the metopes; Circle *6*, the lower line of the architrave; Circle *7*, the lower line of the capitals or base of the echinus or amulets; and Circle *8*, the lower line of the necking, while the same circle renders also the width of the five intercolumnations towards the centre.

The angle of 22° 30′ (one half of the basic angle of 45° of the square), drawn from the centre of the diagram in the lower quadrant, will cut the sides of the primary square at *S* and a horizontal line drawn from *S* decides the height of the stylobate or top of the platform; while the vesica piscis of the square in passing from *V* to *G*, cuts the primary circle at *G*, verifying the placing of the line of the platform, the arc of this vesica piscis cutting the angle of 48° on the lower line *i* at the outside of the first column.

It will now be recognized that the progression of the square is the fundamental element in the proportions of the above portico, while the angles of 42° with its diagonal of 66°; the angles of 14°, 51° 30′, and 36° are correlated with this progression in the most perfect manner; also that the seven harmonic circles in the larger and smaller series are in unity with them.[1]

In order still further to prove that the above diagrams produce just proportional spaces, as adopted by Nature, I shall now insert a drawing of one of her most beautiful objects,—a snow crystal, taken from an accurate micro-photograph. In Plate 17 will be shown the influence of polar force in the hexagonal form of the snow crystal, and the reader will at once recognize the minutely exact application of many of the principles which have already been explained. This diagram is inserted here as a definite illustration and to "point the moral" of what has been said, but I shall reserve the detailed explanation of the particular crystal until the chapter on that subject is taken up in its regular order.

[1] Mr. Jay Hambidge was the first in modern times to recognize the unity of the progression of the square with the proportional spaces of the Parthenon, and lectured on this subject before the Hellenic Society of London with distinguished success. He there met the late Mr. Penrose and had access to his measurements of the Parthenon now established as the most perfect. He produces the proportional spaces of its portico by the simple progression of the square as described in the Chapter on Architecture.

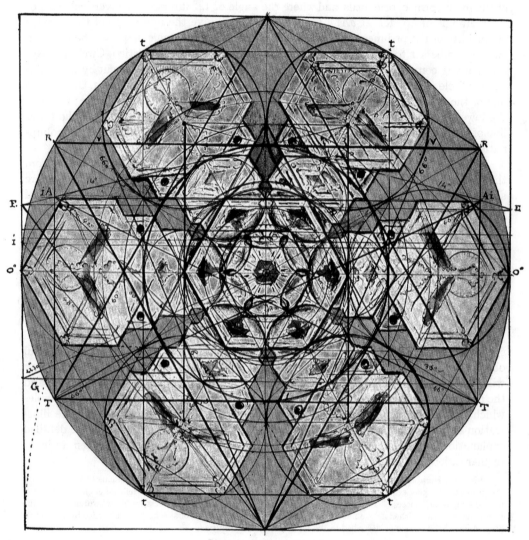

Plate 17. A Snow Crystal

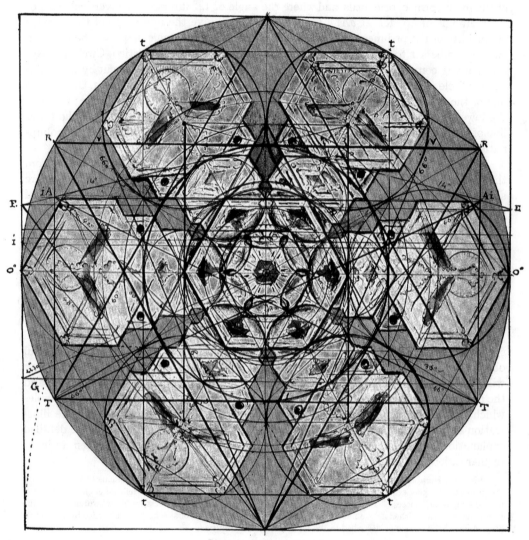

42

CHAPTER IV

GEOMETRIC FORMS—CONTINUED

The Egyptian Triangle

THE progressions of the Egyptian triangle [1] as produced in Plate 18 are of nearly as great value as those preceding, harmonizing so perfectly with the progressions of the square and the equilateral triangle, and in many obvious ways with the pentagon. The rectangle of the Egyptian triangle creates at once one of the most important of all parallelograms, measuring as it does eight parts long to five wide, "thus constituting a prolific generative source, encouraging impressions of contrast between horizontal and vertical spaces." Its discovery and the name of its inventor are lost in antiquity, but it was probably one of the Egyptian priests living centuries before the Christian era, for its general proportions were employed to produce the design of many of the great pyramids and these are the first record of it in history. It was also used in the temples of that period for the like purposes. This ratio of 5 : 8 as we have already seen, produces an approximation to extreme and mean proportion, which latter is one of the most vital among all of those employed by Nature, and is easily recognized throughout all the forms of plant growth. It was considered of such value that the rectangle of similar powers was called by both Pythagoras and Euclid the "Divine Section." [2]

In order to draw the progressions of its angle of 51° 30′ correctly, we must proceed as described in the former progressions, by ruling this angle in a given circle, when another circle concentric with the first and so drawn that the sides of the prime angle are tangent to it, will be the circle of the first progression, and so on, until we have all required. As illustrated in Diagram 18 there are five progressions. Each pair of resultant circles will then bear an harmonic relation resembling the "Fibonacci" series of which we have spoken. It may now be recognized that this progression has rendered five rectangles drawn in the lower quadrant of the primary circle, each rectangle being eight parts long and five parts high and each with diagonals of 58°.

[1] See Note E in Appendix on Egyptian triangle.—EDITOR.
[2] For details, see note on "Extreme and Mean Ratio" in the Appendix.

43

It will also be found that insofar as the pentagon and the square are harmonious, so will there exist unity between the pentagon and the Egyptian triangle, and as the equilateral triangle, the square, and the pentagon all coincide at certain points, so where the Egyptian triangle unites with one, it will unite with all in those particulars. For example, we have found that the square in its second progression coincides with the equilateral triangle in its first progression, as well as with the pentagon in its first progression of 18°. We have also found that the square in its fourth progression coincides with the greater of the two angles of the Egyptian triangle in its prime position.

The progression of the angle of 38° 30′, if carried out, would produce a series of circles harmonic to those of the angle of 51° 30′ and the progression of 18° of the pentagon, commencing in the primary circle, will result as before stated in the series of circles of which the second is coincident or nearly so with the second circle of the progression of the Egyptian triangle.[1] Thus in either way we obtain a resultant double rectangle of the Pythagorean triangle with diagonals of 70°,[1] and it will be found that the various angles of the pentagon will intersect those of the progressions of the Egyptian triangle at noticeable points. If, for example, the centre of the lower horizontal side of the rectangle of 5 + 8 in the first progression at P is examined, it will be found that the pentagon rendered at that point will be inscribed in the circle of the first progression of 18°, doing likewise in the progression throughout the plan, while the upper horizontal side of this pentagon will rest on the side of the square in the first progression, as at the points *so* and *os*, though this coincidence will not be recurrent. Also the line *so*, *os* produced to the side of the primary circle at T will render the equilateral triangle there.

There will also be found numerous points of harmony between the Egyptian triangle and the pentagon, and between their progressions. It is, however, not only unnecessary but impracticable to take up in a work of this kind every coincidence of these harmonic forms, as they are simply innumerable.

If the lower horizontal side of the rectangle of 51° 30′ on its fifth progression be produced to the outer or primary circle at the point i, it will render the rectangle of 42° of the ideal angle with its sides on the sides of the primary square or at the points *ii*, *oo*, and i^2, and the diagonal of the ideal angle rectangle, which we know is the angle of 66°, will also within the error of drawing intersect the angles of 45° in the primary square where they are cut by the lower corner of the rectangle of the Egyptian triangle in its second progression. This rectangle of the ideal angle is proven harmonic with the Egyptian triangle and is also of great value as an interpreter of perfect proportional spaces, for it is of the same dimensions as the ground plan of the Parthenon and of its portico, as it escribes all of that part of it below the pediment. The Egyptian triangle

[1] For the mathematical accuracy of this statement see Note E in the Appendix.
[2] *Ibid.*

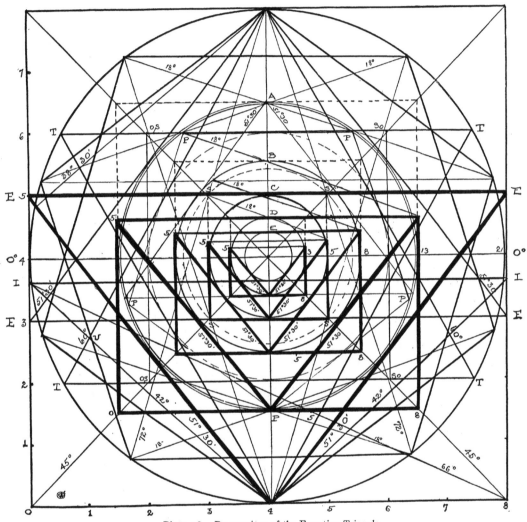

Plate. 18. Progressions of the Egyptian Triangle

45

is also harmonic with this portico, for if its angle of 51° 30′ is drawn from the apex of the raking cornice, it will intersect the centres of the corner columns where they rest upon the platform. (See examination of the Parthenon in Chapter XIV.)

As a further evidence, it may be here noted that the angle of 66° passes tangent to the circle of the first progression of the triangle of 60°, which is inscribed in the pentagon, and the square at this point,[1] Plate 19, discloses more clearly the above unity of angles as many of those in Plate 18 have been omitted.

The most marked example of the use of the Egyptian triangle by the architects of the Gothic period is the Amiens Cathedral (see Chapter XIV.). There are numberless others, as well as frequent examples of its employment in Nature, perhaps the most remarkable of which will be found in the shell *Dolium pendix Linn* in the Chapter on Conchology.

It has now been described how the progressions of the octagon, the hexagon, the square, the equilateral triangle, the Egyptian triangle, and the ideal angle are all so harmoniously united that any one of them has a distinct influence on each of the others, all having a part in the joint effect of the Parthenon and together proving that the judgment of time was right in proclaiming this work to be perfect in its proportions; but this harmonic relation could by no possibility come to pass unless this work had been designed on a similar combination of the same geometric parts or angles; for there are too many correlating points between the two to be the result of accident or chance.

Many critics will undoubtedly say, "Penrose's measurements may not have been followed correctly by the author," or that the principles of modifying geometric spaces by the changing of a straight line into a curve (in order that it may appear straight from the position from which it is to be viewed by the eye) would preclude the possibility of working out the problems correctly, but this is not so, for these modifications must be slight, since if too apparent they would defeat their very purpose and destroy the beauty they were intended to enhance. Moreover I have the hardihood to say that if in any slight particular the measurements did not correspond to the results of the above combinations it is more probable to find it an error in the measurement than in the geometrical correlations, since they are systematic, while *every measurement must largely stand by itself*.

Mr. Hambidge found, however, in working on these measurements, that they corresponded to the progressions of the square to within a fraction of a foot in the greatest dimension, which is extremely small when we take into consideration the vast size of the edifice and the mistakes that must unavoidably occur in working out the original design. It must be borne in mind, however, that the above progressions are exactly harmonic with the combination of angles to within a minute fraction too small to be regarded.

[1] As to the mathematical accuracy of this statement, see Note E in Appendix.—EDITOR.

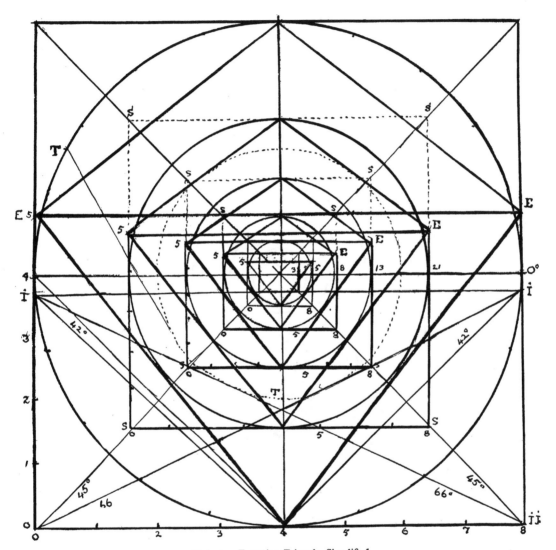

Plate 19—Egyptian Triangle, Simplified.

47

The Ideal Angle

The ideal angle continually appears in Nature as an interpreter of her proportional divisions, especially in the spirals of many families of shells, but all pentamerous forms of flowers declare its influence on their beauty, for it is one of the great elements in phyllotaxis.[1]

The progression of this angle is described in Plate 20, where in a given circle the angle

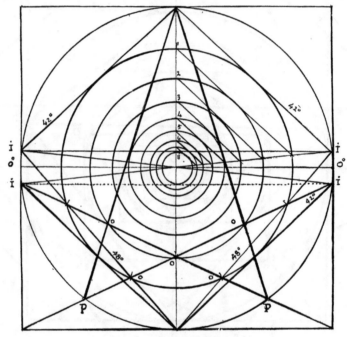

Plate 20—Ideal Angle

of 42° is first drawn and a second circle struck so that the sides of the first angle shall be tangent to it, and so on as described in other progressions. In the diagram there are drawn eight of these, as being all that are required.

The fourth circle passes tangentally to the pentagram drawn from the pole of the primary circle, while a horizontal line ruled tangent to the eighth will indicate the rectangle of 42° with its diagonals of 66°. These lines intersect each other at the point *o*. Plate 21 discloses the relations of this progression to that of the square on the circles *A* to *F*, circle *B* placing the equilateral triangle on the points *T T*, the dotted circle *D*

[1] For a description of the ideal angle and its history, see Note G under that head in the Appendix.—EDITOR.

of the progressions of the square rendering the inscribed square *F* of the fifth progression as practically escribing the circle of the sixth progression of the ideal angle,[1] which circle in the progression of the square divides the quadrant vectors in a ratio of approximately 5 : 8, while the horizontal sides of the fourth progression of the square (on Circle *5*) produced to *E*, as we have before seen, renders the Egyptian triangle in the primary

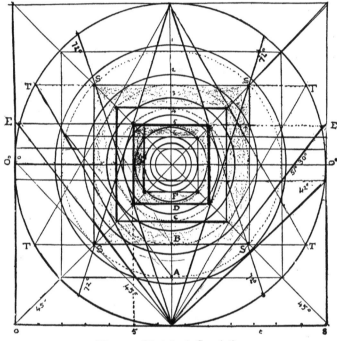

Plate 21—Ideal Angle Correlations

circle. Plate 22 reveals the harmonic relations of the progression of the angle of 42° to the pentagon by its angle of 18°, as in the dotted circles.

 The Pythagorean triangle on the pentagram in the primary circle has its horizontal side resting on the Circle *4*, producing the pentagon escribing that circle, the inclined sides of which correspond to those of the pentagram in the outer circle.[1] The angle of 18° drawn in this circle will within approximation give the pentagon in Circle *5*.[1] If a vertical line is ruled tangent to Circle *5*, it will cut both the primary square and the rectangle of the Egyptian triangle having the horizontal side of the primary square as its base, into the ratio of 5 : 8.[1] Plate 23 discloses the relations of the ideal angle to the

[1] As to the mathematical accuracy of these statements, see Note G, Appendix.—EDITOR.

4

two rectangles of 42° and 48°, the first in the lower quadrant of the primary circle and the second in its upper quadrant, as at the points C and Ci iC. The rectangle of 42° comes on the points i and iC and Ci. This combination of angles will render one large or four small rectangles of 42° with diagonals of 61°, while the rectangle of 48° above Ci

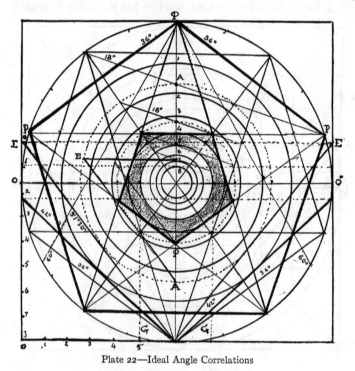

Plate 22—Ideal Angle Correlations

will subdivide into one large rectangle with diagonals of 61° or four small ones with diagonals of 66°.

It will be recognized from the above analysis that the Egyptian triangle, the square, the pentagon, the hexagon, and the octagon, together with both forms of the ideal angle, are in absolute harmonic unison with each other, making it possible in many instances by the correlating points of one to produce any one of the others; and they, with the vesica piscis, constitute all that are necessary in an analysis of any form in Nature. These together are all that are required by the architect or designer in order to perfect the proportional spaces in the design for an edifice or any other work of art.

As before stated, the Parthenon has been selected by me as a test, or object in perfect proportion, to which may be referred the theory of harmonic proportions as herein

presented, in relation to works of art, and the principles involved in Plate 23 in relation to the ideal angle will presently be applied to the portico of the Parthenon, disclosing the influence of the angle of 42° on its proportions.

The Vesica Piscis

This geometric combination has been employed so much by architects in the great

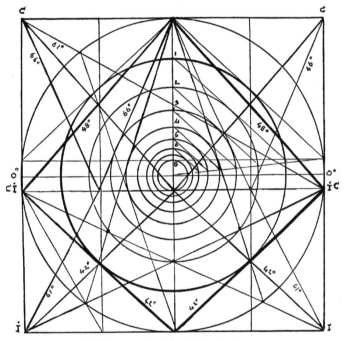

Plate 23—Ideal Angle Correlations

periods, that it deserves at least a short description, and it has been mentioned many times in old chronicles in relation to art, Albrecht Dürer having considered it of such importance that he published a treatise on the subject. It certainly was much in use during the Gothic period of architecture, and it was even thought by some writers to have been the origin of the "pointed style,"—perhaps with reason, since there is hardly a doorway or window of that time which has not been influenced in relation to its pro-proportional spaces by this figure. As customarily employed it is one of the derivatives of the hexagon by its angle of 60°, and may be produced at once, by drawing this angle of any size base, when the terminations of the two legs will mark the points for the

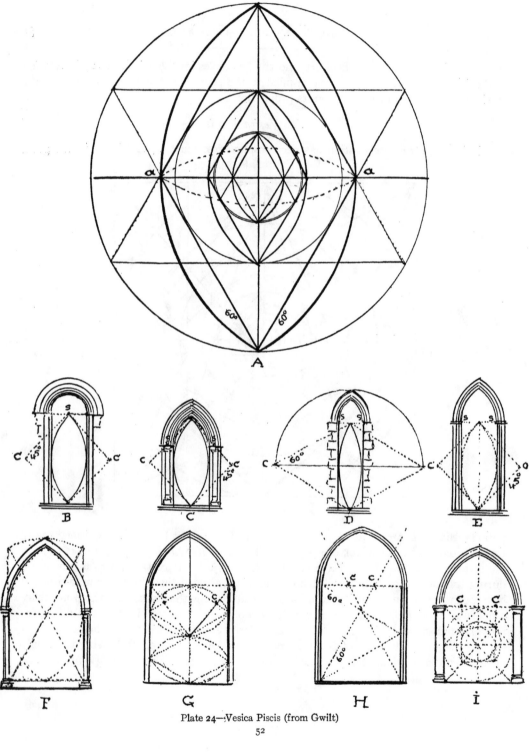

A

B C D E

F G H i

Plate 24—Vesica Piscis (from Gwilt)

52

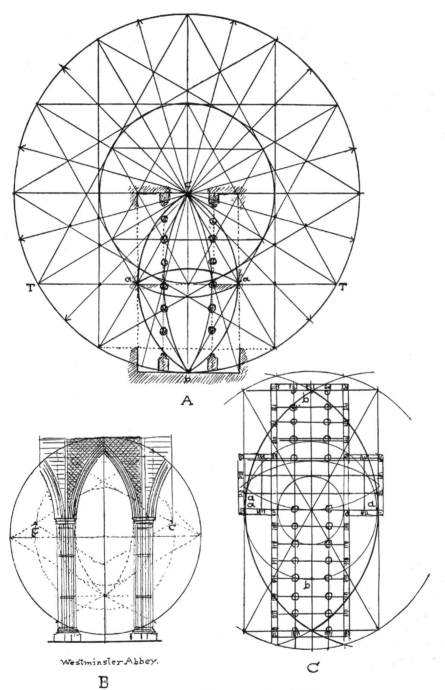

A

Westminster Abbey.

B

C

Plate 25—Chantrell System, etc. (from Gwilt)

53

centres of the circle the radii of which are the sides of the triangle (see Plate 24). Gwilt gives a full description of this in his book on architecture, with many illustrations, some of which will be presented here.

The regular progression of this form of vesica piscis resembles that of the angle of 60°, described under the equilateral triangle, and two progressions are shown in the

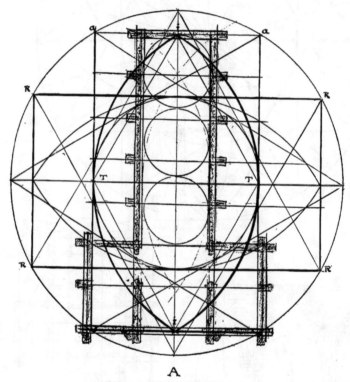

A

Plate 26—New College Chapel

above plate, diagram *A*; but with this a secondary form of the progression is given on the horizontal vector drawn in dotted arcs at the point *a*. The foci of these arcs are at the upper and lower points of the primary vesica, the radius being the leg of the original triangle. Diagram *B* is an example from Norman work where the vesica was produced from the square, which is still another variation. Another example of first pointed work is drawn in *C*, where the square touches the head and sill. Diagram *D* of this plate represents an example of this form to be found in lancet windows of

traceried style of first "pointed." Other diagrams are drawn, *E* to *I*, representing further examples, and explain themselves.

Plate 25, diagram *A*, represents Chantrell's system of producing proportional spaces, which closely resembles the one herein advanced in the progression of the angle of 60°. This has been applied to the ground plan of a church, with the regular vesica drawn at

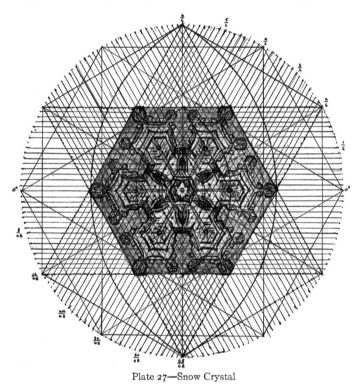

Plate 27—Snow Crystal

Ab and the secondary progression at the point *a*. Diagram *B* is from Gwilt, showing the pointed arches from Westminster Abbey, the circles and dotted angles with the centres for the arcs of the vesica piscis at *C*, *C* being supplied by the author. Diagram *C* is also from Gwilt and explains the determination by the symbol of vesica piscis of the length and breadth of a church, the subdivisions of the squares placing the aisles, piers, and other parts. A similar design is drawn in Plate 26 in relation to the ground plan of New College Chapel; Gwilt discloses also how the rule for obtaining the various heights of the vaulting, roof, spires, etc., of a church is applied, by erecting equilateral triangles upon a plan laid out in equal divisions as shown in Chapter on Architecture.

By applying the progressions of the vesica piscis or by octaves, the resultant points will be found to correspond to the chief divisions of almost any plan.

That the above applications of the vesica piscis form as just a method for producing true proportional spaces in a work of art as the equilateral triangle may be absolutely proven by applying it at once to a snow crystal, an object in Nature perfectly planned. A photograph is presented in Plate 27 where four progressions of the vesica piscis accurately separate its great proportional spaces.

An almost endless number of examples might be obtained disclosing the same principles, but those hereafter given will have to suffice.

The Rectangles

In all of the geometric forms which have been examined, excepting only the vesica piscis, we have found some symbolic rectangle resulting almost of necessity from the configuration, and we may rely upon Nature to furnish us with ample evidences of her recognition of each of these. Indeed, so general is her application of the rectangles so created that it can safely be said that hardly a form of growth exists which may not properly be escribed by one of them. Nor has man been behind in his will to follow Nature, for we shall find that the ancient architect almost invariably so escribed the design for his greatest works.

Reference to the various illustrations already introduced will recall to the mind facts which may be summarized as follows:

Figure	Generated Rectangle	Position	Approximate Diagonal of the Rectangle
Pentagon	One of 36°, one of 54°		60°
Equilateral triangle	A half square in height	Octant	63°
Square	A half square		58°
Egyptian triangle	51° 30′ and 38° 30′	5 : 8	66° and 61°
Ideal angle	42° and 48°	Pentagram line	

Pythagorean triangle has approximately the same functions as the pentagon.

No clearer illustration of the persistence with which Natural forms fall into these rectangles could be found than is furnished by Plate 28 where various families of leaves are drawn and explained, showing them to be, in every instance, so escribed. Nature's use of these harmonic rectangles is not confined, however, to leaves, but they will be found to escribe all living things in a more or less exact way; for the nuts, as well as leaves and petals in the various plants and flowers are governed in like manner as shown

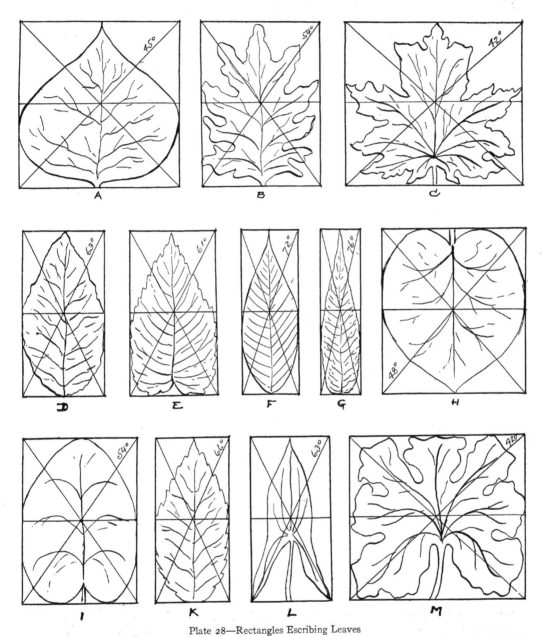

Plate 28—Rectangles Escribing Leaves

(Fig. A), Poplar; (B), Oak; (C), Maple; (D), Cherry; (E), Elm; (F), Milkweed; (G), Willow; (H), Convolvulus; (I), Yellow Water Lily;
(K), Raspberry; (L), Arrow-head; (M), Bloodroot

57

in the Chapter on Botany, and the same principle holds good in the case of insects, animals, and even man.

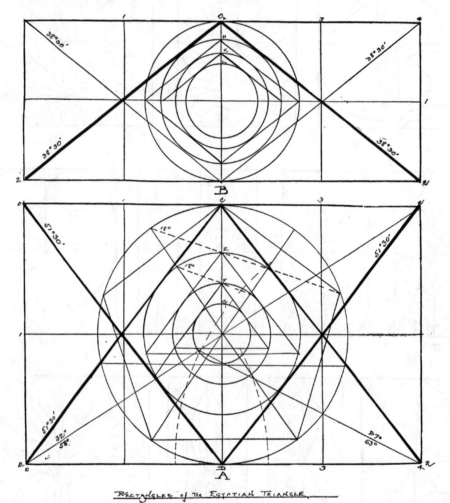

Plate 29—Rectangle of Egyptian Triangle

Many examples of architecture considered perfect in their proportions by numerous judges and illustrating this claim, will presently be presented,—the Parthenon and the Cathedral of Paris, the façades of which are enclosed by rectangles of the equilateral

triangle, and other examples where this or another of the harmonic angles has been similarly employed will be shown in the Chapter on Architecture.

The rectangle of the Egyptian triangle is shown at Plate 29 and as already set forth is characterized by the remarkable way in which it produces the ratio of 5 : 8. The

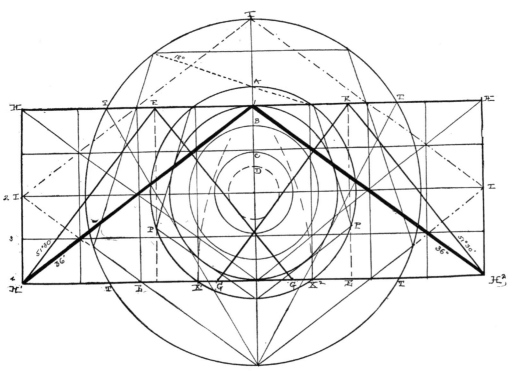

Plate 30—Rectangle of 36°

angles of 51° 30′ being first drawn in the rectangle with its diagonals of 58°, the progression of the pentagon has been added, the circles of which produce extreme and mean ratio in each succeeding pair. Every repeated concentric Egyptian triangle is also in the ratio of 5 : 8 as against the one following. The angles of 51° 30′ ruled from the four corners of the rectangle will intersect each other on the horizontal, dividing the rectangle by the vertical *C D* into four rectangles of 38° 30′ each.

Examining diagram *B* of this plate we find that the progressions of the pentagon may

be there added to the repeated concentric angles of 38° 30′, every succeeding circle being related to the preceding by extreme and mean proportion. The union of these two rectangles with their resultant perfect harmonics constitutes a proportional scheme of great value to the architect or designer, containing, as they do, many different variations in size and position of the extreme and mean proportion.

A plan of the rectangle of 36° with its harmonic relations is drawn in Plate 30, a

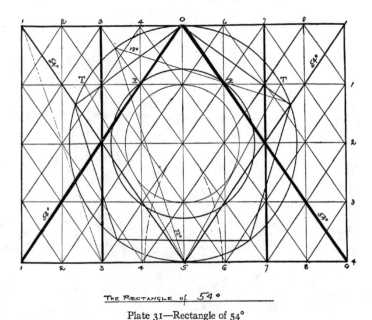

THE RECTANGLE of 54°

Plate 31—Rectangle of 54°

circle being inscribed in the rectangle and an equilateral triangle drawn tangent to it, to the point T on the upper line. A prime circle now passed through these points T has been drawn and the progressions of the pentagon inscribed as shown by the circles A to D, the intersecting points P, E, and H showing the important correlations. If now the angles of 58° and 63° be drawn from the corners of the primary rectangle at H, they will place the arcs terminating at the point X where the base line is divided into extreme and mean ratio, though in this case the factors are overlapped, the greater factor being from H^1 to X^1 and the lesser from X^1 to H^2.

The lines on the angle of 36°, ruled from the poles of the prime circle and the circle of the first progression, will intersect at various points of the rectangle, dividing it naturally into sixteen smaller rectangles of the same proportions and producing many of the

smaller divisions of a design, this being one of the methods continually in use by architects in the drawings of their façades and porticos.

The study of this diagram will require some patience, but will reward the trouble because of the harmonic unity it produces as well as its utility. Its counterpart, the rectangle of 54°, is drawn in Plate 31 together with the pentagon, and this plan, by the natural intersections of the angle of 54°, also produces sixteen lesser rectangles of the same proportions, and can be examined by the reader without further comment.

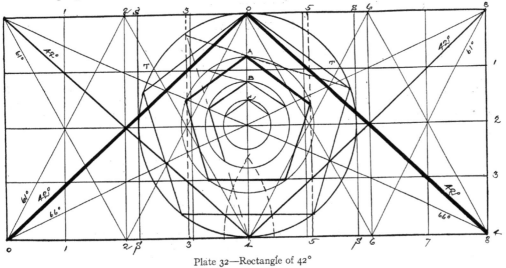

Plate 32—Rectangle of 42°

The rectangle of 42° will next be illustrated and harmonizes perfectly with the pentagon. It is drawn in Plate 32 together with three progressions of the pentagon at *A*, *B*, and *C*. The base line of the second progression of the pentagon will be seen to fall on one of the logical division lines of the rectangle as at *1*. By these lines and the corresponding verticals on the intersections of the other angles, this rectangle is divided into sixteen natural subdivisions of the same effect as described in the preceding rectangles, and the extreme and mean proportion will be repeatedly found throughout the diagram.

Examples of this kind might be carried on indefinitely, but enough have been furnished to explain the applications which will follow later.

CHAPTER V

FORM EVOLUTION

ASSUMING now that the reader has familiarized himself with many of the prominent interrelations of those geometric figures which we have seen to combine in the structure of the regular polyhedra, the constant effort of Nature to attain precision in form will be more easily understood. The various manifestations of her processes will be taken up separately as soon as a brief examination has been made into one or two of her methods of regulating form construction. She has a number of rules which she applies irrespective of the characteristic outline or symbol of geometric form, among which one of the most interesting is the principle of molecular structure, which we may examine in order to ascertain something of

The Geometry of Segmentation

Cellular or molecular structure being a fundamental principle in Nature, it may be well to disclose how definitely geometric she is at the point where formation first commences, for the geometry of segmentation explains very clearly the binary principle. Growth comes to pass in all things by the addition of one cell to another on some such ratio as 1:1, 2:2, 4:4, etc. Plate 33 represents this segmentation in the oöspoom of a frog, diagram *A* showing the first stage of growth; diagram *B*, the second, where the circle

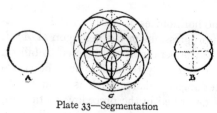

Plate 33—Segmentation

is divided by two; diagram *C* renders the third stage where the form has proceeded to four members. Plate 34 represents another method of such a formation in the third and fourth stages of growth, diagram *A* showing the third stage, with its division into four, while diagram *B* shows the division into eight parts.

Plate 35 discloses the geometry of the segmentation of a colony of non-sexual reproductive zoöid, diagram *A* again representing the first stage, diagram *B* the division into two at the second stage, diagrams *C* and *D* again showing the four- and eight-membered

stages respectively. It will easily be recognized how perfect is the system which will produce such unity as these segmentations, and the above diagrams apply equally well to many others, for the botanists tell us that the spores of many forms of vegetable life divide themselves in their progressive growth on the same principle as the zoöid, Plate 36 illustrating this development of spores from one into a colony of sixteen.

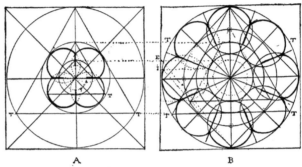

The principle of segmentation, or natural reproduction by mere subdivision, governs thousands of minute species and will be recognized wherever the microscope is in use. This rule exerts a controlling power on the

Plate 34—Further Segmentation

form of infinitesimal myriads, and is one of the methods most frequently employed by Nature for the multiplication of her lower orders.

Another principle which influences many forms of growth is one which we have already looked into somewhat in a preceding chapter. We find that proportional formative spaces are frequently governed by what is mathematically recognized as an

Extreme and Mean Proportion

Too much importance can hardly be attributed in a work of this kind to the principle of extreme and mean ratio, for there are few objects in the living forms of Nature which do not reveal its effect, thus declaring the law to be one of the fundamentals of true proportion. Pythagoras was, as has been before stated, one of the first investigators of the subject, but unfortunately we know very little definitely as to what his precise discoveries in this line were. It is more than likely that the principle was first brought to his mind during his analysis of the pentagon, for it is one of the integral parts of that polygon. If we take, for example, the side of this

Plate 35—Reproductive Zoöid Colony

figure from the apex to its extremity and compare it with the longer pentagram line passing from the apex to the opposite angle of the pentagon, the two lines bear a ratio to each other designated as extreme and mean proportion; or if we introduce the regular progression of the pentagon, the resultant circles will be divided in each suc-

ceeding pair by the same ratio, as shown in the study of that figure. It has also already been noted that the ratio of 5:8 is considered sufficiently similar to an extreme and mean proportion for the purposes of a work of this kind, and that in these pages the two expressions will be found frequently used as approximately synonymous. The error is so slight that in diagrams and designs like these it is seldom apparent to the

eye, so that in art, where sight is gence may usually be disregarded. pursue his investigations along this mathematical knowledge, since the error of observation and this is all of plants or architecture as the one

Plate 37 represents several different exact or practical extreme and mean A is perhaps the simplest and most ally perfect, and is the ancient plan method, shorn of technical diagonal in the lower half L, and upon it lay off Lp base line JK lay off JX P to J on the diagonal JL, dicate the division of the and mean proportion. as disclosing that by ruling triangle from the opposite dropping a vertical from the base will be cut approx- Diagram C is a method achieving a sufficiently

Plate 36—Spore Colony

the determining sense, the diver- The botanist or other reader may line without the need of exact geometrical diagrams are within the that can be required in such a study before us.

ferent methods of producing an ratio in diagrams A to F. Diagram direct, as well as being mathematic- explained by Mr. Coan.[1] The geometry, is to draw a of a square, as from J to equal to Lk. Then on the equal to the distance from when the point X will in- line JK into the extreme Diagram B is interesting the angles of the Egyptian ends of a given line and the point of intersection, imately into the same ratio. devised by Mr. Coan of satisfactory result in a di-

rect and simple manner and for practical use constitutes the best form of the problem I have yet seen, since the two angles 58° and 63° are both harmonic, the former being the diagonal of the rectangle of the Egyptian triangle and the latter the diagonal of the half square.[2] The method may be explained as follows: take a rectangle of half a square, or any base line which is to be divided, and from one end draw the angle of 32° (complementary of 58°) and from the other end draw the angle of 27° (complementary of 63°). Then with the latter end of the base as a centre and the distance from this point to the intersection of the two angles as a radius, lay off the arc MX, which will

[1] See note on Extreme and Mean Proportion in the Appendix.—EDITOR.

[2] The diagonals used are very nearly, though not absolutely, 58° and 63° respectively, as shown in notes on the square and Egyptian triangle and the rectangles in the Appendix.—EDITOR.

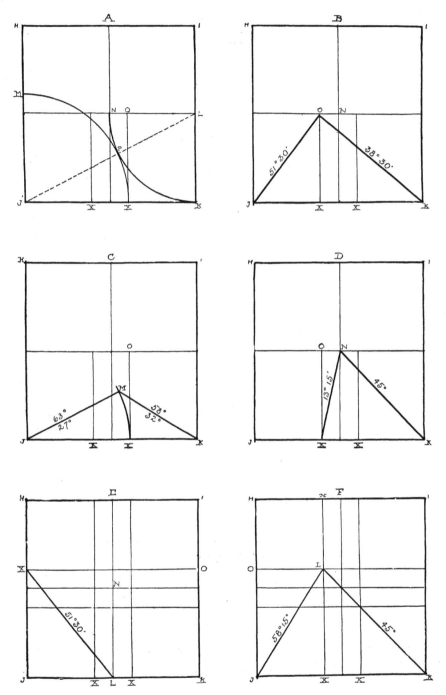

Plate 37—Methods for Obtaining Extreme and Mean Proportion

65

be found to intersect the base line, dividing it into extreme and mean proportion within a very small and negligible fraction. The remaining methods are illustrative though less accurate than those described. Diagram D is produced by drawing the angle of 45° at the corner of a rectangle of half of a square and at the point where this line intersects the upper side of the rectangle, as at N, drawing a line making the angle of 76° 45′ with the base, which at the point of its intersection will render the desired proportion. Diagram E is taken from the subject of the Egyptian triangle, and will be understood without further explanation. It divides the side of the square into the proportion of 5 in height to 8 of the base and the side itself into two parts of 5:8. The method illustrated in diagram F is produced by ruling angles of 45° and 58° 15′ from opposite ends of the line to be divided, when a vertical let fall on the base from their intersection will produce the approximation desired.

With the methods above set forth in mind, the relation of the extreme and mean proportion to the regular progressions of the polygons may be deduced as drawn in Plate 38, having first rendered the extreme and mean proportion on the four sides of a square by the method described in diagram A of the last plate. In this plan the regular progression of the pentagon will give the series of circles in pairs related to each other by a ratio of 5 : 8 as was seen in examining the principles of the pentagonal progressions, and squares now inscribed in these circles will be related to each other in like manner, while the angles of 58° and 63° may be repeated in each succeeding circle in regular order, the same proportion being found repeated in many parts of the diagrams. The side of each pentagon will bear this proportion to the next in progression, the pentagram lines also being in this ratio to the sides of the pentagon as we have before seen, and so on throughout. It will also be noted that the vertical erected upon the division of the base line into this proportion coincides practically with the side of the square escribed about the circle of the fourth progression of the pentagon, and this relation of spaces seems to have been utilized by the Greek architects, as will be seen on comparison of the diagrams in the chapter on the subject of Architecture. This plate, taken in conjunction with the progressions of the square and other polygons, becomes a most important geometric combination, furnishing a sufficient number of proportional points for almost any design, and the architect or artist must go out of his way to make a mistake. In this relation it may be well to recall that, as stated in the chapter on the pentagon, at Plate 9, the line OI in that plate passes horizontally through the points V at the intersection of the pentagram lines, thus dividing the primary square into rectangles of 42° and 48° of the ideal angle by the production of the horizontal to the square. It will also be remembered that the pentagram lines at this point are themselves divided harmonically as shown in the pentagon.

Turning again to Plate 18, we find that it illustrates the harmonic unity of the proportion which we are examining and the equilateral triangle, since the arcs of the smaller

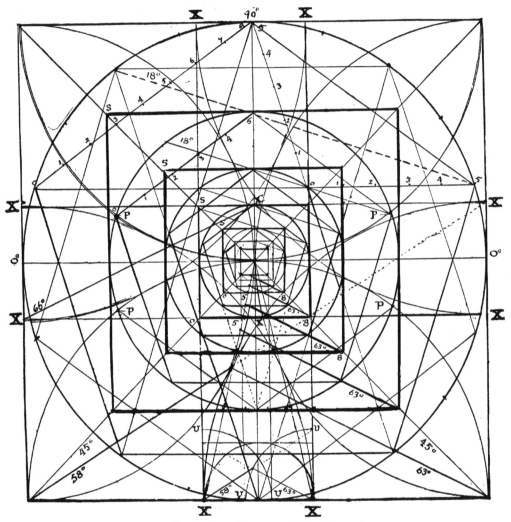

Plate 38—Correlations of Extreme and Mean Proportion.

semi-circles used in producing the ratio in diagram *A* Plate 37 will necessarily cut the prime circle at the point *T* where is seated the equilateral triangle. The harmony of the Egyptian triangle with the ratio under observation has already been shown, and can be followed out in any of the diagrams at length.[1]

By a re-examination of the diagrams set forth under the chapter on the correlations the reader will find a great variety of cases in which extreme and mean proportion exists, as was pointed out under those paragraphs, but as the pentagon is, of all, the most persistently subject to this ratio, so we may expect to find extreme and mean proportion best illustrated in pentamerous objects, greatly contributing to the perfection of their design as will presently be disclosed in their examination.

[1] For the mathematical accuracy of all statements relative to Plates 37 and 38, see Appendix, Note A, on " Extreme and Mean Proportion."—EDITOR.

CHAPTER VI

W E have already seen how intimate are the relations of numbers with each other and how the common geometric configurations are correlated. It is now in logical sequence to learn in what manner Nature appropriates each in her works, and to this end we may first study her law of numbers.

In this examination it immediately becomes apparent that Nature is, as usual, consistent, and selects groupings and serials in harmony with the form determined upon. If the form be pentamerous, the parts will largely be found grouped harmoniously in fives or tens, even where mere utility could be as well served by another number,— while if the form be hexagonal, the groupings with equal tenacity will cling to the numbers three and six, or to the almost interchangeable exponents of the square, two, four, and eight; and where extreme and mean proportion appears in the form, it will almost certainly be found represented in the numerical series by the numbers $3:5:8:13:21:34$.[1]

Darwin has well said, "Observation can only lead to successful result through theory," and thus the student may find an *open sesame* to an understanding of the laws governing the exact proportional spacing of the details of an object in their relation to the general mass by an examination of the theory of Nature's measurements in phyllotaxis. All plants grow under the influence of a formal law, and put forth their leaves at points marked for them by regular progressions, the two principles passing hand in hand to their perfect work and placing numbers as beacon lights along the way.

All natural growth and formation are completely governed by this ever present rule, and it would appear that when Nature had once decided to select the octagon for the base in the construction of a flower, for instance, then the numbers two, four, and eight must of necessity become integral parts in its proportional spaces, and at once the petals, stamens, and pistils must appear in similar numbers that the harmony may be complete; or if she desires pentagonal symmetry as an obvious proportion of a plant, then the angles of the pentagon with its consequent numbers of five and ten come into control, for an object of five sides must have five members with divisional spaces multiplied or divided by five.

[1] See note in Appendix on "Extreme and Mean Proportion."—EDITOR.

There has been much discussion as to why all plants are thus numbered and the subject is an engrossing one, but in following out an analysis of structure, this question may be clearly comprehended on geometric principles, which of themselves prove that rationally the details must be grouped in numbers harmonic with the form. This numerical system is, therefore, the gateway through which the student may pass, guidiny him at once, if the arrangement be obscure, to the true geometric plan, which is the basic element of all form, for beauty, whether symmetrical or asymmetrical, consists, as we have already seen, in "unity," and arises from the principle that the number characterizing an object decides the angle, while the angle decides the curve of all the varied lines, and this is true throughout all Nature.

This rule can be exemplified in innumerable ways, but of all of these the realm of botany offers those most easily recognized; and to this field I would turn the student's attention for a short time, since it is from the intelligent research of the modern botanist that we learn that every flower, leaf, and seed-vessel has its own established number by which all of its parts are controlled as by magical enchantment. These enthusiasts have, for instance, discovered many remarkable things in the *coniferæ* or pine family, the needles or leaves of which grow in clusters of two, three, and five according to the species, while their seed-vessels and cones are numbered in like manner with two, three, five, and eight spirals of the continuing series of spaces mentioned in the previous chapters and explained more in detail in the chapter on Botany. This integral form of extreme and mean proportion appears throughout their growth and is a principle and fundamental attribute in nearly all objects of perfect proportion.[1]

To illustrate exactly what I mean by specific examples, I might quote the botanist, Gray, who thus describes the flower of wood-sorrel or *oxalis:* "Sepals five, pistils five, bases somewhat united, stamens ten, usually membranous, five-celled and more or less five-lobed." In order that this description may be more clearly understood, a theoretic diagram of the blossom is produced in Plate 39.

This flower, having five petals, declares at once that the pentagon will interpret its proportional parts, while its curves must be those produced by one of the angles of this figure. If, therefore, the ellipse forming the edge of any petal be continued (as shown by the dotted lines), it will be found that the transverse axis of the completed ellipse coincides with the angle of 72° of the pentagon, and the same curve will be found to pass directly through each of the five petals, taken in succession. It will be noted that the ellipses intersect on the circle marked 5, which is that inscribed in the pentagon of the first progression, while similar smaller circles enclose the torus with its system of stamens and pistils, all maintaining the correlations of the pentagon.

The same authority describes common dog-wood or *cornus* thus: "Flower perfect; calyx minutely four-toothed; petals four, oblong, spreading; stamens four, small with a

[1] See note in Appendix on "Extreme and Mean Proportion."—EDITOR.

two-celled, two-seeded stone." From this, without even seeing the blossom, we decide at once, and correctly, that its proportions are governed by the square.

As a further example, a theoretic diagram of the flower of *cosmos* is produced in Plate 40, which, having eight petals with four ribs in each, declaims at once that the octagon will interpret its proportional parts. A cut-out ellipse, constructed as described in the chapter on Botany, and placed upon the radii ¼, ⅔, etc., with its transverse axis coinci-

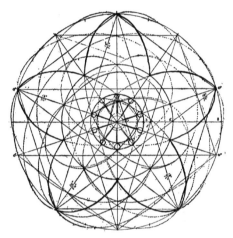

Plate 39—Wood-Sorrel

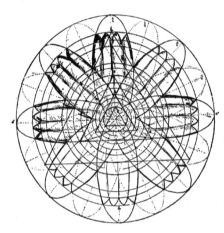

THE FLOWER OF COSMOS.

Plate 40—Cosmos

dent to the radius, discloses the relation of the angle to the curve as well as the correlations shown by many of the intersected circles of the progressions of the octagon and of the equilateral triangle. At the points where the elliptical curves intersect the second circle, the petals are generally cut sharply off, as a characteristic of this flower. This would almost appear to be a playful fancy of Nature, as it would seem from the plan that the petals were intended to pass to the outer circle, as in fact they really do in some cases.

These plans of *oxalis* and *cosmos* are called "theoretic" in that they are drawn from a perfected blossom, but it will be found that the more perfect is the natural flower, the more nearly will it conform to the geometric plan. These characteristic examples will apply with slight variations to the leaves, flowers, and fruits of all plants. Similar floral analyses will be taken up in greater detail in later chapters, but this is sufficient to show the harmony of numbers with form.

All forms of beauty may be similarly described if we may judge by analogy. At present our knowledge in many branches is too limited to furnish us with means of exact proof, but the time must come when the whole truth will be revealed to the earnest

student. There are, however, many departments of science wherein we may scrutinize Nature's work in this regard with definite results. There can be, for example, no question as to her intention in regard to the action of polar force, as this invariably results in numbering its forms by two, four, six, eight, etc., thus demonstrating that in all cases influenced by this power, angular magnitude demands the presence of the hexagon or octagon. If we take the laws governing light, heat, and sound, the same principle will be repeatedly recognized, and it is thus within the bounds of probability that polar force has a more or less direct influence on all forms of production in the universe.

It will be shown in the chapter on Conchology that shells are numbered, not only in their spirals, but also in the details of their decoration. If writers upon this science have not mentioned the fact, it is because they have not, as yet, investigated the subject in the same thorough manner in which botanists have analyzed plant growth.

Examination proves that the same law of numbers governs the animate as well as the inanimate world, from the lowest to the highest form of life. The lexicographers will describe to us an insect as "An articulate animal with six legs." Thus if we examine a fly entombed in amber where he may have remained for thousands of years, he will be found to answer the definition precisely as though born in the sunlight of to-day, his legs being six, the joints of these legs divided by three. Learning thus that insects are divided or numbered by six, it would be a natural conclusion to suppose that their proportions would be interpreted by the square, the hexagon, and the equilateral triangle, and this we shall find to be precisely and emphatically the case when later we come to analyze them in detail.

Had we the time to go deeply into this portion of the subject, we should find that beasts and birds were equally amenable to the rule. The quadruped with his four legs, and the bird with two, each submits to the universal law, their proportions and the grouping of their organs being governed by the harmonic numbers of two, four, and eight, the various species producing each two eyes, two ears, two horns, if any, birds having two wings, each of two sections.

To all of these rules the human family is no exception, and we find in it prominently established the number *two*, together with the continuing series of 1, 2, 3, 5, and 8.

Substantiating the idea that the human figure is governed primarily by two as its modu'e of division we find, upon placing the drawing of a young man with the proportions taken from the Greek Canon in a diagram divided by one progression of the triangle of sixty degrees (the resultant circles being octant as already seen), that where the prime circle measures the whole height from the crown of the head to the soles of the feet, the upper arc of the second circle will pass directly through the nipples, while its lower arc will define the placing of the patella or knees. This arrangement is well known by artists and applied not only to all well proportioned persons in real life, but also to the same divisional spaces in most of the Greek statues.

Examining the human figure, we find, taking the head and chief bones of the skeleton, these numbers in evidence: head, one; mouth, one; nose, one; eyes, two; ears, two. In the body there are arms, two, each containing three bones: the humerus, radius, and ulna; legs, two, each divided by three: femur, tibia, and fibula; each arm has one hand with carpal group, one, phalanges and digits, five; each leg has one foot, with tarsal group, one, phalanges and toes, five. These are, of course, only certain prominent members and bones, there being many others perhaps equally necessary and certainly equally harmonic.

This system of numbering obtained with the first cave-dwellers and the denizens of their forests, and will stand unchanged in the main to the end of time, except as Nature by new combinations, to fit new creatures to new duties, originates further forms under the guidance of her inexhaustible imagination, for there can be no doubt that the numbers governing the necessary organs and members with which all creatures are variously endowed are chosen from the fact that thus endowed they can best walk, see, hear, climb, fly, and perform whatever function is necessary for their existence, and thus the peculiar harmonic beauty which characterizes each family and species results from Nature's application of her law of numbers.

Numbers have been employed in a symbolic way almost as far back as history extends; *three, five*, and *seven* have always had a mystical meaning. It is not improbable that the Greek temples took their distinguishing numbers of *four, six, and eight* from some geometric system similar to that above described, while, on the other hand, Christian churches in the early and Middle Ages had their ground-plans developed symbolically from the cross, the unit of which is the square, the arms numbering three and the foot five, making altogether the mystic seven. These figures are, of course, general and not invariable, and refer to the architecture of the Roman and not of the Greek church. The unit of the square, first introduced symbolically, finally came to dominate geometrically not only the ground-plan but the elevation as well. Gwilt, that great architect, declares that "The connection of the bays of the nave with the terminating polygon of the choir was such that the polygon was inscribed in a circle whose diameter was the measuring unit of the nave and generally of the transepts which always form the side of the square intercepted by them." This harmonious apsis was generally octagonal or produced by three sides of the octagon as in the case of the Church of St. Vitale at Ravenna, shown in chapter on Architecture, while in Cologne Cathedral the apsis is decagonal, and in Westminster Abbey it is hexagonal with twelve pillars in the nave. In the Duomo of Milan the apsis is formed by the side of the nonagon with the bays of the nave harmonically carried out.

After the thirteenth century we thus find on the continent that the architects quite logically began to regulate the details of their churches upon the form of the apsis, and if this is developed by the hexagon, then the number *three* or its multiple will

be carried into the bays, windows, and other details. This correlated arrangement was undoubtedly developed by the study of geometric laws in which numbers are an integral part and all of this led to that perfect unity in the churches of the period which impresses even the ignorant while it strengthens the love and admiration of the wise toward the resultant ideal work.

Thus it is, that "if the stem or primary impulse of a plant is rightly numbered, the leaves, flowers, and fruit that follow will be similarly numbered, finally taking their just proportional forms." It does not follow from all this that the master-masons of ages long gone by studied botany or understood its laws as one might perhaps infer, but their profound feeling for geometry, which is the parent of the law of numbers, eventually produced the same results.

We shall be able in the following chapters, especially those on Botany and Conchology, to trace this interesting subject further, and shall find it an ever-present factor in disclosing the elements of harmony.

CHAPTER VII

CRYSTALLOGRAPHY

WE may now feel that we have equipped ourselves for an intelligent examination of the wonders of Nature at first hand. The reader has been patient over the preliminaries and acquired that knowledge of Nature's obvious mathematics which is absolutely essential to an understanding of her methods. He knows that there can be but five regular solid bodies or polyhedra, including the three formed by the equilateral triangle, one by the square, and one by the pentagon. These cover all possible forms of regular solids and those which are semi-regular are produced from combinations of the same figures. We have, moreover, examined the various progressions and correlating points, together with the historic triangles and rectangles, and are now ready to pass from mere abstract reasoning to the field of the examples, where I trust ample reward will be found to await all who follow.

It is, perhaps, but logical that in examining our material we should first take up the inorganic forms, then organic, leaving the study of energy or force until a later time. Now, of all the inorganic combinations in Nature's store, the crystal is pre-eminently the example of harmonic form. To crystals in their many varieties, therefore, let us turn and see if we may be able to interpret the signs of the master-builder's handiwork.

The first thing which will come to our notice will be the absolute uniformity with which every species of these creations, from the tiniest prism to the largest example, demonstrates in every dimension and angle that it has been the creature of polar force from its earliest inception, and this is equally true whether we choose an aged and hoary quartz, older perhaps than mankind itself, or a whirling snow-flake formed and reformed while making its one terrestrial journey from the dull, gray, wintry cloud that conceived it through a few short seconds to the drift where it joins its storm-born mates. Examine these myriads never so carefully and we stand amazed at our discoveries, for we learn beyond possibility of doubt that, while we might spend a lifetime looking for two snow crystals patterned alike, and while the variety of other crystals is almost infinite, yet in every case the whole structural form and even the decoration (if there be a decoration) is designed to the most minutely accurate demonstration of the angles of polar force. Indeed, few other angles than those of 30°, 45°, 60°, and 90° will be found controlling

75

their important spaces, and we see the equilateral triangle, the square, and the hexagon repeatedly laid out as with ruler and compass.

Among the interesting crystal illustrations of polar force, I would invite attention to the drawing of the hydrous silicate *Harmotome* (Plate 41) which, it will be noted, is developed by three progressions of the square, superimposed upon one progression of the equilateral triangle. The form of this crystal most frequently found is represented by the diagonals crossing at the centre, indicating the pyramidal apex so frequently met with in this, as in many other crystals. *Harmotome* occasionally appears in the

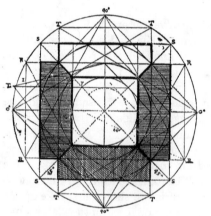

Plate 41—Harmotome

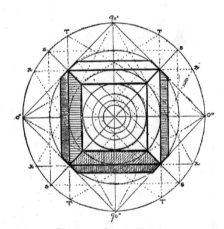

Plate 42—Cuprus Uranite

very interesting form indicated by the heavy lines of the third progression of the square showing the tetragonal platform with which it sometimes terminates instead of the pyramid. It will be understood that in each of the permanent crystals illustrated, the drawing is made in perspective, looking from the top or apex of the pyramid, so that in the case in point the centre of the diagram represents the highest portion or apex, the sides sloping up the inclined facets, shown by the converging lines, to their common meeting-place at the centre in the pyramidal species, and in others to the flat top circumscribed by the third square as I have already described. In the latter case the sloping sides of the pyramid continue only to the truncation. Examination proves also that the inclination of the bevel or slope of the sides is governed strictly by the angles of polar force.

Another interesting example of symmetrical formation is the crystal of *Cuprus Uranite* shown in Plate 42, which again results from the combination of three progressions of the square with one of the equilateral triangle. In this, the outer corners of

the crystal are cut off by the sides of the square placed diagonally in the prime circle, and the proportions of these corners are nearly always harmonic with the diameter of the circle of the sixth progression. Here again the bevelled angle is governed by the principles of polar force, and the facet approaches the eye at the angle of 60°. In the case of the crystal of *Dolomite* represented in Plate 43, we have an example of a triangular platform or top, although this species shows also the square platform in several of its varieties. In this instance the outer form of the crystal, as looked at from above, is

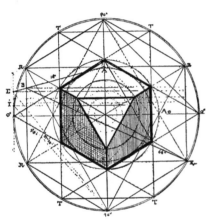

Plate 43—Dolomite

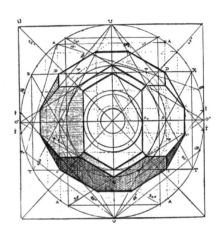

Plate 44—Iolite

measured by the circle of the secant progression of the hexagon, while the equilateral triangle describing its flat facet is exactly inscribed within the circle of the third progression of the square.

Taking one more example of permanent crystals for examination, the *Iolite* is found in Plate 44 where the general proportions are developed by the angles of 45° and 60° and the secant progression of the hexagon, intersecting at the points A and Ao. The other angles and proportions may be followed without description further than to state that, as viewed in perspective, the inner lines of the smallest facets, CD, will be found to coincide with 48° of the ideal angle passing from the pole u to i. In a minor degree the pentagon is also harmonic, as the vertical lines AA, erected from the points marking the extremities of the base of the inscribed pentagon, will be found to coincide with the inner edges of the same small facets, CD. We thus learn that while the law of natural indices precludes the possibility of angles except those of polar force appearing fundamentally in any crystal, yet we may sometimes expect to see other harmonic

proportions in an incidental way, especially when examining the specimen in perspective.

In like manner, all of the regular crystals will be found to be perfectly proportioned under the influence of the laws of angular magnitude, and to say that they are beautiful to the eye is surely to speak advisedly, since all of the parts are of the most perfectly balanced unity, and we shall again and again see how true it is that beauty and unity are identical.

In accordance with the plan outlined earlier in the work it may not be without interest to see how well our standard of beauty in architecture, the Parthenon, responds to the measurements of Nature as pronounced by her in the crystal. Let us compare this wonderful portico with the drawing of *Dolomite* and a snow crystal, as shown in Plate 45, and see how perfectly the chief proportional spaces are rendered, the whole façade being inscribed within the rectangle of the triangle. The raking cornice on the angle of 14° passes to the prime square at the point crossed by the horizontal line from E, while from this point E to the lower pole of the primary circle the angle of 51° 30′ may be drawn. The angle of 66° drawn from the lower right hand corner of the rectangle to the point B, as shown in Plate 43, will indicate the height from the base of the pediment, while at the same time the horizontal from this point B will place the facets of the crystal. Again we observe, that the horizontal from the point E, which we already know places the lower line of the dentils in the great creation of Ictinus and Pericles, also indicates the position of the circle of the fourth progression of the square, which is an obviously harmonic link between the circle of the third progression, circumscribing the triangular facet of the crystal and the fifth progression, inclosed in the same triangle. Upon comparison we shall also find that the upper line of this facet, being coincident with the fifth progression of the square, marks the lower line of the tryglyphs and metopes of the Parthenon, and should we carry the analysis further we should again and again assure ourselves that, however much or little the ancient Greeks knew about crystals, they certainly were thoroughly convinced of the benefit to be derived from the use of these geometric proportions in producing that unified beauty for which their structures and sculpture are so justly celebrated. Besides the Parthenon, many other Greek temples have their proportional spaces established by the same principles, and this is, moreover, true of the Gothic churches of the Middle Ages, the same means having been employed by the architects of those periods.

In the minute and transitory snow crystal we shall discover quite as astonishing an exemplification of the principles already laid down, and any one of these microscopic marvels would serve as the text for a sermon either upon the harmonies of Nature, or upon their adaptation by man, though few persons there are at the present time who recognize this or consider these waifs of the air as interpreters of architectural proportions. It would be quite impossible to analyze such almost infinitesimal objects with

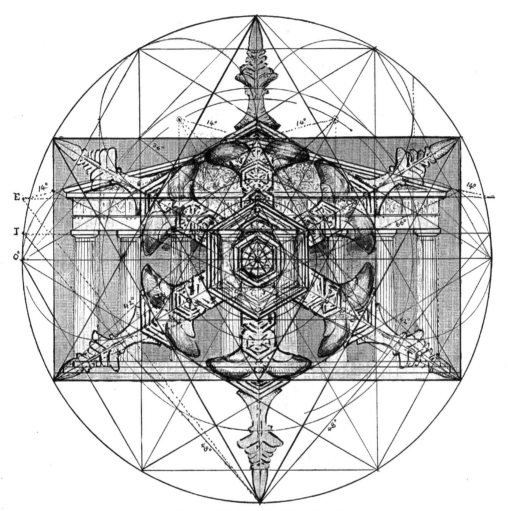

Plate 45—Parthenon and Snow Crystal

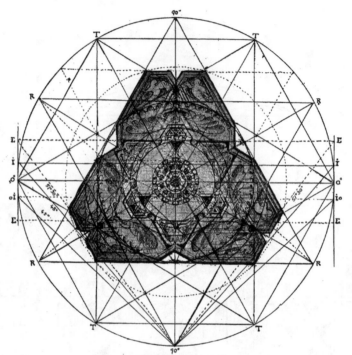

Plate 46—Triangular Snow Crystal

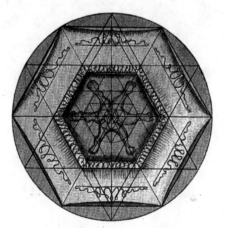

Plate 47—High Altitude Snow Crystal

80

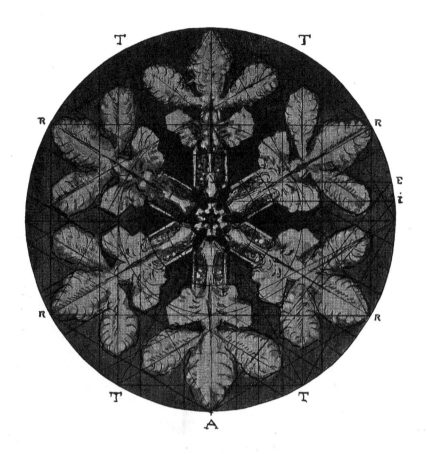

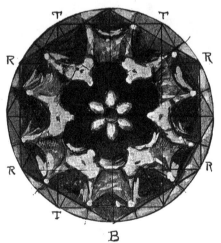

Plate 48—Snow Crystal and Enlargement.

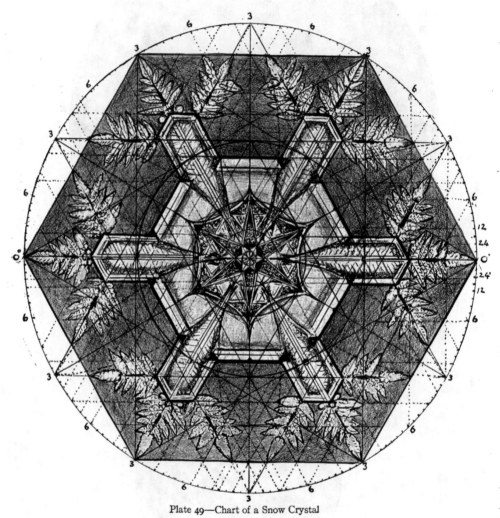

Plate 49—Chart of a Snow Crystal

any degree of accuracy were it not for the science of micro-photography, but by its use forms invisible to the normal eye are clearly revealed, and no difficulty or uncertainty is encountered in their examination. [1]

When we consider the great height at which these fragile forms are first outlined, and how they are hurled from their cloudy couch by the whirlwind, buffeted from first to last by the storm, subjected to sudden differences of temperature, and deposited where chance wills, it seems incredible that any of them should reach the ground in a state o perfection, nor could we hope to find a single specimen intact were it not for the fact that the law of polar force never for a moment leaves them in their wanderings nor ceases to exercise its formative and controlling influence. They start at first with a simple or primitive design, and, as moisture is added and temperatures change, this becomes more and more elaborate, the ever-present force constantly remodelling readjusting, and restoring each tiny flake to the very end.

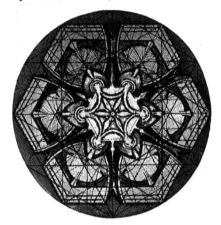

Plate 50—Catenary Curves on a Crystal

Most of the illustrations submitted on this subject are directly from micro-photographs, *precisely as the flakes fell from above* while a few are from enlarged drawings, it being found that no matter what the magnification, the design continued to be always geometrically perfect.

A simple form of high altitude crystal is submitted in Plate 46 which will be seen to be triangular, developed by the angle of 60° together with the progressions of the square. The circle of the first progression clips the angles of the crystal as shown in the illustration, while the next circle (unfinished in the drawing) is that of the secant progression passing through the intersections of the triangles of 60° as has been noted in the explanation of this subject. This circle places the three dark hollows or pits near the notches in the short sides, which are seen to give so much character to the design. It will be remembered that this circle is the fundamental one of the seven harmonic circles which illustrate the packing of molecules in space, and in the example at hand the arcs of the seven circles intersect various members of the crystal, deciding the position of the concave hollows modelled on the face of the design as well as many other features.

[1] Mr. W. A. Bently of Vermont has devoted his life to the development of the science of micro-photography particularly as applied to the study of snow crystals, and he has succeeded in producing wonderful results. A collection of his prints should be in the hands of every student of beauty or design. Among the thousand or more examples secured by him, not a duplicate has been found. The examples of snow crystals given here are taken from Mr. Bently's collection.

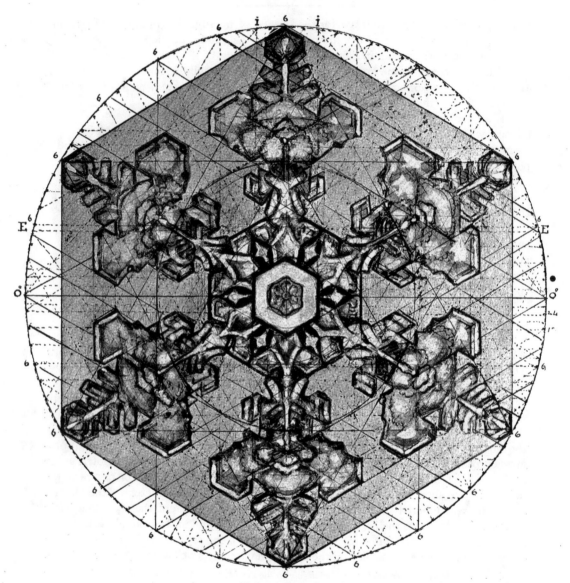

Plate 51—Snow Crystal

If the angles of 42° of the ideal angle are drawn from the points R of the great rectangle, they will be found to intersect definite points on the plan and indicate various correlations as described in the explanation of the subject of the seven harmonic circles. The ideal angle and these seven circles must always be found together to some extent, since certain points are common to both, as was seen in the initial examination. The very clearly defined dark triangle escribing the light disk in the centre will be found to lie precisely upon the triangle of the second progression of the angle of 60°. This in turn is equivalent to saying that the horizontal line marking the upper portion E to E, indicates the positions both of the Egyptian triangle drawn from the lower pole and also of the forth progression of the square, since we have seen that these three positions always coincide. It follows from this that the light disk to which attention was an instant ago called, is absolutely coincident with the circle of the third progression of the equilateral triangle, which also indicates the three deeply marked triangles which form so conspicuous a portion of the decoration.

Thus it is that every important proportion of this crystal, as in every other, is developed by the progressions of the angles of 60°, the square, and the hexagon. The evidence of the occasional appearance of the ideal angle and the Egyptian triangle of 51° 30′ is here introduced in order to disclose instances of their harmony. Far from disputing the sway of the angles of polar force in the government of crystalline forms, these examples show definitely that other angles than those almost never appear except at such correlating points as our original investigation has shown always to indicate a necessary conjunction of other angular indices beside those of polar force. We have learned, for example, that in equal prime squares, the upper leg of the fourth progression of the square always coincides with both the second progression of the equilateral triangle and the prime Egyptian triangle, and hence it follows that where we find the one, the other two will necessarily await disclosure, whether they be characteristic of the example under examination, or only incidental correlations. In such instances, where only one is mentioned, it will be because the others are either obvious or because only one is really characteristic, the others being, as I say, merely incidental and omitted to avoid confusion and complexity.

Plate 47 represents a high altitude crystal showing the magnetic curves passing over the face of the design similar to the waves developed by sound and occurring in clean-cut incised lines. Plate 48 shows a much more elaborate example, diagram A giving the whole form while diagram B represents the small interior section greatly enlarged, disclosing the manner in which the different progressions repeat each other in principle as far as the examination can be carried with the finest microscope.

For the purpose of detailed analysis of snow crystals it is generally advantageous to divide the arcs of the primary circle into segments of $\frac{1}{3}$, $\frac{2}{3}$, etc., and by subdividing to reduce the chart to sections of not over $\frac{1}{48}$. By constructing diagonals on the angle of

60° as shown in Plate 49, the minor proportional divisions will generally be found clearly divided. Many crystals of high altitude, as is this one, are characterized by straight,

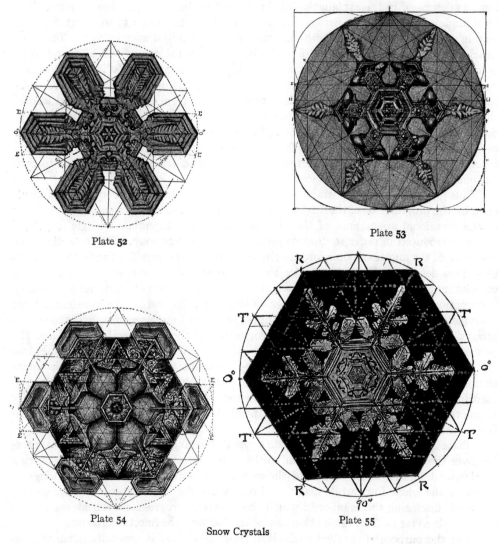

Plate 52

Plate 53

Plate 54

Plate 55

Snow Crystals

clean-cut mouldings on many of the subsectional divisions, the consideration of all of which will well repay the student and designer, as disclosing many of Nature's principles.

Numerous snow crystals have been found to bear most elaborate decoration, with ornament piled upon ornament, yet all enclosed in a simple outline. Very many of these

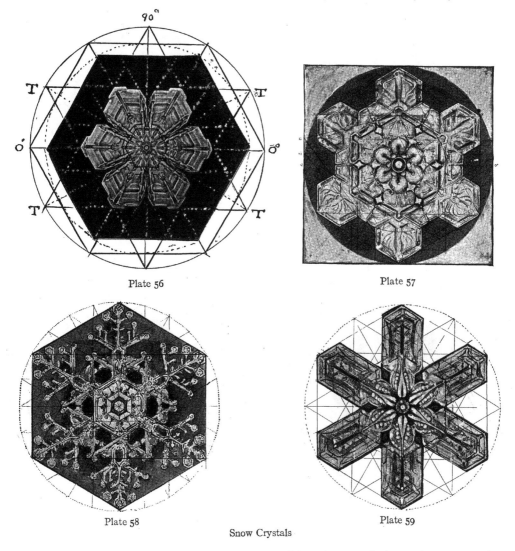

Plate 56

Plate 57

Plate 58

Plate 59

Snow Crystals

ornaments are composed of magnetic curves, although true circles and arcs are also present. These magnetic curves, or those of gravity, so greatly interested Faraday

that he never ceased to study them, and for the illustration of precisely what is meant,
it may be explained that they do not form perfect circles but may be defined as the

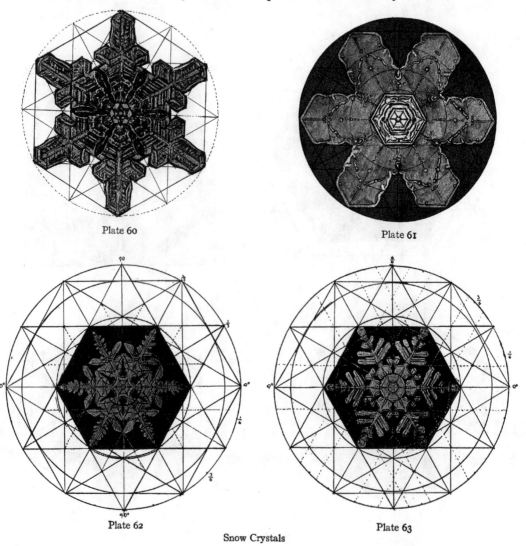

Plate 60

Plate 61

Plate 62

Plate 63

Snow Crystals

curves described by a flexible chain suspended at both ends. Plate 50 represents
a snow crystal decorated with two sets of these curves, one set outlining the six most

prominent leaves or portions of the design, the second set crossing these farther in on the form of the decoration of each leaf, and other lesser curves occurring in arcs easily detected.

The snow crystal discloses how perfectly the principles of geometry are united to the laws of art deduced by man from centuries of study, close observation of Nature giving force to each theory. The most important of all of these laws of unity are the laws of repetition, continuity, and contrast, the latter disclosing the great value of simple or blank spaces in close proximity to those richly decorated or having many details, while curved lines are contrasted with straight ones, flat surfaces with sculptured forms, and intaglio with relief, and all of these are illustrated again and again in Plates 51 to 63.

The tiny snowflakes described in this chapter never fail in rendering all these things with a degree of perfection impossible for man to imitate. To study them reveals the fact that no object in Nature can be too small or insignificant for the artist's careful attention, since many things seen only under the microscope prove to be among the most perfect examples of proportional form, numerous diatoms, for example, almost rivalling snow crystals in this respect; nor are crystals and diatoms alone in the power to command admiration for their expressive beauty, as we shall see in our further pursuit of the subject.

CHAPTER VIII

BOTANY

WE have seen how conspicuously the laws of harmony are followed by Nature in the creation of her inorganic forms, and I beg the student next to inspect the evidences of similar intent in the vegetable kingdom where we may gain an idea as to her plan regarding organic life.

It has long been recognized by botanists that leaves and shoots are usually arranged on their stems in spiral series, but it was to the fertile imagination of Goethe that we owe the discovery of the ever-present spiral tendency in all vegetation. The study of phyllotaxis, or the order of leaf growth, is of so difficult a character that nothing can be more striking in an examination of the subject than the large number of hypotheses put forward, most of which are impossible either to prove or to disprove. Various botanists in the past have differed in their views, one of the older of modern authorities, Sachs, for example, ridiculing the ideas of his predecessors and contemporaries in relation to the spiral principle and stating that the plan of a series as applied by them to phyllotaxis "is more or less simply playing with figures, introduced gratuitously by some writers without showing any necessity for its use toward the welfare of plant growth." On the other hand, Professor Church of our own day, and with deeper and a much clearer vision, expresses his conviction that all deductions concerning phyllotaxis can be based on a single hypothesis, as "*the distribution of energy follows definite paths which may be studied by means of geometric construction,*" and he shows many examples of spiral construction developing the ratio of progression, 2–3–5–8 and 13 of the series as described in the chapter on the Correlations of Numbers. This truth Dr. Church describes in his remarkable paper on "Orthogonal Trajectories," where he says in effect that the precise phenomena developed in the growing apex of a plant are too obscure to be followed out to their conclusion in our present state of knowledge; we know, however, the spiral principle to be a geometric one. Still it tells nothing of causes, but can only express facts.

In the analysis of the principles of proportion as developed in plants and other objects of Nature examined by me, no attempt is made to prove my statements by measurements impossible of verification. I rely upon drawings, photographs, the accu-

rate counting of serial parts and similar means which for this purpose are ample, for it should be remembered that the subject is here approached from the standpoint of the artist, where the results finally appearing are all that are required; and if I do not offer the measurements of a flower or crystal in inches, it must be understood that it is because it is its correlative and not its independent measurements which are the basis of my—

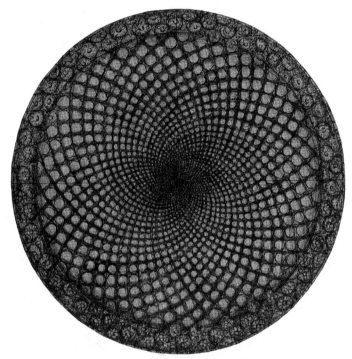

Plate 64—Sunflower Capitulum

indeed of all—theories. Nature herself is rarely exact in every portion of any one flower, yet if she presents us with an object numbered by five, such as the laurel blossom, for instance, no possible reasoning offered can change the obvious fact that she intended the form to be pentagonal even if it is several degrees removed from a symmetrical measurement, *for the law of uniform growth is expressed by the average of geometric correlations and not by single disconnected measurements*. However exact her principles may be in the abstract, or however clearly to be proven by scientific methods, it is in the appearance that she seems to take most delight.

Professor Church, in his analysis of plants, takes the sunflower capitulum (Plate

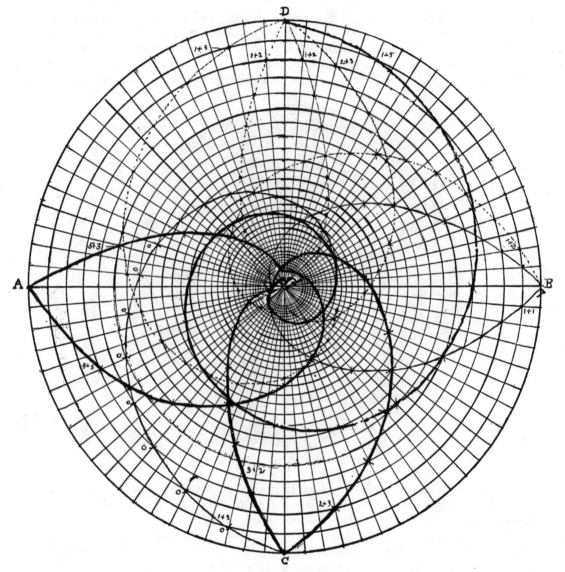

Plate 65—Spiral Method (from Church)

92

64) as a representative object in describing form distribution, and he reveals that, "with a pair of simple spirals, the plan of the disk can be drawn with sufficient accuracy, and

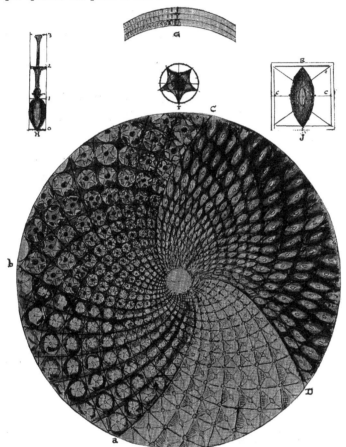

Plate 66—Stages of Sunflower Growth

excepting for a few simple arrangements by which a slight modification of these spirals may be made, they will then, within the error of drawing, accurately chart out the flower, leaf or apex growth, and distribution of very many families of plants, where the law of normal growth is in force."[1] These spirals are logarithmic, that is, they have the property that the tangent at any given point will make a constant with the radius vector, and they are therefore equiangular spirals.

[1] *On the Relation of Phyllotaxis to Mechanical Laws*, by A. H. Church, M. A., D. Sc.

The method of drawing such spirals for the purpose, Dr. Church sets forth in this way: "Describe a large circle (as in Plate 65) and divide it into any convenient number of equal parts by radii (say 50 to 100); then draw with the same centre a series of concentric circles making with the radii a meshwork of squares as near as can be judged by the eye; in this circular network of squares arranged in radial series, in geometric progression, all lines which are drawn through the points of intersection in any constant manner are logarithmic spirals, or when drawn in the opposite or reciprocal way, will intersect at all points orthogonally."[1]

Seven of these spirals are drawn in this plate of varying proportions, two of which are symmetrical, or with opposite sides alike (at *B*) the other five are asymmetrical. One of these represented at the pole *C* is perhaps the most generally applied to the forms of plant growth. In this case two continuous curves are drawn across the meshes or squares of the plan, that to the right passing through the corner of every third square in every other circle, starting from the intersection of the perpendicular radius on *C* with the outer circle and continuing in the same way. The left hand spiral of this pair proceeds from the same pole, passing through every second square of every third circle from the same vector and so on. These two reciprocal spirals of growth show a combined progress of the 3 : 5 class and will produce remarkable results within the error of drawing for the purpose of charting out the spiral construction of numerous plants of the various orders of phyllotaxis; and it will be employed in the capitulum of the sunflower as a representative example, this being rendered as it is usually selected as typical of the Angiosperm families. The average division of this capitulum appears to be one of thirty-four long spirals to fifty-five short ones, although smaller flowers have been observed in proportion of twenty-one spirals to thirty-four while under very favorable conditions they have been known to reach 55 and 144. This division of the disk into its proportionate number of spirals of a fixed class is here referred to as an "order" of phyllotaxis.

To lay out the plan of the capitulum in this illustration (Plate 66), the primary or given circle must be divided by equal parts of 34 and 55; then a cut-out spiral of the 3 : 5 class as described in Plate 65 must be pinned to the centre of the circle through the intersection of its quadrant vectors, and fifty-five spirals drawn on the short arc with thirty-four on the long one. These, where they intersect each other, will render the proportions of the seed-vessels as they diminish toward the centre. The different stages of growth here are of interest and are described in the plate where the first stage of growth is represented in the passage between *a* and *d*, showing the rhomboid sockets on which the seeds are placed; the passage *c* to *d* represents the placing of these seeds; the passage *a* to *b* is the top covering of the seeds; and *b* to *c* the rayflorets as they are shown on the outer rim of Plate 64, with the disk-flowers which gradually cover the entire surface.

[1] Same work, Part I., p. 52.

The disk-florets are pentagonal in form though occupying approximately orthogonal or square spaces; the passage *a–b* contains hexagonal forms; that of *c–d* (the top of the seeds) discloses their form to be on the vesica piscis as in diagram *J*, which plan develops the proportions of the light spot on the seeds with their ratio of 1 in 3 with the length of the seed. This form of the vesica piscis is developed by taking the space *CR* as a radius and *C* as a centre. Diagram *I* represents the pentagonal construction

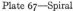

Plate 67—Spiral

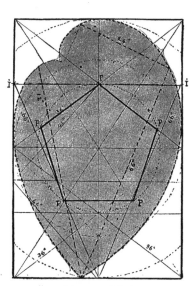

Plate 68—Spiral

of the disk-florets; and diagram *H*, the side view of the proportional spaces in the four planes of the above, the seed representing two planes of the florets, the top of the florets representing the third plane, while the long tube from the florets continues to the fourth; each of these members bearing a ratio to the others of one in three. Diagram *G* more clearly describes the arrangement of these planes or platforms. The figures appearing on these planes represent the trinity of polyhedra, or approximately the hexagon, the pentagon, and the square, and all of these details are of importance, as they reveal how Nature carries her geometric arrangements down to the smallest details.

We will now return to Diagram 65 in order further to describe the principle and to examine the spiral of 3 : 5 on the point *c* as analyzed in Plate 67. The arcs of this spiral are there shown to be escribed in the rectangle of 60° with the circle of the first progression of that angle; and if the pentagon is drawn in this circle with the circles of the progression of 18°, they will be found in the first progression harmonic with these spirals.

In Diagram 65 the spiral arcs of the 1 : 3 class are drawn from the point *B* where it is disclosed that this spiral passes through the intersections of the circles and the radii of 1 + 1 and 1 + 2. This spiral is analyzed in Plate 68, where the two parts are shown escribed in two rectangles of 36° / 54° of the pentagon with the diagonals of 56° across the two. We find that a logarithmic spiral of these proportions develops the angles of 24° and 66° as illustrated by the quadrant chords,[1] and the rectangle of the ideal angles

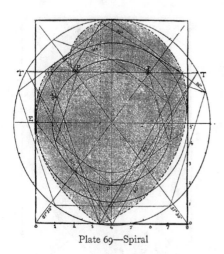

Plate 69—Spiral

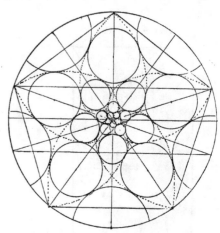

Plate 69A—Symmetrical Construction
(from Church)

of 42° is in evidence at the points *i* and *ii*, and if a circle be struck tangent to the horizontal at *ii* and the pentagon drawn in it with its progressions of 18°, the resultant intersections will disclose the harmony.

The spirals of 1 + 3 and 2 + 3 classes are drawn from the point *D* in Plate 65 and are analyzed in Plate 69, where it is disclosed that they are escribed by two rectangles of the Egyptian triangle of 38° 30′ and 51° 30′ which are the diagonals of the main rectangle. If a circle is inscribed in the upper and lower lines of this rectangle, and the regular progression of 51° 30′ is produced, as at the points *E*, they will bear a ratio to each other of 5 + 8 in each succeeding pair. It naturally follows that the pentagon is harmonic in many particulars with the above spirals, as its progressions of the angle of 18° produces, as we have before seen, the series of five plus eight in each pair of circles as described in the Chapter on the Pentagon.

<hr>

[1] The editor understands perfectly that a logarithmic spiral is one which intersects all radii vector *at the same angle*, and that therefore this angle must in reality be a constant and not a variable or alternating one, as it would seem to be if viewed only from the perpendicular. For further explanation, see Appendix, Note L, on spirals.—EDITOR.

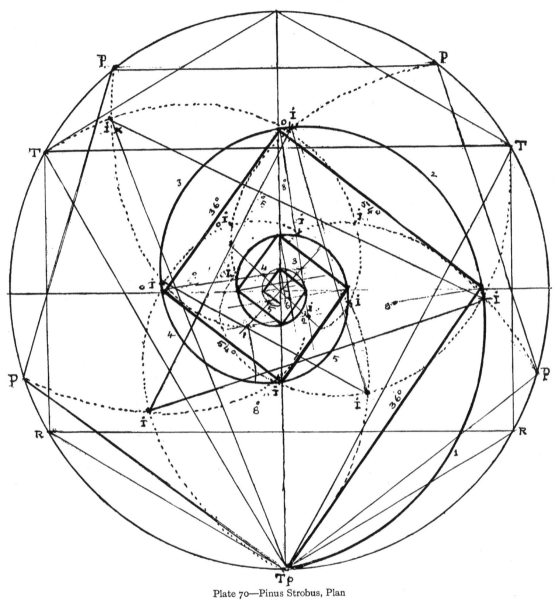

Plate 70—Pinus Strobus, Plan

97

The other spirals as described in Plate 65 are not analyzed, as these are enough to show the geometric principle controlling all logarithmic spirals, and these examples will presently be applied to various forms in Nature, but before doing so two of Professor Church's diagrams will be presented. Plate 69A shows the symmetrical construction of the true pentamary representing the principle observed in many flowers of the *Dicotyledon* family, and differs from the ones heretofore examined in that both spirals are of equal curvature.

Plate 71—Pinus Strobus

The most interesting form of a symmetrical phyllotaxis and perhaps the most beautiful is to be found in the family of the *Coniferæ*, some examples of which will now be produced. If one is so fortunate as to find himself on a summer's day in a pine forest with his mind awake, he will soon recognize that other delights besides the beauty of the trees and the aromatic odors are in the air which will appeal to him, for the testimony of the fruit or seed-vessels scattered over the ground discloses numerous points for consideration which will soon absorb the student. If he find a cone with two turns to the long spiral enclosing the seed he may be absolutely sure that the short spiral passing in the opposite direction will have three turns; or if it be one of three long spirals passing to the right, he will know that five short spirals pass to the left; and these numbers characterize many of the Fir-tree family. On examination of a cone of the Pine-tree family with five turns of the spiral passing one way he may rest assured that the opposite long spiral will have eight turns, and so on to 8:13 which is the highest number I have ever found among the *Coniferæ*. The only exception to the above rules is that the student may find on examination that he has counted the spiral of the higher number first, in which case the ratios as expressed will be inverted.

We will commence our examination with the 3 + 5 order which develops the cone of the "white pine" or *Pinus strobus* as in Plates 70 and 71. The former renders the general plan with spirals of the 1 + 1 and 1 + 2 classes, and in this case a given circle must be divided by three and five equal parts, the triangle of 60° appearing on the former and the pentagon on the latter. The spiral of 1 + 1 and 1 + 2 now pinned (as before described) to the centre of the plan and its arcs drawn, the long one on the division by three, and the short one on those by five, the intersections of the spirals will render the proportions of the seed-vessels as they continue towards the centre, the ideal angle of 42° / 48° passing from the intersecting points of these throughout their

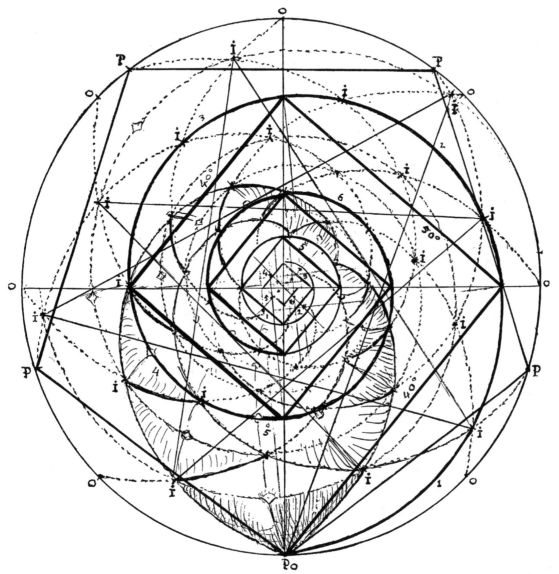

Plate 72—Yellow Pine, Plan

99

diminishing spaces, as at the points I.[1] A secondary spiral, with constant quadrant chords which from the vertical position appear as 36° / 54° of the pentagon produced from the pole TP, will pass from point to point of the quadrant vectors of the primary circle, while the similar quadrant arcs of 36° / 54° will continue through the intersections of the spirals $1 + 1$ and $1 + 2$.[2] Plate 71 represents the base of the cone drawn from Nature.

The 5 + 8 system is illustrated in Plate 72, the proportions of which are decided by the spirals of $1 + 3$ and $2 + 3$ (as in Plate 69) illustrating the cone of yellow pine.

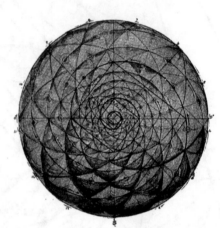

Plate 73—Yellow Pine Plate 74—Oregon Pine

The intersections will render the secondary spiral with constant quadrant chords which viewed from the vertical are of 40° / 50°, passing through the points I of the ideal angle.[3] Plate 73 is taken from a cone of yellow pine, drawn from Nature, which discloses the proportions of the progressing spaces in the seed-vessels as seen from the under side of the cone. In this example small pits, enclosing horn-like projections, occur near the centre of the seed-vessels, and these pits are all intersected by the secondary spiral of 40° / 50°; but if these spiral arcs are repeated as in diagram A as shown by dotted lines all of the pits in the cone will be intersected by them.

This principle is more clearly disclosed in Plate 74, illustrating the base of the cone

[1] In order to prove these statements, a spiral of $1 + 1$ and $1 + 2$ should be cut out of stiff paper from the example in Plate 68 and pinned to the centre of the plan through the centre of its quadrant vectors as above described.

[2] See Appendix, Note L, on spirals, which note will be more clearly understood with the aid of the Diagram 70. —EDITOR.

[3] *Ibid.*

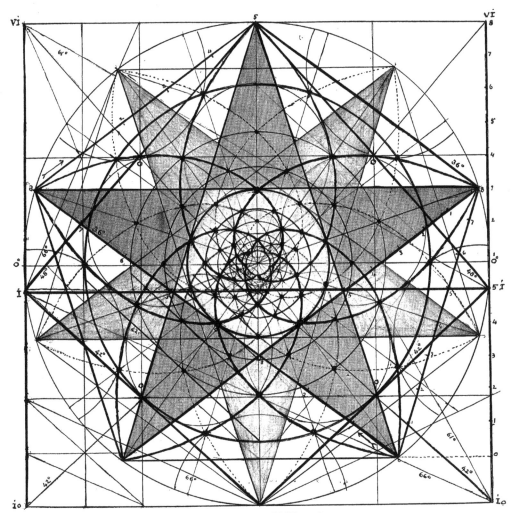

Plate 75—Plan of Milkweed

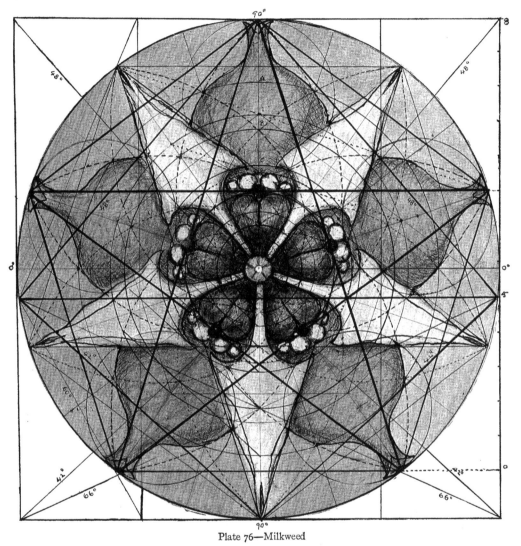

Plate 76—Milkweed

of Oregon yellow pine of the 8:13 order, developed by the pair of spirals of the 1 + 1 and 1 + 2 class, and as this is the same as described in *Pinus Strobus*, a diagram of its construction is omitted. It may be stated that the action of the secondary spiral of 36° / 54° passes through all of its pits by repeating their numbers, as on the arrows. As all the cones of the pine- and fir-tree family, with their various species, are to be represented by slight modifications of the above principles, these examples must suffice for want of space to illustrate the others.

It may here be noted that among the many interesting things revealed by the pine cone is the fact the the seed-vessels, or the shells enclosing them, are related in extreme and mean proportion which occurs in each pair as they diminish in size towards the centre, either in length to their width, or length to width of one of the sides; in some examples, however, the comparison is one between the length of a seed-vessel and the length of the next in order, either of those on the same spiral or the one immediately over it.

We will now turn to the spiral principle in flowers commencing with one of the Asclepias or milkweed family which are among the most symmetrical. One form of milkweed is illustrated in Plate 75, and being pentamerous the cut-out symmetrical spiral of 5:5 is pinned to the centre of the plan and the spirals drawn from the five sides of the pentagon as shown in the diagram. Circles struck to pass through the intersections of the spirals will be on the progressions of 42° of the ideal angle, which angle is harmonic with the entire plan, as described in the Chapter on the Pentagon. The angle of 42°, ruled from the lower pole of the primary circle to *I*, will be on the first circle of these progressions and its horizontal side will be on the points *I*, dividing four of the five pentagrams at their intersections in the lower quadrant and enclosing the plan of the flower in the two rectangles of 42° and 48° at the points *i*, *i*, and *io* and *vi*, which will produce four rectangles with diagonals of 66° and four of the same proportions in the upper quadrant, or one of 66° in the lower and one of 61° in the upper quadrant. Extreme and mean proportion now occur at numerous points throughout the plan as described in Plate 6.

In this diagram the blossom of the milkweed can now be produced correctly as illustrated in Plate 76, and another flower of the milkweed family is drawn in Plate 77 to which the same principles may be applied as before. The tiny blossom of henbane (Plate 78) has its proportions developed in a similar manner, united to the progressions of the angle of 18° of the pentagon which renders some of the spaces. As before stated, all pentamerous forms must be thus harmonious, since every progressing circle of the angle of 18° bears extreme and mean ratio to each succeeding one. The beautiful blossom of Parnassia is drawn in Plates 79 and 80; the former represents the upper surface of the flower disclosing that its proportional spaces are developed by the angle of 18° on its progressing circles, while the latter renders its under side with its five sepals and their pentagonal base.

We will now examine flowers numbered by six, such as the lily family; and Plate 81 represents the proportions of the jonquil. This is divided, in its general form, by the

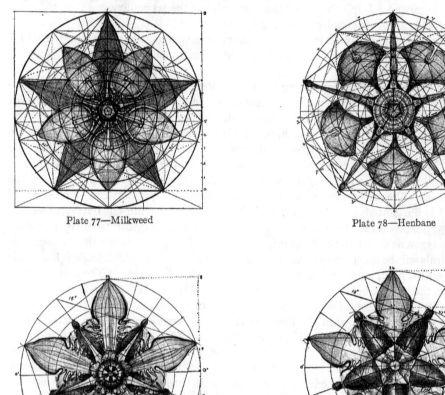

Plate 77—Milkweed

Plate 78—Henbane

Plate 79—Parnassia

Plate 80—Parnassia

angle of 60° and if a cut-out spiral of 1+1 (as drawn from *B* in Plate 65) is pinned to the centre of the plan, its arcs will intersect each other on the circles of the progression of the angle of 60° and on the diagonals of 30° / 60°, and these render its proportions; the primary circle places the extremities of the yellow petals, the circle of the first progression, the trumpet-shaped corolla; the circles of the second progression, the diameter

of the tube; the third, the diameter of the base of the tube; while the fourth escribes the three-lobed stigma of the pistil.

Plate 82 is drawn from a tiger lily, and here also the equilateral triangle renders its

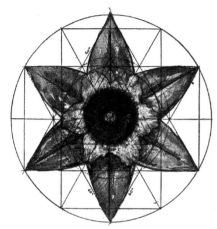

Plate 81—Jonquil

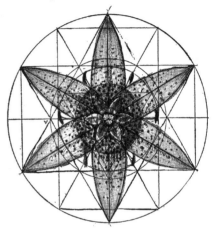

Plate 82—Tiger Lily

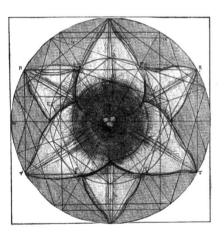

Plate 83—Easter Lily

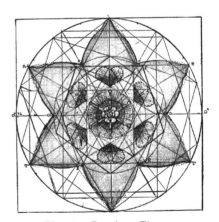

Plate 84—Zygadenus Elegans

proportional spaces, either by its regular or its secant progression, the central tube coming on the inner circle, the smallest circle places the diameter of the three-lobed stigma, while the length of the stamens and their anthers is decided by the circle of the first progression of 60°. The curves of its six petals are developed by the spirals of 2 + 6

as at the left of D in Plate 65, the arcs of which intersect each other on the circles of the secant progression of 60°; and here also the inner circle renders the size of the three-lobed stigma.

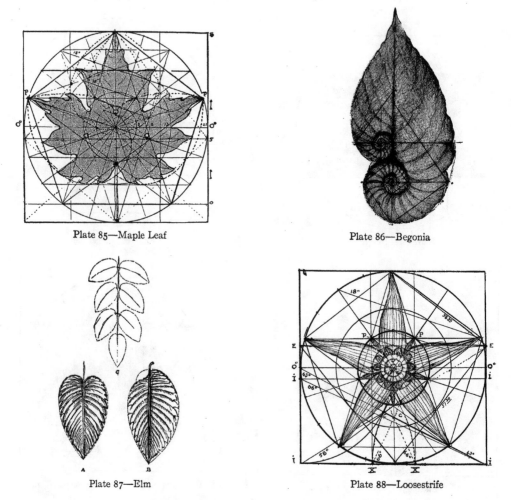

Plate 85—Maple Leaf Plate 86—Begonia

Plate 87—Elm Plate 88—Loosestrife

In Plate 83 an Easter lily is drawn, the same angles as in those just described producing its chief spaces, while the spiral arcs of $5 + 6$ render the curves of its petals which intersect each other at the points o on the circles of the progression of 18° of the pentagon. As before stated, the first circle A produces the pentagon on the horizontal

sides of the rectangle of 60° as at *P. R.* The same general plan may be applied to Plate 84 representing *Zygadenus elegans*.

A few examples of leaves will now be presented, which are under the influence of

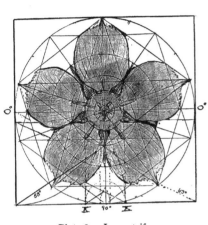

Plate 89—Loosestrife

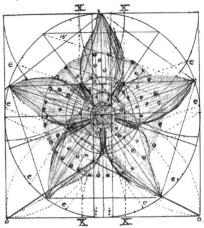

Plate 90—Hypericum

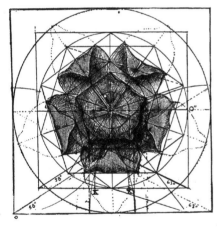

Plate 91—Sarracenia Purpurea

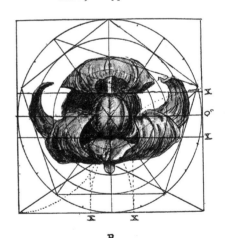

B

Plate 92—Sarracenia Purpurea

the same principles. The leaf of one of the maple family is described in Plate 85. This species has five lobes and a tracing of it from Nature will just be inscribed in a pentagon, while the progressions of its angle of 18° will produce a series of circles which will inter-

sect some of its proportional spaces. If two spirals of $1+2$ and $1+3$ are traced from the upper poles of the outer circle, their arcs will intersect other points. If the asymmetrical

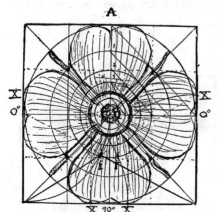

A

spiral is placed at the points P on the upper angle of $36°$, one arc passing to the left and one to the right, they will escribe other points of the leaf as well; while the pentagram drawn from the upper pole will pass tangentally to others. This species of maple is characterized by three light circular spots on most of its leaves, and these always come on the angles of the Pythagorean triangle.

The leaf of the begonia family called the snail, on account of the decided resemblance to that mollusc, is drawn in Plate 86, where it may be seen that the spiral curves of $36°/54°$ describe its proportions. These arcs remain equiangular in the earlier passages of the leaf, or from the points o in the large spiral and from the points a in the lesser side (to the left). From the lower points o and a

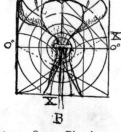

B

Plate 93—Onagra Biennis

they change to the angle of $18°$ and $72°$ of the pentagon. The cause of this change, which is apparent in many leaves, as well as in shells, is not yet understood, but it may be the result of a more or less vigorous growth.

A spray or termination of a branch of one of the elm family is illustrated in Plate 87, diagrams A, B, and C. The leaf at A usually found on the termination of a branch is inscribed in the symmetrical spiral of $5 + 5$; that drawn at B is inscribed in the asymmetrical spiral of $3 + 5$; and a part of a spray of leaves is rendered at C, disclosing the above combination.

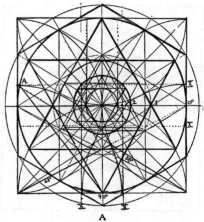

A

Plate 94—Lily, Analysis

The perfect blossom of *Lysimachia stricta* of loosestrife is drawn in Plate 88 where it will be seen that two of the five sepals at the points P produce extreme and mean ratio on the square at the point X. All of the other sepals would do the same were each in

the same position with relation to the diagram. If the ideal angle is introduced as shown, it will measure the anthers by a circle escribing them, and a similar perfection of proportion is shown in Plate 89 representing another example of the loosestrife family. Plate 90 represents the blossom of *Hypericum perforatum*, the numerous pistils of which are distributed over the space included in the circle of the first progression of the pentagon where the anthers are shown by small round spots. The width of the petals is decided by the lines dividing the base into extreme and mean ratio.[1]

Two views of the blossom *Sarracenia purpurea* or pitcher plant are represented in Plates 91 and 92. The former is a drawing from the face or full view of the flower where the umbrella-shaped top of the pistil is in the form of the pentagon, as escribed on the second progression, the five petals more or less over-arching it. The central circle is of the size of the receptacle under the pistil, and divides the pentagon related to the pistils into extreme and mean ratio. If these petals are rolled out to their full length, as in the dotted lines, they will be found to be inscribed in a circle related to the sides of the pistils by the same ratio.[1] Plate 92 renders the side view of the same plant, disclosing the receptacle, the style, and the pistil in their relation to the petals.

A flower divided by four, *Onagra biennis*, is shown in Plate 93, diagrams *A* and *B*. These will sufficiently explain themselves when it is understood that the equilateral triangle, drawn in the circle of the third progression of the square, cuts the point *X* producing the circle enclosing the receptacle of the flower and indicating its position on the lines of extreme and mean ratio.[1]

Another example of a flower numbered by six, or with six petals as the common lily, is drawn in Plates 94 and 95. The plan of the flower is given in the former, as it differs from many in that it is based upon the secant progression of the hexagon which here exercises a controlling influence, instead of the regular progression of the equilateral triangle. The flower has three wide petals and three narrow ones, the latter being also shorter, as drawn from Nature in Plate 95 where it will be seen that the wide petals divide the entire width of the blossom on the lines of extreme and mean proportion.[1]

The blossom *Rudbeckia hirta* is drawn in Plate 96 as it is a characteristic example of many families of plants. In a large number of these the capitulum bears a relation in width to the length of the petals of extreme and mean proportion. This feature is not persistent, however, as Rudbeckia varies considerably in its spaces like many of the ray or composite family. The example illustrated was picked at random and may be taken to represent the average blossom, and in the diagram will be recognized the lines of the angles of 58° and 63° together with the points *X* indicating extreme and mean -ratio,[1]

[1] Sufficiently accurate for purposes of design. It is always more or less improbable, however, that the mathematically perfect extreme and mean proportion will be found directly associated with progressions of the square or equilateral triangle. See Appendix, Note A.—EDITOR.

and measuring between them the width of the capitulum, and it will be noted that the width of the petals is determined by the ideal angle as at the points *C*.

I have referred repeatedly to the use of the great triangles of Nature and their rectangles as they are utilized by her and copied by man in his works, and this chapter cannot be more fittingly concluded than by illuminating the subject with illustrations taken from the various nut forms of fruition. These I have reserved for this especial purpose since they so adequately summarize the principle, being always escribed by a rectangle

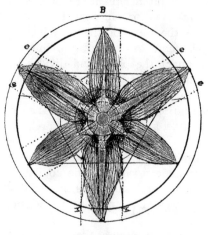

Plate 95—Lily

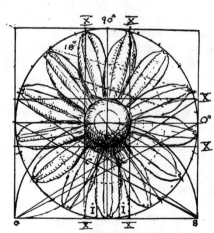

Plate 96—Rudbeckia

either that of the pentagon, the equilateral triangle, the Egyptian triangle, or of the ideal angle. Plate 97, diagrams *A* to *L*, represents a series of these forms, taken from drawings measured from Nature. Diagram *A* shows a front view of the ground nut, where the double rectangle of 36° escribes the form with the diagonals of the Pythagorean triangle, while *B* represents the side view which is inscribed in the rectangle of 42° of the ideal angle with its diagonals of 66° or in the same proportions as the ground plan of the Parthenon. Diagram *C* is drawn from one of the species of the hazelnut family, of the long and narrow kind. This is the front view enclosed in a double rectangle of 54°. Diagram *D* is the side view of the same nut which is inscribed in the rectangle of 30° / 60°, or the rectangle escribing the portico of the Parthenon. Diagram *E* was taken from the front view of the pecan which is inscribed in the rectangle of 5+8, or 51° 30′ of the Egyptian triangle, while *F* is the side view of the same nut with diagonals of 30° / 60°. Diagram *G* represents the side view of the almond which is inscribed in a double rectangle of 63°, and diagram *H* is drawn from the front view of the same nut, escribed by two squares, each with the diagonal of 45°. The English walnut is rendered with its front

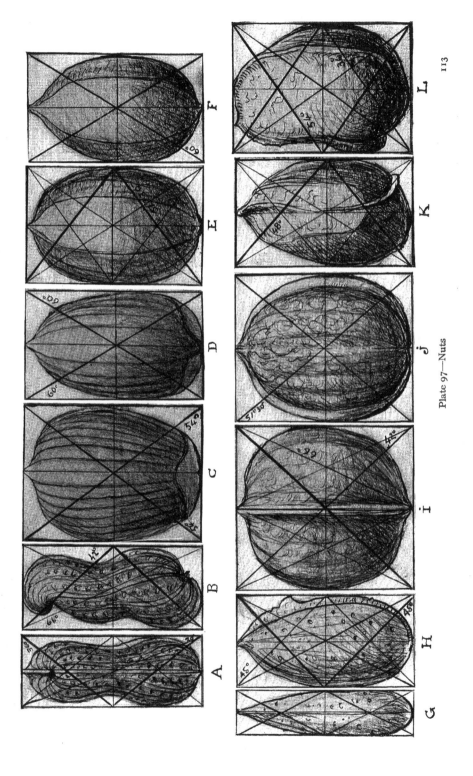

Plate 97—Nuts

113

view in diagram I and inscribed in two rectangles of 42° of the ideal angle side by side, with the diagonal of 66° or twice the width of the groundnut at B; its side view is inscribed in two rectangles of 51° 30′ as in diagram J. Another nut is rendered by its side view in diagram K inscribed in two rectangles of 48° of the ideal angle with the diameter of 61°, while the front view derives its proportions from the familiar rectangle of 54°. Many of these nuts of the same species somewhat vary in their proportions, some being a little wider in relation to their length while others are the reverse. These, however, are the exceptions which "prove the rule," for the large majority are like the above diagrams. It must be remembered that such variations occur in everything in Nature, the majority conforming to the law.

The examples of the laws above described are almost infinite in Nature, revealing their presence in a more or less modified form, but as my object is to impress the principles of proportional form rather than the study of botany alone, I wish to reveal as much as possible of many different natural phenomena and will now proceed to apply the above principles to the examination of shells.

CHAPTER IX

ON CONCHOLOGY

AMONG all the enchanting things in the realm of beauty, the shell is one of the most perfect as a representative form of spiral construction and the one where the spiral is most obvious to the casual eye, at once announcing itself a geometric product. That the Greeks studied the shell from the standpoint of the architect and designer may be proven by ample evidence: they were largely a seafaring race and the rare shells their sailors brought back from distant lands must have attracted the attention of artists and students of beauty in those days as they have in

many subsequent periods. We know that the Greek artists created from lines of the shell most beautiful things many of which can never be improved upon for they were constructed under the influence of fundamental laws of Nature. Of

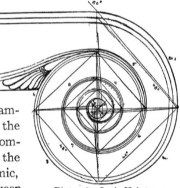

Plate 98—Ionic Volute

these the Ionic volute is perhaps the most perfect example (see Plate 98). That this was designed under the influence of geometric principles is shown by the compass marks still in evidence on marble fragments of the period and also by the fact that its spiral is logarithmic, a principle which could not have escaped their keen eyes; and seeing as they did, that this form can be naturally correlated with other parts they set aside the non-equiangular spiral which can have little harmonic unity. That the shell is the source of the Ionic volute is emphasized by the fact that in this volute the equiangular spiral ceases at the last turn where the curve passes into the horizontal lines of the capital, corresponding to the last turn in the spiral of many shells always equiangular to that point, as described in relation to the begonia, and as will presently be seen in the shell of the nautilus family. We also know that the echinus of the Doric capital was taken from the curve of the sea-urchin, hence its name.

While investigating the principle of proportion as represented in shells one cannot fail to be impressed by the architectonic laws which govern them and which are constantly in evidence, [1] as well as by the fact that they are under the influence of the law of

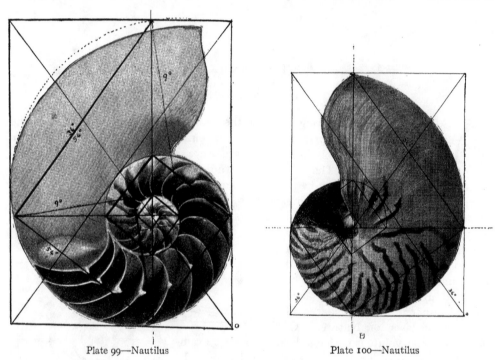

Plate 99—Nautilus Plate 100—Nautilus

numbers in a similar way that the proportions of plants are controlled, and for the same reasons. A plant is numbered by the geometric figure which renders its general form, influencing the division of its petals, stamens, and pistils; shells receive their distinguishing number from the turns in their spirals, generally six, but sometimes running from three to fifteen according to the family. The number of ribs and horns which decorate many shells is also decided by the intersecting lines of their spiral arcs and the geometric plan. Moreover the logarithmic spiral is manifested in their construction as continually and as perfectly as in plants, while pentagonal influence is just as frequently in evidence: and although, excepting the star-fish family, shells are rarely in the actual form of the

[1] Mr. T. A. Cook, in his excellent book entitled *Spirals in Nature and Art*, declares that: "If any particular class of natural objects should be chosen by a student for purposes of study in relation to so mathematical and creative an art as architecture, the class of shells would be most suitable inasmuch as they suggest with particular emphasis those structural and mathematical problems the builder has to face."

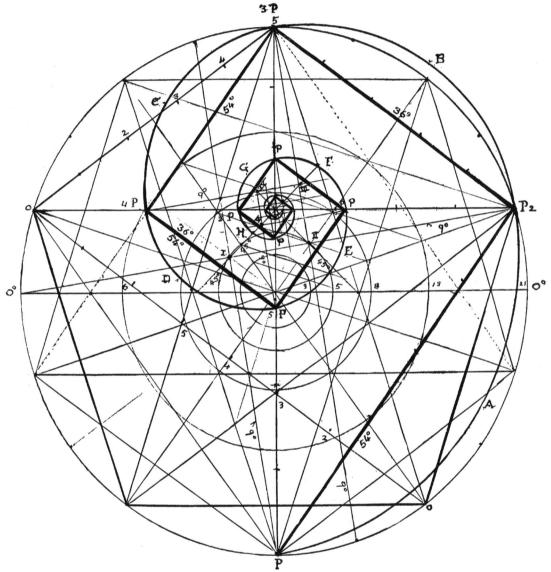

Plate 101—Spiral of Nautilus

117

pentagon, still that figure exerts a strong influence in many, and it is most apparent in the nautilus. In many shells the hexagon and octagon appear to have an almost equal power, while in all families of turbinated shells the ideal angle is ever present.

In the American Museum of Natural History, which contains one of the finest collections of shells in existence, there is an example of *Nautilus pompilius* sawed through its axis, the parts being approximately flat. A photograph renders its divisions with a sufficient degree of accuracy for a reliable analysis, and in this example (Plate 99) the entire spiral is exposed and the inner subdivisions revealed. An examination discloses that its spiral chords are equiangular excepting in the last turn when old age or some other cause has diminished the force of the creature inhabiting the shell. This may be only an accident, however, as other members of the species are equiangular throughout as in Plate 100, which is also a photograph from Nature. This illustration discloses the fact that the general form is inscribed in the rectangle of the Pythagorean triangle.

An examination of Plate 101 will disclose how complete is the unity of *Nautilus pompilius* with the pentagon, for each one of the quadrant chords passing from *1p*, *2p*, *3p*, and so on will be the hypothenuse of a right-angled triangle, the two legs of which are the quadrant vectors; the legs have, in the instance under examination, within a minute variation, the measurements following: the shorter one measuring three parts, the longer leg four parts, and the hypothenuse five parts. The entire curve of the spiral, by quadrant points, therefore, is thus formed by these triangles lying side by side, the four units of any triangle becoming in each case the three units of the succeeding one, and it will be remembered that these are the recognized proportions of one form of the Pythagorean triangle; to wit, that of three, four, and five parts, which triangle is in a sense a fundamental part of the pentagon.[1] If the pentagon itself be inscribed in the primary circle, together with its angle of 18° and its pentagrams, the resultant circles will be found harmonic with the spiral, while the angles of 18° will divide the plan into the circles showing the series $3 : 5 : 8 : 13 : 21$ etc., as explained, and carrying the idea of the Divine Section throughout. The angle of 9° of the pentagon, which is one half of the harmonic angle of 18° and therefore itself harmonic, ruled from the intersections of the quadrant chords with the spiral at the points *p* will result in lines that intersect the angle of 45° passing through the centre of the plan as at the points *I*, *II*, *III*, *IV*, and *V* and greatly assist us in constructing the spiral curve. If *I–A* is taken as a radius, and *I* as the centre then the arc of the spiral, passing from *1P* to *2P* will result; then continuing with *II* as a centre and *II–B* as a radius will give the arc from *2P* to *3P* and so on; for the angles of 36° and 45° are related to each other as the sum and difference of 45° and 9° ($45° + 9° = 54°$ while $45° - 9° = 36°$). The same principle may be employed for the production of the approximately true curve in the arc of all of the spirals illustrated in

[1] See Appendix, Note F, on the Pythagorean triangle.—EDITOR.

these figures.[1] This principle will be further described when we come to the spirals of other shells.

An analysis of another example of the same species of *Nautilus pompilius* will be found at Plate 102 where the spiral was equiangular throughout. In this case the exact shape of the outline was cut out of cardboard and pinned to the centre of the circle and as it was revolved around this centre, its outline was traced at equidistant points on the circle. The fact is shown that this spiral repeats itself within the circle throughout its course to the centre, and as this shell is faintly corrugated the corrugations come on these parallel curves as is the case in other species described in *Haliotis corrugata*.

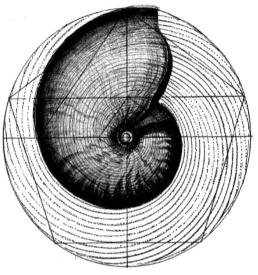

Plate 102—Shell Markings

In order to truly appreciate the wonderful harmony of Nautilus and its relations to the pentagon, the following analysis of its symmetry is presented in Plate 103. This may be described by first drawing the quadrant vectors of the spiral and quadrant chords, the latter on the continuing angle of 54° (being of course alternately 36° and 54° from the perpendicular), then from the intersections of these chords and vectors (as at *V*) as centres and with a radius equal to the distances from the respective intersections to the focus of the configuration, circles may be struck which will pass tangentally to the horizontal or vertical vectors; continuing in like manner with *V*, *V*, *V* as centres the series of circles may be produced, the whole being found to be escribed in a double rectangle of 51° 30′.[2]

If in these circles, the pentagon is drawn with its apex at the centre of the plan, and repeated at the opposite pole, then the second angle of the pentagon in one circle will rest on the second angle of the inverted pentagon in the next smaller circle throughout the series as at the points *O*; or if the angle of 54° from the horizontal be drawn from the pole of one circle to the pole of the next smaller circle, as from *A* to *B* and continued thus from pole to pole of all the circles, it will intersect each pair of circles in succession. If the pentagram is drawn in one circle with its apex at the centre of the plan, and pro-

[1] For details as to producing spiral curves see Appendix, Note L.—EDITOR.

[2] This system of producing the plan of symmetry in shells was suggested to me by Mr. J. Hambidge.

duced beyond it, it will place the pentagram in the opposite or third circle in succession. This of itself is of small moment, since it would do this however large or small these circles were, but its lines intersect the others at harmonic points, and this it would not do unless they were in unity; furthermore, if the sides of the various pentagons are pro-duced across the plan they will be found to intersect numerous other lines at vital places (see dotted lines).

The harmony of the curves of Nautilus with the hexagon or its triangle of 60° is also worth noting, for if the triangle is drawn from the left-hand pole of the largest circle at t, then its side in a vertical position tt produced will continue through the circles of the fourth of the series to O, cutting corner of the pentagon in the fourth circle approxi-mately on the line of its pentagram; while the lower side of the angle of 60° will pass tangentally to the arc of the next smaller circle of the series and produced beyond T will pass to the pole of the fourth circle at d, which principle may be repeated through-out the progressions. Whatever variation may be found in these measurements comes within the error of observation. If the square is drawn in any one of the circles, its inner horizontal side will rest approximately on the second intersection of quadrant chords and vectors of the spiral at its second turn at V or as in the largest circle at the point $S\,V\,S$. It follows of course that the circle of the first progression of the square will pass through V, but that of the second, while passing tangent to that of the triangle of 60°, will have its inner arc resting on the first progression of the square in the fifth circle and that of the fourth progression with its centre on A will be of the same dimen-sions as that of the third progression in the second circle with its centre on B, the same correlation continuing throughout the plan. The triangle of 60°, as has already been described, finds its regular progression on every second one of the square and is therefore harmonic with Nautilus. We have already seen that in many ways the pentagon is an integral part of this correlation, and it naturally follows that further examination would disclose further unities, but it would require a very much larger diagram to describe this with accuracy. (See note on page 127.)

This unity of Nautilus, with the Trinity of polyhedra and their geometric correlations, characterizes all equiangular shells, though of course in different combinations, and many others of these will presently be presented.

The symmetry of the shell *Haliotis corrugata* is drawn in Plate 104 revealing that here also the pentagon is strongly in evidence, for the quadrant chords are on the angle of 63° presenting alternately an angle of apparently 27° from the perpendicular, and these angles of 27° and 63° are the harmonic sum and difference of the pentagonal angles of 36° / 54° and 9°, as 36° − 9° = 27° while 54° + 9° = 63°. The side of the pentagon in one circle produced will pass to the intersection of the quadrant chords and vectors as from O to V and so on, dividing the side of the pentagon in the next smaller circle and its arc at A. Innumerable other examples could be cited were it necessary. The

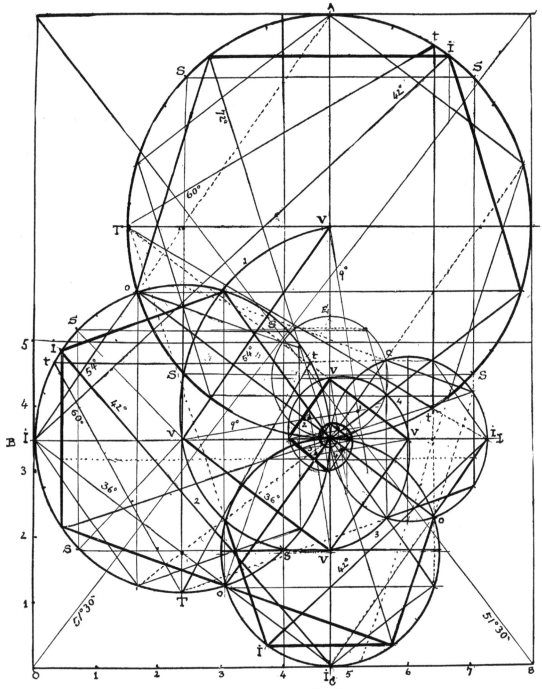

Plate 103—Symmetry of Nautilus

triangle of 60° drawn in the larger circle with its apex at the pole E will find its base line T if produced, passing through the centre of the next smaller circle and intersecting the quadrant chord at V, doing likewise in all of the following circles. The square S

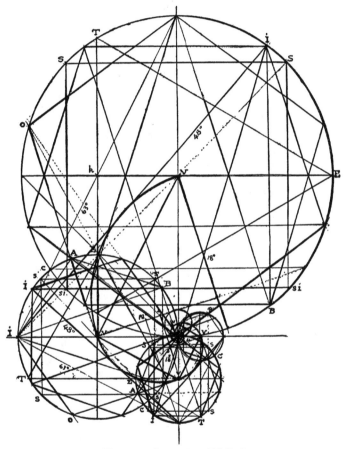

Plate 104—Symmetry of Haliotis

in one circle will have the centre of its diagonals on the chord V as a matter of course, but if they are produced they will intersect two of the poles in the next smaller circle at E and I; the side SI produced will pass through the next smaller circle at BI on the side of the ideal angle triangle cutting the corners of the pentagon in its course. If the side of the ideal angle be ruled from the corners of the two pentagons in one circle at iB, its

opposite side will pass to the pole of the next smaller circle as at *ii* continuing tangent to the arcs of the spiral at similar points throughout. (See note on page 125.)

The same shell is drawn in Plate 105 showing its corrugations. If a spiral of 27°/63° is cut out of stiff paper and fixed to the centre of the movement by a pin and revolved around this centre describing the arcs from fixed points, then the proportions of the corrugations passing in this direction will be produced; if the spiral plan is then removed

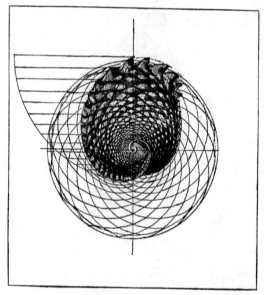

Plate 105—Haliotis Corrugata

and again pinned to the same point in a reversed position and the process repeated, the proportions of the corrugation passing in the opposite way may be rendered. Each of the lines will now repeat the shape of the shell throughout. This principle applies to all shells produced on logarithmic spirals, and was discovered by Canon Moseley about 1830. Relative to turbinated shells one author writes: "By cutting any part of a turbinated shell in the direction of the plane of its axis every section will result in a form exactly similar to the form in the operculum, for the form of a turbinated shell is produced by the revolution of the perimeter of the figure formed by the operculum round the axis of the shell. In the Nautilus this figure is an ellipse which revolves around its minor axis and increases in geometric progression without ever changing its form as it revolves."[1] This truth discovered so long ago will be found in evidence in several examples of shells herein presented, revealing that the logarithmic spiral has a peculiar property of its own which constitutes a convenient measure for the shell throughout its parts. Professor Church considers this to be "the manifestation of a law always at work for the increase of the various organic bodies of vegetable life," and the same rule holds good in shell formation. An examination of Plate 106, representing a shell of the *Murex* family with six turns to the spiral, will disclose the truth of the above statements, for at the point of each of the horns or the projections, the shell repeats itself in all of its proportional parts until towards the centre the hexagon with six sides takes the place of the spiral. In the Chapter on Botany it was stated that "shells are governed by the same laws controlling plants," and the various diagrams in that chapter should therefore be re-examined in

[1] *Spirals in Nature and Art*, T. A. Cook.

order to appreciate the truth of these words. The same principle is now repeated in the plan of Murex by dividing a given circle into eight and thirteen equal parts, then the short spiral of the 3 + 5 class is described on the division of thirteen, and the long spiral of the pair on the divisions of eight. The two spirals will now intersect each other at the dark points of the series, and through every other one of these a secondary spiral may be produced, the quadrant chords of which will be on the constant angle of 42°, representing as before described the alternate angles of 42° / 48° of the ideal angle when viewed from the vertical.[1] This is the true spiral of the shell, the arcs of which will just enclose the projecting horns throughout the progression, and a similar spiral drawn within the first one will render the arcs of the shell itself. The surface of the shell is decorated with rippled lines, or corrugations passing towards the centre, while another set follows the curves of the spiral: the former set comes on the arcs of the short spiral of 3+5 seated on the thirteen points of the primary circle. These arcs also follow the curves of the various horns of the shell throughout the series. In the Chapter on Botany it was described how the ideal angle oscillates from point to point of the intersecting arcs of the spiral of 2+3 or 3+5, so in this case the angle of 42°/48° passes from horn to horn of the series. Only a few of these lines are drawn but they can be continued to the very end.

The profile or side view of Murex is rendered in Plate 107, where the influence of the regular progression of the ideal angle may be recognized. If the angle of the shell, whatever it be, is ruled from the points where its progressing circles cut the horizontal line it will pass tangentally to the arcs of these circles and produce the inclination of each turn of the spiral.

The method of producing the spiral of the perspective of this shell, which is measured by the ideal angle, is drawn in Plate 108. Having first drawn the quadrant chords on the constant angle of 48° from the radius, or measured from the perpendicular the alternating angles of 42° / 48°, then the angle of 3° ruled from the intersections of these chords with the quadrant vectors (or from A, B, C, etc.) will cut the minor angle of 45° drawn across the centre of oscillation at 1, 2, 3, 4, etc. A to 1 will now be the radius for the quadrant arc A, B; then with 2 as a centre and B as a radius the arc B, C, may be described, and so on; for $42° + 3 = 45°$, $45° + 3 = 48°$. These angles of 3° must be ruled to the angle of 45° crossing the centre of the plan. All the great spirals or volutes in natural forms can be produced by this method, and as they are all equiangular they should be the ones employed in art. The spirals of Nature are few in number, generally produced by the angles of 36°, 40°, and 38° 30′. This plan will now disclose the fact that the shell is inclosed in two rectangles of 42° vertically placed with diagonals of 66° on the line S.

The symmetry of shells similar to Murex[1] is described in Plate 109 where the apex of the pentagon is placed at the upper pole of the larger circle, and by producing its

[1] See editor's Note L on this subject in the Appendix.—EDITOR.

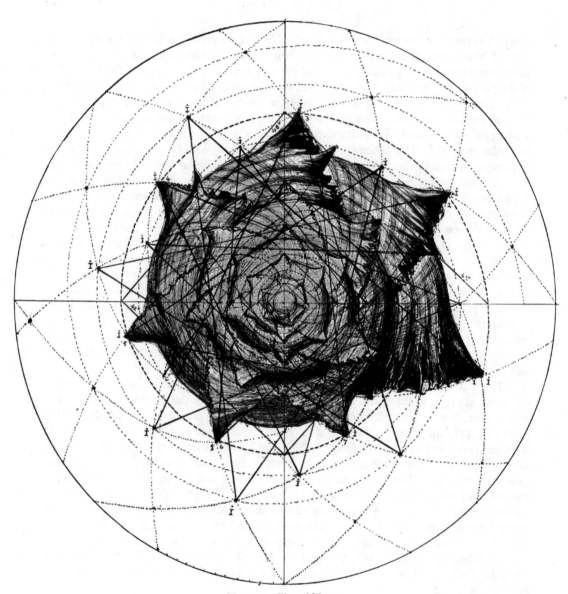

Plate 106—Plan of Murex

126

inclined sides of 72° they will pass to the pole of the third or opposite circle of the series, rendering the pentagram there at p, and this principle can be carried throughout the diagram. Furthermore the line of the diameter of each of the pentagons will rest on the chords and vectors as at p and W. The pentagon may be variously placed in the circles disclosing similar unities, and experiments of this kind may be of interest to the student.[1]

The triangle of 60° is also harmonic with this spiral of the ideal angle, for if it be drawn (Plate 110) from the left hand pole of the largest circle, its vertical side tt pro-

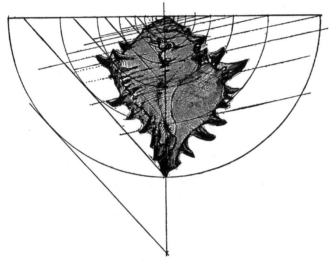

Plate 107—Murex Profile

duced will pass into the pole of the eighth circle of the series, and it will approximately render the diameter of this circle, intersecting the chords and vectors at V, and continuing to do the same throughout the series. One progression of the square (see the dotted circles) will pass tangentally to the first progression in the next smaller circle of the symmetry, and so on, as at the points x, and the circles of the second progression will bisect the vectors, while the angles passing through the centre of the plan will intersect the poles of all of the circles at the centre point as they will do in any example of this system of symmetry of logarithmic spirals, though the intersecting points of the shells may vary.

There are many families of shells which are governed by this same spiral of the ideal angle, a few examples of which are illustrated here, such as the common snail shell of our meadows (Plate 111) and *Xenophora solaris* (Plate 112), the symmetry being the same

[1] For mathematics of these symmetries, see Appendix, Note L, on spirals.—EDITOR.

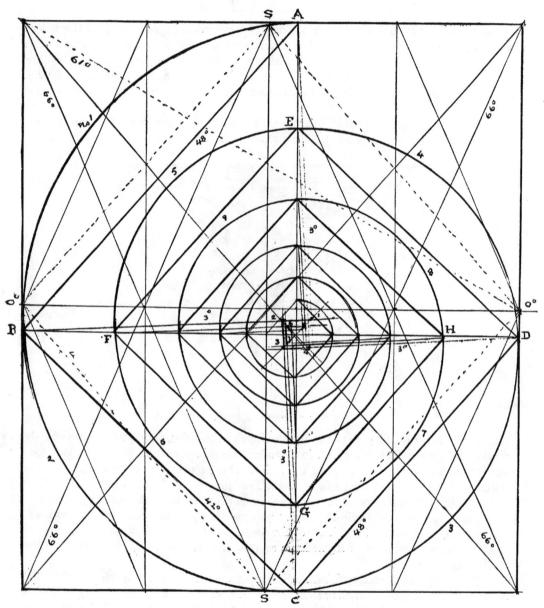

Plate 108—Spiral of Murex

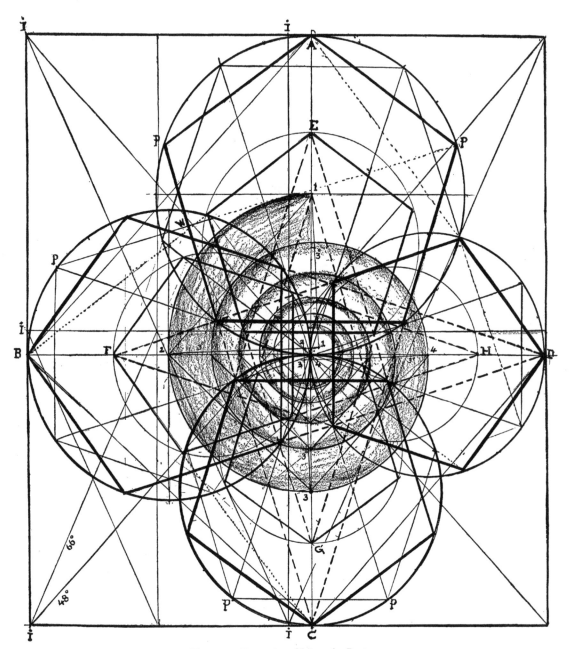

Plate 109—Symmetry of Murex by Pentagon

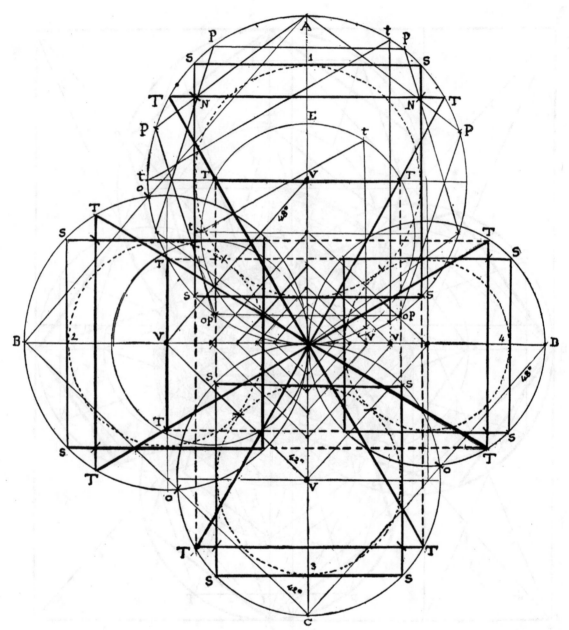

Plate 110—Symmetry of Murex by Square

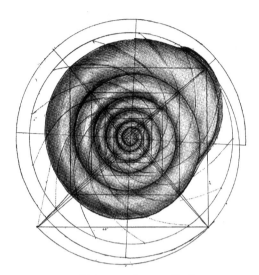

Plate 111—Common Snail

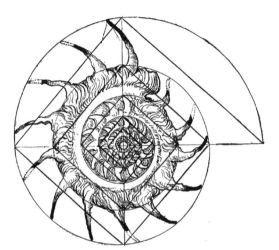

Plate 112—Xenophora Solaris

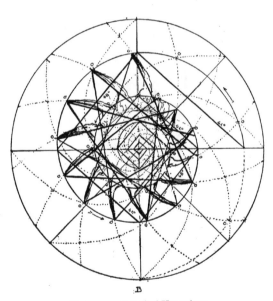

Plate 113—Spiral of Xenophora

131

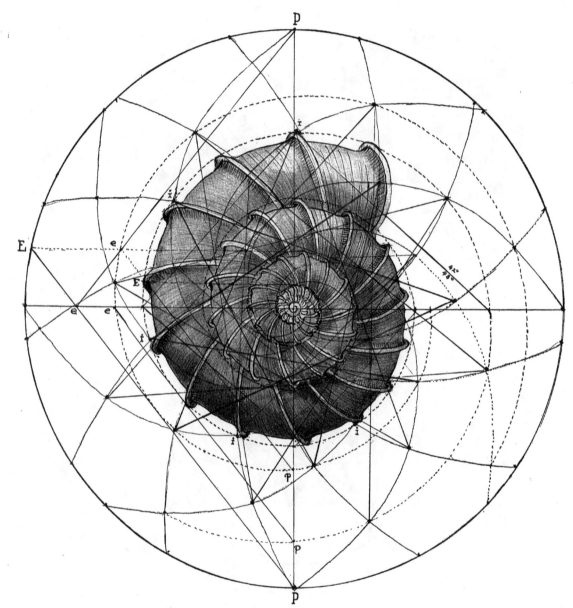

Plate 114—Scalaria Pretiosa

in all of them. The latter is placed in a circle divided by the 8 + 13 order of phyllo-taxis (see Plate 113), with thirteen short spirals and eight long ones of the 3 + 5 form, described from those points, the result being the same as in Murex, the spiral of the ideal angle passing through the intersection of the arcs and quadrant chords on the

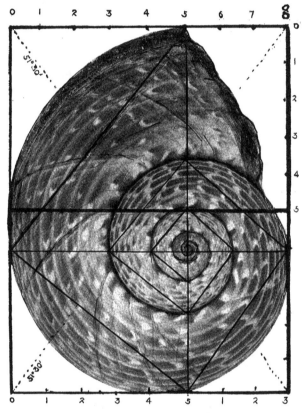

Plate 115—Dolium pendix Linn.

constant angle of 48° or as viewed from the perpendicular, the angle of 42° / 48° pro-ducing the curves of the shell. This species is characterized by thirteen long, curved spines on the arc of the short spiral which renders their proportions, the spines dimin-ishing in size as they approach the centre. It will be seen that the ideal angle oscillates from intersection to intersection or from point to point of the horns as shown previously. The point of each spine will be on the angle of 42° / 48° as at *o*. Unfortunately these spines are so long and frail that I have never seen a Xenophora where several were not

broken, but by the above system all may be accurately restored. It will be readily realized that a system which enables the student to restore the broken parts here would be of equal value to the anthropologist when he seeks to restore proportionately the missing parts of prehistoric creatures, in place of the arbitrary methods which many times obtain. The same system and spiral controlling Xenophora influences in a like

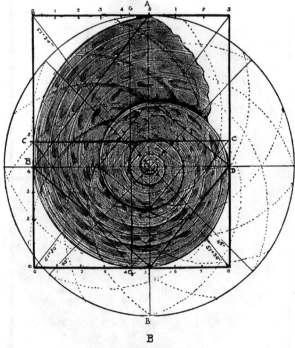

B

Plate 116—Plan of Dolium

manner the beautiful shell *Scalaria pretiosa* (Plate 114), the ideal angle passing from rib to rib of the object.

A photograph of the shell *Dolium pendix Linn* is given in Plate 115, which is especially interesting as it so strongly suggests the profound wisdom of the Egyptian priests in selecting their great triangle of 38° 30′ / 51° 30′ as a measure for the production of proportional spaces in their architecture.[1] An examination of this plate discloses the fact that the quadrant chords of its spiral are on the angle of 38° 30′ presenting, as viewed from the perpendicular, the alternating angles of 38° 30′ and 51° 30′; the

[1] See Appendix, Note E, on the Egyptian triangle.—EDITOR.

outlines of the shell itself being inscribed in two rectangles of 51° 30′. Plate 116 which
is drawn from this photograph is divided (on the turn of the second spiral) on the line
C C of the superimposed rectangles of 5 + 8 and the vertical line *G* into four rectangles
of 51° 30′. If a circle is described from the centre of the shell and divided into eight and

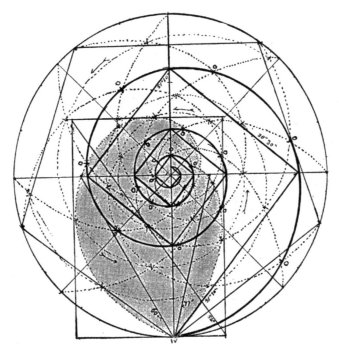

Plate 117—Spirals of Dolium

thirteen parts and the short spiral of the 3 + 5 class described on the divisions of thir-
teen, its arcs will pass through the curved dark markings of the shell.

The correlations of this pair of minor spirals are described in Plate 117, the long one
on the ratio of 1 + 3 and the short one on the ratio of 1 + 1: which pair are placed at
the lower pole of the primary circle, or with their extremities at *W* by dividing the circle
into five and eight equal parts and tracing the long spiral on the divisions by five and
the short spiral on the divisions by eight their arcs will intersect each other at the points
o. If the quadrant chords of Dolium are drawn in succession from *W* towards the centre,
and the quadrant arcs of the main spiral are then drawn, they will also of necessity
pass to the points *o;* the same spiral arcs will also pass through the minor divisions of

the primary pair, as indicated by the arrows. It may be noted in passing, that this primary pair have quadrant chords of 60° and 77° which pair on W are inscribed in the

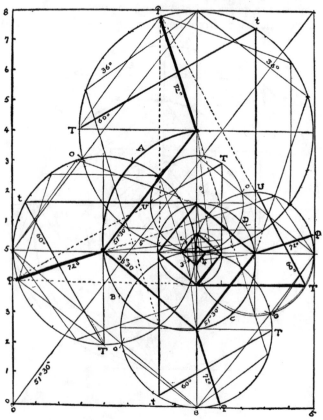

Plate 118—Symmetry of Dolium

rectangle of the pentagon with diagonal of 36°/54°. Plate 118 represents the symmetry of Dolium with the harmonic relations of the pentagon, the hexagon, and the square as at the points $P\ T$, 60°, 72°, and 6° 30′; the latter producing the centres for the quadrant arcs of the chords of 38° 30′ and 51° 30′ as viewed from the perpendicular, being, as above described, in fact, constant angles of 51° 30′. The angles of 51° 30′ ruled from the pole of the primary circle, or those established by the symmetry, pass through the intersections at the point o and also serve as a check in the correctness of the diagram.[1] These cross intersecting points are important as points of reference, as

[1] As to this, see Appendix, Note L.—EDITOR.

a variation of the minutest amount throws the entire diagram out of its established symmetry.[1]

Shells of the Ammonite family are among the oldest known to us, and prehistoric or petrified examples are to be found in our museums; some of which are of such large dimensions (fourteen to eighteen inches in diameter) that they lend themselves to a correct analysis. One of these or *Ammonites Parkinsoni* is illustrated in Plate 119, where the quadrant chords of its spirals are described on the constant angle of 50° or from the perpendicular, the alternating angle of 40° / 50°, the system of its symmetry being rendered in the same diagram. In this it is disclosed that the square and its progressions have a distinct influence over its proportions. The plan of this symmetry is inscribed in two rectangles of 67° 30′, being the harmonic difference between 45° and 90° of the square, while this harmonic angle passes from the pole of each succeeding circle to the quadrant chords and vectors of its spiral, and the angle of 45° ruled from the pole of one circle passes tangentially to the next smaller circle in the series throughout, as at U, oC, MC. The diameter of the circle of the first progression of the square in the largest circle, equals in diameter that of the circle in the opposite quadrant as Aa, while the circle of the second progression of the square B in the same circle equals in diameter that of the fifth circle of the symmetry, the same principle continuing in the whole plan. The triangle of 60° in one circle of the symmetry will have one of its sides passing tangentally to the succeeding fifth circle of the series as from T, N to T, which circle as we have seen is of the same dimension as that of the second progression of the square in the same circle of the symmetry in which the triangle of 60° is drawn.[1] It will be noted that every shell spiral may be circumscribed by one of the great rectangles, as seen in the case of the *Dolium pendix Linn.*

The geometric construction of the shell *Trochus maximus* is represented in Plate 120, diagrams A and B. Diagram A describes the shell looking down on it from the apex, and discloses the fact that the quadrant chords of its spiral are on the angles of 43°/47° or a little more tightly wound than Murex, the ratio being 5 + 7 between each pair of spirals. The side view of the shell is drawn in diagram B with its inclined sides. This view gives the spaces between each pair by the progression of the angle of 47° and appearing wider apart though in reality this is only a question of perspective. In this view, the angles of the spiral in crossing the shell are those of 15° while the vertical spaces are measured by progressions of 47° as are the horizontal ones. The under side of this shell is represented in Plate 121 showing its proportional spaces and the series of concentric arcs passing across the surface of the shell regularly diminishing toward centre. If a circle escribing the form is divided into thirteen parts as in Murex, and the shorter line of the spiral of 3 + 5 is drawn on these divisions as from 1, 2, 3, 4, etc., then the deeper colored markings of the shell may be produced in proportional order, and

[1] As to this, see Appendix, Note L.—EDITOR.

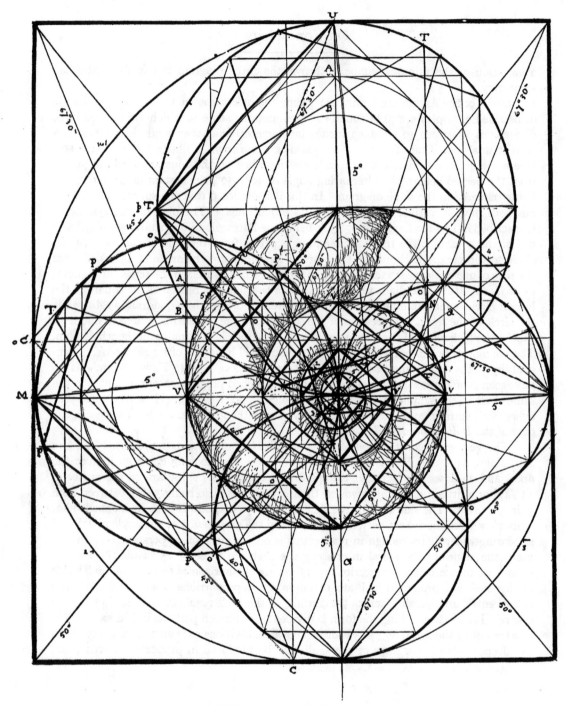

Plate 119—Ammonites Parkensoni
138

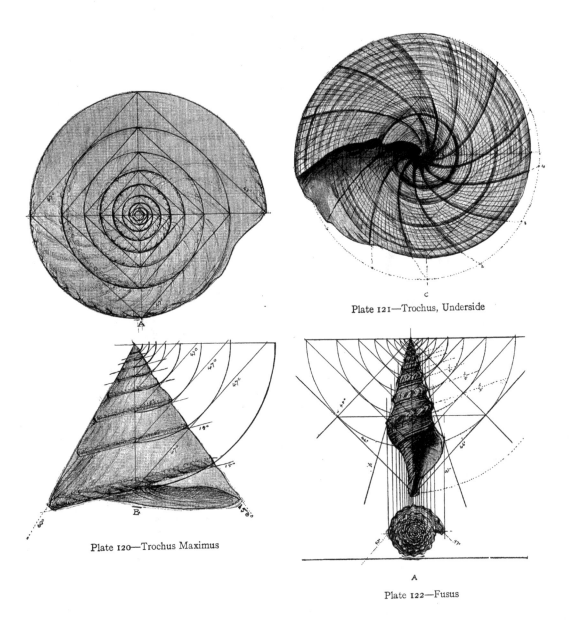

Plate 121—Trochus, Underside

Plate 120—Trochus Maximus

Plate 122—Fusus

between these the same curves are repeated in fainter shades in regular order over the entire surface. This intricate construction is exact, but only revealed by removing the outer layer of the shell and never could be drawn by the eye unaided by the geometric plan.

There are numerous examples of different families of shells equally as interesting as those described, but enough have been explained to disclose the general principles controlling all. Many families are long and narrow as the *Terebra* family where fifteen turns to the spiral occur, which is the limit of my observation. These are more difficult to examine ac-

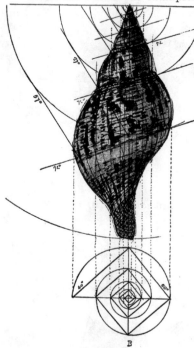

Plate 123—Facelaria

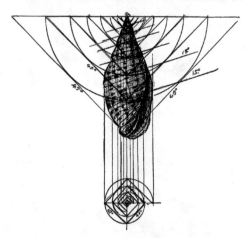

Plate 124—Mitra

curately as their quadrant chords are so close to the angle of 45°. The side views of *Fusus*, *Facelaria*, and *Mitra*, are described in plates 122, 123, and 124, which are united to the proportional spaces of their base and explain themselves. The side view of *Fusus* clearly discloses the influence of the regular progressions of the square.

All of the above examples go far toward the justification of the hypothesis that the three simple figures of geometry, the square, pentagon, and hexagon, with their progressions, constitute the principle by which Nature co-ordinates her design, revealing that the study of the shell alone may teach man how to reach a similar perfection in his architectonic compositions.

CHAPTER X

ON DIATOMS

THE beauty of form and intricacy of pattern in diatoms have frequently been noted, but nothing has been stated in an adequate way of the perfection of proportion to be discovered in this microscopic cryptogam. It offers some of the clearest revelations of Nature's methods of establishing her proportional spaces and these expressed in no doubtful or vague way. Other families of plants and shells disclose equally remarkable presentations, but none show a more direct influence of the octagon, the hexagon, and the angles of polar force of 45° and 60° than is displayed in the composition of these marvellous creations; and owing to the fact that their cell-walls are strongly impregnated with silica, these flinty forms preserve their perfect beauty even under the action of acid or intense heat. Their fixed and enduring shape thus lends itself to analysis and when is added to this the fact that by placing them in a coloring matter the various details become more strongly

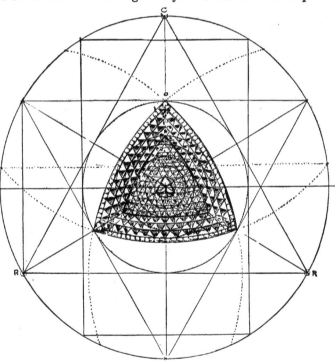

Plate 125—Diatom Shield

marked, their uses as examples for study will be appreciated. It might be justly ques-

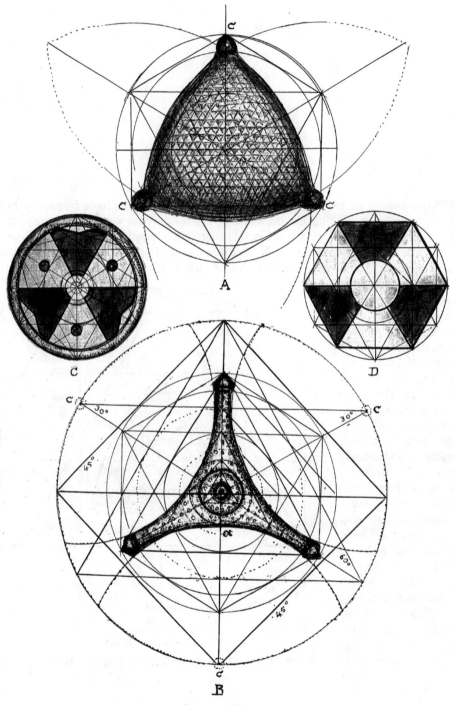

Plate 126—Diatoms

142

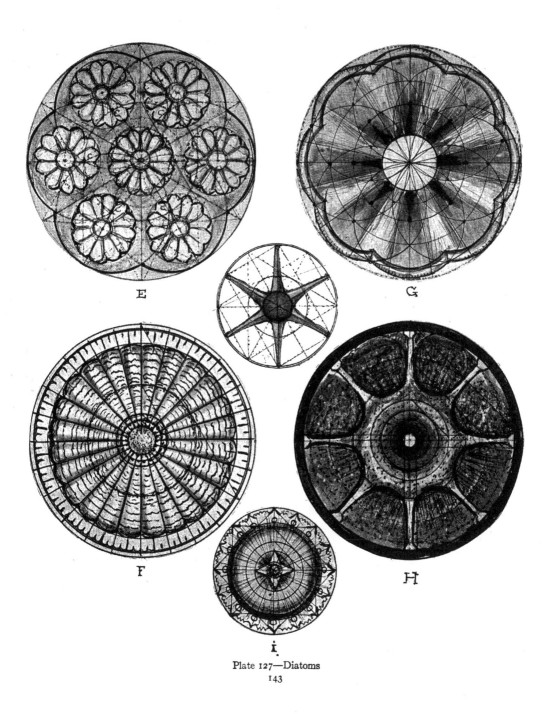

E

G

F

H

i

Plate 127—Diatoms

143

tioned how it is possible to analyze these minute microscopic species with accuracy sufficient to make the findings of value, and it would indeed be difficult to do so if important aid were not forthcoming outside of mere measurement,—in this case of almost infinitesimal degree. But this aid is to be found as with snow crystals in the art of microphotography as well as through a knowledge of the action of polar force by which we shall find that their proportions are controlled. With the combination of microscope and camera these tiny objects may be enlarged and all of their parts accurately measured and divided, and from such examinations we learn that Nature never changes her binary progressions, especially when her forms are enclosed in definite geometric plans, and no change caused by accident can be considered as of moment in the judgment of her law.

Diatoms were once considered a form of animal life, but under modern investigation they are classified with the monocellular *Algæ*. It was not until the close of the eighteenth century that this form of vegetable life was discovered and as late as 1824 only forty species were known, although to-day they are numbered by thousands, their forms including all of the five polyhedra with many so attenuated as to appear simple linear ones; the pentagon, octagon, and hexagon are the most prominent. All of these are to be found in a single drop from a salt- or fresh-water pool where they abound. Under the microscope they reveal an immense variety of beautiful decorations in a perfect balance of parts, many of them covered with almost innumerable lines. Some idea of their extreme minuteness may be gathered from the fact that one of them measures fifty one-thousandths of an inch in diameter, and this larger than the average size. They are characterized by their form, which frequently resembles that of two covers, one shutting into the other like the lid of a box, one rim having a decorative moulding on the outer edge as disclosed in many of the following diagrams. Their mode of increase is by two, with the ratio of $1+1$. Vast deposits of their remains are found in various parts of the world, the most notable bed being near Richmond, Va., extending there for several miles.

A diatom shield is represented in Plate 125, the surface of which is covered with minute triangles of 60°, and the progressions of this triangle united to those of the square render the series of circles controlling the proportional spaces. If the distance between points R and o in the primary circle is taken as a radius, then with C and R as centres can be described the outer curves of the shield and by gradually shortening the radius, the inner ones. The small inner circle of the progression of the square will render the proportions of the central ornament. A similar form is drawn in Plate 126 where in diagram A with the points C as centres the arcs of the diatom may be correctly rendered, while the proportions of the three knobs are decided by the circles of the first progression of the side of the hexagon between which and the prime circle they lie. A like method may be followed in describing the diatom in diagram B, where the arcs of the object

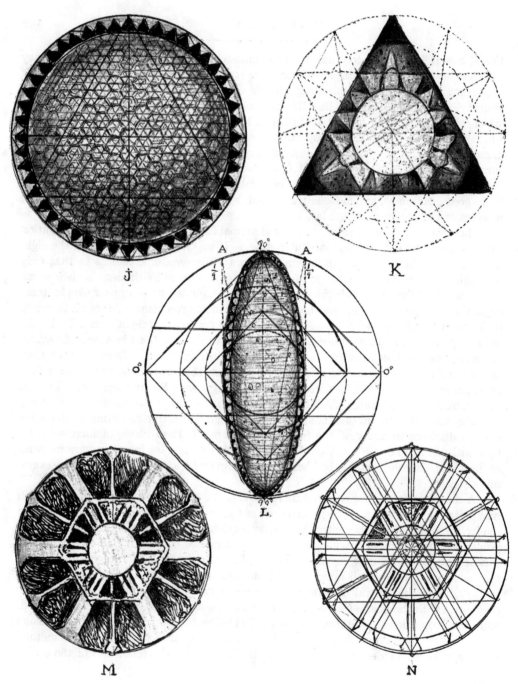

Plate 128—Diatoms
146

are concave ones described with Ca as a radius and the points C as centres. Diagrams C and D of this plate are so simple that they explain themselves, both representing forms of diatoms.

In Plate 127, diagrams E to I, we have illustrations of some of the circular forms of diatoms. In diagram E, the circles are described on the progression of the square, 60°, and the side of the hexagon; the scalloped edges by circles measured by that of the first progression of 60° and centred about the circumference of the original circle of that progression on the points C at the hexagonal angles. The seven flowerlike decorations

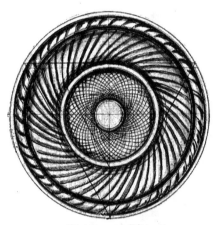

Plate 129—A Diatom

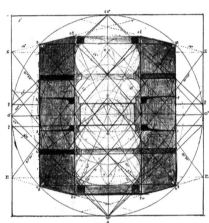

Plate 130—A Diatom

are all of the same proportions as that of the circle of the second progression of the angle of 60° and their centres come on the circle of the first progression of the square where it is intersected by the angles of 60° and 0°. The diatom in diagram F is developed by two progressions of 60°, two of the square, and one of the side of the hexagon; the disk has twenty-four radiating lines each subdivided by four, and these again subdivided by four; the first of this series comes on the angle of the hexagon. Diagram H has its proportional spaces decided by one progression of the angle of 60° and six of the square, the smallest of these producing the light inner disk, the diameter of which gives the width of the eight knobs on the outer rim of black; the width of this band is determined by one progression of the octagon in the outer circle. The curves which come between each of the radiating lines of ornament are the catenary curves of gravity and may be reproduced by hanging a flexible chain on the points where the curves terminate in the octagonal radii.

Another group of diatoms is drawn in Plate 128, diagrams J to M. Diagram L is of oval form the curves of which are like those just given in diagram H except that in

10

this case the flexible chain would be hung on the angle of $\frac{1}{8}$ as at *A*. The remaining
figures of this diagram can be followed without description.

An interesting example of one of these objects is drawn in Plate 129 where the
various spaces are developed by two progressions of the angle of 60° and one progression
from thence of the square, while the outer rim is on the progression of the side of the

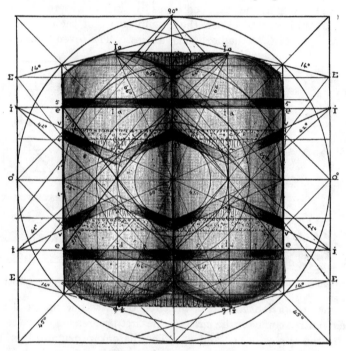

Plate 131—A Square Diatom

hexagon. Pinning a cut-out spiral of the 3+5 class, as explained in the Chapter on Botany
to the centre of the plan and dividing the outer circle into forty-eight equal parts, and
using only the short spiral on these divisions will render the ribs or curves that pass
across the face of the diatom to its centre; and if the spiral be now reversed and the short
spiral again described on the above divisions where they cut the circle at which the
ribs terminate, they will produce the inner or double set, the result then resembling the
"turning" on the case of a watch.

One of the most interesting examples of the numerous diatoms examined by me is
rendered in Plate 130, which is nearly square. Six progressions of the square will produce
the chief proportional spaces of the object, when it will be found that the Egyptian

triangle of 51° 30′ and the ideal angle of 42°/48° will be developed. The central panel will be of the same proportions as that of the ground plan of the Parthenon, with its diagonals of 66°, or the rectangle of 42°, which rectangle may be subdivided into smaller ones of equally perfect proportions by the angles of 42° and 48°. By ruling the angle of

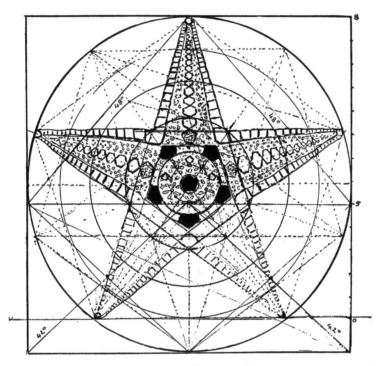

Plate 132—One of the Asteroidæ

14° from the corners of the square S to E it will cut the main rectangle of 42° at the points *oi* and *io* at its upper and lower extremities, while the angle of 51° 30′ drawn from E in the upper quadrant to *eo* in the lower one will produce the rectangle of five in eight within the four points E, and by repeating the same process in the lower quadrant with the angle of 14° on E and *io* and from E to *oi* in the upper quadrant the same rectangle as before will be rendered on the points E; horizontal lines now ruled from *oi* to *oi* in the upper quadrant and from *io* to *io* in the lower quadrant will produce the whole length of the diatom, while the angle of 14° will give its bevelled corners. Horizontal lines ruled through the points *e* will decide the position of the narrowest bands of dark decorations on lines 5 and 3. The square *ss* is subdivided into sixteen smaller ones

somewhat in the same manner as that employed by the Greek architects in the designs for their temples to adjust their proportions.[1] The curved lines in the ornamenta-

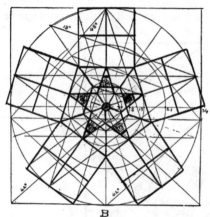

tion of the large rectangle on *oi*, *io* are taken from the inner Circle 6 and other harmonic measurements with their centres on the points *c*. It may now be recognized that this object, in perfect proportion, is harmonic with the rectangles of the ideal angle and of the Egyptian triangle in its ratio of five in eight, both of which are salient features of the portico of the Parthenon and of its ground plan as well. I appreciate that this diagram is very complicated, but it presents a marvellous adherence to the principles claimed.

A similar diatom is illustrated in Plate 131 which has its proportions developed by the progressions of the square and the rectangle 42°/48° of the ideal angle and the rectangle

Plate 133—Antedon

of 5+8 of the Egyptian triangle; the latter coming on the point *E*. The rectangle of 42° occurs at the points *i* when horizontally placed, the vertical position

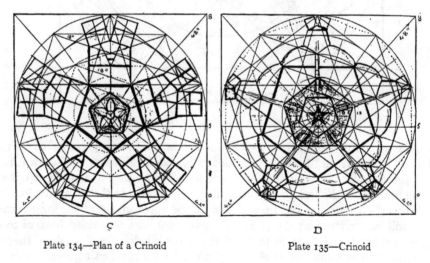

Plate 134—Plan of a Crinoid Plate 135—Crinoid

[1] Gwilt describes that the temples of the Ionic tetrastyle order were designed in twelve squares in width to twelve in height, while the Ionic hexastyle order are in a plan fourteen squares high by eighteen squares wide.

being at the points *io* and *gi* while smaller ones are developed at *id* and *ia* and at *gi* and *id*, the diagonals of 66° producing all of them. The angle of 14° ruled from the points *E* passes tangentally to the upper and lower curves and *A*, *B*, *C*, *D* mark the four circles of the progressions of the square.

Other forms of minute vegetable and animal life disclosed by the microscope are to be found in countless numbers among the various families of Asteroida, Echinoderma, Crinoids, etc., revealing the fact that their proportions are produced by similar geometric principles, many of them developing a beautiful mosaic work such as that drawn in Plate 132, representing one of the asteroidæ in which the angles of the pentagon with its progressions of 18° render the proportions. The square escribing the form is divided into the rectangles of 42° and 48° of the ideal angle. This idea is further illustrated by Plate 133 which represents the nervous system of *Antedon*. Plates 134 and 135 render the form of one of the Crinoidæ. One of the Echinoderms is rendered in Plate 136, also marked by a mosaic work, while another species is drawn in Plate 137.

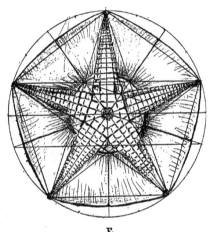

Plate 136—Echinoderm

This beautifully decorated object is developed from the pentagon as are all of the others. That figure appears to characterize these creations, while the hexagon establishes the proportion of the majority of diatoms, although the pentagon sometimes, but more rarely, has the primary influence. All of these examples have the rectangle of 5+8 in evidence in various places of their proportional spaces, as well as the ideal angle. Four progressions of the angle of 18° renders the chief proportional spaces of diagram *F*, and a pentagon escribed on the outer arc of this figure will develop circle *A*, on which five smaller circles of the same dimensions as that of the second progression of 18° (starting from the circle outlining the figure) with their centres on the points *C* or on the angles ⅓ and ⅔ will produce the five arcs on the rim; and if the same circle is placed with its centre on the point *d* it will approximate the curve on the central five-pointed star, though probably this is in fact a catenary curve. The circle of the first progression of the pentagon taken upon the compasses will then, with the points *o* where the small interior circles intersect the outer pentagon as centres, describe the arcs passing through the black dots at the extremities of the dark five-pointed star. All of this series of circles will pass tangent to each other or intersect some proportional space; and while most of these spaces are those of gravity or polar force, yet these circles

will place their position with accuracy. This is one of the most **remarkable** examples I know of the correlation of progressing circles and is well worthy of study.

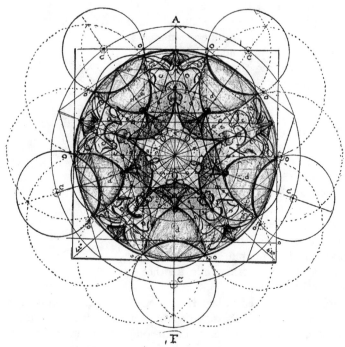

Plate 137—One of the Asteroidæ

CHAPTER XI

ANIMATE FORMS

Insects

THE insect kingdom offers numerous examples proving the power of geometry on proportional form, such for instance as may be found in butterflies. These creatures are always distinctly geometric, even to the casual observer, and while each species has its own peculiar form still the angles of 45° and 30°/60° are always in evidence and the influence of the ideal angle is generally present. Plate 138,

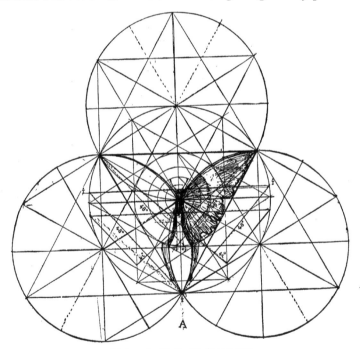

Plate 138—Butterfly Symmetry

represents the general plan controlling the different families. Plate 139 is a drawing

153

from Nature on a larger scale of a South American species. As in the former example if the semi-diameter of the circle enclosing the insect is taken as a radius, and the lower angles of the rectangle *R*, *R*, as centres, arcs may be struck which produce the curves as well as the length of the wings. The other proportions are derived from the angle of 45° and 30°/60°, the circles of these angles also give the width of the light band near the

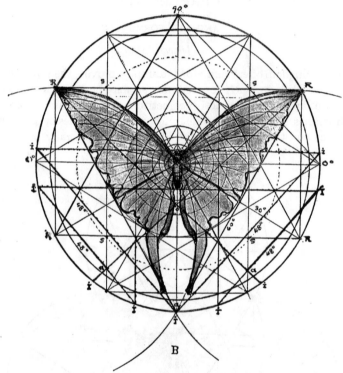

Plate 139—South American Butterfly

centre of the wings. The ideal angle ruled from definite points of the plan (see dotted lines) will place some of the proportional spaces or verify others, as at the point *I*.

Plate 140 is a drawing from Nature of a butterfly of the same family, and this plan and the placing of its proportional spaces being similar to the former one may be followed without words. All butterflies have four wings, two on either side of the body, and their separation is usually along one of the angles of the plan. In this case it is approximately on the angle of 0°, which is the average position; moreover, the ideal angle usually measures the length of the body, or if drawn from the extremities of the

wings to the horizontal side of the triangle of 60° as in Plate 138, it will measure the width. Plate 141 shows the progression of 42°/48° of the ideal angle in relation to this insect.

The proportions of the humblebee are drawn in Plate 142 revealing the same

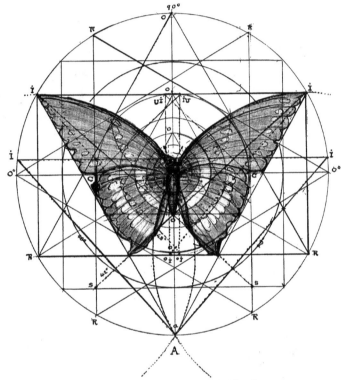

Plate 140—A Butterfly and Triangle

influences of the triangle of 60° and the square, while the spaces are verified or others given by the ideal angle as drawn in dotted lines. If the quadrant chords of 42° and 48° are started from the pole of the primary circle at 0° they will oscillate around the form intersecting many important spaces in the proportion of the bee; for instance, the angle of 42° produced from 0° will pass to i on the same circle, from which point, as is usually the case, a vertical line will place the width of the head, while the same angle drawn from the extremities of the wings to the rectangle at oi renders the width of the body which is much greater in proportion to the wings than that of the butterfly, where the

angle of 48° from the extremities of the wings gave the proportions *oi*. Nevertheless, it will be noticed that the cases are equally harmonic, the measuring angle in the one

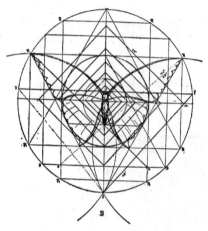

Plate 141—Butterfly and Ideal Angle

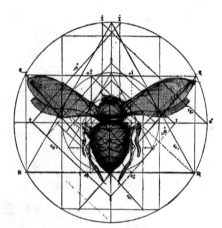

Plate 142—Humble Bee

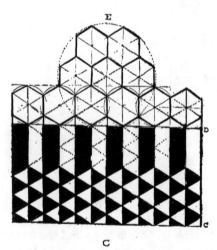

Plate 143—Wasp's Nest, Plan

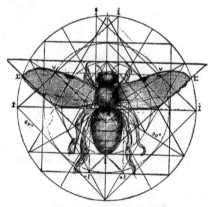

Plate 144—Honey Bee

case being the complement of the angle in the other. This principle as to the measurement of the head appears to be a general one with all insects. If not from the pole of the primary circle, it will be determined from the pole at 0° in one of the other circles in the

progression of the square and even in the human family this law appears to be in force.

This bee is a distinguished object in coat of yellow and black as it forages among the flowers, while the honey-bee worker proceeds with an absorbing industry, for as she gathers sweets, she is storing material to build her house. This tiny confectioner was one of the earliest architects to employ geometric principles for use as well as beauty, considerations which man so continually ignores. Her building intelligence is so remarkable that it attracted the attention of Réaumur, the naturalist, who thus wrote:

Plate 145—Wasp's Nest, Vertical Section

They have solved a very difficult problem of geometry, for only a limited material or wax is at their disposal for the construction of their house, the rooms or cells of which must be of a determined capacity of the largest size, and with the strongest walls in proportion to the amount of matter to be employed. . . . The cylindrical form would seem to be the best adapted to the shape of the bee's body, but this would leave vacant or waste room between the contiguous cells; on the other hand, had the cells been square or triangular, they might have been constructed without so many unnecessary vacancies, still they would have required more material and then not fitted the body of the insect. . . . The six-sided form of the hexagon fulfils the problem in every particular; the base of each cell, instead of forming a plane, is composed of three diamond-shaped pieces placed in such a manner as to produce a shallow pyramid, which structure imparts greater strength while giving a larger capacity with the smallest expenditure of time and material. The angles of these cells on the longest space measure 109° 28′ and on the smallest, 78° 32′.

Réaumur, desiring to learn why these particular angles were chosen by the bee, submitted the question to a geometer without giving a clue to the object he had in mind, excepting to learn what angle would give the greatest strength with the smallest expenditure of material. As a result he was told that the angles of 109° 26′ and 78° 34′ were those he sought, these being in variation $\frac{2}{60}$ of a degree from those employed by the insect as measured by Réaumur.

The construction of the honeycomb as well as the nest of the wasp is on the same principle as that described in the packing of the molecules, and it is illustrated in Plate 143 representing the plan of the wasp's nest. The form of the honey-bee is drawn in Plate 144 where it is disclosed that this also has its proportions decided by the same

general principles as that of the comb itself. The influence of the ideal angle may also be traced in a similar way as just described in the diagram of the humblebee, the points *I, I* giving the width of the head; while the angle of 42° ruled from the lower pole of the fifth progression of the square places the top of the head at *V*.

Plate 146—Wasp's Nest, Vertical Plan

The pasteboard-making wasp builds its nest on the same general principles. Six stout circular platforms are fixed to the walls of the nest at equal distances apart, on the ratio of 1+1 (a great architectural law), and these platforms, or floors, which are smooth and concave above, have convex and hexagonal walls beneath. The centre of each platform is perforated for the admission of the wasps, and for their access from story to story. On these platforms they can move about and attend their young. Plate 145 represents the nest with an opening cut out to show a part of the interior or five of the floors. Plate 146 discloses some of the geometric principles of the construction; the generator of the plan drawn at *G* shows that the progressing widths of the six platforms are developed by the progressions of the side of the hexagon at the points *1, 2* etc. The vertical divisions of six platforms are produced in the plan in circle *H*, by the side of the triangle of 60°, at *T, T*, with their ratio of 1+1. The plan in circle *I* is the result, but each division between these platforms is covered with minute hexagons in relief caused by the modelling of the inner cells, which arrangement has been described on a larger scale with more decided lines in Plate 143. In this plan the portion from *C* to *D* represents a part of the outer division of the inner cells occurring between each platform, while the hexagons in the circle *E* reveal the construction of the cells.

It can hardly be supposed that these marvellously exact works result from the thoughts or superior intelligence of the bee or wasp, as Réaumur suggests, but rather from the instinct with which they are endowed by the Creator, for otherwise we might as well assert that the con-

struction of the snow crystal on equally exact principles was also the result of its intelligence. Of course intelligence is the cause of this perfection, but it is the intelligence of the power wherein all things in Nature come to life.

Many other examples of a like exact geometric construction might be produced in the habitations of insects, but none are more remarkable than the web of the spider. These creatures resemble the human family in so far that some are careless and slovenly in

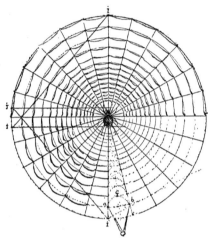

Plate 147—Spider's Web

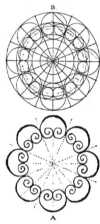

Plate 148—Nest of Willow Leaf Roller

their work, while others even in the same species appear to take pride in the perfection of their spinning. Many seem to become discouraged by repeated accidents to their webs until finally any makeshift suffices if only it may succeed in catching a fly now and then. The family of spiders building hexagonal or nearly circular webs such as described in Plate 147 appears to be especially endowed with a sense of proportion and with mathematical instincts so strongly developed that they employ their legs as measuring rods by means of which they obtain an exact ratio, using them as compasses with which to strike correct arcs. It is by this means that they obtain that perfection of construction which gives man so much cause for wonder, admiration, and thought. These webs are most perfect in the early morning and at the same time most beautiful when they are covered with minute dewdrops that sparkle in the sun like so many diamonds, and their form is then clearly distinguished.

On the lower arc of the quadrant of this diagram the principle is described whereby the spider accurately secures correct progressions which come on the regular lines radiating from the common centre; for at each step the leg is passed from *a* to *b*, placing at the point *c* the position of the next series of lines. The silk is now fastened at *a*, and this

process is repeated until the web is complete, the length of the leg producing that regularity of form which renders the proportional spaces. Of course this result cannot be always exact as the spider is so frequently interrupted, but every passage of continuous work is quite perfect, the resultant circles progressing in harmonic order. Gravity now comes in to make the web even more beautiful, as from each point of intersection of the silk the catenary curve is developed, each curve differing from its neighbor by the regular progression throughout the structure. The question may well be asked: Would this architectonic object be any more beautiful if less mathematical?

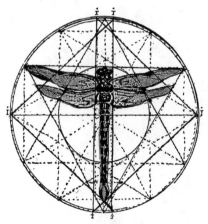

Plate 149—Dragon Fly

The nests of some caterpillars reveal the fact that their builders also have remarkable geometric instincts as described in Plate 148, diagram *A*, showing a cross-section of one of these nests by the "Willow-leaf Roller," while diagram *B* renders its geometric plan. Plate 149 is a drawing from Nature of a dragon-fly, and is developed by the angles of 45° and 30°/60° connected with the ideal angle. A drawing

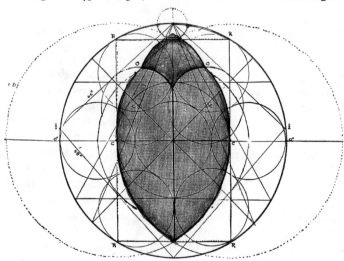

Plate 150—Water Beetle

of the water-beetle is analyzed in Plate 150. This insect is the most beautiful in form of

all beetles, and as it is designed to pass swiftly through the water its proportions are decided by the vesica piscis, as described in a previous chapter, while the curves dividing the upper part of its shell and the arcs from thence to the top of the head

Plate 151—Peacock

Plate 152—Hawk

are those developed by the angles of 60° and 45°. The whole form is just enclosed in the rectangle of the hexagon as at *R, R*. The vesica piscis which produces its great curves is rendered by taking the semi-diameter of the primary circle as a radius and then, with the points *C* as centres, the arcs may be described which form the body.

On Birds

The peacock is called the most beautiful of birds and its geometric analysis is drawn at Plate 151. Marvellous color is one of its principal charms, but the *form* of its spreading tail fills one with quite as much wonder and admiration. The iridescent "eyes" that come on the extremity of each feather are all placed in proportional ratios, in gradually diminishing size, based on the progressions of the pentagon, and if the quadrants of the circle enclosing the spreading tail be divided into ten equal parts each, and the spiral of 3+5 placed on the radiating lines to correspond to each angle, the resultant arcs will intersect each other on these angles on the progression of the pentagon, and these intersecting points will be the centres for the so-called "eyes" of each feather. If the pentagon be drawn in the primary circle with its apex at the upper and lower poles, then lines ruled across the horizontal pentagrams of each pentagon, as at the points *ap* will render the extreme height of the bird from its feet to the top of its head. The ideal angle of 48° ruled from the extremities of the horizontal vector will pass out of the circle of the lower quadrant at the point *i*, and vertical lines erected from *ii* will pass

tangentally to the sides of the bird's body, as with many insects, while a circle inscribed in these lines will bear the ratio of approximately 1 : 3 with the whole height, the legs and neck bearing the same ratio.

This drawing is a conventional one only, for in Nature the separate feathers bend in catenary curves instead of being in straight lines as in the diagram; the plan simply discloses the law of distribution of the feathers and various "eyes." Plate 152 shows the Hawk in which the measurements of the head, tail, and wings are decided by the ideal angle drawn in the various progressions of the square. A similar principle controls the proportions and spacings of the feathers in the various families of birds: all being related to the size of the body in a like manner.

On Fish

Fish are also constructed on a geometric system. The star-fish is an exact pentagon

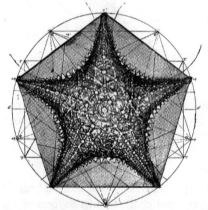

Plate 153.—Star-fish

in its outlines, and the progression of the pentagon renders its chief proportions (drawn in Plate 153). The surface of the form is covered with small knobs or excrescences and together they produce a network of pentagons which gradually grow smaller towards the centre of the object on the progression of the angle of 18°, these knobs are therefore related to each other by extreme and mean proportion in each succeeding pair, although in many places they are more or less distorted. The limpid character of the element in which fish live lends itself to the influence of gravity on their forms; we therefore find catenary curves strongly in evidence in the arcs of their various families, this of itself rendering exact correlations difficult, though none the less interesting. The length being inscribed in a circle, width, size of head, and other parts are always found to be placed upon harmonic points.

Mammals

Numerous drawings of animals might be produced, all disclosing the controlling power of the above progressions or their proportions, but I will confine myself to an analysis of the horse and the lion as representative examples, the particulars of which apply in a similar way to all others. The Greeks always conventionalized the horse in their statuary on the same principles as applied in their architecture, *i. e.*, on the progressions

of the angles of 45° and 60°. The bronze horses of St. Mark's are the best preserved examples remaining to us, and Plate 154 is a tracing from a photograph of one of these four horses, clearly revealing the influence of the above angles. Dürer must have had these horses in his mind when he wrote his treatise *On the Proportions of the Horse*, now unfortunately lost; for his drawing of that animal in his famous engraving of *Death and the Knight* corresponds very closely to those in Venice where he spent much time.

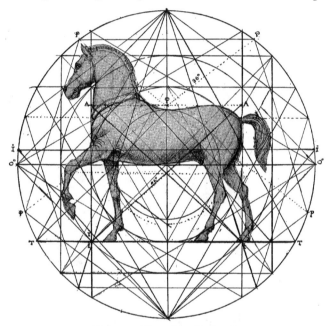

Plate 154—Horse from St. Mark's

A tracing of the horse and his rider from Dürer is drawn on Plate 155, enclosed in a geometric plan with the progressions of the above angles. There is no other example in modern times where the rider so perfectly sits his horse and where the relations between the two are so well expressed. A large number of equestrian statues have been produced since Dürer's day, but in most instances the rider is placed too far back or too far forward in the saddle, although there are some fine examples where this principle has been well considered, especially among the works of American sculptors. In Dürer's case the artist seems not to have been satisfied merely by his intuitions or his eye, but places his proportions on the geometric basis, and it is a well-known fact that he was one of the most ardent disciples of the principle of applying geometry to art. His remarkable engraving called *Melancholia* has excited the imagination of many in the effort to

read its hidden meaning. It would appear to be the presiding *Spirit of Geometry*, represented by a woman occupied in profound thought and holding in her left hand a pair of compasses, regarding in the distance radiating light, a rainbow, and other objects. Her face is filled with profound sadness, considering the shortness of life and the amount of knowledge to acquire. Time is represented by the hour-glass and the bell, while the

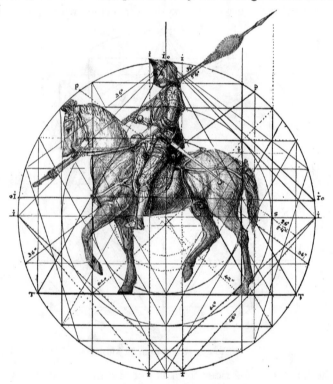

Plate 155—Dürer's Knight

sphere, the crystal, the square, divided into sixteen equal parts are also pictured, all of which symbolize the principles of geometry in their relation to art. This idea appears to be verified by his own words on the subject, "Those arts and methods which most perfectly approximate to exact measurement are the noblest."

An examination of the two plates of the horse above referred to will show the fact, that the tracings of these animals can be enclosed in the same geometric plan, the correlation of the intersecting points being alike in both cases. The Greek example is the finest in its general form, but Dürer's is the best in the rhythmic expression of move-

ment. The cause of this may doubtless be found in the fact that the artist of the Greek example overlooked the truth that the horse, as most other animals, steps out with one forefoot and the opposite hind foot at nearly the same time, bringing the two feet on the same side alternately together and then separated by their extreme distance. In both of these examples the main body of the diagram is enclosed in two rectangles of 42° and 48° of the ideal angle, while the diagonals of 36° of the pentagon coincide with this measurement as at the points p, producing the height of the top of the haunches. The

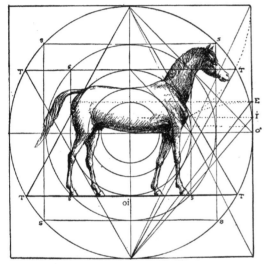

Plate 156—Horse from Nature

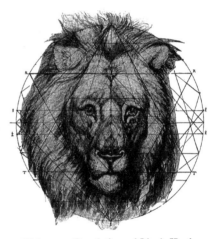

Plate 157—Correlations of Lion's Head

influence of the pentagon is further expressed by Dürer as he places the angle of the sword and the spear both on 36° passing in opposite directions.

In Plate 156, a normal horse is represented, traced from a photograph from Nature and enclosed in the progressions of 45° and 60° with the angles of 42° and 48° added. The upper angle of the square ss with the lower line of the angle of 60° on T produces the extreme height. The top line of the girth comes on the pole of the circle of the third progression of the square, while the lower line rests on the line 0°; from this line to T decides the length of the leg. The ideal angle of 48° has its horizontal side at i, the line i, i placing the point of the chest and the top of the curves that pass from the legs into the body; the angle of 42° ruled from oi also places the point of the chest, passing tangentally to the base of the chest while other angles of 42° and 48° indicate other important portions. The pentagon (see the two former diagrams), has an influence at the points p for the horizontal ruled from the central point so marked indicates the height of the

top of the thigh; while the side of the pentagram continues through the elbow of the foreleg; moreover the line of the pentagram on *op* decides the position of the tail, indicating where it leaves the body. The same angles in each of these three examples render the same coincidences on the correlating points in the same way, and it therefore appears reasonable that both Dürer and the Greek sculptor employed the same principles to establish their proportions. An examination of these three diagrams would perhaps almost lead one to think that the geometric plan was first drawn and the proportions of the animals then produced in them, but exactly the opposite was the case, and when the angles were drawn I had no idea that they would come out in such an exact manner excepting from theory.

The head of a lion is rendered in Plate 157, where it is disclosed that the same angles govern its proportional parts; the side view and whole body are not given for want of space, but their divisions are controlled in similar manner, as are those of other animals.

CHAPTER XII

THE HUMAN FIGURE

WHEN approaching the subject of the human figure in its relation to the theory of proportion, it would appear that the application of principles must become more difficult, for the figure is symmetrical only if seen exactly in front or rear views. Still in both these cases the progressions of the square and of the equilateral triangle are quite as strongly in evidence as in crystals, and sym-

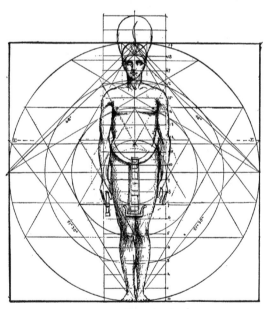

Plate 158—Egyptian Canon

metrical flowers, and the extreme and mean proportion occurs again and again throughout the form. The ideal angle and the Egyptian triangle also have their influence in many

important places, and this in so marked a manner that an examination of the subject causes one to feel that the Greeks, in forming their canon of proportion for this subject, must have been influenced as in their architectural work, by the above angles. This conclusion is further emphasized when we regard the Egyptian canon of the proportions of the human figure and learn that Polyclitus, one of the Greek sculptors, wrote a

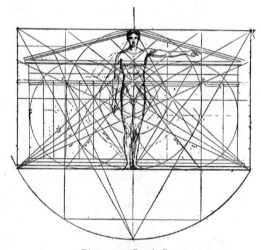

Plate 159—Greek Canon

treatise on the subject illustrated by his celebrated statue of Doryphorus, the measurements for which were taken from this Egyptian canon.

Plate 158 was copied from the latter canon in which it must be observed that the length of the great finger was taken as a module for the measurement of the whole figure, the latter being nineteen times the finger in height. It has been shown from existing copies that the Doryphorus did not vary a twentieth part of an inch in its proportions from those derived from the above index. If a drawing according to this canon is placed in a diagram of the regular progressions of the square, as I have drawn it in the above plate, the coincidences will be found to correspond in the proportional spaces derived from this progression to those measured by the index. It may be noted that the circle of the first progression of the square passes under the chin and measures the length of the head, which is just one seventh the height of the diagram. Many authorities unite in stating that a large number of Greek statues are divided in this way, and among these, some of the best. It must be remembered, however, that this varies according to the character of the figure to be presented and these are generally divided into three classes,—seven heads, seven and a half, and eight—depending on what was the desire of the artist, and whether

he wished a tall and slender figure or one shorter and more muscular. The measurement of eight is, however, the one usually employed by writers on this subject, and the statement of Vitruvius that "The Greeks evolved the proportions of their temples from the same principles that control those of their statues" becomes significant if we superimpose the drawing of a figure eight heads in height as in Plate 159 upon a tracing of the portico of the Parthenon, for the proportional spaces in both these examples are derived from the progressions of the square. It is well known that the Greek sculptors employed

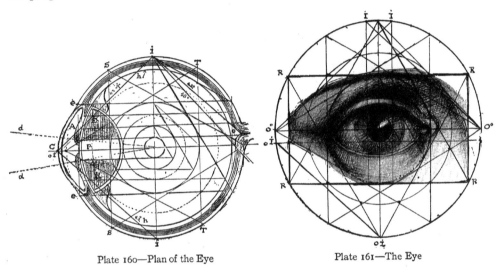

Plate 160—Plan of the Eye Plate 161—The Eye

different parts of the body as modules for measurements according to the character, or the age, or the sex they desired to describe. In some cases it was the length of the great finger as stated, while in others it was the length of the nose, for example. When this latter was used as the module, four of these rendered the length of the head, and eight times the latter in a figure eight heads in height, or thirty-two parts of the module rendered the entire length of the body. The above progressions of the square apply with equal value to the minor details of the figure, such as the eye and ear.

A drawing of the general construction of the human eye is given at Plate 160, taken from one of the most advanced works on optics, and this diagram discloses that the progression of the square and the angle of 60° render proportional spaces corresponding to those in normal examples. The normal eye is enclosed in an approximate circle, while the metropic, an abnormal eye, is enclosed in an ellipse longer horizontally and the hypermetropic in an ellipse vertically placed. In the above plate it is disclosed that the proportional spaces are developed by the progressions of the square and the triangle

of 60°; the first progression of 60° places the line *e, e* which renders the length of the cornea *C;* the circle of the third progression decides the diameter of the normal pupil with the opening at *p;* the circle of the third progression of the square places the circle of the iris at *E* in the chamber of crystalline humor; the angle of 42°, passing to the point

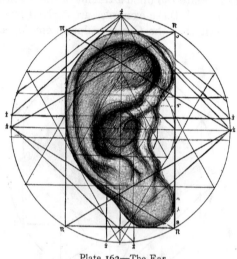

Plate 162—The Ear

oi, decides the position of the outer arc of the cornea at *C;* the same angle passing to the right from the upper pole of the primary circle (enclosing the sclerotic) decides the position of the entrance to the optic nerve at *o;* the first progression of the side of the hexagon renders the proportional space which includes the sclerotic coat and choroid *K*, the inner line placing the arcs of the retina *h*. Of course the pupil varies in size, not only in relation to the amount of light it receives but also on account of the temperament of the individual. In warm temperaments, the pupil is abnormally large, in cold ones it is the reverse, but in the normal or average eye, the proportions of the pupil correspond to the diagram in the above plate, and also in Plate 161 representing the full view of the eye.

In Plate 161, the progressions of the square and of the equilateral triangle coincide with the chief proportions; the circle of the first progression of 60° decides the length of the eye, that of the second, the diameter of the iris, while the third places approximately the diameter of the normal pupil. The eyeball, length of the eyebrow, and the lower lid are enclosed in the rectangle of 60° on *R R;* the ideal angle of 42° ruled from the lower pole of the primary circle passes to *oi*, the horizontal side of its triangle passing tangent to the lower line of the pupil,—the angle of 48° produced from the poles o° will pass to the points *i*, while vertical lines from these points again place the diameter of the pupil. Plate 162 represents a normal ear measured from Nature. Like the eye, it is constructed according to the laws of proportion. It is here inscribed in the rectangle of 60° in a vertical position, the circle of the first progression of 60° deciding the width of the ear with its proportion to the length; the circle of the fourth progression of the square places the opening of the ear, and so the harmony continues throughout.

An analysis of the ideal head taken from the statue of "Hermes" by Praxiteles is presented in Plate 163, where the influence of the pentagon is most apparent. So much

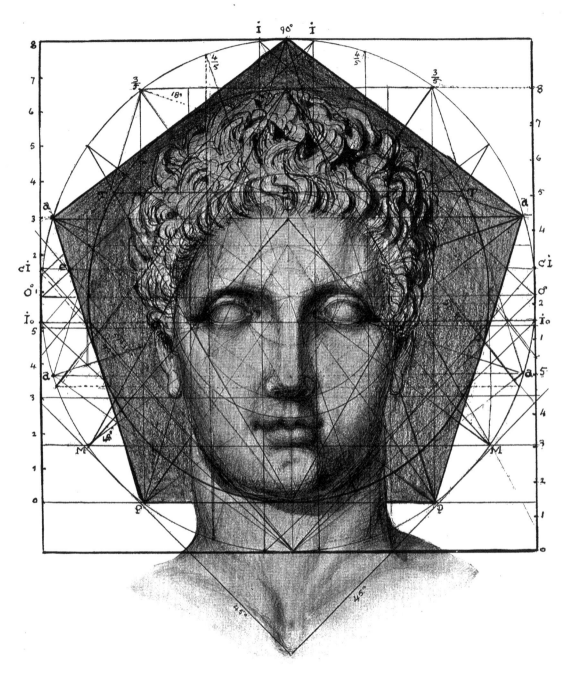

Plate 163—Hermes of Praxiteles

171

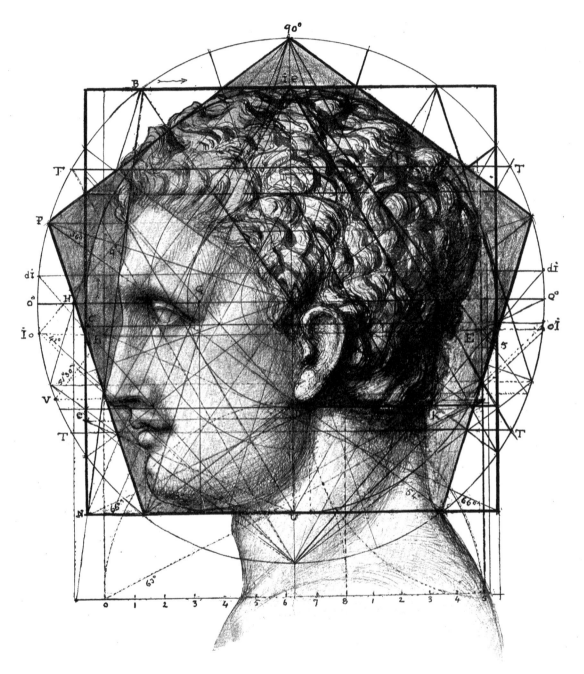

Plate 164—Hermes, Side View

173

was this the case in my investigation of this beautiful work of art that after drawing it in a circle of the same diameter as the height from the crown to the bottom of the chin, with the pentagon escribed, and radial angles of 18° being drawn across the plan, these angles alone were found to correspond to many of the proportional spaces. When the pentagram was added at the points p and horizontals at the points a, more coincidences occurred. The upper line on a passing through the divisional line of the forehead and hair; the lower line a intersecting the upper lobes of the nose and ears. The pentagram in the primary circle resting on the bottom of the chin on the line P, P, will be seen to pass to the upper pole at 90°, intersecting in its course the outer line of the eyes, while the horizontal line under the nose will intersect the sides of the above pentagram at the lower lobe of the ears. Vertical lines ruled from the points marked $\frac{4}{5}$ will pass through the outer extremities of the eyes, and vertical lines on $\frac{2}{5}$ will give the width of the head. If the progression of the angle of 60° is now added in the circle giving the length of the head, the first progression will place the base of the nose, while the third progression decides the width between the eyes, the width between the lobes of the nose, the width of the under lip and that of the chin. The ideal angle of 48° ruled from the poles of the outer circle at 0° will pass to the upper quadrant of this circle at the points I, and vertical lines ruled from these points will also render approximately the same widths of the eyes, nose, under lip, and chin; and the same angle ruled from the lower pole of the outer circle will pass to the points Io, the horizontal side placing the bottom line of the eyeballs. This governing plan of the pentagon produces the great extreme and mean ratio in numerous places in the diagram. It may also be noted that the ideal angle of 48° ruled from the top of the forehead at its centre $+$ will pass to the point M where a horizontal will place the bottom of the lower lip.

The side view of the head of "Hermes" is quite as remarkable in its relation to the angles of the pentagon, for if a measured drawing is placed in the same plan as that in the foregoing plate the correlating parts marking the proportional spaces will be quite as numerous, while others are also apparent. This is done in Plate 164, and here also the radial lines from the angles of 18° (five in each quadrant) will intersect many points of the head. For example, the angle of $\frac{2}{5}$ in the upper quadrant on the left will pass through the top of the eyelid, while that of the same angle in the lower quadrant will intersect the point of the upper lip and the outer lobe of the nose. Extreme and mean ratio occurs again and again, as it must wherever the pentagon is the vital principle of the proportion of any object, one example only being given here; as from the vertical 0° at the tip of the nose to the back of the jaw where it cuts the lower lobe of the ear, which measures eight units, while from that point to the back of the neck measures five of the same units. Examined by the square, we also see interesting disclosures, for if the square be subdivided into eight equal rectangles by one vertical (U to $90°$) and three horizontals (at DK, $0°$, etc.), then the lower horizontal will place the nose and lower

lobe of the ear; the middle horizontal, the top of the eye and ear; the upper one will mark the top of the forehead, while the vertical will divide the cheek from the ear, and so on.

The astonishing correlating points in these two views of the head of Hermes make it appear more than probable that Praxiteles employed the pentagon and square in his designs, especially when we consider that the properties of the former were then well

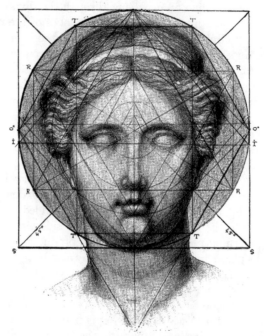

Plate 165—Venus de Milo

known. Moreover the peculiar attributes of this head being unlike any other in Greek art as an ideal creation appear to be largely owing to the influence of the angles of the pentagon; for if we take the large majority of Greek ideal heads they disclose the more pronounced influence of the progressions of the square and 60° with the pentagon much less strongly in evidence.

An analysis of a head of these proportions, that of the Venus of Milo, is drawn in Plate 165 where it may be seen that the influence of these angles is more prominent. The circle of the second progression of the square or the first progression of 60° places the position of the top of the forehead and the bottom of the nose somewhat as in "Hermes"; the primary circle corresponds to the bottom of the chin. The rectangle of 60° as at R R marks the same points, while this rectangle in a vertical position decides the placing

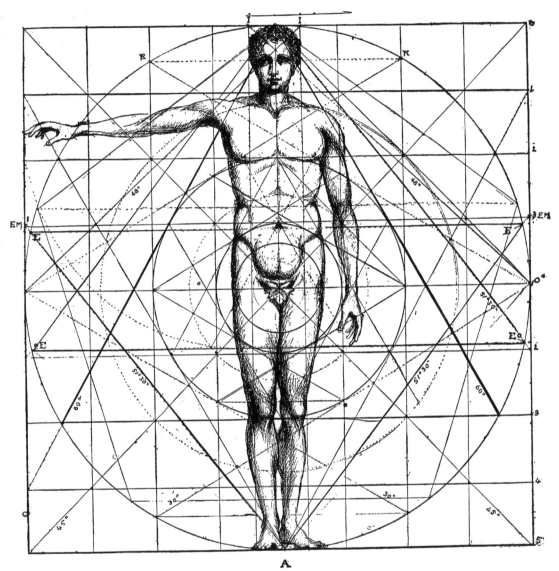

A

Plate 166—Figure of a Young Man

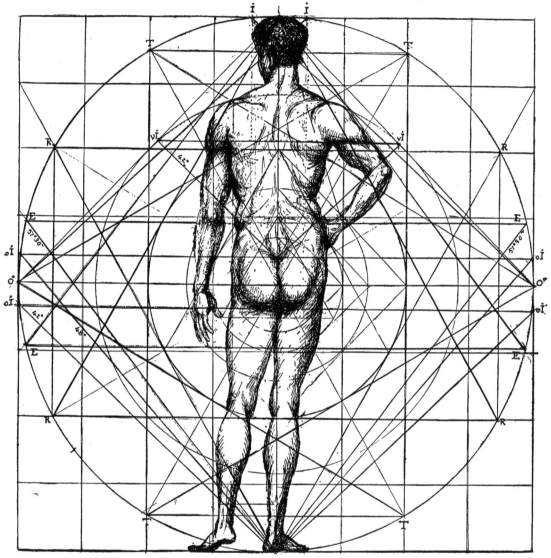

Plate 167—Back of a Young Man

of the top of the head and the point of the chin, with the width across the face where its curves intersect the base of the ears; the horizontal line $R\,R$ and the angle of 45° ruled from the corners of the square S also cut the same points. The circle of the first progression of the square decides the lower line of the under lip and top of the chin, and that of the third progression of 60° gives the width between the eyes, the lobes of the nose, the underlip, and chin. The angle of 60° ruled from the bottom of the under lip will pass to the outer extremities of the eyeball; and a circle struck from point A will place the position of the top of the lip.[1]

A full-length figure of a young man is drawn in Plate 166 according to the canon of eight heads in height, the proportions of which correspond in the different spaces to the progression of the square and the angle of 60°. The circle of the first progression of the square places the height of the shoulders; the second one of the square or the first of 60° decides the line of the nipples and lower point of knee; the third progression of the square renders the position of the top of the muscle where it cuts the side of the figure, intersecting above the oblique muscle of the abdomen; the fourth progression circle places the umbilicus; and fifth, the width between the thighs. If the Egyptian triangle of 51° 30′ is ruled from the crown of the head it will pass to the point Eo in the opposite quadrant of the primary circle from which point a horizontal line will mark the place for the extremities of the arms hanging at the sides; and if the arms are extended to their full length in their horizontal position they will just touch the side of the primary square. The angle of 51° 30′ ruled from the lower pole of the outer circle will pass to E in the upper of quadrant, and a horizontal line drawn from EM where the Egyptian triangle intersects the prime square will mark the umbilicus. This line will divide the whole figure in proportion of five parts in eight. If the square enclosing the figure is divided by eight squares horizontally and vertically placed, the horizontal lines will divide the figure into its chief proportional spaces; which principle Gwilt declares was the general method employed by the Greeks in establishing the proportions of their architecture. Finally, if the angle of 48° be ruled from the pole at 0° of the primary circle it will pass to the points i on the arcs of the same circle above, when vertical lines erected will place the width of the head and abdomen. It will be seen also that an extreme and mean ratio exists as between the height and the width of the shoulders, and that the horizontal line marking the division into this ratio will place the umbilicus in one case and the length of the arm at the side in the other. If extreme and mean ratio be again applied, it will be found to measure the relation between the width of the head at the

[1] The classic standard for the width between the eyes is the length of the eye, or a line divided into four equal parts gives three parts for the length of the eyes and the width between them. The other part is divided in half and renders the space between the outside of the eyes and the curve of the face or the line of hair. The usual standard for vertical divisions of the head is to take it as divided into four equal parts, but in many Greek heads the forehead, nose, and chin occupy the three lower divisions in equal parts while the height from the forehead to the top of the head occupies one-fifth of the length of the above spaces. The head of Venus is an example of this kind.

eyes with the width of the throat, while various other parts of the body will be found related in the same manner. The widest part of the thigh bears this relation to the narrowest part, the width of the leg at the calf with the ankle, the forearm with the wrist, the thumb with the middle finger, and so on indefinitely, and we have already seen in the examination of the head of Hermes other instances.

The back view of a young man is drawn in Plate 167, placed in a similar diagram

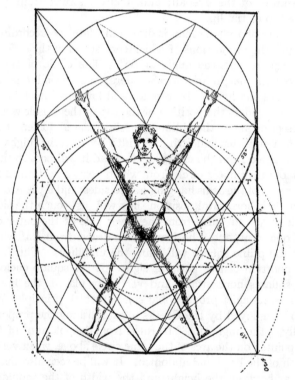

Plate 168—Young Man with Arms Upraised

and may be followed without further description except to say that the ideal angle ruled from the lower pole of the primary circle will pass to the points *oi* and *i* on this circle, from whence two horizontal lines will place the upper and lower parts of the *Gluteus maximus* muscles.

The most interesting example I can furnish in connection with the subject of extreme and mean ratio is the human figure with the arms and legs extended as drawn in Plate 168, where it has been inscribed in the square in which the angles of 58° and 63° have

been drawn as explained before. It will now be found that the upper line of this ratio intersects the umbilicus while the lower will mark the extension of the arms at the side. This plate is divided on the lines and arcs necessary for obtaining the mathematically correct extreme and mean ratio as explained in the passage on that subject, and the width of the shoulders, position of the umbilicus, size of the head, and length of the arm will be found to correspond to the rules laid down, while the instances of this proportion,

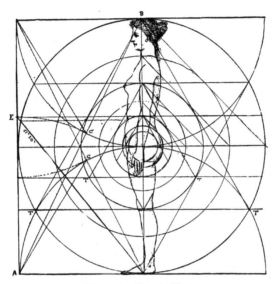

Plate 169—Female Figure

to which attention has been called in previous explanations, will be found repeated in the plate before us.

The side view of the female figure is drawn at Plate 169. This is in the proportion, of eight heads in height, and in this example the progressions of the square have been indicated. It will be noted that here again the horizontal drawn from the Egyptian triangle places the umbilicus and the length of the extended arm.

The student has but to turn to his human companions or to the best in sculpture to make such investigations as will satisfy him beyond all cavil of the truth of the conclusions here drawn.

NOTE: For mathematical analysis of the various statements in this chapter, see Appendix, Note M—EDITOR.

CHAPTER XIII

FORCE[1]

IN the preceding chapters, the examination of the principles enunciated has been confined to the materialistic side of Nature and has necessarily restricted itself to form only, for it will be clear upon a moment's consideration even to the non-scientist, that sound, with its art of music, and light, with its wealth of color, are vibratory and belong to the realm of *force*, along with gravitation, heat, and other forms of energy. For sound and light, like all other evidences of motion, are without substance, transitory, and illusive. They possess none of the properties of matter, are not subject to contraction, expansion, or cohesion; have neither length, breadth, thickness, nor other material attributes, being, as we know, the result of mere undulations and recognizable by man through the nicely adjusted nerve senses furnished to him by his Creator only as they set the ether, air, or other material substance in motion.

The examination of *force* therefore must proceed on a somewhat different basis from that employed with matter, since the latter can readily be measured, weighed, and compared, while the calculation and form of motion are not so obvious. Notwithstanding this, we know that Nature is quite as uniform, harmonic, and precise in her regulation of *force* as elsewhere, and we know as well that in many ways *force* responds much more readily to purely geometric laws than does matter.

In times gone by—indeed, if we may believe common report, in times quite recent, —alchemists have burned the midnight oil in searching for the "philosopher's stone" which should transmute all base metals into virgin gold. The idea was impossible, academic, a chimera, the child of that wish which is ever father to the thought, to be classed with the pursuit of perpetual motion and forever dismissed. Not so, however, the transmutation of *force*, for science teaches us in the study of *correlation of force*, that, given the proper conditions, energy can be and constantly is changed from one form into another,— that heat, light, and sound are so closely allied, so utterly harmonic, that, despite the complete difference in their form as it is recognized by the physical senses, they are, one might almost say, mere variations of the same thing. They have their distinguishing features, since segments of vibration are not all in the same direction

[1] Chapter by the Editor, including drawings and extracts from other papers by him.

184

nor of the same powers, but these are questions which cannot be taken up here, nor do they concern us now. The point of interest is the fact of their absolute unity, their subjection in great part to the same harmonic laws and system which control matter, and the possibility of their correlation by being transformed one into another.

Sound cannot be measured with a foot rule, nor color with a circle, yet comparisons of the forces of sound and light can be made, their harmonies distinguished, and the laws governing them compared with those geometric laws by which material forms are controlled.

Let us, for example, note the striking similarity between a few of the laws governing sound, light, and gravitation; and for this purpose I do not ask the reader thoroughly to understand either the derivation of the law nor the mathematics necessary to chain it to science. The comparisons which are to be introduced will be symbolized for the purpose of making them clear.

Newton, after a life of theory and experiment, evolved certain formulæ for the measurement of the force of gravity which are quite as geometric as any of the principles heretofore examined. Among them the following is universally recognized:

Rule—The force of gravity varies inversely as the square of the distance through which it is exercised.

Reduced to a commonplace statement this may be taken to mean that, roughly, the farther away from each other two bodies are, the less they will attract each other.

Bearing this in mind for a moment, we will examine a corresponding law relating to sound. For instance, it has long been recognized that the intensity of sound depends upon the velocity of the impact of the waves upon the tympanum of the ear. Our correlative law will therefore have to do with the diminution of intensity by reason of distance, and we find it to be:

Rule—The intensity of sound varies inversely as the square of the distance through which it passes.

If now we find a law governing the diminution of light in proportion to the distance, may we expect it to be in keeping?
Let us see:

Rule—The intensity of light varies inversely as the square of the distance from the luminous body.

Here we have the law governing the diminution of three of the great forces by distance from the source, and even the most cursory glance reveals the important fact that not only are they in every case, similar, but they are *absolutely identical*. Surely this is a unity worthy of consideration, and in order to insure its being understood, the operation of these laws is illustrated in a very brief and simple manner in the tabulation below, wherein it must be understood that the forms used are by no means to be taken as

A SYMBOLIC TABULATION

Showing the comparison of the powers of Light, Sound, and Gravitation in proportion to the distances exercised.

	Lines representing the distances over which forces of gravity, sound, and light are to travel in two hypothetical cases.	Measure of the respective forces at each of the two hypothetical distances.
Gravity, 1st distance		
Sound " "		
Light " "		
Gravity, 2d distance		
Sound " "		
Light " "		

Plate 170—Tabulation of Sound, Light, etc.—EDITOR.

intended to convey a shape, since force has no shape, but merely to indicate pictorially the mathematical comparison in such a manner as to be clear to all.

Again, as between sound and light, let us call to mind that while sound varies in intensity by the lateral distance through which each wave vibrates (or, so to speak, the width of the wave) it varies also in *pitch* in accordance with the rapidity of the vibration. The harmony of this law with the corresponding one governing light is instantly manifest when we consider that what pitch is to sound, so color is to light, governed in precisely the same way, that is, by the rapidity of the vibration.

Any number of other similar coincidences might be brought to the attention of the reader, were these necessary to prove the absolute harmony of the laws governing these forces, and their complete unity with the general conception of Nature's whole creative plan; but time and space preclude more than can be compassed in a brief examination of each of the forces since we must to some extent understand each before we can comprehend its laws. It must be clear, however, by what has already been said, that a unity of purpose undoubtedly exists in the laws of force such as is the result of no mere accident, and such as could be expected only in a whole harmonically arranged and consistently controlled.

Sound

In any general analysis of sound, four branches of investigation will at once present themselves for consideration: (1) as to intensity, (2) as to quality, (3) as to pitch, and (4) as to combination. Of these, the first three, it will be seen, have to do with individual sounds, the last only with sounds in groups, and some knowledge of these is absolutely essential to an understanding of the geometry of sound.

We have already examined one of the rules governing the intensity of sound, finding that the intensity varied inversely as the square of the distance away from the source. This law has been shown to be so strikingly at one with those governing other forms of force in regard to distance, that further attention need hardly be paid to it. Were we in position to go more deeply into these relations, we should find by another perfectly adjusted mathematical rule that the intensity of sound also varied as the square of the wave-width or amplitude, and new and interesting correlations would be yielded in an investigation. Suffice now to say, that put into ordinary phrase, this law means that if one string be struck four times as hard as another, its tone will be twice as loud. The two rules which we have here read would of themselves serve as the text for a series of correlating diagrams, but other and more familiar instances press for recognition, and the same may be said of dwelling on the question of quality of tone, the rules governing which are so technical as to be comparatively uninteresting. We may therefore at once pass to the more productive fields of pitch and the harmony proper.

Taking pitch first from a more or less mechanical standpoint, let us see in a few

words what it stands for. We know in a general way that what we call sound is the effect of waves of vibration, communicated through one medium or many until at last they reach the extreme inner ear where the auditory nerves translate them to the brain as sounds. Clearly then, vibrations may be fast or slow, they may be strong or weak, and these may come in any of the four possible combinations, that is, they may be: (1) strong and fast, (2) strong and slow, (3) weak and fast, or (4) weak and slow. From this statement, the vibratory difference between pitch and intensity may perhaps be more easily comprehended, since the stronger the vibration the more intense the tone, the faster the vibration the higher the pitch. Thus the one condition can be changed without in the slightest affecting the other. It follows then that in tone we may have four results exactly reflecting the four vibratory combinations, i. e., a sound may be: (1) loud and high, (2) loud and low, (3) soft and high, (4) soft and low. Let it then be clearly kept in mind that the form of the wave vibration, or its width, which indicates its strength (called amplitude) affects the intensity only, while the rapidity alone governs the pitch. Let it also be kept in mind that the human ear is so adjusted as to recognize sounds only within certain limits of intensity and pitch, but that scientifically sound cannot be said to stop at these points since the waves continue and would be recognized by other ears differently attuned as readily as they are by instruments adjusted for the purpose.

The comprehension of all of these facts and those to follow is necessary to the proper understanding of the beautiful unity between Nature's laws governing sound, and those controlling matter, for the unity cannot generally be recognized unless the law be at least known.

We must now spare a few moments to the examination of tones agreeable to the ear, the sound-art known as Music. If ten intelligent persons were asked the nature of the diatonic scale which is the basis of all present-day music, and whether the notes constituting it were chosen upon a scientific and mathematical principle or were an arbitrary selection by taste, a large majority of them would say that the choice was a mere matter of following the consensus of well-regulated taste, and had nothing whatever to do with science of mathematics, and that these would be the death of any artistic sense.

That the original choice was by reason of the general acceptation of the agreeable sense produced by the combinations or sequence of the notes sounded is doubtless true, but it is equally true that this good taste is not only the result of no arbitrary and reasonless temperamental edict nor blind following of a preconceived idea, but that it has the soundest of logic to uphold it. It has behind it, as truly good taste must ever have, whether recognized or no, substantial, scientific, and demonstrable reasons. The opinion has long prevailed that good taste is a thing so diaphanous as to escape the net of the finest definition and to defy all reason or explanation. Far from this, taste is merely the instinctive acceptance of those right and beautiful forms which have back of them, in the final

analysis, actual and philosophical reasons to uphold them. The good taste, being almost instinctive may far outstrip the disclosure of the reason, but as surely as the taste is good, so surely is there a reason behind it.

Thus we shall find that however apparently accidental may have been the choice of the intervals constituting the diatonic scale and the common chord and its inversions and a hundred rules of harmony thought to be arbitrary, all will be found with Nature's rules behind them. In this of course I do not refer to mere style of composition. That is transitory. I refer to the few fundamentals of the laws of sound which are the web and woof of all the science and art of Music, and these, I say, are the result of no capricious accident, no vague and ill-defined preference. There is behind them, as behind all such lasting foundations, real and substantial reasons, natural evidences of harmony which cannot be overlooked with impunity if we would understand Nature's government of sound, and once examined, cannot be misunderstood.

The study of psychology shows us that the human mind receives a pleasant stimulus in observing the actual occurrence of that which it has anticipated. Also, and perhaps for the same reason, we must recognize that the mind approves and is pleased with a balance, or rhythm, or recurrence in any form of motion, as it is with a sufficient regularity in fixed outline. Upon this we may postulate the explanation of many of man's most familiar pleasures,—the rhythm of music, of poetry, the surge of the ocean, the swing of the dance, the undulation of the ballet, the marching of troops, the play of color and shade, and a thousand and one others; and to these, upon examination, we shall find may well be added the harmony of tone as well as of time, since even harmony itself is dependent upon that rhythm of vibration which we shall learn is the correlating factor in pitch composition.

Analyzing pitch with a view to harmony and the construction of a suitable scale, it might easily be supposed that the two pitches or notes having the greatest number of characteristics in common (for notes have characteristics) would present the greatest unity, and hence be the most pleasing together; and this theory we shall find substantiated in very truth, for, five centuries before the Christian era Pythagoras discovered that, by dividing a vibrating string into three equal parts and fixing it at one of these nodes, the tone produced by sounding the shorter portion was peculiarly harmonic to that emitted by sounding the longer. It was indeed the octave of the lower note. Pythagoras then divided his string so that the two portions were to each other as two is to three, and again the tones, while less in unity than before, were most agreeable since they formed the tonic and dominant of the present scale. Then selecting the next simplest numerical relation, he divided his segments so that their relation was as 3 : 4, the result being another agreeable pair, the tonic and subdominant. From these experiments Pythagoras was enabled to deduce, without scientifically knowing why, a most important and perfectly reliable rule, to wit: *The simpler the ratio of the two seg-*

ments into which a string is divided, the more perfect is the harmony of the notes produced.

Pythagoras could himself plainly feel the harmony of the result, though it was long ages before any logical reason for the harmony was forthcoming. Science eventually developed the wave theories and disclosed valid enough reasons, upholding the claims of ancient Pythagoras, for she proved:

I. That the pitch depends on the rapidity of vibration.

II. That rapidity of vibration is inversely proportional to the length of the string.

And from these she proved that in Pythagoras' experiment, the pitch and vibration varied in proportion with the ratios of length.

It follows therefore that in the first case, the longer portion of the string being twice the length of the shorter, the notes were a so-called octave apart and the vibration of the upper was at a rate precisely twice that of the lower. In other words every other sound wave or vibration of the upper note was exactly timed to and coincided absolutely with a vibration of the lower, and this will be recognized as a matter of no small moment when it is realized that saying this is equivalent to stating that in the case, for instance of C^2 and its octave, the enormous number of five hundred and twenty-eight vibrations per second would coincide.[1]

This uniformity of the octaves appeals so strongly and undeniably to the ear and mind, that it has long been characterized separately, for all movements written or performed by various voices or instruments in octaves are said to be in *unison*. Why this unison should be agreeable to the ear has been cause for endless speculation. Euler had theories concerning it, Helmholtz explained it in a highly scientific manner utterly beyond the untrained mind, but whatever the theory, it is plain to any intelligent reader that the less clash there is in vibration the more reasonable it is to expect a pleasant consonance as a result, and we find that the facts exactly carry out this theory.

To test this, we will proceed to Pythagoras' second experiment where we see at once upon examination, that by his division into ratios of 3 : 2 the shorter string emits a note now known as the dominant or fifth of the longer tonic string, and that the vibrations were three of the upper in the same time-space covered by two of the lower. In other words, every third wave of the shorter string coincides with the second wave of the longer; and we may proceed in the same way to construct the subdominant with a ratio of 4 : 3, the mediant with a ratio of 5 : 4, and the sixth with its ratio of 5 : 3, and other members of the scale.

If the reader will have the patience now to glance at the tabulation which I have compiled to illustrate these facts (see Plate 171), he will instantly see why the tonic, mediant, dominant, and octave concur in the long recognized triad or "common chord," and why the tonic, subdominant, sixth, and tonic are also agreeable, and why the dominant

[1] English Philharmonic standard.

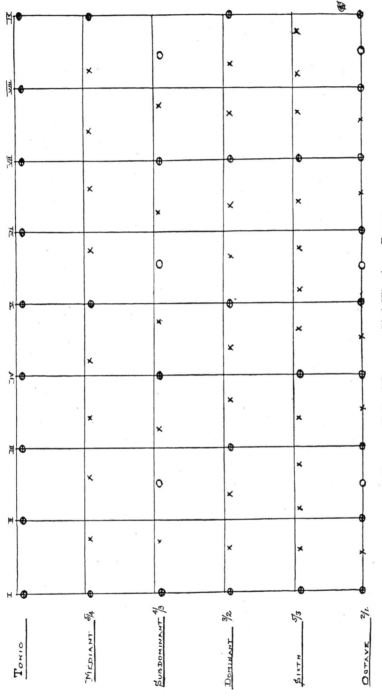

Plate 171—Table of Concurrent Pitch-Vibrations—EDITOR.

Vibrations concurring with Tonic are indicated by the cross-circle
Vibrations concurring without Tonic are indicated by the circle alone
Vibrations non-concurrent are indicated by the cross alone

and subdominant, each of which accords or harmonizes with the tonic, are discordant when sounded together. All of these statements are true, all are in absolute keeping with our theory based upon the coincidence of vibrations, and all are deducible with perfect clearness from our tabulation. An instant's examination shows that the tonic, mediant, dominant, and octave (constituting the common chord), *all* concur on every fourth wave-beat, or on lines 1, 5, 9, etc., in the tabulation, the dominant and tonic meanwhile having made additional concurrences and the tonic and octave still others, so that in this common chord, in every four vibrations of the tonic there will be one wave-coincidence of the mediant, two of the dominant, and four of the octave. Could result ever follow theory more closely, or be more mathematically perfect?

Expending now a moment on the inversion of this chord presented by the simultaneous sounding of the tonic, fourth (subdominant), sixth, and octave, we find it, as we should expect, slightly less harmonious and pleasing than the former. For while the *fourth* and *sixth* concur in every fourth wave-beat as shown on lines 4, 7, etc., of the tabulation, yet there is no intervening concurrence of the sixth with the tonic, corresponding with that of the dominant in the previous case.

All of this must be accepted as proof that even in the musical scale and common harmony, there is much besides mere chance and that the result is tuneful because it could not logically be anything else.

Accepting now the diatonic scale as something more than accident, let us apply to it one or two of the laws of the geometric measurements, for it must by this time be clearly seen that the laws of sound, like those of all force and motion, are part and parcel of the kingdom of polar force, and we shall find many exact correlations on examining Plate 172 which I have prepared for the purpose of illustrating the subject.

With the most accurate mathematical measurement, the relation of the prime circle T^3 to that of the first progression of the equilateral triangle at T^2, by their respective diameters, represents vibratory difference of exactly the octave which we have been studying, while the second progression of the hexagon at D^2 represents the dominant of the same tonic, and this with the utmost nicety and precision, as has been carefully figured by the actual ratios of vibration superimposed upon a trigonometrically calculated diagram of the progressions, thus achieving an accuracy far beyond the limits of the drawing which is nevertheless the only means of illustrating the subject.

Examining Plate 172 we see that the vibratory rate of our supposed tonic is measured by the distance from T^3 on the one side to T^3 at the other end of the diameter of the prime circle, while the vibratory rate of the octave below is measured by the line T^2 to T^2. Inspection shows that this latter is the diameter of the circle of the first progression of the equilateral triangle, and is therefore, as it should be, octant to the T^3 diameter. In order to make the matter clear to the reader without the use of logarithms and all of the paraphernalia of scientific measurements, a scale has been added to the diagram so

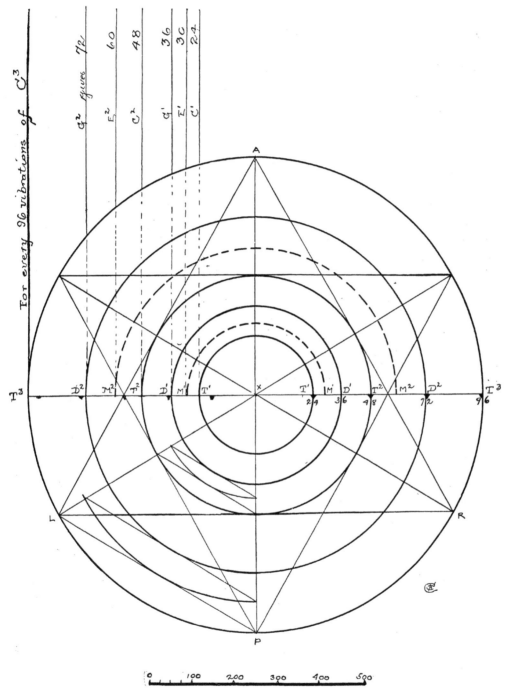

Plate 172—Geometric Diagram of Pitch Intervals—EDITOR.

193

that it could be put to an illustrative test. Let us substitute the actual note C^3 for our hypothetical tonic. Then by the scale of measurements we shall see that the distance from T^3 to T^3 represents 1056 units of this measure, and this corresponds with the number of vibrations per second necessary to produce the note C^3. Measuring again, we find that from T^2 to T^2 equals 528 of the same units, or just half. This we recognize immediately is the octave below, or C^2. Again measuring we find that from D^2 to D^2 is an almost imperceptible amount less than 800 units, giving us accurately the ocular equivalent of the note G^2 which of course is the dominant of the tonic C^2 and is in fact produced by 793 vibrations per second. We may go further and add between these at M^1 and M^2 the measure of the vibration causing the mediant, by dividing the radius $X-T^3$ into extreme and mean proportion at M^2 or the radius $X-T^2$ into the same ratio at M^1 and so producing the circles representing the mediants E^2 and E^1 for our tonic C. The interesting mathematical accuracy with which these statements are true can only be disclosed by recourse to the dry process of calculation which probably would not interest the reader but which is demonstrable nevertheless.[1] All of the rest of the notes of the present standard diatonic scale might be analyzed with equal interest, but lack of space forbids more than has been shown, and if from this it has been made clear that the laws of pitch are geometric and are persistently similar to those which govern outward form, my object will have been attained.

That the vibrations of sound follow the laws of polar force can be further ocularly demonstrated by the observation of Chladni's experiments. Taking a glass plate clamped in the centre he scattered fine sand over the surface and set the waves of sound vibration in motion by drawing a violin bow across the edge. The grains of sand were thus agitated, and seeking rest at the points where there was least motion of the surface of the plate, formed themselves in clusters and lines along the nodes, thus showing clearly to the eye the lines between the ventral segments. The forms taken by the lines of sand will thus always agree with the nodes, while the bare spots will indicate the portions most agitated. The pattern thus formed may be frequently varied at the will of the experimenter by the means of damping the edge of the plate in one or more spots, thus causing intervening nodes to occur, which will always be repeated by the vibration at other correlative points so that whatever be the position of the dampened node, the diagram of the sand after vibration has ceased will invariably be found perfectly geometric, with straight lines and curves at perfectly balanced distances and showing features in many instances distinctly similar to those exhibited in the forms of crystals and other bodies governed by polar force. A number of the patterns thus produced are shown in Plate 173 having been taken from personal experiments as well as from drawings made by various authorities.

Where the plate is round, the pattern closely resembles the known vibratory effect

[1] English Philharmonic Standard. See details in Note N, in the Appendix, on Force.—EDITOR.

of the tolling of a bell, the use of the violin bow corresponding to that of the tolling hammer. If no artificial segment be introduced by damping or otherwise, the point struck by the hammer or sounded by the bow will always be found to be the centre of a

ventral segment, the circle dividing itself automatically into four nodes at equal distances, the point of impact being always the centre of one of these. The vibrations of the round plate differ somewhat from those of the bell in the fact that the former are vertical, so to speak bending the horizontal plate in curves, while the vibrations of the bell are of course lateral, bending the walls into ellipses, crossing at the nodes. These features are illustrated in Plate 174 showing the round disk and Plate 175 showing the bell.

If now the same experiments be tried by sounding the bow on the edge of a bell glass filled with alcohol as in Melde's demonstration, the wheels or spherules formed by the agitation of the surface of the liquid will be found to gather on the nodal lines in precisely the same way. Any number of further combinations may be tried, all beautiful and always with the same result,—the formation of a geometric pattern following perfectly along the lines of polar force, with the angles of 45° and 60°, the formation of squares, triangles, and hex-

Plate 173—Chladni's Experiments

agons, with innumerable catenary curves, exactly as could and must be predicted

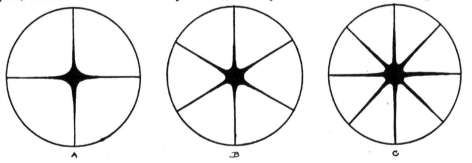

Plate 174—Patterns on Round Disk

from the study of the subject, even in the absence of demonstration. Nor, should it be borne in mind, are these vibrations so powerless as might perhaps be supposed,

as it is quite possible to shiver a long glass tube into exact segments by the mere application of sound waves.

Limited as is the space permitted to the subject of force in a work of this kind, I have devoted a generous proportion of that space to the branch of Sound for the

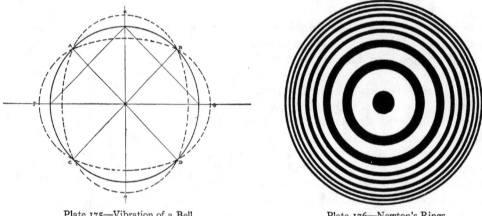

Plate 175—Vibration of a Bell Plate 176—Newton's Rings

reason that sound vibration is more familiar to the general reader than the laws governing the other forces, and the combination of sounds in the musical "common chord" would be much more likely to be comprehended than the combination of the primary colors in a composite effect. A few interesting facts concerning the other forms can be set down briefly, in order to emphasize the fact that the laws governing all of the forces of Nature are perfectly harmonic and, in many instances, as we have seen, absolutely identical.

Plate 177—Patterns by Heat

Light

In the examination of the laws governing the vibrations of light we may safely assume, from what we have already learned, that we shall find a great similarity in operation between these and the laws of sound, and in this we shall be amply justified.

Let us first, then, understand that the intensity of light, like the intensity of sound, depends upon the strength of the wave, while the color, like the pitch, depends upon the rapidity of the vibration regardless of its intensity. Having examined the corresponding laws as to sound it will not be necessary

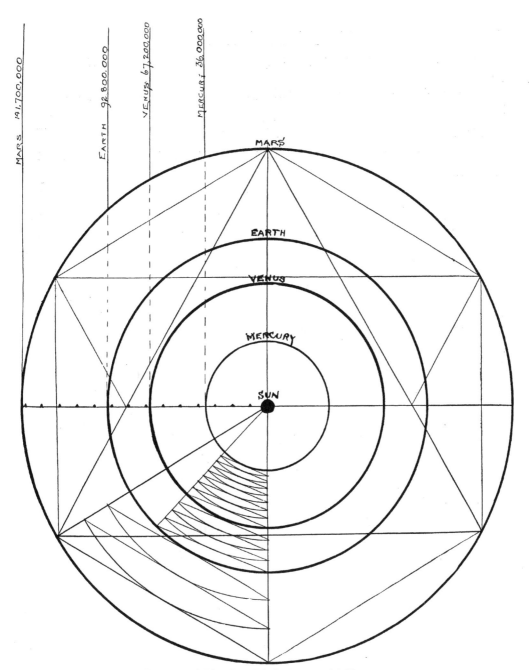

MARS 141,700,000

EARTH 92,800,000

VENUS 67,200,000

MERCURY 36,000,000

MARS

EARTH

VENUS

MERCURY

SUN

Plate 178—Orbits of the Inferior Planets with Mars

197

to examine these again in detail, but only to state the conclusions which may be drawn.

Our examination shows us the following parallels which are too striking to be overlooked:

(I) The intensity of both sound and light depends upon the strength of the wave of vibration;

(II) The intensity of both sound and light diminishes with the distance from the source, *one rule governing the ratios of both.*

(III) Both pitch and color are governed by the rapidity of the wave of vibration. The one being sound while the other is light.

We noted in our examination of sound that science does not recognize the limitations of the human ear in receiving vibrations as the termination of sound or the laws governing it. So in the case of light the human eye is attuned to the acceptance of vibrations covering approximately one octave only,—which is to say that the shortest visible ray, the violet, compares in rapidity with the longest visible ray, the red, about as one is to two. The whole compass of the subject of light, taken from the viewpoint of rapidity only, would fall compactly within the measure of one progression of the equilateral triangle, typifying the octave.[1]

It has been noted by many authors that color has its primaries as the sound scale has its dominant and mediant, and these relations are not without truth and value, for as surely as the remaining colors of the spectrum can be produced from the primaries so can the other tones be produced from the tonic, dominant, and mediant. For illustration, the note G is the dominant of the key of C, but if we use G itself as a tonic, and measure its dominant we shall have arrived at the note D which is an entirely new tone, and this is precisely the correlative of the process by which red and green lights (not pigments) may be made to commingle in the production of yellow and is similar to any of the other familiar combinations of primary colors.

By the use of the polariscope and other means at the disposal of the scientist, the patterns of interfering light rays may be recorded in infinite variety. Always, however, they will be found to be harmonic, balanced, geometric, and well illustrating the laws of polar force. Space permits the insertion of only one of these illustrations, taken from the experiment of Newton in which he permitted a film of air to lie between the face of a convex lens and a sheet of glass. The proper observation of the ray emitted in a monochromatic light shows rings or bands as illustrated in Plate 176. These are known, in compliment to the discoverer, as Newton's rings and whatever be the light used, or the combination of lens and air-film, the pattern invariably is one of perfect gradation and symmetry.

A comprehensive comparison of the color rays, the rays which escape the power of

[1] See Appendix notes on Force.—EDITOR.

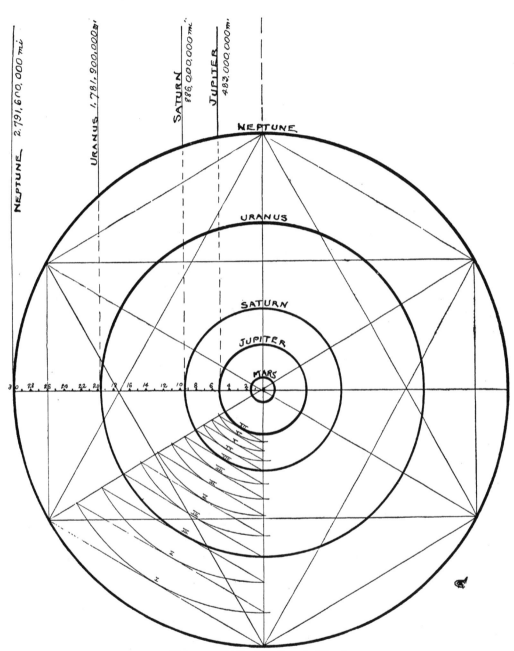

Plate 179—Orbits of the Superior Planets

The numbers on the horizontal diameter are astronomical units or multiples of the distance of the earth from the sun, and are not measurements of miles.

the eye by being either too rapid or too slow, the interferences of rays shown by the polarization of light and kindred subjects, would be of great interest but involves a considerable knowledge of the intricate laws governing these branches, and enough has been shown to clearly prove not only that the various forces are governed by laws mutually correlated,—for this must be accepted if we are to credit the demonstrations of those learned in these sciences,—but further, that these laws are logical applications of those generalizations by which Nature not only governs motion, but creates her myriad forms as well.

Heat and Radiant Energy

Science having now accepted the statement that in many ways heat and light are identical, we may relieve ourselves of the necessity of going deeply into this branch, which presents great complications.

One or two illustrations, however, of the geometric patterns created by the effect of heat will not be without interest. These are produced by applying heat symmetrically to a glass plate which is thereby unequally expanded, introducing areas of strain and pressure. If these be examined with the aid of polarized light, the pattern produced will be perfectly geometric and follow the laws we have been examining, showing that the pressure fractures caused by the heat denoted the presence of heat waves along these exact lines. Plate 177 illustrates this, the drawing being taken from Tyndall, though any number of patterns may be observed by those performing the experiment.

Gravitation

It has already been demonstrated that at least one law of gravitation is identical with the law of sound and light, and it is by the operation of this very force of gravity that a large number of the most beautiful forms in Nature, defined by catenary curves, are governed.

The forces of gravity and inertia combine to control in general the entire sidereal system, and in no possible field could we look for the revelation of harmony in natural laws with greater assurance of success than among "the stars in order, twinkling in the skies." These disclosures, however, are not easily explained or symbolized without long study because of their complications, and we shall examine only a few facts best illuminating the harmony of the whole.

For this purpose I have drawn Plates 178 and 179: in which we shall see that the intervals between the inferior planets can be readily and correctly platted out by the progressions of the octagon and those of the superior planets by the use of the hexagon. I need hardly say that the orbits as illustrated are the circular equivalents of the various ellipses,—the distances being compared by the mean vectors. Examining them we should

find, if we compared the actual trigonometrical measurements of the progressions with the astronomical distances, that, as in the case of pitch, the mathematical correlations to which attention is called were true beyond the hope of perfect depiction in a drawing.

We know, for instance, that in round numbers, Mercury is 36,000,000 miles in mean distance from the sun and Venus 67,200,000 miles, while the earth is 92,800,000 miles away. All of these comparisons are shown on Plate 178, sustained by the mathematical calculations of the progressions themselves.[1] In Plate 179, we continue from Mars outward through the planetary system to Neptune at his enormously remote position of thirty times the distance of the earth from the sun, yet all is clearly shown by the diagram with a correctness quite sufficient for the purpose.

These illustrations might be multiplied indefinitely, but opportunity permits only the rapid survey which has been made. Enough has been developed, however, to show beyond doubt the homegeneity of the laws governing matter and those controlling force.

[1] For the details of these statements, see Appendix, Note N, on Force.—EDITOR.

CHAPTER XIV

ON ARCHITECTURE

A LARGE number of forms in Nature such as crystals, flowers, and shells have now been analyzed, and in this investigation it has been disclosed that their proportions are all easily produced by various harmonic progressions which we have been examining. The latter always have a perfect result either in themselves or as a check and verification of each other. As these geometric principles control the growth of plants and so many other objects in Nature, it naturally follows that man should employ them when he seeks to construct forms of beauty either in architecture, sculpture, or other design. Our investigation has been conducted for purposes of proof, for no theory can be of lasting or convincing value without the direct sanction of Nature. When it is stated that the harmonic progressions, with the great rationic series produce just proportional spaces, a justification for the statement must be forthcoming. We continually see it written that some great building "is in perfect proportion," but the reason *why* this is true is never given. If now we can give some example from Nature with her absolute accuracy, the comparison will be of immediate value; and by studying the same authority we can understand the causes which led the immortal architects of past ages to employ the Pythagorean, Egyptian, or other perfect triangles as a constructive form in their work; for although the knowledge of the modern botanist was then long distant, still, these men understood the value of geometric principles as Nature applies them, which was practically the same thing. We therefore find that the triangles and rectangles herein described, enclose a large majority of the temples and cathedrals of the Greek and Gothic masters, for we have seen that the rectangle of the Egyptian triangle is a perfect generative medium, its ratio of five in width to eight in length "encouraging impressions of contrast between horizontal and vertical lines" or spaces; and the same practically may be said of the Pythagorean triangle.

It is hard to say where in Nature to look for the *best* examples of the evidence of the principles of these triangles, but they are almost innumerable; and many of these have been carefully analyzed in previous chapters. As being specially illustrative of the great triangles and rectangles which are the basis of all architecture I would again refer to

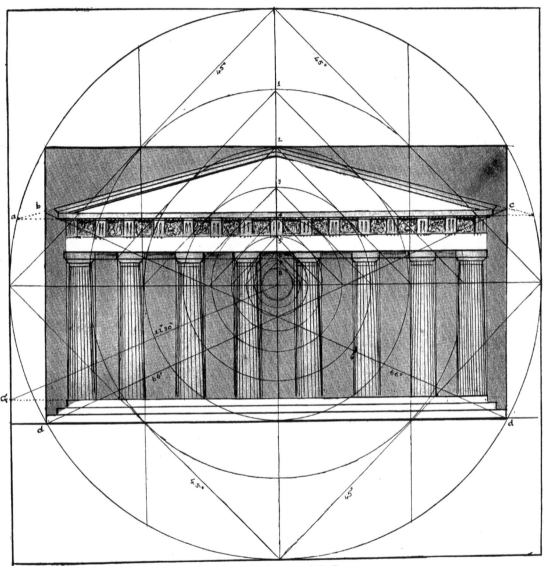

Plate 180—Parthenon and the Square
(Correlations by Mr. Hambidge)

Plate 97, showing the several varieties of nut fruition, this being a perfect commentary upon the point which I wish to impress.

Looking again at the diagrams D and F which, as we saw, are inscribed in the rectangle of 60°, we remember that this is the rectangle inscribing the portico of the Parthenon; and Mr. Hambidge's drawing of this subject is reproduced at Plate 180

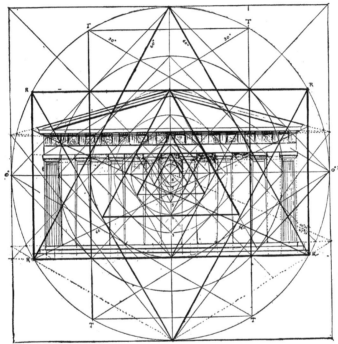

Plate 181—Parthenon and Equilateral Triangle.

wherein his method for obtaining its proportions is rendered. These result from the regular progression of the square, the eighth circle placing the width between the two central columns, the primary circle escribing the rectangle producing its length, and the circle of the second progression placing its extreme height and also defining the position of the inner line of the next to the last columns; the fourth circle places the lower line of the dentils on the line *a*, while the line *b* decides the base of the pediment which is confirmed by the angle of 66°, the diagonal of the ground plan. The circle of the fifth progression decides the position of the triglyphs and metopes or the divisional line of the entablature; the sixth circle decides the lower line or the architrave; the seventh places the underside of the abacus. The diagonal line of 22° 30', or the harmonic half

of the angle of 45° ruled from the centre of the plan to G on the side of the primary square, renders the top of the platform. By this method Mr. Hambidge has produced the chief proportions of this portico to within a minute fraction of the "Penrose" measurements which are now considered by the best authorities to be the most perfect.

There is probably no other work in existence by the hand of man, where the correlation of the parts is so remarkable and where the harmony is so complete with the various angles of the trinity of the polyhedra and with the spaces of the building itself; for if we place a tracing of the portico in the progression of 60° of the equilateral triangle as in Plate 181, these angles in the primary circle decide at once the rectangle RR in which it is inscribed, the position of the main cornice, the underside of the architrave, and the distance between the central columns. If we place it in a similar plan as in Plate 182 and add the angles of 51° 30′ of the Egyptian triangle drawn from the main points of the primary square and circle, and also at other principal points, then this triangle as so drawn will be correlated with the proportional spaces of the portico.

The angle of 51° 30′ in this plate ruled from the lower pole of the primary circle will pass to the points E, its horizontal side resting on the lower line of the dentils under the main cornice, and a line ruled from E to the apex of the roof at the centre of the upper line RR will be that of the raking cornice on the angle of 14°, just as the same angle meets the horizontal of the upper line of dentils in Plate 180. If the angle of 51° 30′ is ruled from the upper pole of the same circle it will intersect the former line of the same angle at the point dividing the width of the colonnade or that part of the portico above the platform. The same angle again ruled from the corners of the primary square at S will pass to the points T of the main rectangle correlating this in its upright position. The lines on the angle of 51° 30′ from the upper corners SS and from the pole U as well as the vertical T all intersect to confirm the position of the upper side of the raking cornice, and again, if the angle of 51° 30′ is ruled from the centre of the stylobate it will pass to e on the upper line R, intersecting e at a point where a vertical line will decide the width and height of the portico, enclosing these in the rectangle of the Egyptian triangle with its ratio of 5:8. The dotted circles are on the progression of 51° 30′ or from A to E, being related to each other by their radii in the ratio of 5:8.

One of the primary principles of the architecture of the Greeks and always strictly adhered to, was that of composing the raking cornices of their buildings by employing an angle which would be correlated with all parts of the work, as is strikingly illustrated in this portico and described in Plate 183, where it is shown that this cornice on the angle of 14° is closely related to the building in many harmonic ways, and that if ruled from the pole of the circle of the first progression of 60° at the apex of the roof it will pass to E. The angle now reversed will intersect the centre of the plan at A and produced beyond will intersect E in the opposite quadrant, and again drawn from this point passes out of the lower pole of this circle dividing the height in two equal parts. If the angle of 14°

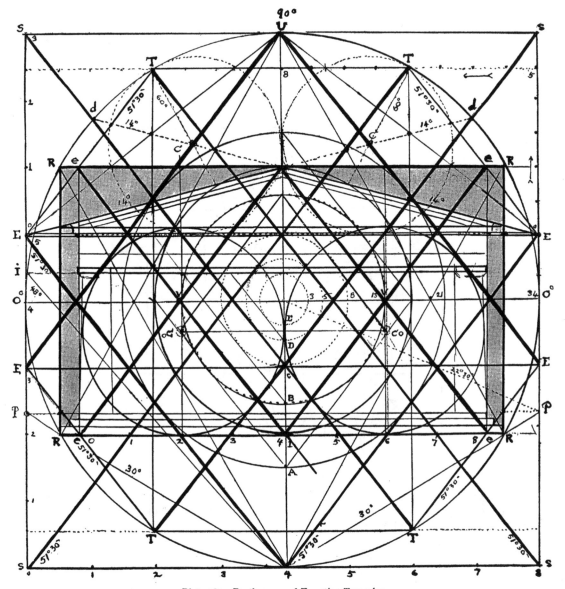

Plate 182—Parthenon and Egyptian Triangles

is again ruled from the upper and lower poles of the primary circle, as shown in the plate, then the various angles of 14° will be found in exact correlation with numerous proportional points of the composition; and if again drawn from the extremities of the cornice itself at the points a, reversed it will cut A, in the line of the echinus. This reversed angle of the raking cornice characterizes all of the Greek temples. The same principle also obtains in their ground plans, which in this edifice is that of 66° as before stated,

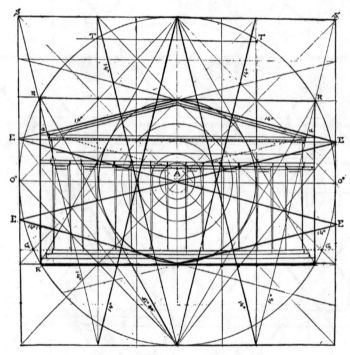

Plate 183—Parthenon and Angle of 14°

and if this diameter is ruled across the face of the portico, as in Plate 184, it will disclose a similar unity and correlation of parts; for if this angle is ruled from the upper pole of the primary circle it will intersect the vertical line d, at the architrave on the horizontal line MM.

If the angle of 66° is drawn through the points R in the lower quadrant it will pass to N at the junction of the raking cornice and the vertical line R, intersecting in its course the architrave where it is joined by the second column. If the same angle of 66° is ruled across the centre of the plan, it will cut the third column at the line of the architrave in the upper quadrant, and the points G in the lower one where it crosses the outer

circle, the horizontal line G placing the top of the stylobate or platform. The position of the platform is not only decided by this angle of 66° but is confirmed by the harmonic angle of 22° 30′ drawn from the centre of the plan to the outer square and also by the angle of 30° drawn from the lower pole of the primary circle to the same point. If the angle of 66° is drawn from the points e in the upper quadrant it will pass to p at the centre of the lower line of the architrave. As this angle of 66° constitutes the diagonal of

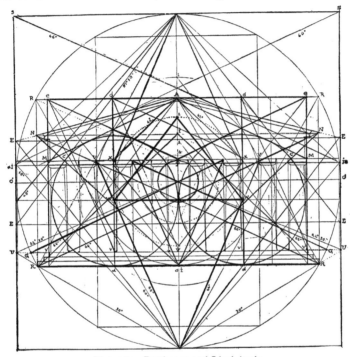

Plate 184—Parthenon and Ideal Angle

the rectangle of 42° of the ideal angle and the ground plan of the Parthenon, it naturally follows that its influence on the proportions of the portico must be in evidence. We shall not therefore be surprised to find that the most important one of these rectangles is seated on the points NN and RR, while the angles of 42° extend from the same point R to i in the lower centre of the pediment and from N to oi in the centre of the base; also that the same angle is repeated from ai on the line producing the under side of the abacus to s at the corner of the square above, while other examples of the same rectangle of 42° will be found indicating the points dx (with the angle of 42° at Ax) and on the points ed-vv, Ad-vv, and eM-Ap.

It has already been shown in Mr. Hambidge's drawing how perfectly the progressions of the square produce the proportions of this portico, and Plate 185 is now added, in which the square, placed in different positions, also renders the chief proportional spaces, for if the square of the second progression is produced to the prime one at the points *C* it will render the height of the portico, and if the sides of the square of the third progression in the oblique position, as inscribed in Circle *2* be produced, the diagonal

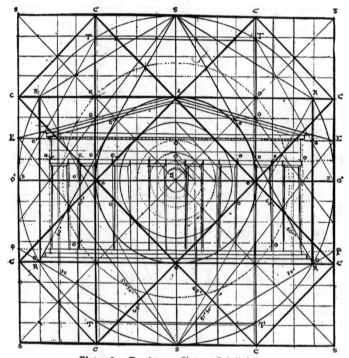

Plate 185—Parthenon, Sixteen Subdivisions

lines of 45° ruled from the points *C* will create five squares, the central one of which will correspond to the height of the portico and the width of the columns next to the extremities of the colonnade. This combination will also render sixteen squares of equal proportions, and if each one of these is subdivided into sixteen smaller ones, numerous intersecting points will be produced dividing the portico in proportional ratios, as at the points *o*. This principle is already noted and corresponds with Gwilt's methods.

If the regular progressions of the angle of 18° of the pentagon are also placed to correspond with the primary circle escribing a tracing of the portico of the Parthenon, it will be found that the proportional spaces established by this progression will, in new

points, be in unity with the façade, and perhaps quite as interesting as those above described. It is not represented here, however, for want of space. Those I have already given are sufficiently remarkable to justify so long a dissertation, entered into with the view of showing conclusively that the arrangement of geometric and harmonic sequences

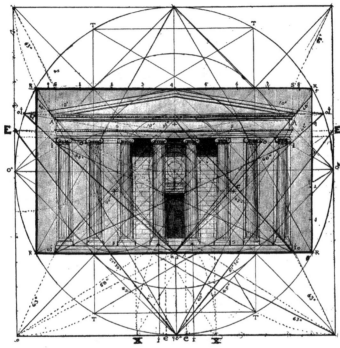

Plate 186—Temple of Aphrodite

and angles according to Nature's plan constitutes a system leading to perfect and exact results in architectural design.

That this system is not confined to the Parthenon may be proven by applying it to other temples of the same Greek orders such as to the Ionic temple of Aphrodite, Plate 186, which like the Parthenon is of the octostyle order, but with proportions quite different though equally controlled by a harmonic system. In this example the portico has been drawn in the rectangle of the hexagon, which produces its height, while the width of the base line is established by the angle of 48°, starting from the under side of the main cornice at X and continuing to the lower point i, while the extremities of the raking cornice are decided by angles of 48° from the point ai, cutting in its course the side of the outer capital next to the architrave. The colonnade

is inscribed in the rectangle of 42° of the ideal angle with the diagonals of 66°, and included in the points *i*, the latter angle of 66° intersecting the angle of 42° on *ai*, *oi* at the corner of the outer abacus on *i*. The line *ai*, *oi* is harmonic with the raking cornice on the angle of 10°. If the side of the square in its fourth progression is produced it will pass through *C* to the lower line of the stylobate at *i*, the points *C* being the centres of

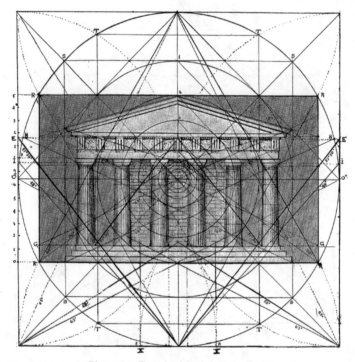

Plate 187—Temple of Jupiter Panhellenius

the circles which divide the colonnade into two squares from the top of the architrave to the base line, and the angle of the raking cornice reversed from its extremities will cut the upper line of the architrave at its centre. Other points of unity might be cited interminably, but these will easily serve to uphold the position.

If we now employ the great extreme and mean ratio to the portico of this temple, we shall find that in this case the architect placed the four columns in the centre, with relation to this proportion, as at the points *X* and *e*, while vertically it will be found to mark the line of the dentils.

The portico of the Temple of Jupiter Panhellenius at Ægina more lately ascribed to Aphaea is represented at Plate 187, this being of the hexastyle order, and if this

edifice is drawn in the rectangle of 60° to accord with its height, then the angles of 42°/48° of the ideal angle and the diagonals of 66°/51° 30′ of the Egyptian triangle, 36°/54° of the pentagon, 45°/90° of the square, and 15° of the hexagon, drawn across the face of the diagram, will produce and verify all of the important proportions by their intersections. The angle of 15° of the raking cornice ruled across the arcs of the primary circle, where it is intersected by the angle of the Egyptian

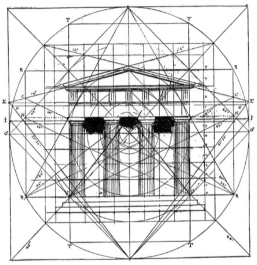

Plate 188—Tetra Style Order

triangle from the lower pole, will yield the horizontal line determining the tops of the metopes, while *EE* will decide the position of the lower line of the main cornice. If the angle of 66°, drawn from the points *H*, be produced it will pass to the outer extremity of the stylobate cutting the corner of the outer capital at the upper line of the architrave. If the same angle is ruled through the centre of the plan it will pass to *G* on the vertical line *R*, and *GG* joined by a horizontal line will place the top of the platform. The angle of 48° produced from the lower pole of the outer circle to the points *i* and *ii* and these joined by a horizontal line will decide the position of the under side of the abacus, while if the entire rectangle *RR* be divided into fifteen squares long by nine high, then eleven of these squares toward the centre will divide the columns and intercolumniation into equal parts, while six in a vertical position will render the height from the base to the lower line of the triglyphs. The points *o*, *oi*, and *v* disclose further proportional spaces. If the extreme and mean ratio be now applied by its angles of 58° and 63° in the primary square, it will place the points *X* measuring the two intercolumnar spaces and thus

it will decide the width between the columns, while vertically measured it will be found to indicate one half of the height at the portico.

Another Greek temple is drawn in Plate 188 and is in the tetrastyle order. Here, again, the same angles render its proportions, though of course not in precisely the same correlation, and substituting the angle of 14° in place of 15° for the raking cornice. In

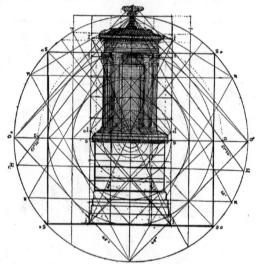

Plate 189—Choragic Monument

this case the ratio of 5 + 8 occurs in the space between the platform and the entablature, and from thence to the top of the pediment, the latter occupying three divisional spaces and the former five in height to eight in base. The colonnade itself is just escribed by the rectangle of 51° 30′, with this ratio of height to length of 5 to 8, its horizontal side on the points v, and if the angle of 66° is ruled from the points R it will pass to c at the intersection of the angle of the raking cornice and the vertical line R. The horizontal side of the larger Egyptian triangle on EE establishes the under line of the metopes, while its intersections with the prime circle e place the lower line of the triglyphs. The spaces enclosed by the horizontal line NN and the lower one of RR constitute a rectangle of 42° of the ideal angle, while many other interesting points may be found upon inspection.

The beautiful choragic monument of Lysicrates is represented in Plate 189, disclosing the fact that the same harmonic combination of angles renders its proportions, the circles on the progressions of the square indicating many of the spaces. The circle of the first progression on the points So, os gives the height from the base line to the

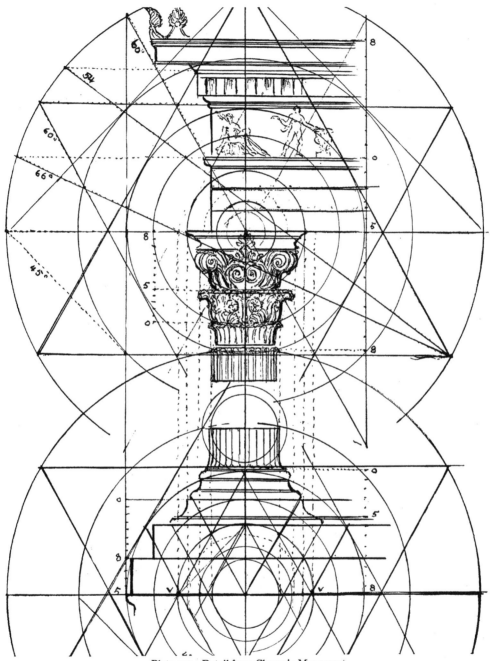

Plate 190—Detail from Choragic Monument

entablature, while the smaller squares on *ss* and the lower *ii* divide the base to the chief moulding into one square and from this moulding to the volutes of the capitals is occu-

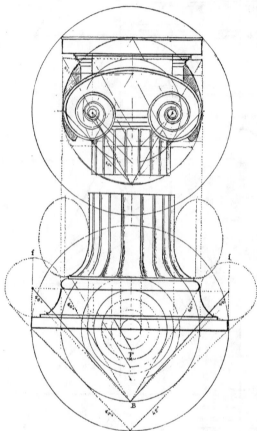

Plate 191—Greek Capital—Bassae

pied by another. The whole monument from the base to the middle of the finial is inscribed by four squares in width to ten in height; and the space included in width and height to the bottom of the main cornice is inscribed in the rectangle of 42° of the ideal angle on the points *i*. The Egyptian triangle by its angle of 51° 30′ passes from the upper pole of the primary circle to *E* intersecting in its course the corners of the capitals, and the angle of 48° ruled from the point *o* will decide the positions of the top of the finial, the horizontal line on *TT* (measuring the diameter of the rectangle of the circle of the first progression of the equilateral triangle) will place the top of the main cornice; and the angle of 60° ruled from the upper pole of the outer circle will intersect the angle of 66° on a line deciding the base of the capital.

As all of the above architectural works have their proportions decided by the same series of angles, of course in different combinations, it would appear that their designers must have employed the same principles, otherwise the coincidences could not be so many and so exact in each one of the series herein analyzed.

To further strengthen this statement, the details of all of the capitals which I have examined of many Greek temples, in conjunction with their bases, conform to the same system of progressions united to the same angles; that of the Lysicrates monument being reproduced at Plate 190. In this case the progressions of the square and of 60° were first described adding to these the secant progression of the latter at *V;* then these circles were reproduced above on the section containing the cornice, entablature, and capitals, and connected with the circles at the base by vertical lines disclosing the corre-

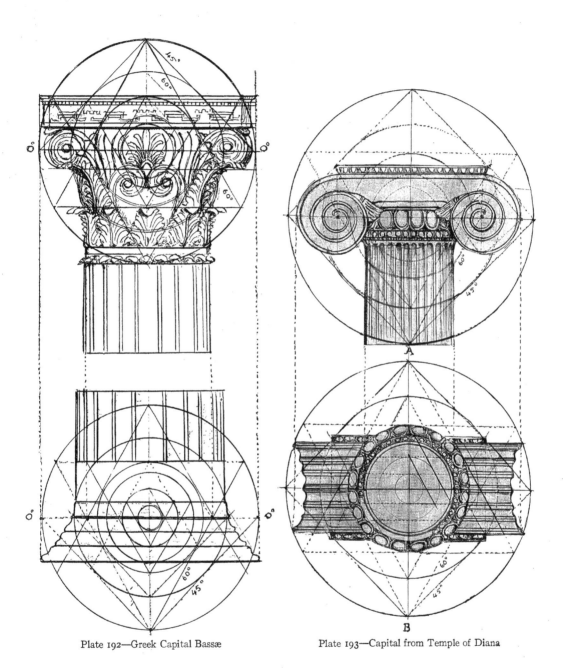

Plate 192—Greek Capital Bassæ Plate 193—Capital from Temple of Diana

spondence. This resulted in showing the systematic proportioning of the various parts, and the correlation of those at the base with those at the capital.

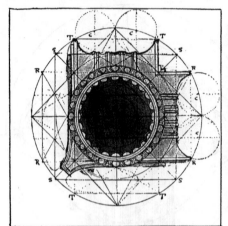

Plate 194—Ionic Angle-Capital

The capital and base of the Greek Ionic order at Bassæ are shown in Plate 191, with similar progressing circles at the base and capital, connected by vertical lines as before, showing the relation of the two sections. The curves of the lower moulding *f* are established by the circle *F* of the fourth progression, and the volute above was produced as described in the shell Murex, in the Chapter on Conchology, on the quadrant chords of the continuing angle of 48° of the ideal angle. Another column and its base are represented at Plate 192, being one of the Ionic order, also at Bassæ, where again the chief angles are those of 45° and 60°. The capital of the columns on the temple of Diana at Ephesus is drawn at Plate 193, representing the front view with volutes on the quadrant chords of the continuing angle of 50°, and in diagram *B* is shown the under side of the capital and volute, with the same

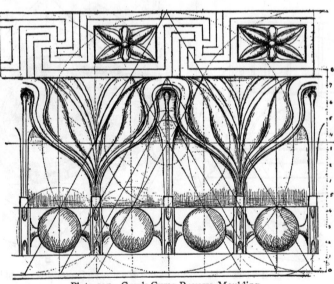

Plate 195—Greek Cyma-Reversa Moulding

progressions in force. In Plate 194 an angle-capital of the Greek Ionic order as seen from beneath is shown where the same principles are manifestly in evidence, the exterior curves being produced by a circle of the progression repeated at the points C and the general proportions of the angle indicated by the horizontal and vertical rectangles of 60° at TT and RR.

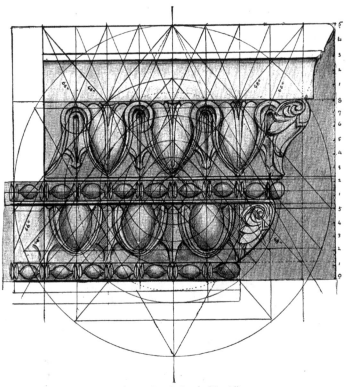

Plate 196—Greek Ovolo Moulding

Nor are these harmonies limited in application to the larger portions of the work. Nothing more perfect than the proportion of Greek mouldings has ever been produced, and a few examples of these will be analyzed to show with what completeness they conform to the rules set forth.

The front view of a Greek cyma reversa moulding, decorated with a water-leaf and fret ornament on the upper fillet, is shown in Plate 195, while Plate 196 is ornamented with conventional leaves, beads, and ogee ovolo, in which the proportional

spaces are decided by the progressing circles of the ideal angle and the rectangle of 42°
with the diagonals of 66°.

A number of similar mouldings are drawn in Plate 197, *A, B,* and *C. A* represents

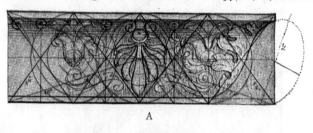

A

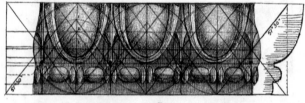

B

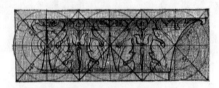

C

Plate 197—Greek Mouldings

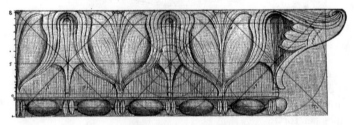

Plate 198—Greek Water-leaf Moulding

a decorated cyma recta moulding where the proportional parts are established by the
angles of 36° and 54° of the pentagon, and the curve of the cyma recta is produced by an

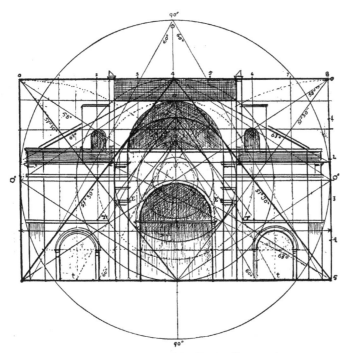

Plate 199—Basilica Constantine

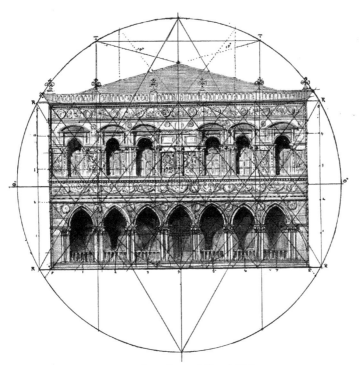

Plate 200—Paraphrase of Doge's Palace

221

ellipse of one in three, with its transverse axis placed on the angle of 72°. It may here be stated that the Greek architects generally adopted some form or section of profile for a moulding, and then doubled it or repeated it reversed as a basis of the lines of its decoration. By this method they obtained artistic results, for their moulding never lost its character however elaborately it was ornamented. This principle is already

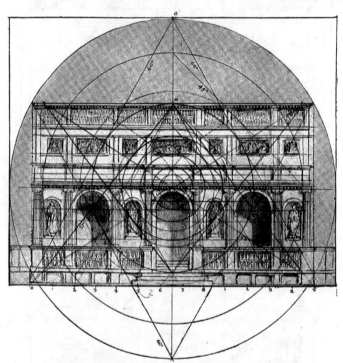

Plate 201—Design for a Loggia

shown in these drawings. Diagram *B* of this plate illustrates an ovolo moulding with beads, the proportions of which are produced by the larger angle of the Egyptian triangle, while the diagram *C* represents a Greek cavetto moulding, the proportions in the latter instance being decided by the ideal angle. In Plate 198 we have a Greek moulding in ogee form with water-leaf ornament, designed on the progressions of the square.

Returning now to the examination of buildings I would ask the reader to consider in detail the application of the rectangles to design and ground plan.

That the rectangle of the Egyptian triangle was frequently applied by the architects of past centuries is proven by numerous examples, and this not only in its form of

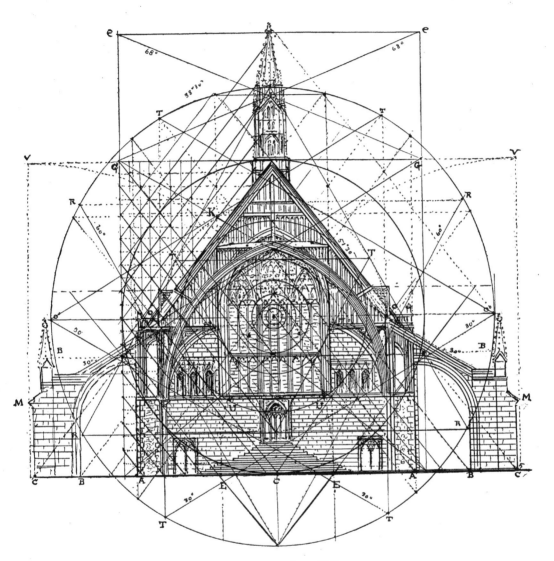

Plate 202—Westminster Hall

223

51° 30′ but also in combination with that of its complement of 38° 30′. The former is, however, the most common, and is well illustrated in Plate 199, showing a transverse section of the Basilica Constantine where the angles of 58° and 63° decide the proportional spaces, the latter giving the raking cornice and placing the main entrance, showing it to be a member in the extreme and mean proportion of the width of the edifice.

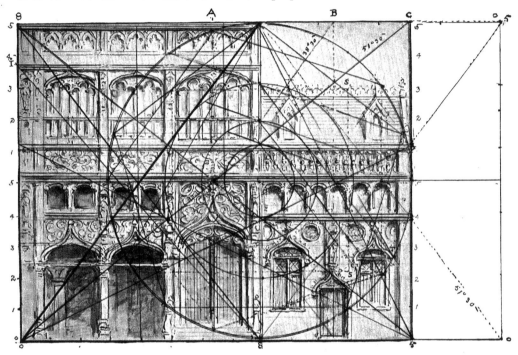

Plate 203—Chapelle du St. Sang

These principles were employed not only by the Greek architects in their temples but were also much in use by the master masons of the Middle Ages, and two designs will now be submitted disclosing what may be done toward obtaining a true proportion in the design of a façade by the use of the above principles by one not educated as an architect. These are in the Italian style, Plate 200 being a paraphrase of the court of the Doge's Palace at Venice, where the angles of the Egyptian triangle and those of 60° are united; while the other (Plate 201) is a design which I have prepared for a loggia based upon the same angles coupled with the progressions of the square.

The transverse section of Westminster Hall is shown at Plate 202, enclosed in the rectangle of the Egyptian triangle in combined form, that of 58° 30′ being superposed

upon one of 38° 30′, as shown at the line *BB*, the lower one being again repeated at the top on the points *G*. The line *BB* between the two lower rectangles places the horizontal divisional moulding of the central window, while the angle of 51° 30′ produces the position and inclination of the raking cornice of the roof. Again, this angle reversed from the point *o*, rests at *C* at the foot of the flight of steps, on the base line of the building. If the vertical line be divided into twenty-four sections and the Egyptian triangle erected upon each, these lines produced will give numerous minor proportions of the edifice, while the line of the raking cornice produced to the points *C* will decide the outer line of the piers, and the angle of 60° added as suggested in previous cases will render additional divisions. Drawn from *T* in the lower arc of the prime circle, it will indicate the tops of the finials on the outer buttresses, and drawn from *G*, it passes to *M*, placing the inclined lines over the buttress arches. Arcs described from *V*, with *C* on the lower line as centres, will place the height of the apex of the roof and will indicate by the points *U* the width of the great window, or carried to *E* will place the outer moulding of this window and the extreme and mean proportion of the whole width of the hall. It will scarcely be contended that all of these coincidences or correlating points are accidental or that they came to pass unless the designer had purposely employed the rectangle of the Egyptian triangle, and the angle of 60° in its construction.

A paraphrase of the Chapelle du St. Sang at Bruges is shown at Plate 203, the design being governed in its proportions by the same rectangles used horizontally. This is asymmetrical in form and demands a slightly different treatment. The entire mass of the façade comes in a double rectangle of 51° 30′ while the vertical side at the left is escribed in a double rectangle of 38° 30′ taken from the base. At the intersection on the vertical *A* is placed the centre of the great doorway, and this marks the position of the two windows above it. Drawn from the same centre, the angle of 38° 30′ will intersect the upper horizontal at the point *B*, while a perpendicular, dropped from this point, will pass through the centre of the side door. These lines on *A* and *B* indicate the same proportions as the rectangles, superposed as seen in the instance of Westminster Hall.

An original composition in the style of the Venetian Gothic is drawn in Plate 204, escribed in the same rectangles including all the structure to the top of the balustrade, while the upper story and roof are placed within a second rectangle of 51° 30′ superposed. The central balconies and massed windows are divided thus in extreme and mean ratio as indicated at the points *X*, while other definite points will be seen upon inspection.

In further proof that these rectangles produce perfect proportional spaces, let us study any of the examples taken from Nature already given, as for instance, Plate 88 showing *Lysimachia stricta*. This is pentagonal in form, with circles on the progression of 18° rendering many of the same proportional divisions as those of the Egyptian triangle, with the circles producing extreme and mean ratio on the side of the escribing

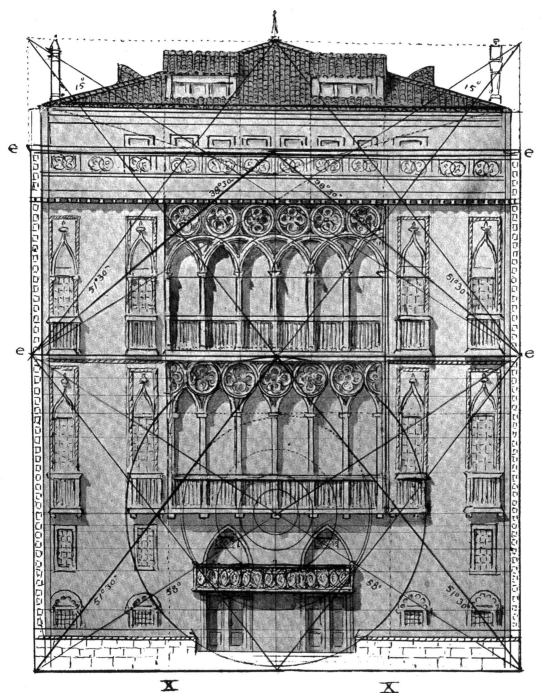

Plate 204—A Composition in Venetian Gothic

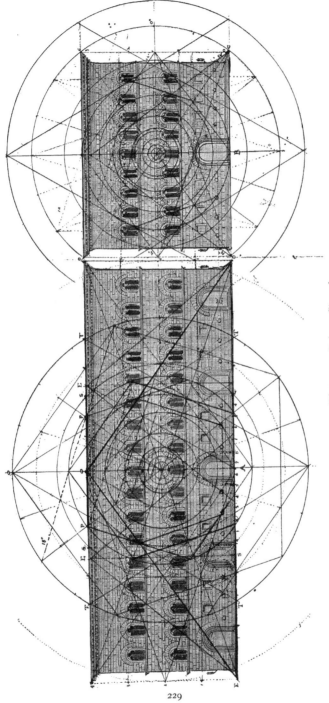

Plate 205—Palazzo Strozzi

229

square on the line of the third circle as at X which, as we have seen, is approximately the horizontal of the Egyptian triangle and which line divides the square almost exactly into the rectangles of 51° 30′ and 38° 30′ at the point X.

The celebrated palace of the Strozzi at Florence is shown in Plate 205, which represents both the front and side views. The front view is escribed by the rectangle of

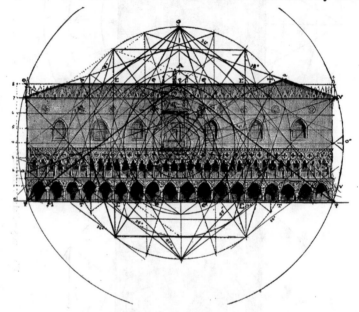

Plate 206—Doge's Palace

36°, and its proportional spaces correspond very closely to the correlations shown in the examination of that figure. We have seen that this rectangle is naturally divided into four horizontal zones and these are here recognized as marking the top of the openings in the row of upper windows, the height of the arches over the doorways, and other points. The Egyptian triangle drawn from E produces a number of correlating points, indicating by the intersection of the two sides, the top of the arch over the central doorway, and thus deciding the height of all of the others, while verticals, dropped from the points E, give the centres of the two doors on either side of the central one. One remarkable thing about this building is the fact that as the main façade is inscribed in the rectangle of 36° of the pentagon, so the narrower ends are inscribed in the rectangle of 54° of the same figure, going far toward proving that its architect employed these two rectangles in its design.

The main façade of the Ducal palace at Venice is drawn in Plate 206 and appears

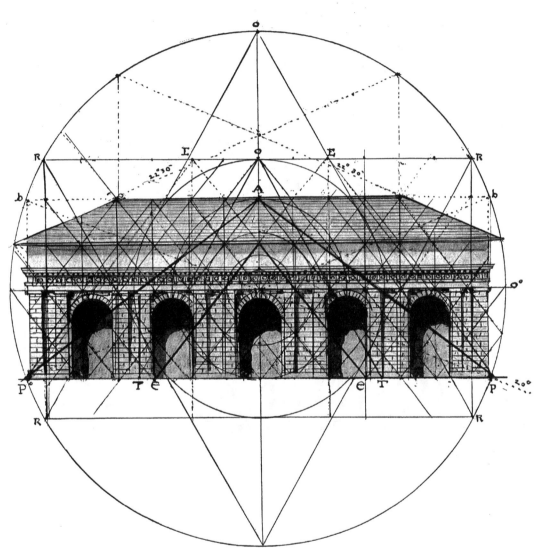

Plate 207—Porta del Palio

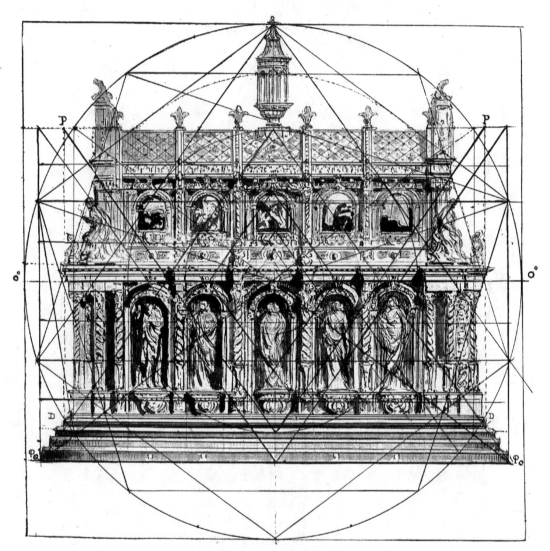

Plate 208—Chasse St. Remi

232

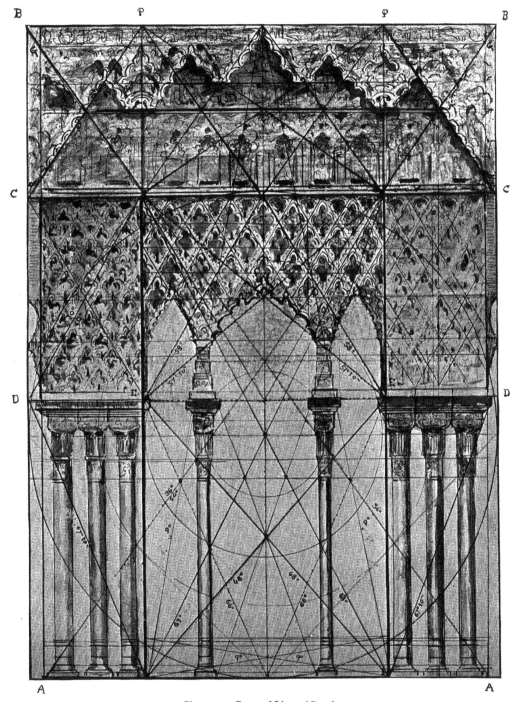

Plate 209—Court of Lions, Alhambra

233

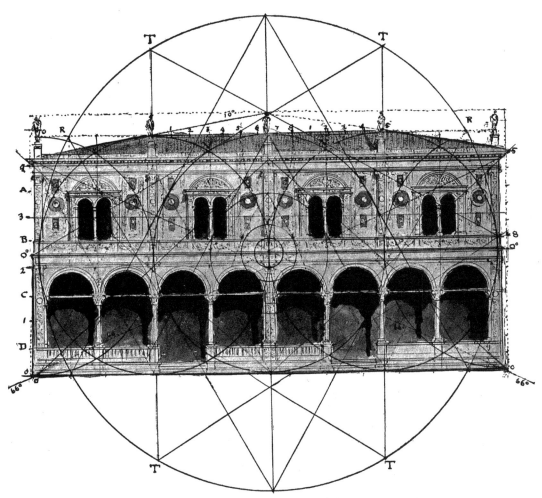

Plate 210—Loggia del Consiglio

235

to have been designed on the same plan, as it is exactly escribed by a rectangle of 36°, the point E placing the fifth column while the angles of 45° from the pole in circle O decide the position of the balustrade of the roof. Plate 207 represents the beautiful Porta del Palio at Verona, by Sanmicheli, which is inscribed in this same rectangle of 36°. The raking angles of the roof are those of 22° 30′. The balance is so simple that it

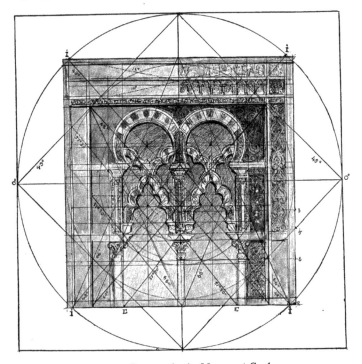

Plate 211—Doorway in the Mosque at Cordova

explains itself. A famous work of art, the reliquary of St. Remi at Rheims, which has its proportional spaces indicated by the angle of 54°, is given in Plate 208 with the circles of the progression of the pentagon, together with the small subdivision of the rectangle of 54°.

I have chosen one more example of the application of the rectangle of 36° to architecture, this time looking to the Moor for the source of his inspiration. Lack of space and time precludes the selection of more than one illustration from the Alhambra, and for this I have taken the beautiful entrance to Mohammed V.'s sumptuous Court of the Lions (Plate 209). The whole detail is enclosed in the double rectangle of 36° / 54°

and the doorway itself in the double rectangle of 63°. The rectangle of the ideal angle reaches from the base of the doorway at the outer columns to the capital; a double rectangle of the Egyptian triangle of 51° 30′ superposed reaches to the top of the doorway proper; that portion of the design going to the height of the line *C* marking the top of the doorway is a perfect square, in which the circle of the second progression measures

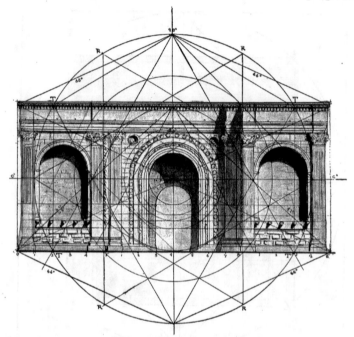

Plate 212—Porta San Pietro

the width of the three openings and the circle of the fourth progression places the middle opening at the central columns. The other obvious correlations in this design are so numerous and easily discerned that the plate may safely be left to the reader's own examination.

An interesting and beautiful example of the use of the rectangle of the ideal angle will now be given, in the Loggia del Consiglio at Verona, by Fra Giacondo, at Plate 210, where the rectangle of 42° occupies the space from the base line of the façade to the main cornice. The horizontal divisional lines *1* to *4* place the position of the upper curve of the eight arches of the colonnade, the top of the eight lower niches on either side of the windows, and the main cornice. The eight divisions in a vertical position indicate the centres of the windows and the seven columns below and many other points.

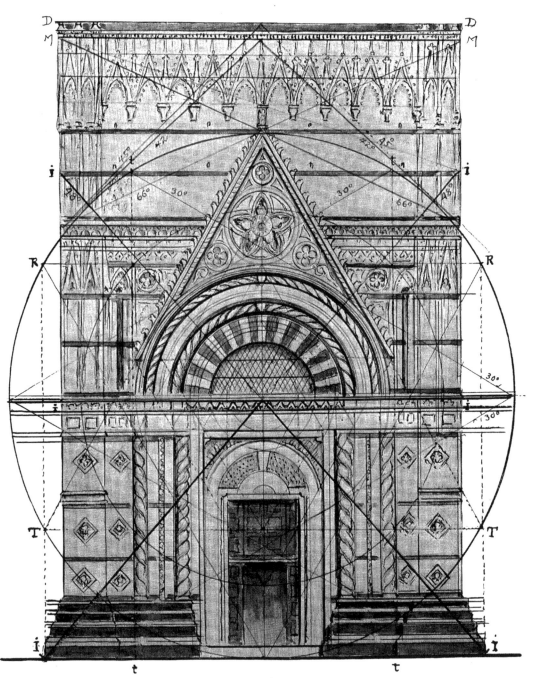

Plate 213—Baptistry at Siena

239

Another example of architectural design depending to a large extent for its character upon the ideal angle is the detail from the interior of the old mosque at Cordova, shown in Plate 211. Here the whole design is escribed by two superposed rectangles of 48° with upright diagonals of 66°, and we notice these further facts: that the angle of 51° 30′ from the point E at the exterior corners of the doorway reaches to the height of the capital; that this angle, repeated from the capital, reaches to the height of the

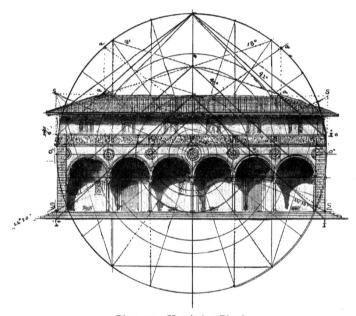

Plate 214—Hospital at Pistoia

secondary capital at the interlacing of the flying arches; that the same angle, with the apex at the base of the central column, reaches to the height of the same secondary capital; that the first progression of the square indicates the top of the circular doorway; that the circle of the third progression of the square indicates the width of the doorway. Many other correlations might be noted but they are unnecessary for the purpose.

The Porta San Pietro by Agostino Duccio, shown at Plate 212, is worth a moment's consideration, being also escribed by the rectangle of the ideal angle. Here the whole central portion R to R bears an extreme and mean ratio to either end, and we notice that the circle of the fourth progression of the square places the outer moulding of the central recess, the circle of the fifth progression of the square places the line of the door recess, and that the circle of the sixth progression measures the line of the door itself,

16

while the circles of the third and fourth progressions measure the balustrade and the position of the lions' heads in the outer recesses.

The entrance to the Baptistry at Siena is shown in Plate 213. It is escribed by a double rectangle of 48° (*I, I, I, I*) which includes the whole portion from the base to the apex of the pent covering the door, and we see that the circle of the second progression of the square marks the beading encircling the outer rope-work moulding over the door;

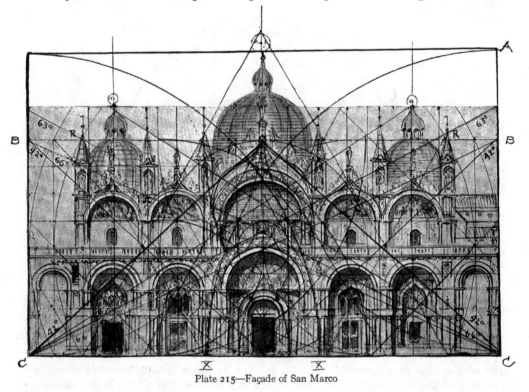

Plate 215—Façade of San Marco

that the circle of the third progression of the square marks in the same way the rope moulding of the inner circle; that the central of the seven harmonic circles of the secant progression places the actual arch itself. We find that the façade of the Hospital at Pistoia resembles those just described in many ways, as will be seen by the examination of Plate 214.

The façade of San Marco (Plate 215) will also declare itself as escribed in the rectangle of 42°, and we shall note that the main doorway shows extreme and mean ratio as compared with the entire width, and that the rectangle of the square takes in up

to the tops of the side domes, while the rectangle of an extreme and mean ratio of height and width will enclose the entire structure to the top of the middle dome, on the line *AA*.

Examining another famous and beautiful building, at Plate 216, we find that the Ca d'Oro of Venice is included in the same classification as those just before described,

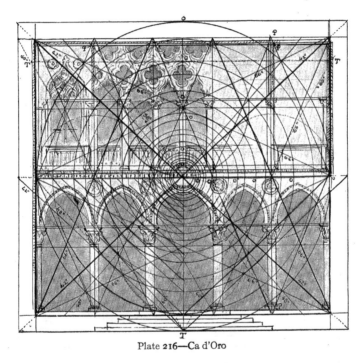

Plate 216—Ca d'Oro

being enclosed by a rectangle of the ideal angle. Also that the line dividing the double rectangle gives the cornice above the windows of the main story; that the angle of 66° from the ends of this moulding, drawn to the roof and base line, indicates by its intersections every pillar and window subdivision of the entire front, while the progressions of the ideal angle place other divisions of the design.

Mention has been made of the frequent use of the vesica piscis by the architects of the Middle Ages in their designs, and one of the most striking examples will be found in the detail drawing, Plate 217, showing the main portal of Amiens Cathedral, where the vesica is identified with every succeeding line from the outer moulding to the form of the door itself. In this example, the second progression of the square measures the exterior width of the doorway, while the fourth progression measures the width of the

interior of the moulding, and the fifth places the door itself. Another fine example will be found at Plate 218 where the north-side entrance of the cathedral of Siena is drawn, escribed in a square from base to finial. Inspection shows that the angle of 60° marks the pent over the door; the circle *B* is the first progression of the actual hexagon; the first progression of the square in the last circle gives the line of the interior moulding

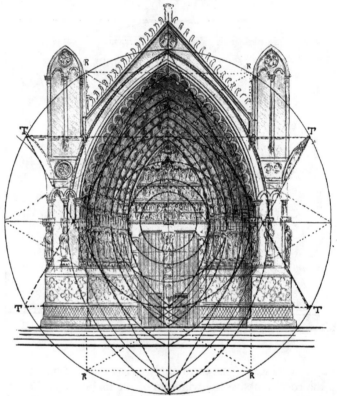

Plate 217—Amiens Cathedral, Great Door

over the door; the width of the door is measured by the second progression of the square in the same circle and that of the doorway is measured by the perfect vesica piscis.

I shall now ask the reader to examine with me a few works of architecture of the Romans at that period when it was still under the influence of the Greek principles in the reign of Augustus. In all of these examples the progression of the square is plainly in evidence as in Plate 219, representing the Arch of Augustus at Aosta, where three progressions of the square produce the chief proportional spaces, united to two rectangles

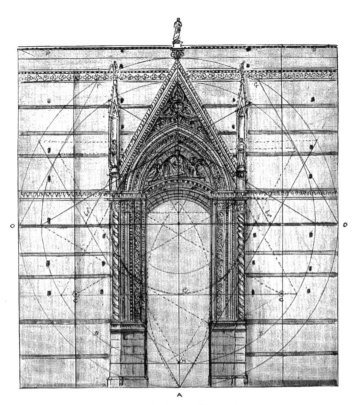

Plate 218—Siena—Entrance

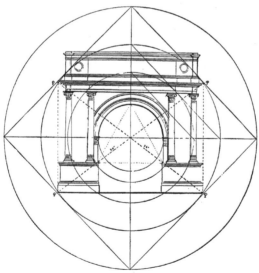

Plate 219—Arch of Augustus, Aosta

245

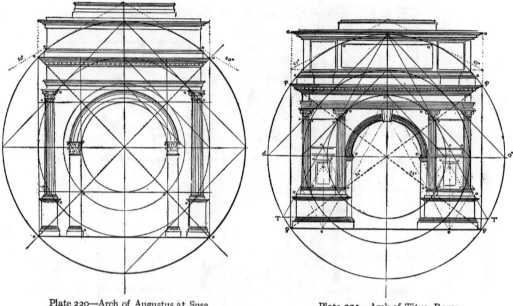

Plate 220—Arch of Augustus at Susa Plate 221—Arch of Titus, Rome

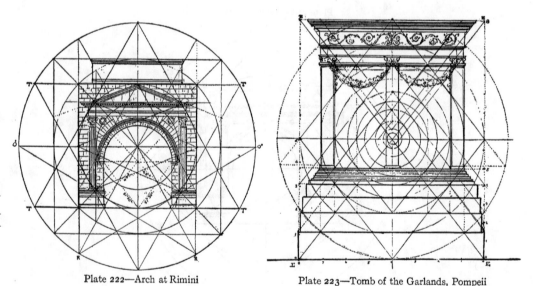

Plate 222—Arch at Rimini Plate 223—Tomb of the Garlands, Pompeii

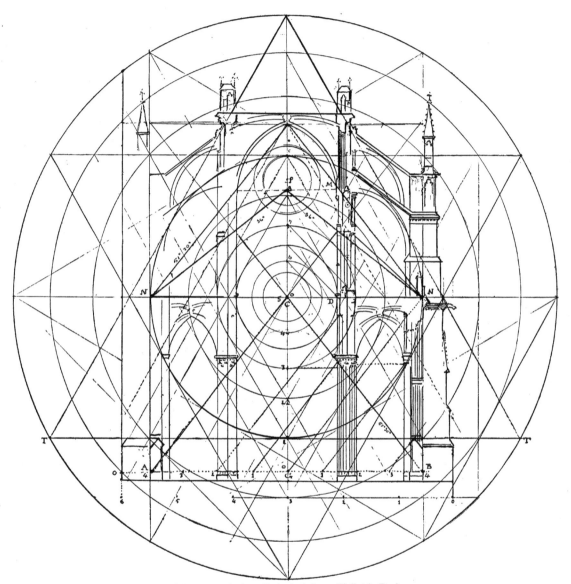

Plate 224—Amiens Cathedral (from Viollet-le-Duc)

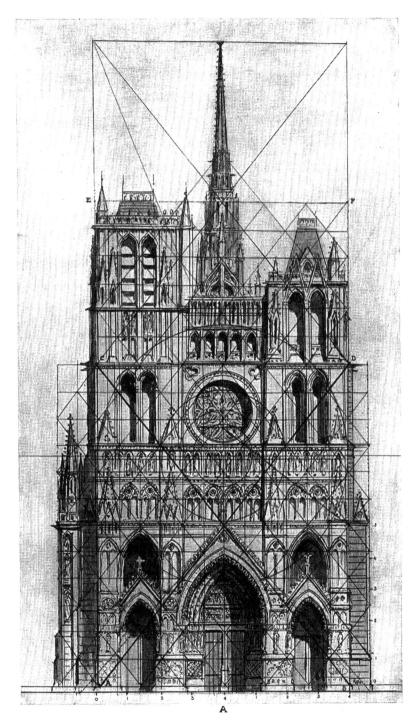

Plate 225—Amiens Cathedral

249

of 36°. The latter will escribe all of that part of the façade to the top of the main cor-
nice as at the points *p*. The Arch of Augustus at Susa is drawn in Plate 220 and discloses
a similar influence as combined with three progressions of the square. In this case the
work is escribed by the rectangle of 45° to the top of the main cornice, the height of
the attic being decided by the angle of 30° passing tangent to the primary circle. If the

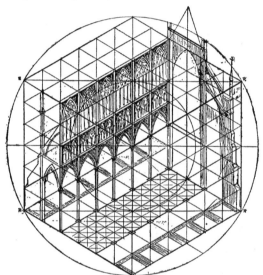

Plate 226—Cathedral of Amiens (from Gwilt)

rectangle is divided into sixteen squares, these will render many of the proportional
spaces, as at the points *o*.

The Arch of Titus at Rome is now generally considered to be the finest of all of the
triumphal arches in existence and is drawn at Plate 221. Its beauty would seem to be
largely achieved by the judicious use of some such principles as applied in the cases of
the other arches, though perhaps with more intelligent originality. Three progressions
of the square, coupled with one of the triangle of 60°, will be found upon examination
to place its proportions. Here also two superposed rectangles of 36° escribe the work to
the top of the main cornice at the points *p*. I would also call attention to the correlating
points *o*. The placing of the main triangle of 60° and the smaller ones at its base is
from Viollet-le-Duc, who in his *Discourses on Architecture* gives us numerous other
examples of this triangle similarly applied. The correlations at the points *o* in this
diagram are remarkable and should be carefully followed out.

The Arch of Augustus at Rimini, Plate 222, illustrates the same principle but with
a pediment above, the raking cornice of which is at an angle harmonic with the plan.

This angle, as in the Parthenon, may be repeated and reversed again and again and still disclose a unity with the mass.

An example from Pompeii, the Tomb of the Garlands, will now be presented in Plate 223 which is a refined and beautiful design, but unlike those above is a progression of the Egyptian triangle and is inscribed in two rectangles of that figure super-

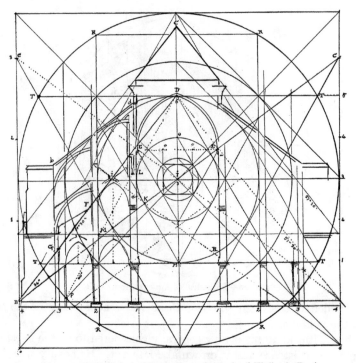

Plate 227—Cathedral of Paris (from Analysis of Viollet-le Duc)

posed or with their proportions related to their sides as 5:8. As before stated the use of this rectangle can never fail to have good results where it is intelligently applied.

We will now pass to examples of architecture of the Gothic period, commencing with the cathedral of Amiens, a cross-section of which is produced in Plate 224, and taken from the analysis of M. Viollet-le-Duc, who was conversant with all of its details, having restored it; the dotted lines are his, but the others, with the circles on the progression of the square, are my own. The base line *AB*, according to what seems to be the usual custom of the period, rests on the bases of the piers, which he has divided into eight equal parts as the base of the Egyptian triangle with its apex at *C*, the vertical

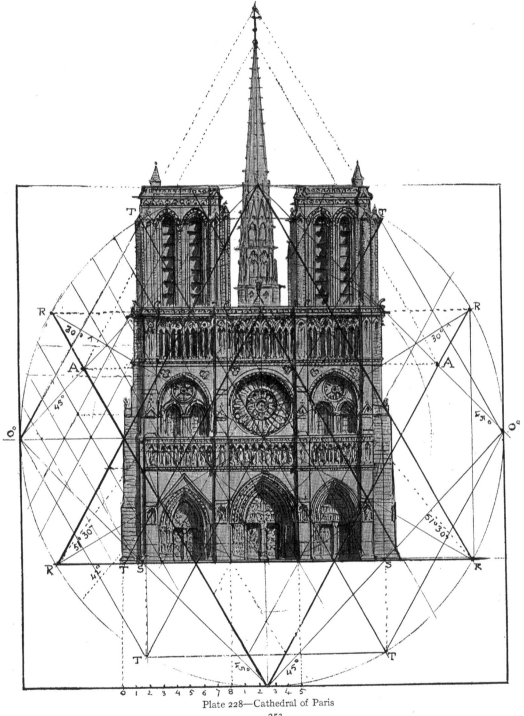

Plate 228—Cathedral of Paris

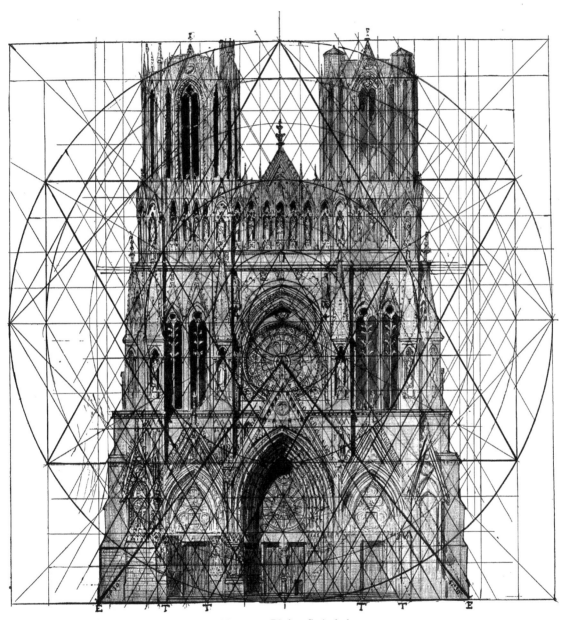

Plate 229—Rheims Cathedral

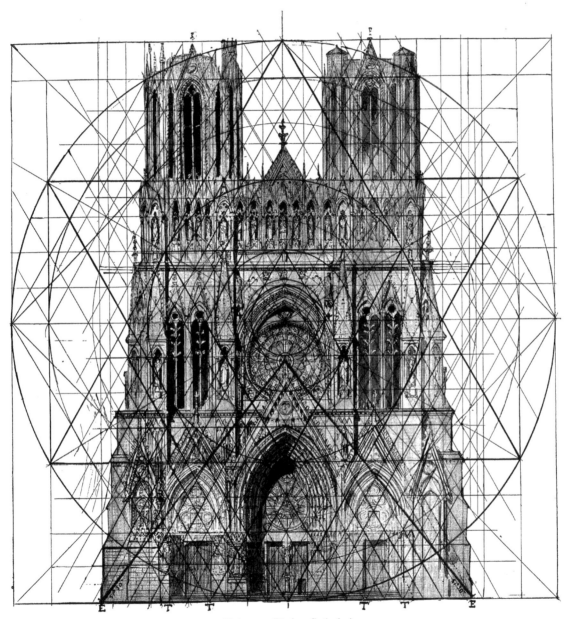

Plate 229—Rheims Cathedral

255

line of which is divided into five of the same parts; and on the new base C is produced a second Egyptian triangle with its apex at the extreme height of the central aisle. This renders two rectangles of 51° 30′ superposed, as just described in Plate 223, and this rectangle renders the chief proportions of the interior of the edifice. The base line AB, divided into eight parts gives, on points 2, the outer faces of the aisle piers; while the points 4 place the outer lines of the piers at the side aisles, and the inner sides of the

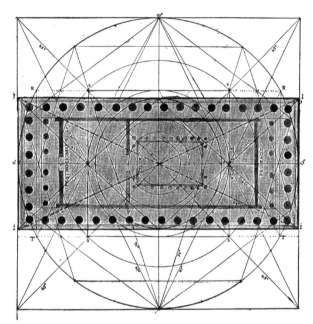

Plate 230—Parthenon, Ground Plan

buttresses. The upper side of the lower rectangle places the decorated string course at D, dividing the interior into two equal parts and the vertical line CG, is divided into five of the same parts as the eight in the base line. The division 1 gives the level of the aisle windows; the point 3 the astragal of the capitals, etc.; the level on 5 (C) terminates the first division, or that of the aisles. Viollet-le-Duc has produced at the points N the Pythagorean triangle, with its apex at 8, which places the level of the springing of the arches at the top of the main aisle, etc. If now several regular progressions of the square are indicated by a series of circles, they, with the rectangle of 60°, will be found to correspond to many of the proportional spaces. The spring of the main arches, the sills of the aisle windows, and other points are decided by the various intersections of the plan as may be followed without further words.

An analysis of the façade of the Amiens Cathedral is rendered in Plate 225, and here unmistakable evidence of the use of the Egyptian triangle may be found; for two such triangles placed in the same relative positions as described by Viollet-le-Duc will, in one case, place the position of the string course, while the apex of the upper one will be on a line with the base of the belfries as at the points C and D, and if these rectangles

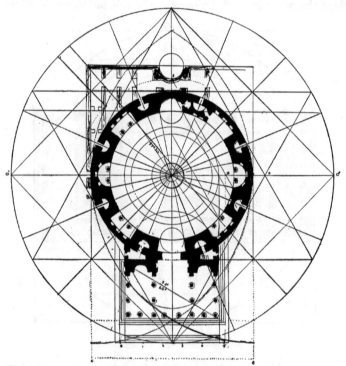

Plate 231—Pantheon, Ground Plan

are subdivided into thirty-six parts with lines ruled across their intersections, these will place most of the important details. If four rectangles of the same dimensions are superposed, their height will decide the position of the top of the spire, while the angle over the doorway at the centre is the ideal angle and those of the side doorway $51°\ 30'$. If the circles of the regular progressions of the square be introduced, they will divide the vertical lines of the piers proportionally, giving the width of the main and side doorways and placing other important points.

An analysis of the plan of this cathedral is rendered at Plate 226, and treated by Gwilt in this way[1]:

[1] Diagram is taken from Gwilt, by permission.

. Within an isometrical cube may be placed the entire nave of Amiens Cathedral. The better to understand its proportions we must suppose each square or cube into which it is divided to measure twenty-three feet six inches on each side, or the isometric figure to contain two hundred and sixteen such cubes, the total height, width, and length being 141 feet or six times 23 ft. 6 in. On the plan are six divisions in length and width, altogether thirty-six squares; the six outer divisions of the principal figure are devoted to the walls and

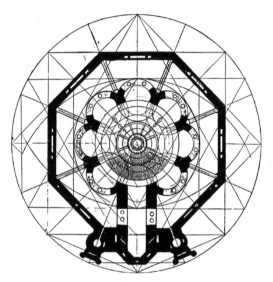

Plate 232—St. Vitale, Ravenna

buttresses; the adjoining six on each side show the situation of the side aisles and the two middle divisions that of the nave. The two side aisles occupy together twelve squares, as does the nave; the remaining twelve being devoted to the outer walls and their buttresses; the entire area therefore has twenty-four squares to represent its interior distribution and half that number its external walls, or one-third walls, and two-thirds voids. Such are the general arrangements of its plan, and its extreme simplicity has enabled its constructors to execute the vaulting of the side aisles and that of the nave by diagonal ribs which in the former extend over one square and in the latter over two, thus giving the nave its due proportion of height without changing the principle of its construction.

Thus is the interior found to correspond as it should, with the harmonic plan of the exterior.

A similar analysis will now be applied to the cathedral of Paris, which is considered one of the finest examples of the Gothic period. As Viollet-le-Duc also restored this work he was conversant with all of its parts, interior as well as exterior, and an analysis

17

of the transverse section is drawn in Plate 227 from his essay on the subject, in which he says:

The total width being known, let *AB* represent one-half of this divided into four equal parts. Starting from the axis *A* and elevating perpendiculars on each of these four divisions, the first from the centre coincides with the face of the nave walls above the columns, the second with the inner face of the columns separating the first from the second aisle; the

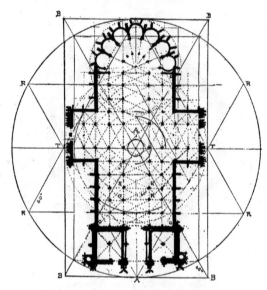

Plate 233—Cologne Cathedral, Ground Plan

third, with the axis of the outer wall; and the fourth with the outermost of the offsets of the buttresses on a level with the pavement of the church. Assuming the upper level of the basis of the nave piers as a base of operation, at *A* we elevate the perpendicular *AC*, on which we space off five of the equal divisions of the base line; the fifth division at *D* gives the height of the Egyptian triangle, and also the height of the main vault; the line *BD*, uniting the extremity of the perpendicular *D* with that of the base *AB*, at *B*, forms the inclined side of the triangle whose height is to its base as 5 to 8. The intersection of this inclined line *BD* with the first perpendicular raised on *AB* gives at the point *E* the springing point of the main vault; its intersection with the perpendicular on 2 at *F* gives the level of the window-sills of the gallery, and with the third perpendicular at *G*, the apex of the windows on the outer aisle. The first division *H* on the perpendicular *AD* gives the level of the springing of the lower arches of the nave walls; the third division at *I* gives the level of the keys of the gallery vaults; the line *KI* of the hypothenuse of the triangle of Plutarch decides the inclination of the upper lines of the flying buttresses, whose centres are in the perpendic-

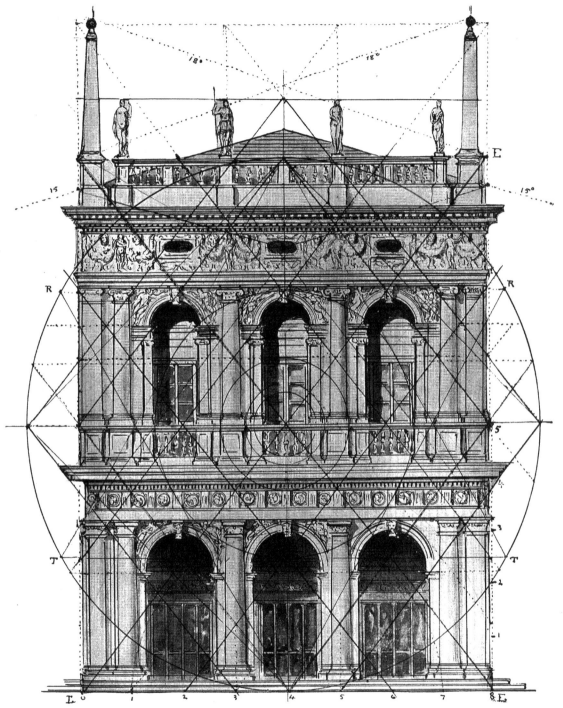

Plate 234—Library of Sansovino

ulars *1* and *2* raised from the base. If we now take *AD* as the height of the equilateral triangle we shall discover that the side *PD* in its intersections with the skeleton lines of the structure, as already established, gives at *L* the lower point of the round triforium windows under the clerestory, and at *M* the floor of the gallery.

If to this analysis of Viollet-le-Duc's the progressions of the square and of the angle

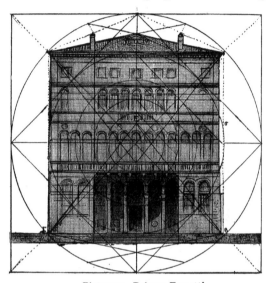

Plate 235—Palazzo Farsetti

of 60° be now added as in this plate, they will be found correlated with it in many points. The primary circle places the width of the building; the circle of the first progression of the square decides the position of the outer aisle wall on *P;* the first progression of 60°, as well as the second progression of the square, gives the inner wall of the next aisle on number *2;* the fourth progression of the square renders the position of the nave walls, and the seventh circle gives the points for the centres of the main arch on the nave by ruling vertical lines tangent to its arcs to *oo* on the line *E.* This discloses the fact that by their use the same correlating points may be established, besides many others. The horizontals on the rectangle *TT* render the lines passing through *D* and *H*, whereas the same rectangle in a vertical position on the points *RR* will give the position of the aisle walls on the points *2* of the base line.

The elevation of the façade of the same cathedral, and from a drawing by the same authority is shown in Plate 228. This is placed, however, in the progression of the square and that of the triangle of 60° which decides the chief proportional spaces. If this is

drawn in the primary circle with its centre on the centre of the balustrade above the "gallery of kings" it will result in the two rectangles of the equilateral triangle on the points *TTTT* and *RRRR*, giving the position of the outer piers, the line above the upper balustrade, and the base line.

These measurements are taken from a diagram accurately copied from Viollet-le-Duc's drawing of the front elevation of this famous cathedral, and present features

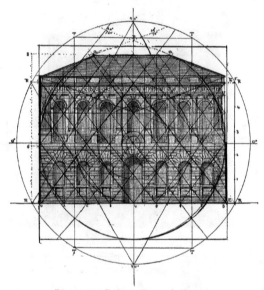

Plate 236—Palazzo Pompei, Verona

impossible of attainment in any photograph or direct sketch, since the elevation disregards perspective and permits the comparison of the towers with the central spire unaltered by the position from which they are viewed. Examining it in detail, we find that the two sides, correlating with equal harmony, are, nevertheless, unlike. The doorways have different arcs and are of varying widths; the left-hand doorway having a cornice above it which is on the angle of 42°, while the angle of the roof is that of 51° 30'.

The central doorway is so placed as to bear the ratio of 5 + 8 with the distance to the base of the left-hand outer buttresses, and if the great triangles are subdivided into smaller ones as indicated, and as described in the plan of Amiens, these will intersect each other at important correlating points which may be followed without further designation.

It will be found upon the comparison of the two last plates that, as in the case of Amiens, the interior construction of the Cathedral of Paris corresponds to that of the exterior, in both of which are felt the influence of the Egyptian triangle as well as that

of the triangle of 60°. It may not be amiss here to quote what Viollet-le-Duc says in his lectures in regard to this famous cathedral:

There is no monument better fitted to illustrate the immense differences which separate Roman art from that of the French lay school than the façade of the cathedral of Paris. The

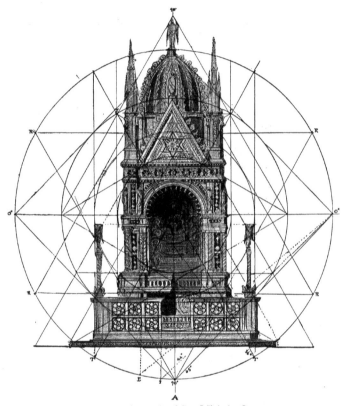

Plate 237—Tabernacle of San Michele, Orcagna

problem being to erect a building which should surpass in size all others in the city, which should fulfil exactly all of the functions of a cathedral, and which, as such, should have both a civil and a religious significance, . . . it would be scarcely possible to imagine a composition more grand in general effect, better reasoned in construction, or more skilfully executed in detail. Every one knows the façade of Notre Dame of Paris, but few persons probably have ever realized how much science and artistic taste, how much painful study and elaborate care, how much perseverance and acquired experience, were needed to build up this colossal pile in the short space of at most ten or fifteen years. But the work is not yet finished, the

two towers should be terminated by two spires to complete and explain the carefully studied lines of the lower structure. . . . I have spoken of how the angles of buildings are arranged with a view to their outline, how forms are modified according to the instinct of the eye, how stones in low courses and stones on end are simultaneously employed not only to stiffen the construction, but to relieve the monotony of horizontal lines, and how construction and decoration should be intimately associated. Nowhere else can these various qualities be found in a combination more complete, more homogeneous, and better reasoned than in this façade.

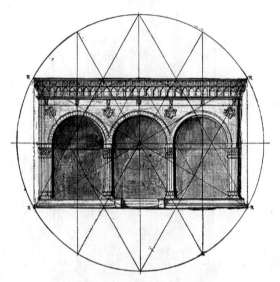

Plate 238—Loggia by Orcagna

. . . This cathedral is very beautiful even in its present unfinished state, but it must be seen that everything is so well prepared in the substructure for the superstructure of the stone spires, that their absence is much to be regretted. As at present existing, there is in the construction and appearance of the towers a superabundant strength which is unjustifiable since they bear no weight . . . ; imagine these spires and it will readily be perceived that everything in the present substructure is but a preparation for them. If from the examination of the general design we pass to the study of the details, every builder will be amazed at the innumerable precautions which have been taken in the construction, and at the manner in which the prudence of the practical mechanic has been united to the boldness of the artist full of resources and imagination. Everywhere we find indications of a thoroughly understood method, of principles strictly observed, of a perfect knowledge of effect, a purity of style unequalled in modern art, an execution at once delicate and bold, without exaggeration and impressed with all the beauty that serious study and enthusiastic love can confer.

Rheims, another great cathedral of this period, is illustrated in Plate 229, and although not in some ways as perfectly carried out as those previously shown, it is still very fine as it is composed under precisely the same principles,—the progressions of the square and of the triangle of 60° united to the Egyptian triangle and the ideal angle. If a circle is described from the centre of the rose window, it will enclose the base and the level of the top of the towers; from the same centre, the circle of the first progression of the square will place the finial on the apex of the roof; the triangles of 60° ruled from the upper and lower poles of the primary circle will intersect each other on the vertical centres of the towers, and its rectangle will decide the position of the Gallery of Saints; the circle intersecting these triangles on the horizontal will give the top of this gallery and the base of the belfries with the width of the façade at the centre of the outer buttresses. The circle of the secant progression of 60° at x will indicate the width between the towers as well as that of the rose window. If the greater angles of 60° are subdivided as in the cathedral of Paris, and vertical and horizontal lines are ruled through these divisions, they will place the proportional spaces throughout the façade and the angles of the canopies over the doorways, which are also those of 60°. If the angle of 51° 30′ of the Egyptian triangle is ruled from the points E on the platform at each side, the two lines will intersect each other at the center of the rose window, and the same triangle may be repeated in many places enclosing proportional spaces and carrying extreme and mean proportion very approximately throughout the façade.

It may not be amiss that a few examples of the ground plans of well-known buildings should be presented, as they will be found equally to demonstrate the fact that they were designed upon the general principles of systematic proportion. Plate 230 represents the ground plan of the Parthenon, which as before stated is inscribed in the rectangle of 42° of the ideal angle with its diagonals of 66°, while the progressions of the square render many of the proportions of the interior construction. The opisthodomus is inscribed in the rectangle of 51° 30′ and the cella in the rectangle of 60°.

The ground plan of the Roman Pantheon is illustrated at Plate 231 where it is seen that the circular structure comes within the first progression of the triangle of 60°, the primary circle of which determines the outer line of the stylobate; the rectangle of that part of the work that encloses this circular form is that of the Egyptian triangle, while the proportions of the vestibule are inscribed in the rectangle of 60°. The elevation of the portico is not given here for want of space, but its proportions were deduced from the progressions of the square as in conformity with the ground plan.

The ground plan of the church of St. Vitale at Ravenna is represented at Plate 232. This is octagonal in form and its proportions were developed by the square and by the regular as well as the secant progressions of the triangle of 60°.

In Plate 233, the ground plan of Cologne Cathedral is shown and here the progressions of the square and of the triangle of 60° are in evidence. The spacing of the columns

of the nave is decided by the rectangle of 30° /60° on *RR;* the first aisle has its columns placed on the diagonals of the square at 45° while the side or outer aisle columns are placed on the angles of 42°.

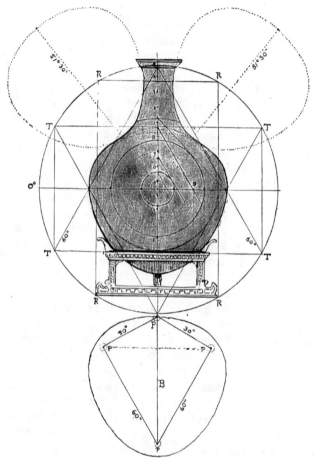

Plate 239—Vase in Chinese Style

The enchanting city of Venice could scarcely be without additional examples of fine architectural proportion. From the many, the library of Sansovino has been selected as one, a portion being shown at Plate 234. Here it will be seen that the main division was decided by the proportion of two rectangles of the Egyptian triangle superposed as at the points *E*, giving to both the upper and lower portions the ratio of 5 : 8. Sub-

divisions of this will produce many of the minor spaces while the progressions of the equilateral triangle will also show their influence.

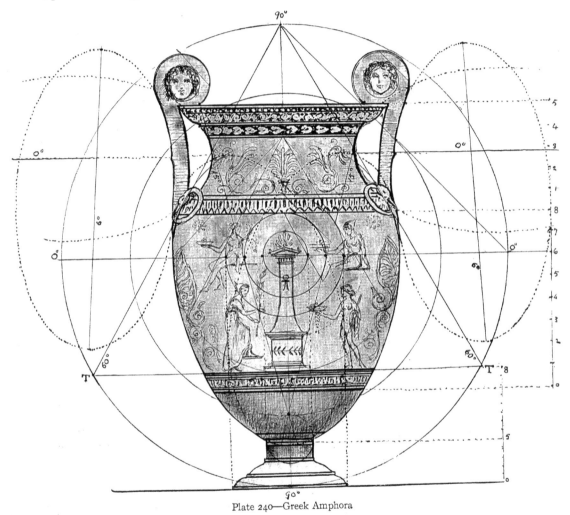

Plate 240—Greek Amphora

The façade of the Palazzo Farsetti (Plate 235) has simple but fine proportions, established, as is shown, by the progressions of the square, while two rectangles of 51° 30′ separate the first, second, and third stories as sectional divisions were found in the case of some diatoms.

The great architect Sanmicheli who flourished about the middle of the fifteenth century left many enduring monuments to his fame, and all his works are distinguished by their fine proportions. Perhaps one of his best is the Palazzo Pompei at Verona (shown in Plate 236), and this building has had a marked influence upon the work of many architects since that time. Here we find the main façade escribed by the rec-

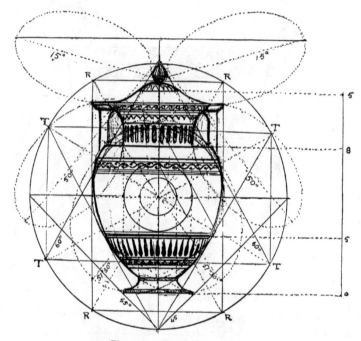

Plate 241—Greek Vase

tangle of 51° 30' and the raking cornice by the angle of 20°. The latter angle, with the form of the roof if repeated in the reverse, will be found to indicate the position of the capitals of the columns on the second story.

Orcagna, another great architect of the period left in Florence one of his most beautiful works in the tabernacle of San Michele, the proportions of which were established by the use of the equilateral triangle and the progressions of the square. (See Plate 237.) The charming Loggia dei Lanzi erected in Florence after the designs of the same Andrea Orcagna in the fourteenth century and apparently patterned upon two progressions of the equilateral triangle is shown in Plate 238.

The art of the potter, no less than that of the sculptor, is governed by the laws which

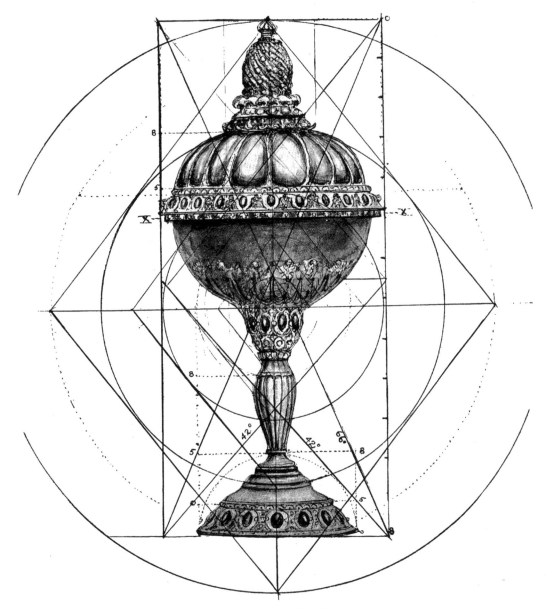

Plate 242—Study for a Cup

271

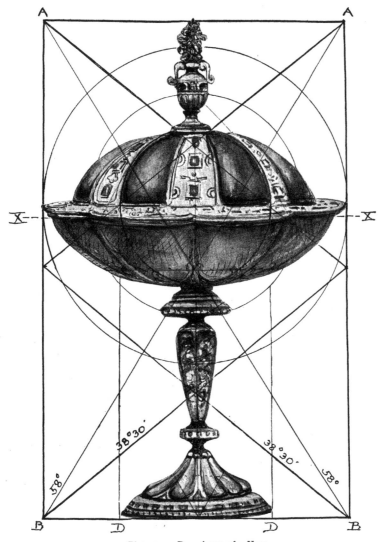

Plate 243—Paraphrase of a Vase

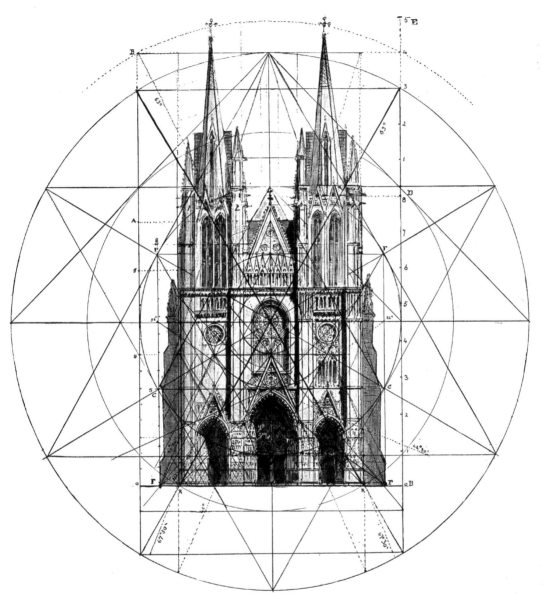

Plate 244—Design for Façade of a Cathedral

275

it is my aim to impress, and in substantiation of this statement, three examples are here introduced.

The bottle-shaped vase in Chinese style shown at Plate 239 is composed on the progressions of the angles of 60°, the secant progression giving the width where these angles intersect each other on the horizontal. The primary circle renders the height while the third progression of the equilateral triangle places the width of the neck. The height of the tripod in which the vase is placed for its support is decided by the first progression of the same angle coming on the base of the triangle, and the width of the stand is rendered by the square in the circle of the secant progression of the hexagon.

If a figure in the form of a composite ellipse be cut out as described in diagram B and placed so as to pass through the intersections of the sides of the triangles of 60° and there traced, it will render the globular curves of the outline, while the same ellipse, placed at a point where its curves will melt into those of the globe, and with its axis on the angle of 51° 30' from the centre, will produce the lines of the neck, the whole form now resulting in an object of perfect proportion.

Hay, in his work *On Symmetrical Beauty*, describes the construction and use of these ellipses. In the case in point, we draw the angles at 30° and 60° as shown in Diagram B, inserting a pin at each apex. Tying a string around the four, we remove the upper pin and substitute a lead-pencil, tracing, on the paper beneath, the outline formed by the slack of the string.

The great museums of the world are filled with vases of the Greek period, a large number of which are most perfect in form and analysis and seem unquestionably to have been constructed upon mathematical principles similar to those here maintained. Plate 240 was taken from one of these where the relation of the height to the width is as one to two, and if a simple ellipse as shown be applied on the angles of 0°, 6°, and 15° the curves produced will outline this amphora or cinerary urn, disclosing the harmonic whole.

Plate 241 represents a similar urn, the proportions of which are produced by regular progressions and the use of the ellipse on the angles of 15°, 50°, and 51° 30'.

The two Greek vases just described are both decorated in black on terra cotta ground, and are very fine examples of their period. They are contained in the collection of the Metropolitan Museum in New York City.

It would be impossible to dismiss our investigation without a brief study of the designs in precious metal, and of these, one writer has well said:

Since art began, the work of the goldsmith has stood well at the top in the school of design. He was inspired by the habit of working in a substance precious and beautiful in itself, frequently ornamented by jewels still more precious, still more brilliant and beautiful; he was unhampered by purely utilitarian needs or motives; unchecked by lateral spaces or

the need of them; the creature of his brain and hand would be tied to no set surroundings or environment. In short he was at liberty, as are few architects or artists, to make of his work what he would, and justified in lavishing upon it all that his brain could conceive or his hand perform. Small wonder then that consummate artists may be found among the craft, though every age will not produce a Benvenuto Cellini.

As an example of the application of the principles which have been put forth to the goldsmith's art Plate 242 is submitted, giving a study for the proportions of a cup, drawn by the author. The enclosing rectangle is one of 42°, the width of the base being measured by the circle of the first progression of the square, the ornament below the bowl by the third progression of the ideal angle, and the height of the flange of the bowl from the base being in an extreme and mean proportion to the entire height. Another example is shown at Plate 243 where is given a paraphrase of the design of a vase to be seen in the treasury at Madrid. We see here that the entire design is enclosed in a double rectangle of the Egyptian triangle; that the height of the flange of the bowl (allowance being made for perspective) is precisely in extreme and mean ratio to the entire height; that the height of the bowl itself is determined by the circle of the second progression of the inscribed square; that the pattern of the jewelled bands is determined in the same way; and that the same circle also measures the width of the supporting base, as shown by the verticals *D* and *D*.

I can perhaps offer no more fitting conclusion to these demonstrations than to add Plate 244, which with the frontispiece presents original designs for the façades of two cathedrals, developed upon the principles claimed, and disclosing in how large a measure these principles would aid the architect, since I, who am not an architect, have thus been enabled to construct designs which as an artist I venture to state have merit.

It is almost unnecessary to say that these same principles, which have been upheld at such length, apply equally well both in theory and practice to the just proportionment of the spaces of any design whether it be of the most magnificent building or a sketch of its decorations, plate, mosaics, glass, or the more modest, though none the less important, furniture which it is to contain. In all of these ways the principles have been tested and in many others not specified, nor has the demand yet been made upon them to which they have not responded in full measure.

NOTE: Regarding the mathematical accuracy of the several statements in this chapter, the reader is referred to foot-note on page 111, as well as to the Appendix, Note N, on Architecture, where will be found an analysis of the principal divergences from absolute precision, none of which, however, exceed the limits deemed compatible with the purposes of design proportion.—EDITOR.

CONCLUSION

We have now examined the evolution of numerical series and geometric forms with their logical correlations, we have interrogated Nature and she has yielded information as to her creative processes and her persistent application of every law productive of unity of purpose and harmony in motion or design; we have exhaustively examined the greatest works of the world's master minds and recognized their constant use of one or other of the universal principles toward the demonstration of which this treatise is aimed. The work must indeed have been poorly done if it leave the reader unconvinced

APPENDIX NOTES

By the Editor

THE APPENDIX NOTES ARE:

A. The extreme and mean proportion and the Divine section.
B. The equilateral triangle and the hexagon.
C. The square and the octagon.
D. The pentagon and the pentagram.
E. The Egyptian triangle.
F. The Pythagorean triangle.
G. The ideal angle and its relations to extreme and mean proportion.
H. The vesica piscis.
I. The progressions.
K. The rectangles.
L. Spirals.
M. Animate life.
N. Force.
O. Architecture.

APPENDIX NOTES

By the Editor

IN preparing the mathematical analysis for this work, it has been the writer's effort to have in mind the ever present idea of the author, that the end aimed at was artistic proportion in design with an accuracy sufficient for effective results, rather than the scientific exactness required in engineering and construction. The editor has therefore studied carefully the amount of deviation from perfect geometric line and angle found to exist in the actual fulfilment of the world's masterpieces, and has considered these deviations as a sufficient warrant for the ignoring of a similar ratio of variation in design here.

By this it is not to be understood that the actual figures of all the important angles, distances, and correlations have not been mathematically calculated to the smallest decimal and the variation, if any, accurately determined; but rather that the reader may rest assured that only those statements have passed unchallenged which might fairly be said, after being scientifically tested, to come "within the error of observation" according to the meaning of the work. In many instances, the actual mathematical variation is set down for the information of the reader, though in general this would prove so dry and uninteresting that it has been omitted.

And finally it should be said that, realizing that the author's work was one which would come largely into the hands of artists and other readers whose needs may not have led them deeply into mathematics, the editor has endeavored to make his proofs and illustrations with as little technicality as possible, employing the simplest practicable methods, avoiding the use of calculus, graphics, complicated formulæ, and unfamiliar expressions, and confining all of the demonstrations presented to such terms and processes as would be more universally understood, occasionally pausing for an explanation which will appear wholly unnecessary to those trained to the lure of mathematical precision. Necessarily, the result at times lacks a brevity and directness which might otherwise be achieved, though perhaps at the sacrifice of the very explanations which it has seemed desirable should be understood by every reader who was sufficiently interested to seek them.

Each of the subjects has been taken up separately, as nearly in the order of the text as was logically possible, the specific problems in each case following the head-notes.

EXTREME AND MEAN PROPORTION

NOTE A

IN writing on the correlations of numbers, the editor to some extent explained the natural or psychological origin of this ratio, to which frequent reference is made throughout the text by the author, and the reader's attention at this point will simplify many of the statements hereafter to be met. In the first place, let it be constantly carried in mind that the expressions "extreme and mean proportion" and "a mean proportional between two other terms" are very far from being synonymous.

The peculiar ratio under examination is in general but rudely understood and must be somewhat further explained. We must in the first place remember that presumably Pythagoras had a clear grasp of the subject, although of course the Egyptians and ancient Greeks were hampered in their use of such proportions by their lack of knowledge concerning fractions. To them the geometric proposition, represented by easily divided lines, was clearly comprehensible, while numerically their knowledge was restricted in all such matters to such use as could be made of integral approximates in place of decimal perfection.

The best definition of this ratio which the editor has been able to construct is the one used in the text, and which is here repeated: By the expression extreme and mean proportion is meant *the division of a quantity into two such parts or proportions as that the measure of the whole quantity shall bear the same relation to the measure of the greater part as the measure of the greater part bears in turn to the measure of the lesser;* or, changing the form without altering the effect, we may with equal truth say that *of two separate quantities, the lesser must be to the greater as the greater is to their sum.*

A moment's consideration will show the difference between this and any other form of proportion, since in all others any one of the terms may be varied, producing a corresponding variation in its opposing member. There is, on the contrary, but one form of extreme and mean proportion, since the last term is fixed, being the sum of the other two. We may say, for instance, that 2 : 4 :: 4 : 8 or 2 : 5 :: 5 : 10, and in both cases the one term is a mean proportional between the other two, yet in neither case is there even an approximation to the extreme and mean proportion. In other words, as the sum cannot

be varied, neither of the other two members may be changed and still remain proportional to the whole.

Thus it will be clear that while the variety of forms in which a mean proportional may be expressed is limited only by the ingenuity and patience of the student in their construction, on the other hand there is one and only one form of an exact extreme and

DIAGRAM A

DIAGRAM B

Plate 301

mean proportion. This form, however, makes up in interest and value whatever it may be said to lack in flexibility, as will be seen.

Since the uses to which we shall put this proportion will not be purely academic, it may not be amiss to understand it geometrically as well as numerically. Looking now at Plate 301, Diagram A, if we consider the line $A B$ to be so divided at the point C as that $C B : A C :: A C : A B$, then the entire quantity $A B$ will be divided into extreme and mean proportion, and this will be demonstrably invariable since the sum $A B$ cannot be increased or diminished to correspond with any change produced in the other terms by the movement of the point C.

We shall find later in these notes that the decimal or percentage equivalent of extreme and mean ratio is almost indispensable to the work, and in order to make this numerical index clear the editor takes the liberty of submitting an Euclidean demonstration of the proportion in question, showing with great clearness how this division may be accomplished, following which the study of the numerical equivalent can be readily pursued.

Examining Plate 301, Diagram B, we find a method of division into extreme and mean proportion for which the editor naturally makes no claim to originality. It has, however, the merit of being perfectly clear, though rudimentary.

Let the line AB be any given quantity. Erect a perpendicular, as BF, from one end, as at B, equal to one half of the line AB. Then with F as a centre and radius BF, describe a circle and connect the points A and E. On the line AB lay off AC equal to AD, then will the point C divide the line AB into extreme and mean proportion, for

In the triangles ABD and EAB the angle A is common, and ABD, formed by a tangent and chord, is measured by one half of the angle BD which also measures the angle E at the circumference. The two triangles are therefore similar and their sides are proportional, hence $AE : AB :: AB : AD$ and by division $AE-AB : AB :: AB-AD : AD$.

Since, however, radius equals one half of AB, the diameter, or DE, will equal AB and consequently $AE-AB$ equals AD or its equivalent AC. Since AC equals AD it follows that $AB-AD$ equals $AB-AC$ or CB. Substituting these values for the terms of the equation we have $AC : AB :: CB : AC$ or by inversion, $CB : AC :: AC : AB$, thus proving that the point C divides the quantity AB into an extreme and mean proportion.

We are now in position to return to our own lines in determining what may be the decimal value or equivalent of the extreme and mean proportion. Turning again to the plate, let us give to the line AB the hypothetical value of one hundred units. Then, as the line BF is half of AB it will equal fifty units and $\overline{AF}^2 = \overline{AB}^2 + \overline{BF}^2$ or by substituting units, $\overline{AF}^2 = 12,500$ or $AF = \sqrt{12,500}$ or 111.803399, and since $AD = AF - DF$, we have $AD = 111.803399 - 50. = 61.803399$.

It therefore follows that when two quantities are respectively $.38196601$ and $.61803399$ of each whole unit of their sum, *then and only then*, they will bear to each other the relation of an extreme and mean proportion, and this expresses their absolutely accurate percentage of the sum.

This matter of the decimal value of extreme and mean ratio has been taken up at some length because, in a long investigation of kindred subjects and the scientific workings of this peculiar proportion, the editor has found numberless instances where a definite formula of expression was absolutely requisite, which should be sufficiently flexible to denote extreme and mean proportion with equal facility, whether as a linear, superficial, bulk, or spherical measure, and of the several forms possible, the decimal equivalent presents the only basis of comparison suited to a work of this kind.

It has frequently been stated in the text of the author that for the purposes of a just proportionment of space, and writing from the standpoint of the artist, he has utilized the Fibonacci series as a measure, and it has been noted in the editor's foot-notes that this series does not constitute a perfect proportion in the usual sense. To call attention to the actual conditions, a tabulation is here presented showing just what is the relation between this series and a true proportion. No reference to the limiting ratio or summation of the Fibonacci series is here made, both because it is too involved and because the author makes use only of the separate members or steps.

Fibonacci Series (imperfect ratios)	Perfect ratios (not extreme and mean)	Decimal ratios (not Fibonacci)
1 : 2 :: 2 : 3	1 : 2 :: 2 : 4	.50
2 : 3 :: 3 : 5	2 : 3 :: 3 : 4.5	.6666
3 : 5 :: 5 : 8	3 : 5 :: 5 : 8.3333	.60
5 : 8 :: 8 : 13	5 : 8 :: 8 : 12.80	.625
8 : 13 :: 13 : 21	8 : 13 :: 13 : 21.125	.615
13 : 21 :: 21 : 34	13 : 21 :: 21 : 33.92	.6190
21 : 34 :: 34 : 55	21 : 34 :: 34 : 55.04	.6176
34 : 55 :: 55 : 89	34 : 55 :: 55 : 88.97	.6181

It will be here noticed that when the perfect ratio has reached the point of 34 : 55 it is approximately the same as the decimal .61803399 of extreme and mean proportion, though this does not hold good for the imperfect member of the Fibonacci series.

It being thus made clear that, when treated either continuously or as an exact proportion, the Fibonacci series contains imperfections, it is appropriate to examine further and see if the same defects inhere in the extreme and mean ratio. Whether we test this proportion arithmetically or algebraically, we shall immediately find that it presents all of the possibilities of a perfect, continuing series.

Referring to our definition, we see that if, of two quantities, the less is to the greater as the greater is to their sum, or if $y : x :: x : y+x$, then the terms are in extreme and mean proportion, and may be solved by the Euclidean formula, $x^2 = y^2 + xy$ which we may express in the words "the square of the greater equals the square of the lesser added to the rectangle of the two." If, now, this proportion is a true continuing series, then the following will be true:

(1) $x : x+y :: x+y : 2x+y$,

and in serial form,

(2) $y : x :: x+y : 2x+y$, etc.

Transforming both of these into their equations, we have the Euclidean formula above as a result in each case, and hence we may add these important generalizations; that *in every extreme and mean proportion, the greater is to the sum as the sum is to the greater plus the sum; the less is to the greater as the sum is to the greater plus the sum; that these two conditions continue indefinitely; and that the true extreme and mean proportion is a perfect continuing series.*

Illustrated arithmetically we find, by the decimal equivalent, that

$$.38196601 : .61803399 :: 1.0000 : 1.61803399$$

which of course is clearly a perfect proportion since its solution gives us .61803399 on both sides.

It is perhaps almost unnecessary to say that the same ratio may be carried out descending, whereby is obtained a series consisting of the square, cube, fourth power, etc., of the decimal equivalent of the greater of the two terms, thus:

$1 : .61803399\ (x) : .38196601\ (x^2) : .2360673\ (x^3) : .145902\ (x^4) : .090170\ (x^5): .055728\ (x^6) : .0344417\ (x^7) : .0212863\ (x^8)$, etc.

The information thus gathered will be sufficient for the purpose at hand in so far as the extreme and mean proportion is treated as a linear or superficial measure. We shall, however, have occasion to consider this series as an angular measure, and a moment must be given to its examination from this standpoint.

Applying now the decimal equivalent of the two quantities constituting a perfect extreme and mean proportion to the 360° into which the circle is for convenience divided, the resultant form of $.38196601 : .61803399 :: x : 360°$ renders, as the angular equivalent of this universal proportion, the two angles of 137° 30′ 27.954″ as being the lesser term, and 222° 29′ 32.046″ as being the greater term.

To these angular equivalents, further reference will be made under the note on the ideal angle.

If the editor has stated the facts and his logical conclusions concerning this great proportion with much particularity and with what may occasionally seem an unnecessary and perhaps rudimentary detail, it is because he has found that astonishingly few, even among well-read persons, have more than a glimmering knowledge in relation to it, while its comprehension will greatly add to the enjoyment of the author's work and to the understanding of the editor's notes upon other subjects; for from a long study of Nature's employment of this proportion, the editor ventures to say, that, *except in matters of design, where the two may be interchanged, he is satisfied that, in any case where it cannot be clearly demonstrated that the Fibonacci series is intended, wherever it appears that Nature is making use of any continuous proportion, a scientific analysis will almost invariably show that what she in fact aims at is not the integral series but rather the perfect and indefinitely continuous extreme and mean proportion.*

The author's correlating statements regarding this subject are mathematically tested, with the following results.

(1) Page 64, Plate 37. In all of the author's diagrams depicting examples of extreme and mean proportion, it should be remembered that the point of division is shown at each side of the centre. The division will therefore be made by either point but not by both, except as hereafter explained. Taking Diagram A of Plate 37 for example, the line *JH* is seen to be divided into extreme and mean proportion at *M*, the portion *MH* being the lesser division and *JM* the greater. Considering this line *JM* as a new descending unit, then it in its turn (or its equivalent *JX* on the right hand) is divided into its extreme and mean ratio at *X* (left hand).

Thus in all of these diagrams on this subject, we must consider that either point X produces the proportion in question, but not both at once.

(2) Plate 64, Plate 37, Diagram B. By drawing the angle of 51° 30′ from one corner of the rectangle and 38° 30′ from the other, and dropping a vertical from their intersection, we obtain a passably correct extreme and mean proportion, with an error amounting to one-half of one per cent. This is discernible, although it may safely be disregarded in the making of a design.

(3) Page 64, Plate 37, Diagram C. The meeting point of 58° and 63° furnishes a reasonably correct method of establishing the proportion. The actual diagonal of the half square is, of course, 63° 26′ 5″ as shown in the appendix note on rectangles, and the angle which with this would actually indicate an extreme and mean proportion in the manner described, would be 58° 16′ 57+″.

(4) Page 64, Plate 37, Diagram D. The meeting of the angles of 13° 15′ and 45° is sufficiently accurate for the purpose to which it is put (being actually 45° and 13° 16′ 57+″) though the angles themselves bear no characteristic or harmonic relationship.

(5) Page 64, Plate 37, Diagram E. This method, of course, deviates from exact extreme and mean proportion to the same extent that the Egyptian triangle of 5: 8 with its decimal equivalent of .62500 must vary from .61803+.

(6) Page 64, Plate 37, Diagram F. The meeting of 58° 15′ and 45° is sufficiently accurate for the purpose. The exact angle which would produce a true extreme and mean proportion would be 58° 16′ 57+″.

(7) Page 66, Plate 38. It is stated by the author that the circles in the plan are related as 5 : 8. Mathematically, the precise relationship is .61803 rather than 5 . 8, the latter being "within the error of drawing" for the purpose of composition.

(8) Page 66, Plate 38. Stated by the author that the sides of the square escribed about the circle of the fourth progression of the pentagon, if produced to the base, would measure the division of that line into extreme and mean proportion.

The correlation may perhaps be useful as a check, though confusion is likely to occur owing to the fact that in one case it is the radius, while in the other it is the diameter which is subjected to the division into extreme and mean proportion.

(9) Page 66, Plate 38. Stated that the primary square is divided into the rectangles of 42° and 48° on the horizontal of extreme and mean ratio. The extent to which this statement is mathematically inexact is examined in Note D on the pentagon, at subdivisions 15 and 19.

(10) Page 111, Plate 89 *et seq.* The author here notes the apparent coincidence of the progressions of the equilateral triangle and the square with extreme and mean proportion. This does occasionally occur, though seldom, and it is necessary to bear in mind that the coincidence of the triangle and the square on the ratio of 5 : 8 (with its decimal value of .625) calls instant attention to the improbability of the concurrence of precise extreme and mean proportion with its value of .6180339. For design purposes it is sufficient.

(11) Page 118, Plate 100. It is stated that the pentagram line will divide the circle in the ratio of 5 : 8. As in almost every case of the pentagon, the division is in the precise extreme and mean proportion rather than 5 : 8, and may be so taken where exactness is requisite.

THE EQUILATERAL TRIANGLE AND THE HEXAGON

NOTE B

THE progressions of the equilateral triangle and the hexagon do not concur, though they have much in common. In order to facilitate the comparison of the various progressions, the editor has prepared a table showing their decimal indices, which will be found under the Appendix Note I (the progressions) and the reader's attention is called to the facts there pointed out. The most conspicuous and constantly recurring fact regarding the progressions of the equilateral triangle is that every circle of this progression is exactly octant to the one preceding, and thus coincides precisely with the alternate circles of the progressions of the square, as appears from the tabulation. No argument is necessary to prove this particular statement, as it will be found set forth in any recognized table of inscribed circles, the decimal index being given invariably as one half that of the circumscribing circle. The indices presented in table at Note I have been worked out by the editor for ten progressions of each form, as will be seen upon consulting the note.

The author's correlating statements regarding the equilateral triangle are here mathematically tested, with the following results.

(1) Page 35, Plate 13. It is here stated that each progression of the equilateral triangle coincides with every second progression of the square.

> The position of the horizontal leg of the equilateral triangle may be found in the same manner as that of the square, or more readily, by reference to any standard tabulation of the decimal values of inscribed triangles, and in any event will be found at Rad. .500000. It has already been seen that this is the position of the second progression of the square.
>
> The statement is therefore mathematically correct.

(2) Page 36–37, Plate 14. The author describes a method of arriving at the secant progressions of the hexagon.

> The results are as follows:
> The position of the first circle, passing secant through the point A where the two

triangles intersect each other as secants, is at .57735. Examination further proves that the circle drawn tangent to the angle of 48° would be measured by a radius of .669130.

If, however, this be taken as the measure of the curve, placing the centres at oC, then the entire diameter of a circle circumscribing the seven as described would be .669130 × 3 or Rad. 2.007390 instead of the real diameter of Rad. 2.000000.

A simpler, and mathematically perfect way of attaining the desired result may be found thus:

(I) Divide the prime diameter into six parts, which will then fall exactly upon the centres and circumferences of the seven circles.

(II) Divide the diameter of the circle of the first regular progression in the same way, with the same result.

Each of these circles will then be measured in terms of the prime radius by .333333. The position of the secant circle was seen to be .57735, and a secant progression based upon this position will produce a secondary secant circle at $.57735^2$, or again, exactly .333333, which is the result desired.

(3) Page 38, Plate 15. Stated that the angle of 14° drawn from the point oC will pass to the point E, intersecting in its course . . . the centre of the line RR.

The distance of E below the line RR is already known to be .25, and at a distance 1.000 horizontally from the vertical. The angle at the point E which will intersect the middle of the line RR is therefore found to be 14° 2′ 11″ rather than 14°.

In the same way it is learned that the angle from the point oC to the middle of the line RR is 13° 3′ 52″ rather than 14°.

From this it follows that no perfectly straight line can connect the three points E, I, and oC. This may be summed up by saying that a line from E at 14° will pass almost exactly through the centre of the line RR but that its prolongation will be somewhat wide of the point oC. It is, however, used by the author merely as a check, and as such is useful, if the inexactness be kept in mind.

(4) Page 39, Plate 15. It is here stated that the angle of 42° from the centre of the line TT will intersect the line RT at the point cut by the angle of 14°.

In this it is necessary to substitute the angle of 14° 2′ 11″ in place of 14°, since it is known that the latter does not perfectly connect the points E and I. It is shown in previous proofs that the distance from T to R, measured in the terms of the radius, is R. 1.000000

Calculation shows that the angle of 42° will reach RT at a point above the line TT equal to R. .779774

The distance ia to R has been found, in terms of the prime radius to be .216513

Distance covered by the verticals of the two angles R. .996287 .996287

This is less than the distance RT by a variance .003713

(5) Page 39, Plate 15. Stated that the vesica piscis will intersect the line RT at the point iA.

It has been shown above that 14° (or 14° 2′ 11″) and the angle of 42° do not precisely coincide at the point iA, but leave a gap of .003713 between them. The intersection of the vesica has been found to come within this space or nearer to either than they are to each other.

The statement is sufficiently near for the purpose to which it is put, and is well within the error of observation.

(6) Page 39, Plate 15. Stated that the horizontal from the point of intersection of the vesica with the prime circle makes an angle of 22° 30′ with the centre.

The mathematical error here is very slight, the real angle being found to be 22° 21′ 50″, and therefore quite negligible for the purpose.

(7) Page 39, Plate 15. Stated that the Egyptian triangle may be drawn from B to e from which a vertical will intersect U on the horizontal radius at the point intersected by the prime angles of 51° 30′.

This is axiomatically true, since the triangles Q-U-$Centre$ and B-e-1 have angles Q and B equal, the sides Q-$Centre$ and B-1 being both R. 1.00000 and the remaining angles equal. The sides U-$Centre$ and e-1 are therefore equal and the vertical from e must pass through U.

(8) Page 39, Plate 15. Stated that a line drawn from T to P will be at the angle of 36°, and will render the Pythagorean triangle.

Examination of the triangle described shows that the angle so produced would be 35° 11′ 11″ and not 36°. The latter could not agree prefectly with the angle of the Pythagorean triangle of 3, 4, 5 in any event since it has been demonstrated that this is 36° 52′ 12″. The error is disregarded because of the very limited use to which the statement is put.

(9) Page 41, Plate 16. Stated that the vesica crosses the line of the angle of 48° at the horizontal of 42°.

The mathematical error in this is decimally expressed in terms of the radius of the prime circle at .01778 but in any drawing or design of convenient size may be disregarded amounting, as it does, to less than one percent. of the diameter.

THE SQUARE AND THE OCTAGON

Note C

THE progressions of the octagon are seldom used in this work, but will be found decimally indicated, together with those of the square in the table of progressions prepared by the editor to facilitate comparisons, and set forth in Note I.

The concurrence of the progressions of the equilateral triangle with the alternate progressions of the square has already been noted and will be found in the table referred to.

The author's correlating statements regarding the square are here mathematically tested, with the following results.

(1) Page 32, Plate 11. Stated by the author in many places that the second progression of the square is octant to the prime square.

> The position of the first progression will be fixed by the measure of the radius of its inscribed circle, which may be learned from any standard tabulation to be Rad. .70710678; or the reader may easily figure this for himself, since the diagonal of the square in its first progression is obviously twice the radius of the prime circle. It follows that the diagonal is an hypothenuse equal to Rad. 2.0000, and that either side must be the square root of one half of the square of 1.0000, or the square root of .5000, which will be found to be, as before, .70710678.
>
> By the same process, the position of the square in the second progression will be found to be fixed in terms of the prime radius, at .5000000.
>
> The square in its second progression is therefore exactly octant to the prime position.

(2) Page 32, Plate 11. Stated by the author that the diameter of the alternating circles of the progression of the square carried to the base, will be to each other as 3 : 4.

> This is clearly true, since by the demonstration above it is found that
>
> (1) Rad. prime : Rad. 2d. Progression :: 4 : 2,
> (2) Rad. prime : Rad. prime :: 4 : 4 —— addition gives
> (3) Diameter : Rad. 2d Progr. carried to base :: 4 : 3

294

Appendix Notes

295

(3) Page 32, Plate 11. Author states that the radial difference of the two larger circles is to the same difference of the three succeeding circles as 8 : 5.

From the proof above it appears that the radial difference of the first two is decimally fixed at .5000 and this, divided by eight, gives .06250

Consulting Note I on progressions, the radial difference of the next three is found to be .50000 less .176776 or .323224, and this divided by five gives .064644

The error amounting, therefore, only to .002144

(4) Page 32, Plate 11. Here it is stated that the four corner circles will cut the prime circle in the proportions of the pentagon.

In Plate 11 it is evident that the distance from the centre of the prime circle to the centre of any one of the corner circles is identical with the radius of the first progression of the square, or .70710678. A triangle may therefore be supposed as joining the two centres, and each centre with the point where the corner circle cuts the prime circle. In this the longer side will be the radius of the prime circle, the second side will be .70710678, and the third side will be the radius of the smaller circle or .5000. Dropping a perpendicular from the obtuse angle to the greater side, and utilizing the formula that the greater side will be to the sum of the others as their difference is to the difference of the segments, the angle at the centre of the prime circle is deduced as 27° 53' 7". By the addition of 45° it is seen that the angle from the vertical to the point where the circles intersect at Q is 72° 53' 7".

Obviously, the angle from the vertical to the apex of the pentagon is 72°

The error therefore amounts to 53' 7".

(5) Page 35, Plate 12. Stated that the horizontal of the Egyptian triangle will be five in height for eight in base.

This is quite correct; see note on the Egyptian triangle.

(6) Page 35, Plate 12. Stated that the rectangle of the Egyptian triangle is the integral equivalent of extreme and mean proportion.

For the explanation of this, see appendix note on extreme and mean proportion, and the editor's foot-note at page 22 of the text.

(7) Page 35, Plate 12. Stated that the horizontal of the Egyptian triangle will coincide in position with the fourth progression of the square.

From the note on the progressions it appears that the position of the fourth progression of the square is R. 25 or (above the base) 1.2500.

The position of the horizontal of the Egyptian triangle is $\frac{5}{8}$ or $\frac{5}{4}$ of prime radius $= 1.2500$. The statement is therefore correct.

(8) Page 35, Plate 12. Stated that the line ii will create the rectangles of 42° and 48°.

As to this, see editor's foot-note at page 32 as well as the appendix notes on the rectangles, giving the exact diameters of these figures.

(9) Page 35, Plate 12. Stated that the angles of 36° ruled from TT will intersect on the sixth progression of the square.

In the triangle $T4P$ (Plate 12), considering the angle T as 36°, the distance from 4 to P is found to be, decimally, .629202, and as TT is .50 above base, the position of P above the base is fixed at 1.129202

Consulting the tabulation at Note I, the position of the sixth progression of the square is found to be at .125 above centre, or, above the base 1.125000

The measure of variance is, therefore, .004202

It should here be observed in this and the succeeding note, that in Plate 12 the author has made no attempt in the diagram to show the difference existing between the position of the sixth progression of the square and the horizontal of the angle of 48°. This difference, while not of great importance in a design, exists mathematically, however, and amounts to .01440. The propositions, as worked out here and in the next note, are based upon the position of the sixth progression of the square.

(10) Page 35, Plate 12. Stated that the angle of 36° continued will cut the centres of the two upper circles at C.

The actual angle, which from the points TT will cut the centres of the circles at C, is found to be 36° 12′ 24″ rather than 36°, but the error is negligible in a work of this kind.

(11) Page 35, Plate 12. It is here stated that the horizontal of the sixth progression of the square, joined to the lines vPT, will render the great rectangle of the Pythagorean triangle.

Taking for a moment the Pythagorean triangle as one of 36°, it will be seen that the variance will be precisely the same as in note (9) above. Upon examination of the appendix note on the Pythagorean triangle, however, it will be found that the angle would be one of 36° 52′ 12″ instead of 36°, thus making the variance proportionately greater.

The statement is sufficient, nevertheless, for the purposes of design.

THE PENTAGON AND THE PENTAGRAM

Note D

THE pentagon or five-sided regular polygon yields the pentagram or five-pointed star by the joining of its opposite angles. The pentagram, otherwise known as the pentacle, is described by a well-known authority as "A mathematical figure used in magical ceremonies and considered a defence against demons. It was probably with this figure that the Pythagoreans began their letters as a symbol of health. In modern English books, it is generally assumed that this is the six-pointed star formed of two triangles interlaced or superimposed as in Solomon's seal. Obviously the pentacle *must* be a five-pointed star or a five-membered object, as equivalent to the pentagram or pentalpha. The construction of the five-pointed star depends upon an abstruse proposition discovered by the Pythagorean school and this star seems to have been from that time adopted as their seal." Another eminent authority refers to this figure as being "the triple interwoven triangle or pentagram—star-shaped *pentagon*—used as a symbol or sign of recognition by the Pythagoreans."

As the theories of the Pythagoreans would apply perfectly to the pentagonal form and hardly at all to the six-pointed one, and as both history and etymology sustain the five-pointed figure, the editor submits as an explanation of the difference of opinion, the reconciling statement that both forms can be originated by the use of interlaced triangles, —the six-pointed star by using two equilateral triangles, and the five-pointed one by the use of three isosceles triangles. This fact seems to have escaped the attention of many observers, who have concluded that only the six-pointed star could be created from the trigon, and have by this been led into calling the hexagonal outline a pentagram,—an evident misnomer.

Having obtained a decimal index of extreme and mean proportion in a preceding note, one of the first striking features in the examination of the pentagon will be the persistence with which it presents this ratio; and that, not in a mere approximation, but in the absolutely true and precise sense. A number of instances in which this occurs in both the pentagram and the pentagon proper will be mentioned as they are reached, but the fact should be kept in mind constantly in the examination.

In the early days of geometry, Euclid originated his well known formula for the

297.

creation of the pentagon ($\sqrt{5}-1$, or the natural sine of 18°), and it is interesting to
note that this figure, which is demonstrated in these pages to be so perfectly coincident
with the absolutely precise form of extreme and mean proportion, should be the
product of a formula so similar to that which, in its solution, yields the decimal
equivalent of extreme and mean proportion ($\sqrt{5}-1 = .61803+$).

$$\frac{\sqrt{5}-1}{2}$$... $$\frac{\sqrt{5}-1}{4}$$

The author's correlating statements regarding the pentagon are here mathemati-
cally tested, with the following results.

(1) Page 22, Plate 5. The author states that in the progressions of the pentagon, the
 radii of the several circles are to each other in extreme and mean proportion or
 practically in the ratio of 5 : 8.

The first step is to ascertain the length of the side of the inscribed pentagon and as to
this, by consulting any standard tabulation we shall find the decimal value of the side
of the inscribed pentagon in terms of the radius fixed at 1.17557, and the distance of
this side from the centre (or the radius of its inscribed circle) fixed at .809017.

This being, however, the first of the correlations met, the details should perhaps be
submitted to illustrate the method to such readers as are unfamiliar with such matters;
and using Plate 302 below we have:

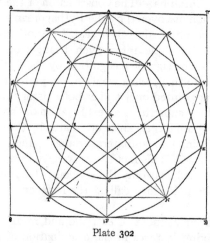

Plate 302

(1) $BG : PG :: \sin P : \sin B$ or

(2) log. 1.000 : x :: log. sin 90° : log. sin 54° or

(3) .0000 : x :: 10.00 : 9.907958.

From this, the logarithmic result of $- 1.907958$, reduced to decimals, gives us the
distance PG (the radius of the circle inscribed in the prime pentagon) as .809017.

To obtain the length of the side BC we have, of course, merely to substitute BP (one half of BC) in place of PG, and 36° in place of 54°, when we obtain in the same manner .58779 for the decimal equivalent of BP, or 1.17557 for BC, the side of the prime pentagon.

Drawing the line BI at 18° in accordance with the author's description, we have:

(4) $BP : PI :: \sin I : \sin B$ or

(5) log. .58779 : x :: log. sin 72° : log. sin 18° or (in logarithms)

(6) $-1.769219 : x :: 9.978206 : 9.489982$

From this we derive the result of log. $PI = 1.280995$ which, reduced to decimals, fixes the length of PI as .190987. By subtraction we obtain:

Position of the prime pentagon at PG .809017
Distance PI .190987

Position of the circle of second progression .61803

Turning now to the appendix notes on extreme and mean proportion, we find that the decimal equivalent of the greater, in extreme and mean ratio, is .618033, while the decimal equivalent of 5 : 8 is .625000 thus proving beyond possibility of doubt that the proportion between the radii is one of extreme and mean ratio rather than 5 : 8.

(2) Page 22, Plate 5. The author states that the side of the pentagon in the first progression, produced, will cut the horizontal at the intersection of the prime pentagon.

We must first find at what point on the horizontal the line VoM produced will intersect, and second, what point on the horizontal is cut by the prime pentagon.

The decimal value of VoC is already known to be .61803399 and the angles Vo and X are 54° and 36°, and solving by logarithms we have the position of X in the triangle $VoXC$ as the decimal equivalent of -1.929751 or at .850650 from the point C.

In the same way, the prime pentagon will be found to intersect the horizontal at a point in the triangle ACX distant on the horizontal precisely the same amount.

The point X is therefore the same in either case and the correlation is correct.

(3) Page 22, Plate 5. The author states that the radius of the circle inscribed within each pentagon is octant to the radius of the circle circumscribing the preceding pentagon.

The position of the prime circle is fixed at Rad. 1.000 and it has already been seen that the radius of the circle of the first progression is .61803399 as well as that the horizontal of the pentagon of the second progression (as all inscribed pentagons) will be placed decimally at .809017 *of its radius* from the centre. It is clear then that the position of the circle inscribed within the latter will be .809017 of .61803399 of the radius of the prime circle, and this proves to be exactly the decimal .50 or the half of the decimal value of the radius of the prime circle. The two are therefore octant.

(4) Page 24, Plate 5. The author states that if with F as a centre and Fio as a radius an arc be struck cutting the horizontal at z the horizontal will be divided in the proportions of 5 : 8.

It has just been shown that the radius $CF = .50$ and $Cio = 1.00$ and hence the radius Fio will be obtained from the equation

$$(\text{1}) \quad Fio = \sqrt{.50^2 + 1.00^2} = \sqrt{1.25} = 1.11803399$$

Deducting from this the distance of F from C or .50 we have left the decimal representation of the distance of z from C as .61803399 which is the equivalent of exact extreme and mean proportion, rather than the Fibonacci series.

(5) Page 24, Plate 5. It is stated that the Egyptian triangle drawn from the pole of the prime circle will pass tangent to the circle of the first progression.

Before it is possible to understand the solution of this correlation, it will be necessary for the reader to examine the editor's Note E on the Egyptian triangle, after which it will be clear why, in all mathematical tests in these notes, the actual angle is 51° 20′ 24″ and not 51° 30′.

If in Plate 5 the line LC be considered as drawn to the centre from the point of tangency to some circle, and the angle LKC be 38° 39′ 36″ (complementary to the Egyptian triangle formed with the base), it will be found that the radius of the circle so inscribed is represented by the logarithm -1.795670, from which it appears that the radius of the circle so inscribed is fixed at .624692 of the radius of the prime circle. Egyptian triangle circle is therefore .624692

It has been previously shown that the position of the circle of the second progression of the pentagon is decimally fixed at .618033

The variation of the statement of the text from the mathematical precision is therefore less than one percent, though visible (see Plate 18) .006558

(6) Page 24, Plate 5. It is here stated that the horizontal of the Egyptian triangle, from the point where it intersects the prime circle, will approximately intersect the pole of the pentagon in the circle of the third progression.

In the triangle $KEiO$ drawn from E (the point of intersection) to the pole of the prime circle at iO, the diameter KiO equals R. 2.000 and the angle $EKiO$ is 38° 39′ 36″, while the angle at E is necessarily 90° and from this we learn that the logarithm of the distance EiO is 1.096700, giving the value of radius 1.2436 to this distance. In the same way we find that the decimal value of the distance of the horizontal from E to the vertical (disregarding for the time the pentagon) is Radius .78049 and deducting this from R. 1.000 we have, for the distance CU, the value .21951.

The position of the circle of the third progression of the pentagon will be found upon consulting the note on the progressions to be fixed at Radius .2360673

Position of the horizontal from the intersection of the Egyptian triangle and the prime circle as above Radius .21951

Amount of variation in this case = Radius .01655+

(7) Page 24, Plate 5. Stated by the author that a horizontal line drawn from the intersection of the Egyptian triangle and the square will cut the vertical at a point octant to the radius of the circle inscribed in the first progression of the pentagon.

It has been shown that the inscribed circle of the first progression of the pentagon has a radius of .500000.

It is shown in the note by the editor on the Egyptian triangle, that the horizontal of the triangle of 51° 20′ 24″ is at 5 : 8 from the base or fixed at Radius .250000.

This is exactly octant to the above distance.

(8) Page 26, Plate 6. The author states that the upper leg of the pentagon in its horizontal position in the first progression, coincides with the position of the first progression of the equilateral triangle and also of the second progression of the square.

Note 3 above demonstrates that the position of the horizontal of the pentagon in its first progression, as measured by the radius of its inscribed circle, is fixed at Radius (prime) .5000000.

Upon consulting the notes upon the equilateral triangle and the square, it will be found that the first progression of the former and the second progression of the latter are alike measured by the same decimal of Radius .5000000.

All three therefore coincide in a position octant to the prime tangent.

(9) Page 26, Plate 6. It is stated that the sides of the pentagons in their two prime positions intersect on the line of the upper leg of the equilateral triangle, and that the intersection divides the side of the pentagon into two segments bearing the extreme and mean proportion to each other.

(1) Is the intersection on the octant line?

(2) Is the segmental division an extreme and mean one?

(1) Designating the upper pole of the prime circle in Plate 6 as N, the octant line TT forms a triangle VAN in which AN is .500 and the angles are 36° and 54° respectively. Resolving the triangle, we find that the position of the point V on the line VN is .85065.

Indicating the crossing of the two lines VN and CM as W it has already been shown that CM is 1.00 and CW is .809017, hence $WM = .19098+$ while the angles in the triangle VWM are 36° and 54° since VMW is one half of 108°. From this it follows,

that the side VW (log. -1.419732) has a decimal value of .262867, and the side VM (log. -1.511774) a decimal value of .324917. The line VN consists of $2VW+VM$ or Rad. .850651, and this position is the same as that of the line TT as shown above. The pentagons therefore intersect on the line TT.

(2) Is the segmental division an extreme and mean one?

The distance VN has been shown to be Rad. .85065
The distance VC is twice VW or Rad. .525734
The ratio of .525734 : .85065 is found to be exactly the decimal value of the greater term in extreme and mean proportion, or .61803+

(10) Page 26, Plate 6. Here stated that the pentagram line MB approximately intersects the corner of the square at S.

The position of the pentagram line at its crossing of the line TT is found in the triangle BAS to be at a point measured from the vertical BN of Rad. .48738
while the position of the point S from the same vertical is known (see square) to be .50000

The variation from precision is therefore measured by their difference, or Rad. .01262

(11) Page 26, Plate 6. Stated that the pentagram line MB will coincide with the line of the pentagon in the second progression.

If this be true, then in the triangle BUH we shall find the side UH equal to the decimal which designates one half of the side of the pentagon in its second progression.

Side UH in triangle BUH equals Rad. .224515.

From the tabulation of progressions it will be seen that the position of the second progression is .3090169 and from this the length of the side is derived, of which UH is one half or .224515.

The correlation is therefore correct.

(12) Page 26, Plate 7. Stated that the angle of 63° drawn from the pole 0° will intersect the apex D of the pentagon and will then cut the corner of the prime square.

Under the note on the rectangles it will be found that the diagonal of the half square is, in exact figures, 63° 26′ 5″, and it necessarily follows that this will be the angle which will precisely reach the corner of the prime square from the pole 0° at the central horizontal.

The distance C to B has been shown in proof (2) to be .85065 and AC is therefore 1.85065 and angle $B=180°-108°=72°$. By comparing the sum and difference of the sides with the sum and difference of the tangents, the angle BOD is seen to be 27° or, exteriorly, 63°.

It will be seen that this does not correspond exactly with the diagonal of the half

square, and further, if measured from the corner of the prime square, the variance will necessarily increase as the distance diminishes.

(13) Page 26, Plate 7. The author states that the circle inscribed within the lines of 63° will measure the rectangle of 42°.

Inscribing a circle to which the side *OX* shall be tangent, the radius will be *CE* and in the triangle *CEX*, the radius *CE* is found to be (-1.650514 log.) of a decimal value, in terms of the prime radius, of .447212, giving the diameter of .894424, while the height of a rectangle of 42° as shown in the notes on the rectangles is found to be .900406. The variance is therefore about half of one percent.

(14) Page 26, Plate 7. Stated that the side of the prime pentagon produced from *G* will intersect the square at the horizontal of the angle of 42° at *i*.

The distance from *B* to *O* in proof (2) is shown to be $1.00 - .85065$ or, in terms of the prime radius .14935
In a triangle drawn from *B* to *F* to *i*, the distance *Fi* is determined to be .14628
 ———
Showing a variance of .00307

(15) Page 26, Plate 7. Stated that the sides of the pentagon and the pentagram lines are in proportion of 5 : 8.

In the diagram 302 it is clear that the triangles *AVH* and *AXH* have the angles *XAH* measured by the arc *TH*/2 and *HAV* measured by *HV*/2, but *TH* and *HV* are equal: further, *VHA* and *XHA* are equal, and the side *HA* common, whence it follows that:

In every pentagon, one side of the perimeter is equal to that part of the pentagram line between the apex and the intersection.

Since the sides of the triangle will be proportional to the sines of its angles, and since the angles of the triangle under examination are respectively 108° and 36°, the difference of their logarithms will yield the ratio of the sides, and we have 9.769219 less 9.978206 = -1.791013, which in its decimal form is easily recognized as the equivalent of exact extreme and mean proportion (.61803+).

Hence the pentagram at the secant is divided into precise extreme and mean proportion and not the ratio of 5 : 8, and the side of the pentagon bears the same ratio to the pentagram line as a whole.

(16) Page 28, Plate 7. Stated that the proportions of the Pythagorean triangle of 3, 4, and 5 units are repeatedly found in the pentagon.

This is nearly, but not quite true. See explanation under Note F on the Pythagorean triangle.

(17) Page 28, Plate 8. Stated that the pentagram lines are divided in extreme and mean proportion at the secant.

 Consult analysis of proof (15) above.

(18) Page 28, Plate 9. Stated that the horizontal of 42° will rest on the side of the fourth progression of the pentagon.

 Note I on the progressions discloses the fact that the position of the fourth progression of the pentagon, in terms of the prime radius, is at .1180336 from the centre, or .8819664 from the base, and consulting the notes on the rectangles, it will be seen that the position of the horizontal of the rectangle of 42° is .900406.

Position of the horizontal of 42°	.900406
Position of the fourth progression	.8819664
Measure of the error of nearly 2%	.0184396

It may here be said that both in this and in the succeeding explanation the horizontal is taken from the intersection of the angle of 42° and the square. If taken from a horizontal drawn from the secant point of the angle of 42° and the prime circle, to insure an angle of 48° thence to the upper pole (as explained in the foot-note, page 32), the error would be slightly decreased; but in that case the ends of the rectangle of 42° would not coincide with the prime square, so that the very slight decrease in the error would be more than offset in design by the greater complication.

 The statement is, however, nearly enough correct if used only as a check and with knowledge of the variance.

(19) Page 28, Plate 9. The author states that the horizontal of the rectangle of 42° will divide the five-pointed star at the intersection of the pentagram lines.

 Again utilizing diagram 302, the value of the line AX is known to be the same as that of AS from proof (15), hence AX in terms of the prime radius $= 1.17557$, while the angles of the triangle AXZ are 18° and 72° respectively. Solving this we obtain a logarithmic value of 0.048454 or 1.11804 for the value of AZ, placing the intersection of the pentagram lines, regardless of the horizontal of 42°, at .11804 from the centre, or, measured from the base, at R. .88196.

 It thus appears, as compared with the above, that the intersection of the pentagram lines is identical with the position of the fourth progression of the pentagon, and the variation between this and the horizontal of the angle of 42° will be the same as in the preceding instance, and measured in terms of the prime radius by the decimal .0184396 or approaching two percent of error. The correlation is, however, useful as a check in design making, and with a knowledge of the amount of the variation, can be safely used for that purpose.

(20) Page 28, Plate 9. It is here stated that the distance from the lower horizontal of

the pentagon to the upper apex is divided by the horizontal line *ii* into a ratio of 5 : 8 or approximately the Fibonacci series.

This statement may be viewed in two ways, either (1st) considering the line *ii* as the pentagram line, or (2d) considering it as the horizontal of the angle of 42°. Testing it under the first condition, the division is found to be as follows:

Pentagram crossing, proof (18), 1.11804

Horizontal of pentagon, proof (1), 1.809017

1.11804 : 1.809017 = (in terms of the prime radius), the decimal value of .61803+

It thus appears that the distance is, by calculation, divided into an exact extreme and mean proportion rather than 5 : 8 when the line *ii* is considered as the pentagram. Otherwise the error would be as shown in proof (18).

(21) Page 32. Statements regarding the progressions of the octagon, square, and pentagon referred to on this page will be found treated in Note C on the square.

THE EGYPTIAN TRIANGLE

NOTE E

IN days of hoary antiquity,—long ages before Abraham the son of Terah left Ur of the Chaldees for the land of Canaan, and a thousand years ere Moses led the oppressed children from beneath the heavy hand of Pharaoh,—the inscrutable spirit of the Nile saw rising in its sacred valley in slow majesty, stone by stone, year by year, reign by reign, those imposing tombs of Gizeh, the pyramid mausoleums of Khufu, Khefren, and Menkewrē, which are among the most stable and enduring of all human structures. They symbolize many of the religious tenets of the old Egyptian faith, and typify many of their mathematical discoveries and engineering marvels. Among other things revealed to us by these proud evidences of a past glory is the advancement made by the priests in the knowledge of mathematics, one example of which is shown in their constant structural use of the figure frequently referred to in later days as the Egyptian triangle.

What may have been the origin of the proportions of this triangle we can only conjecture, since all is enveloped in the mist of dynasties crumbled and peoples long extinct. Whether it arose from an almost prehistoric knowledge of that which Euclid afterward called the "Divine section," whether it had for these early priests a religious or only an architectural significance, and whether their knowledge was an achievement or an accident, will probably never be definitely learned; but this we do know, that the proportional members which they so persistently used in these and other monuments are wonderfully adapted to the proper adjustment of spaces in design, and have been so used from time immemorial.

There have been many archeological surveys covering the dimensions and angles of the principal pyramids, and in view of the ruinous condition of the exterior coating of most of these structures it is not unnatural to find slight diversities in their results, but we may safely take any one authority as fairly illustrating the conditions, and for this purpose the editor has accepted the survey of General Howard Vyse, the British authority, from whose field notes it appears that the angle of the Pyramid of Khufu is one of 51° 52', that of the Khefren Pyramid 53° 10', the Pyramid of Menkewrē 51° 10', and the ancient Pyramid of Meidum, ascribed to Snefru, 51° 52'.

Whether or no the angle aimed at was in all cases the same, it is impossible to ascertain, though the extreme nicety with which the builders laid out their base squares and other proportions would seem to make variation of two degrees in the angle of elevation more designed than accidental. The one showing the greatest inclination (Khefren, 53° 10′) is very closely allied to the angle produced by the double triangle of Plutarch (53° 7′ 48″) as will be found explained in the note on the Pythagorean triangle; while the triangle referred to by several authorities on Egyptology (M. Jomard and others) is that which is eight units in base with an altitude of five of the same units, and of this form with the ratio of 5 : 8 the author has made constant use. This latter triangle the editor has resolved as having a basic angle of 51° 20′ 24″ as shown later, and has been uniformly designated by the author in round numbers as the Egyptian triangle of 51° 30′. Wherever, therefore, this angle is used in the text or diagrams, it must be understood that in these notes it has been treated as in fact invariably meaning the angle of 51° 20′ 24″, and the same explanation is to be carried in regard to the complementary angle of 38° 30′.

Of the Egyptian triangle as so used in the author's text, the first and most conspicuous fact will be seen to be that its altitude is always to its base as five is to eight, and that, therefore, this altitude always coincides with the position of the fourth progression of the square or the second progression of the equilateral triangle, as already shown under those heads in these Appendix Notes. As to Divine Section, see footnote, page 308.

Test of the author's correlating statements.

(1) Page 44, Plate 18. Stated that the second circle of the progression of the Egyptian triangle will coincide with the same circle in the progression of the pentagon, or nearly so.

Consulting the tabulation of the progressions at Note I, it is shown that the second circle in the progression of the Egyptian triangle is	.624692
In the same way it appears that the second circle of the progressions of the pentagon is	.618033
Variance, negligible,	.006558

(2) Page 44, Plate 18. For the diagonal of the double Pythagorean triangle, see Appendix Note on Rectangles.

(3) Page 44, Plate 18. Stated that the lower horizontal of the fifth progression of the Egyptian triangle coincides with the horizontal of 42°.

Tabulation of the rectangles places the horizontal of 42° at .900406 from base or, from centre, at	.099594
Tabulation of the progressions places circle of the fifth progression of the Egyptian triangle at	.095136
Error, negligible,	.004458

(4) Page 46, Plate 19. It is here stated that the angle of 66° from the corner of the
 prime square passes tangent to the circle of the first progression of the equilateral
 triangle.

For the purposes of this proof it becomes necessary to use the real diagonal
of the rectangle of 42° which upon referring to the notes on the rectangles is
found to be 65° 45′ 45″ rather than 66°. The circle to which the angle of 65/
45/ 45 so drawn is tangent is discovered on examination to be of a radius of .501337
Radius of the circle of first progression of the equilateral triangle is known to be .500000

Error, negligible, .001337

EDITOR'S NOTE.—The only form of the Egyptian triangle touched upon here is the one having a ratio of
5:8, since that is the only proportion utilized by the author. This ratio, as has been seen, produces an angle of
51° 20′ 24″. It has been by many supposed, however, that the aim of these ancient builders was to produce a
triangle exactly escribed by the rectangle of extreme and mean proportion. Assuming this for the moment, we
find that the hypothetical Egyptian triangle so formed would have a base angle of 51° 1′ 35½″.

THE PYTHAGOREAN TRIANGLE

NOTE F

THE marvellous mind of Pythagoras, if it did not actually conceive, certainly formed and promulgated the theory of triangles which to this day bears his name. This theory had to do with the creation of true right-angled triangles in whole numbers, and in substance it was to the effect that by taking any odd number for the lesser side, and half of the square of this number diminished by one for the second side, and adding one to this for the hypothenuse, a right triangle would result (*e.g.*, 3, 4, 5, or 7, 24, 25, etc.). Of all the innumerable triangles which it is possible so to create, the form having sides of three, four, and five units respectively is by far the best known, having been especially mentioned by Plutarch and occasionally called by his name.

In the author's text, the triangle denominated Pythagorean is this familiar form, and never one of the many others possible to be composed under the Pythagorean rule.

Because of the long investigation of the pentagon accredited to Pythagoras and the similarity of this triangle with certain features of the pentagon, it is not infrequently stated that its angles are identical with those of the latter. This is in most cases sufficiently correct for the purpose of the illustration for which it is used, but from a mathematical standpoint, wherever the variance may be important, it may be stated that the angles of the Pythagorean triangle are 36° 52′ 12″, 53° 7′ 48″, and 90°, while the angles of the pentagon are 36° and 54°.

Thus it will be seen that two of these triangles standing back to back upon their four unit sides will almost but not quite coincide with that part of the pentagon between the horizontal pentagram line and the upper apex.

THE IDEAL ANGLE AND ITS RELATION TO EXTREME AND MEAN PROPORTION

NOTE G

BY the ideal angle the author is understood to refer to that theoretically perfect measurement at which many botanists have presumed that Nature aimed in sending out leaves, shoots, and cell formations in the early stages of development. Careful examination of the first zone of growth shows evidence that Nature's tendency in plant life is always to put forth shoots alternately at points more or less opposite the original pole, and great effort has been made by authorities on botany to arrive at a definite rule whereby the angle at which the next shoot would appear might be calculated. Many of these theories have resulted in divisions of the first zone of growth into fractional arcs of 138° or thereabouts, of which the ultimate angle at which Nature was thought to aim was called the "ideal angle."

For the purposes of this work, the editor would have the reader particularly note that the author has utilized an average of these fractional arcs by adopting a composite for the comparison of design in an ideal angle of 42° (supplementary of 138°). The correlations of the text are on plane rather than curved surfaces, and it appears almost essential that all of the harmonic angles should be brought within 90°, which is accomplished satisfactorily for the end in view by the use of an angle of 42° with its complement of 48°, disregarding the subdivisions of degrees appearing in the botanical form of the ideal angle as being unnecessarily cumbersome.

For a great many years, numbers of botanists have endeavored both with microscope and mathematics to determine whether these ideal angles of divergence were to be regarded in Nature's hands as a means or an end, and also to ascertain with minutest accuracy what the fractional segment of the ideal angle really was; but so far, all efforts at a definite result have been baffled by the difficulties presented in making the delicate measurements necessary to the proper application of any one of the various theories.

It is clear that, whether the relation of a series is or is not indispensable to plant growth in asymmetrical construction, Nature very surely gives constant evidence of her intention to put forth leaves and shoots at intervals which she governs; and while, as one of the authorities well says, "the numbers of the constructive curves must be integers,"

yet it does not follow that the fractional angle at which they are put forth must be commensurate with a *single* measurement of the circumference, as this circumference is constantly enlarging and Nature may measure as many times around the plant circle in putting forth shoots or florets as she elects before filling out the row or "coming out even" so to speak.

In order to make this explanation as brief and clear as possible, only three examples of the estimated ideal angle will be here stated. Different botanists, some comparing their theories with the Fibonacci series, have calculated the probable ideal angle at $137°\ 30'$, $137°\ 30'\ 28''$, $137°\ 30'\ 27.936''$. Of the three forms here set forth, the first two only are based on measurement and actual observance, the third being the equivalent of the Fibonacci series at infinity and thus theoretical only, since it represents that series at no stated step or stage but, as it might be expressed, is its composite reduced to angular form. In other words, it is what the Fibonacci series would be if it were mathematically perfect and continuing. None of the early authorities offer in support of these ideal angles much evidence other than such as can be gleaned from microscopic examination, counting of parts, and other delicate measurements too minute, too uncertain, either to prove or disprove the theories. It is natural, therefore, that all should differ in their arguments and conclusions, as well as in the mathematical rules deduced.

Arguments as to the probability or extent of Nature's use of a fixed ideal angle have been fully and learnedly carried on by botanical experts and would have no place here, but the point germane to our subject is to show, if possible, some reason which may lead to the fixing of a logical ideal angle upon a basis analogous to other known and accepted practices of Nature. Without, therefore, going into the scientific details deeply, but as being directly in point with the work in hand, the editor will present the outline of a suggestion not perhaps without interest.

All investigations of Natural phenomena proceed along one of two lines: the building of a theory upon proved facts or the construction first of a theory from analogous conditions and its subsequent support by investigation. The first method is unimpeachable where it is possible to ascertain the facts with certainty, but it is admitted by all that the accurate measurement of botanical angles is as yet unaccomplished, and this mitigates strongly against all synthetic theories and arguments concerning the ideal angle, so constructed. The second method is, however, free from this objection. That Nature continually uses extreme and mean proportion as a measuring rod is true beyond peradventure; that the resemblance between the botanically probable ideal angle (as predicated on microscopic measurements) and the limiting ratio of the Fibonacci series has been recognized; that this limiting ratio represents a hypothetical formula at infinity and not a finite condition is demonstrable; that the employment of this series in many of the investigations concerning the ideal angle has been a purely mathematical one and without the slightest recognition of Nature's

continued use of an exact extreme and mean proportion in other departments is seen by examination of various works on the subject; that extreme and mean proportion is a perfect and continuing series we have already seen; and having in the first of these appendix notes shown a method of determining this proportion decimally and, thereupon, angularly as well, we are in a position to declare its use by Nature wherever found, and the farther the search is carried, the more convincing is the proof that extreme and mean proportion is one of Nature's most constantly utilized measures, not only of lineal distances and as governing superficial spaces and bulk proportions but in curves and angles also. This being indisputable, the experiment of applying the angular equivalent of the extreme and mean proportion to circular growth is a natural and logical step, and the outcome is striking.

Ideal angles propounded by various authorities, as stated above:

$$137° \; 30' \; : \; 137° \; 30' \; 27.936'' \; : \; 137° \; 30' \; 28''$$

Angular equivalent of extreme and mean proportion

$$137° \; 30' \; 27.934''$$

The most casual glance will show how perfectly this angle of extreme and mean proportion, which we already know to be one of Nature's standards, coincides with the various angular forms suggested for the ideal angle, and while advancing no argument in favor of or against Nature's use of any ideal angle or series whatever, it is nevertheless not unreasonable to suppose that if and when Nature utilizes any ideal angle botanically in the first or other zone of growth, whatever be the resulting form or integral count at the moment of measurement, it is highly probable that she in fact ultimately aims at the same proportional equivalent toward which she so constantly leans in her linear and superficial measurements.

Accepting this is, of course, at once to understand that no accumulation of microscopic measurements could unaided establish a more fitting solution than that presented by this angular equivalent of extreme and mean proportion, perennially utilized by Nature in all branches of her creative domain.

This one feature of the ideal angle, whether considered academic or practical, is here condensed from a former article by the editor simply because of its bearing on the subject, and with no desire to make the author in any way responsible for it.

The author's correlating statements are tested as follows.

(1) Page 48, Plate 20. It is here stated that the fourth circle of 42° passes tangent to the pentagram line drawn from the pole of the prime circle.

The radius of a circle inscribed within the pentagram line is found to be	.309016
The radius of the fourth circle of the progressions of the angle of 42° is found in the note on the progressions to be	.304991
Error, to be disregarded for the purpose,	.004025

(2) Page 48, Plate 20. Here stated that the horizontal from the eighth progression of
42° will indicate the original horizontal of 42°.

The position of the horizontal of the rectangle of 42° is .900406 above
the base, or, from the centre .099594
 The eighth progression is at .0930215

 Error, immaterial for the purpose, .0065725

(3) Page 49, Plate 21. Stated that the square of the fifth progression escribes the circle
of the sixth progression of the angle of 42°.

Reference to the note on the progressions shows that the amount of error in this
statement is limited to .008339, but is not unimportant.

(4) Page 49, Plate 22. Stated that the Pythagorean triangle in the primary circle has
its horizontal side resting on Circle 4.

For the purpose of this examination, it must be remembered that the Pythagorean
triangle does not coincide with the pentagon. (See Note F on Pythagorean triangle.)
To make any coincidence possible, it must be assumed that the triangle intended is the
one of exactly 36° and 54°, rather than the strict Pythagorean triangle of 3, 4, and 5
parts, since, were the latter employed, its sides would not correspond with those of the
pentagon with which it is here being compared.
Starting then with the triangle of 36°, the result will be found to be the same as that
in proof 1 above.

(5) Page 49, Plate 22. Here stated that the angle of 18° drawn in Circle 4 will, within
approximation, give the pentagon in Circle 5.

This will, of course, be true within the same limits as govern the preceding proposition.

(6) Page 49, Plate 22. Stated that a vertical from Square 5 will cut the base into the
ratio of 5 : 8.

The actual ratio would be five of base *to* eight in height or five *in* eight of the base.
The difference between these ratios of 5 to 8 and 5 in 8 is explained at some length in the
note on extreme and mean proportion (Appendix, Note A) where the editor has tabu-
lated the variations from true proportion shown by the Fibonacci series.

THE VESICA PISCIS

Note H

FROM the earliest Christian times the fish has been symbolic of the religion of Christ, though precisely what may have been the origin of the symbolism it might be difficult to determine. By some it is attributed to the miracle of the draft of fishes, as typifying the gathering in of souls; by others to the anagram ἰχθύς, signifying "fish," and derived possibly from the expression Ιησοῦς Χριστός, Θεοῦ Υἱός, Σώτηρ (Jesus Christos, Son of God, Saviour), the five initial letters of which, treated as an anagram, give the word ἰχθύς as above.

Whatever be the derivation, the symbolism was one of the earliest recognized. It is not at all improbable that the desire to perpetuate this significance in stone led first to the acceptance of the vesica piscis in proportioning of details, and later may be presumed to have had a more or less direct influence upon the growth of the gothic and pointed styles of architecture, since these, whether intentionally or unintentionally, are clearly based upon the curves which comprise the figure so known. Whether the structural advantages of an arch of two foci led to the decorative effects which we recognize under this system, or *vice versa*, is a question impossible to answer, but the geometric similarity between the architectural result and the form of the vesica piscis is impossible to ignore.

THE PROGRESSIONS

NOTE I

FOR both its service and the information it conveys, the editor submits the following tabulation prepared by him to show the decimal equivalents of the horizontal position of the various progressions in terms of the prime radius. It will readily be understood without explanation.

TABULATION OF PROGRESSIONS IN TERMS OF THE PRIME RADIUS.
BY THE EDITOR.

Number	Equilateral Triangle	Square	Pentagon Apex Circles	Pentagon Horizontal
Prime	1.00000000	1.00000000	1.00000000	.809017000
1	.50000000	.70710678	.61803399	.50000000
2	.25000000	.50000000	.38196601	.30901695
3	.12500000	.35355339	.23606730	.19098300
4	.06250000	.25000000	.145902	.1180336
5	.03125000	.17677669	.090170	.072951
6	.01562500	.12500000	.055728	.045085
7	.00781250	.08838834	.0344417	.027864
8	.00390625	.06250000	.0212863	.0172208
9	.00195312	.04419417	.0131556	.0106431
10	.00097656	.03125000	.00813053	.0065778

Number	Hexagon	Octago	Egyptian Triangle	Ideal Angle 42°
Prime	1.00000000	1.0000000	1.0000000	1.000000
1	.8660254	.92388	.624692	.743143
2	.7500000	.853553	.390249	.552261
3	.6495180	.788583	.24379	.410410
4	.56250000	.728553	.15229	.304991
5	.4871390	.67309	.095136	.226651
6	.4218750	.621859	unused	.168437
7	.3653540	.574523	unused	.125173
8	.3164070	.53079	unused	.0930215
9	.274010	.49038	unused	unused
10	.237305	.45306	unused	unused

THE RECTANGLES

Note K

VARIOUS rectangles and their diagonals are referred to by the author. They are here tabulated decimally in terms of a prime radius or half base, and each escribes a double triangle.

Rectangle	Vertical	Base	Diagonal as Referred to by the Author	Actual Diagonal as Calculated
Equilateral triangle	.57735	1.00	60°	60°
½ square	1.000	2.00	63°	63° 26′ 5″
Egyptian triangle	1.250	2.00	58°	57° 59′ 40″
42°	.900406	2.00	66°	65° 45′ 45″
48°	1.11060	2.00	61°	60° 27′ 25″
3, 4, 5 horizontal	.75	2.00	70°	69° 26′ 38″
3, 4, 5 vertical	1.50	1.00		56° 18′ 35″
36° horizontal	.72654	2.00	70°	70° 2′ 7″
36° vertical	1.45308	1.00		55° 27′ 46″

SPIRALS

NOTE L

THE only spiral with which the work has to do is the logarithmic form frequently found in shells and plant life, and concerning this some slight explanation is probably necessary, especially in relation to the method adopted by the author in illustrating its harmony.

To those versed in the logarithmic spiral, three points will at once occur in this connection: first, that in the illustrations, the curve is depicted only by chords joining vectors quadrant drawn from the spiral vortex; second, that as the curve is viewed always from the perpendicular, the angles appear on the diagrams to alternate; and third, that the angle used by the author to designate the curve is that formed by the quadrant chord and radius and in the diagrams is not always the angle which from the technical standpoint would be considered the measure of the spiral.

Regarding the first of these points, the editor need only say that while the author's plan of describing a spiral as shown in the diagrams might at first glance be thought to conflict with the definition which requires that in a logarithmic spiral *every* radius vector must be intersected at the same angle, and not merely quadrant radii from the spiral vortex, actually, however, the question presents no such difficulty, since there is no claim that these angles are the technical measure of the spiral and, moreover, it will be observed that at the termination of each arc, the vectors of the preceding and succeeding portions of the curve coincide precisely so that the measurement of the spiral angle on either would be the same, and this would be true at any point. The curve thus created is a sufficiently accurate logarithmic spiral for the purposes to which it is put, namely, design.

As to the second point, while it is perfectly clear that, since the logarithmic spiral intersects all radii vector at the same angle, this angle must be a constant and not an alternating one, yet it is equally true that if the diagram be viewed only from the perpendicular instead of being turned around to follow the radii, the angle, so viewed, will appear alternately in its own form and that of its complement, and this would be true whether the angle in question be that formed by the quadrant chord or otherwise. If, therefore, the diagram be turned about from radius to radius or from quadrant to quadrant, following the curve of the spiral, and each time viewed from the new base, it

will be found that the angle (whichever be used) will then present a constant and not a variable form. Hence it should be borne in mind, in examining these angles from the convenient upright position, that the author has in the diagrams shown them as they appear, designated by the degrees of the constant angle alternating with its complement, and that this occurs wherever spirals are under consideration in the work.

As to the third point mentioned, the editor realizes that the angle of the quadrant chord as shown in the diagrams may not be the perfect measure of the spiral nor is it at all necessary that it should be so considered. The chords serve to define the position of the spiral vortex and convey the outline of the curve. Their simplicity and clearness recommend them, and their accuracy is entirely sufficient for the design purposes to which they are put.

The author's correlating statements concerning this subject are mathematically examined, with the following results:

(1) Page 96, plate 68. The measurement of this spiral by the angles of 24° and 66° in the manner suggested by the author is sufficiently correct for the purpose although not the customary method.

(2) Page 96, plate 69. The measurement of all the spirals following are made in the same way as those of plate 68 and subject to the same comment.

(3) Page 100, plate 70. The secondary spiral referred to is seen again and more plainly in plate 72, and is frequently referred to by Dr. Church as well as by the author, whose mode of measurement is the same as for the simpler form of spiral.

(4) Page 105, plate 75. The author's statements concerning the pentagram lines should be compared with the editor's notes 18, 19, and 20 in the Appendix Note D on the pentagon, where the existence and extent of such errors as occur are explained.

(5) Page 111, plate 89 *et seq*. The author here notes the apparent coincidence of the progressions of the equilateral triangle and square with extreme and mean proportion. This does occasionally occur, though seldom, and it is necessary to bear in mind that the coincidence of the triangle and square in the ratio of 5:8 (with its decimal value of .625) calls instant attention to the improbability of the concurrence of a precise extreme and mean proportion with its value of .61803.

(6) Page 119, plate 103; Page 120, plate 104; Page 124, plate 104; Page 125, plate 109; Page 127, plate 112; Page 136, plate 118; Page 137, plate 119. The details of the symmetries here described by the author have been sufficiently tested but the meagre use to which they are put in the text does not warrant any review of the facts further than to say that such errors and variations as occur do not disqualify them for the use in design work.

ANIMATE LIFE

NOTE M

THE following statements regarding animate life found in the text should be read in connection with the appendix notes indicated.

(1) Page 154, plate 139; Page 155, plates 140 and 142; Page 163, plates 154 and 155. The correlations used in these plates are nearly all of them dependent upon the figures themselves and can be tested ocularly. In so far as they involve demonstrable statements, they will be found treated in preceding notes.

(2) Page 175, plates 163 and 164. The various statements concerning the pentagon in connection with the Hermes of Praxiteles should be compared with the notes under that head in Appendix, Note D.

(3) Page 176, plate 165. For an analysis of the correlations used in this diagram, see Appendix, Note C on the square.

(4) Page 181, plate 166; Page 182, plate 167. The description of the human figure as correlated, should be read in connection with Note A, subdivision 5, in this appendix, to avoid confusion between the Egyptian triangle and extreme and mean proportion.

FORCE

Note N

I T is almost unnecessary to call attention to the extreme difficulty of reducing any demonstration of force to such a diagram as may illustrate properly the working of Nature's geometric laws. Those offered by the Editor in the chapter on that subject will, it is hoped, convey a fair impression of the ideas which it is intended they should explain.

Page 192, Plate 172. It should be kept in mind that in studying a musical scale the *vibratory relations* of the various notes are all that are important. The arbitrary standard fixing the number of vibrations which shall be called "A" has no bearing on the subject, since, whatever standard be accepted, the *intervals* would bear the same ratio to each other, each note rising or falling as the standard is higher or lower. Thus the theory governing the vibratory intervals will in all standards be the same. The rapidity of vibration quoted by the editor in the statements regarding sound is taken from the English Philharmonic standard, though any other would serve the purpose as well.

Referring to the Plate 172, it will be seen that C^3, C^2 and C^1 are correlated by progressions of the equilateral triangle, whereby it is clear that they are precisely octant. Figured mathematically and without regard to music, their vibratory relation to each other would be 1056, 528, and 264, which are their precise musical relations. Examining the relations of the tonic and dominant from a purely mathematical standpoint, and in accordance with the diagram alone, we see that the relation of T^3 and D^2 is established by two progressions of the hexagon. Consulting the table of progressions, it will be found that the decimal value of two progressions of the hexagon, in terms of the prime radius, is .7500 and applying this mathematically to the Philharmonic standard with which we started, we find that the vibratory rapidity of dominant should be, according to the trigonometry of the diagram and regardless of music, 792 vibrations per second, which is exactly the number set by the standard. Again, testing the diagram by the standard, we find that the value of the mediant is set in the plate at the extreme and mean division of the total number of vibrations of the tonic above (T^3). This is found to be 653 as against 660 of the standard, a variation of one vibration in every hundred or,

approximately, one tenth part of an average whole tone. It follows from this that the diagram illustrates all of the notes of the common chord throughout the entire scale with a variation of one vibration per hundred in every third note, the other two notes out of every three being absolutely perfect.

Page 200, Plate 178. The comparison of the distances as known astronomically, and as calculated from the diagram, are as follows:

	Known Distance from Sun	Diagram distance from centre by Progressions
Mars	141,700,000	141,700,000
Earth	92,800,000	92,100,000
Venus	67,200,000	67,100,000
Mercury	36,000,000	35,800,000

Considering the vast distances and the uncertainity of the actual measurement, the diagram is quite sufficient for the purpose.

21

ARCHITECTURE

Note O

A S a preliminary to the examination of the diagrams presented by the author in this chapter it should be said, that all measurements of the Parthenon as shown in Plate 180, and all comparisons of this famous building with the Penrose compilation in that plate, were made by Mr. Hambidge.

Of buildings of lesser importance, the measurements were taken from reliable drawings and photographs, supplemented where possible by survey measurements. The author's purpose being one of art and design, rather than engineering, these sources of information were deemed by him entirely sufficient for the accomplishment of the end in view.

The following references are made to the statements of the author as found in the text.

(1) Pages 202 to 211, plates 180 to 185. The Parthenon. The correlations concerning the Parthenon, in so far as they are important, have practically all been examined in the chapters on correlations, and will be found under the several heads of pentagon, square, etc.

(2) Page 206, plate 183. The statements of the author regarding the raking cornice of 14° vary from precision in the same way and to the same extent as described in Note B on the equilateral triangle, subdivisions 3 and 4. Their error however, is not sufficient to disqualify them from the use to which they are put.

(3) Page 212, plates 186 and 187. In relation to the statements of the author regarding extreme and mean proportion in connection with these plates, Appendix, Note A, subdivision 1, describing plate 37, should be examined.

(4) Pages 220 and 222, plates 197 and 198. The ellipses here mentioned are so lightly touched upon that no attempt to examine them would be justified.

(5) Page 241, plate 212. The author refers here to the central portion of the Porta San Pietro as being in extreme and mean proportion to the end, though the figures on the base line mark it as being a ratio of 5:8. This is within the

statement made by him at page 64 to the effect that for design purposes he considers the two ratios sufficiently similar to be interchanged. Their actual variation has already been examined.

(6) Page 243, plate 216. The angles actually correlating the Ca d'Oro as described are of course those of 65° 45′ 45″ as shown in the Note K on the rectangles, rather than the exact angle of 66°.

(7) Page 268, plate 239; Page 269, plate 240; Page 270, plate 241. The author describes several ellipses. No attempt has been made to analyze these for the reader by the methods customary in examining the sections of the cone. They are here put to very small service, and the author's explanation and his method of measurement are sufficient for the purpose of their description.

INDEX

A

Algæ, 145
Alhambra, 237
Amiens, cathedral of, 243, 252
Ammonites Parkinsoni, 137
Amplitude, 187
Animate life, 153, and Appendix, note M
Antedon, 151
Aosta, arch at, 244
Aphæa, temple of, 212
Aphrodite, temple of, 211
Arch of Augustus at Aosta, 244
 at Rimini, 251
 at Susa, 251
 of Titus at Rome, 251
Architecture, 202, and Appendix, note O
Arithmetical series, 11
Asteroidæ, 151
Augustus, arch of, 244, 251 (II)

B

Basilica Constantine, 225
Bassæ, capitals at, 218
Beauty, 5
Begonia, 110
Bently, W. A., 83
Butterfly, 153

C

Ca d'Oro, Venice, 243
Canon, Egyptian, 168
 Greek, 168, 181
Catenary curves, 87, 147
Caterpillars, 160
Chantrell, 55
Chinese vase, 277
Chladni, 194
Choragic monument, 214

C (continued)

Church, A. H., 90, 94
Cologne, cathedral of, 267
Compromise, 7
Coniferæ, 98
Consiglio, loggia del, 238
Cook, T. A., 116
Cordova, mosque at, 241
Correlations, 9
 of force, 184
 of form, 13
 of numbers, 9
Cosmos, 71
Court of Lions, 237
Crinoids, 151
Cuprus Uranite, 76

D

Death and the Knight, 163
Design for a vase, 278
 for a cathedral, 278
Diana, temple of, 218
Diatoms, 141
Diatonic scale, 190
Divine section, 17, 28, and Appendix, note A
Dolium pendix Linn, 134
Dolomite, 77
Doryphorus, 168
Dragon fly, 160
Duccio, Agostino, 241
Dürer, Albrecht, 51, 163

E

Ear, 170
Echinoderm, 151
Egyptian canon, 168
Egyptian triangle, 16, 24, 35; analysis of, 43, and
 Appendix, note E
Elm, 57, 110

325